C A L I F O R N I A

A V I S U A L J O U R N E Y

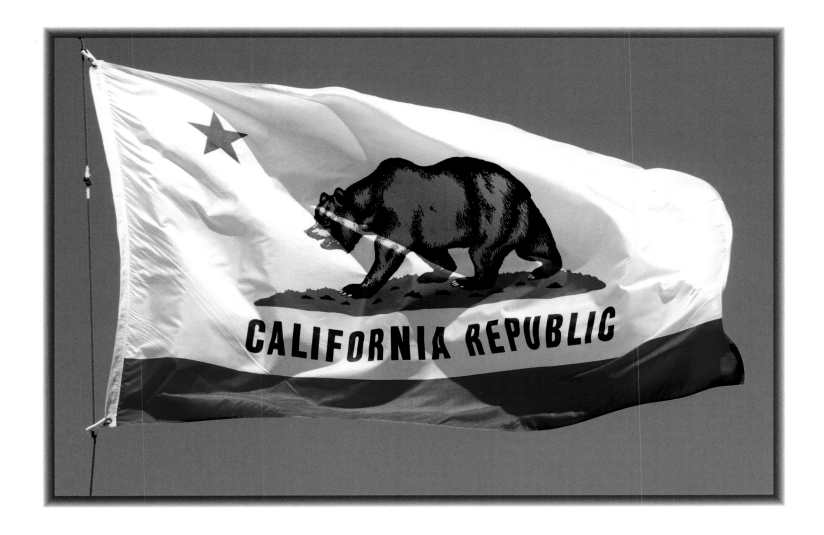

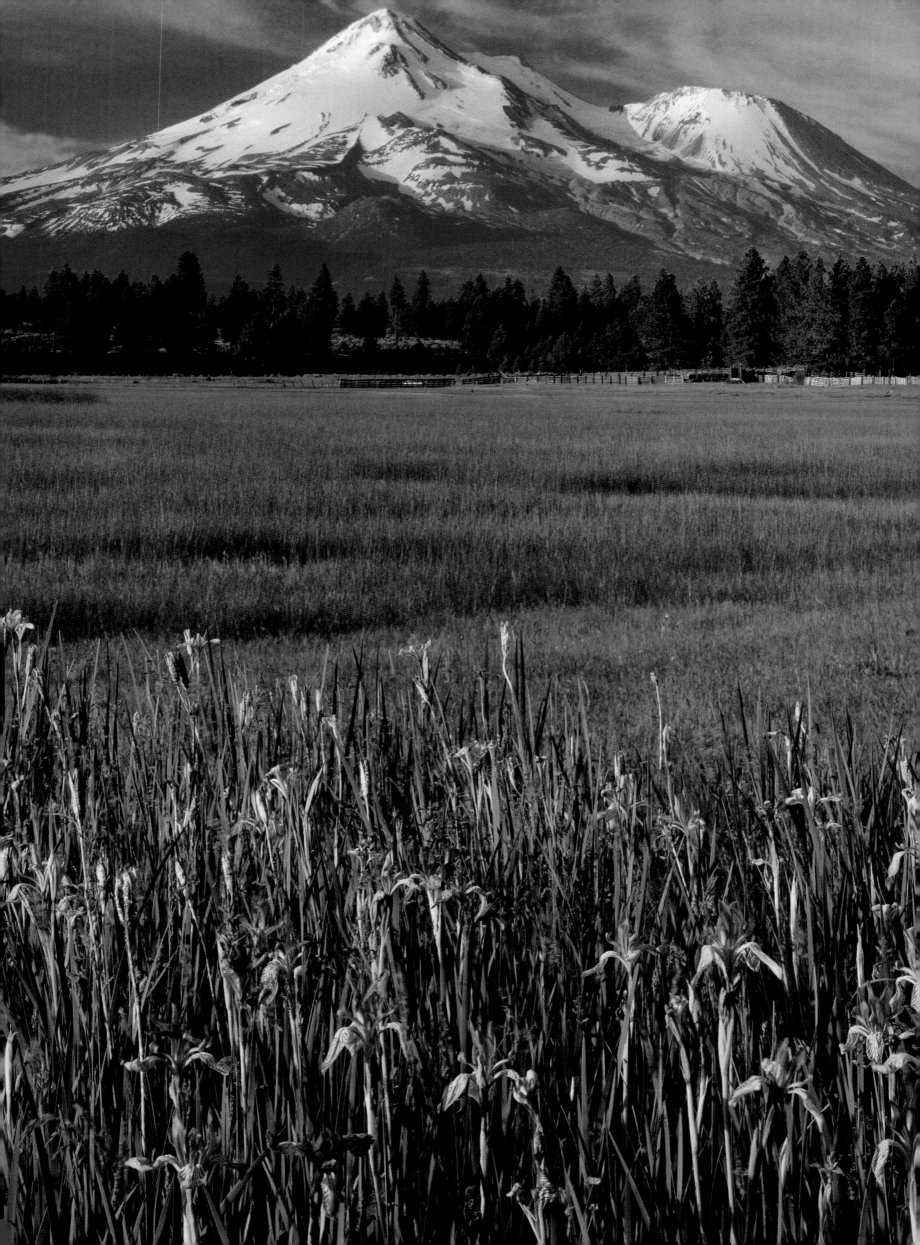

CALIFORNIA
A VISUAL JOURNEY

whitecap

Text and photo selection by Diana Bebek
Edited by Ben D'Andrea
Cover and Interior design by Five Seventeen & Jesse Marchand
Typeset by Jesse Marchand

Printed and bound in China by WKT Company Ltd.

Library and Archives Canada Cataloguing in Publication

Bebek, Diana
 California : a visual journey / Diana Bebek.

ISBN-13: 978-1-55285-851-6
ISBN-10: 1-55285-851-0

 1. California--Pictorial works. I. Title.

F862.B43 2007 979.4'054092 C2006-904990-4

The publisher acknowledges the financial support of the Government of Canada through the Book
Publishing Industry Development Program (BPIDP) and the Province of British Columbia through
the Book Publishing Tax Credit.

For more information on other Whitecap Books titles,
please visit our web site at www.whitecap.ca.

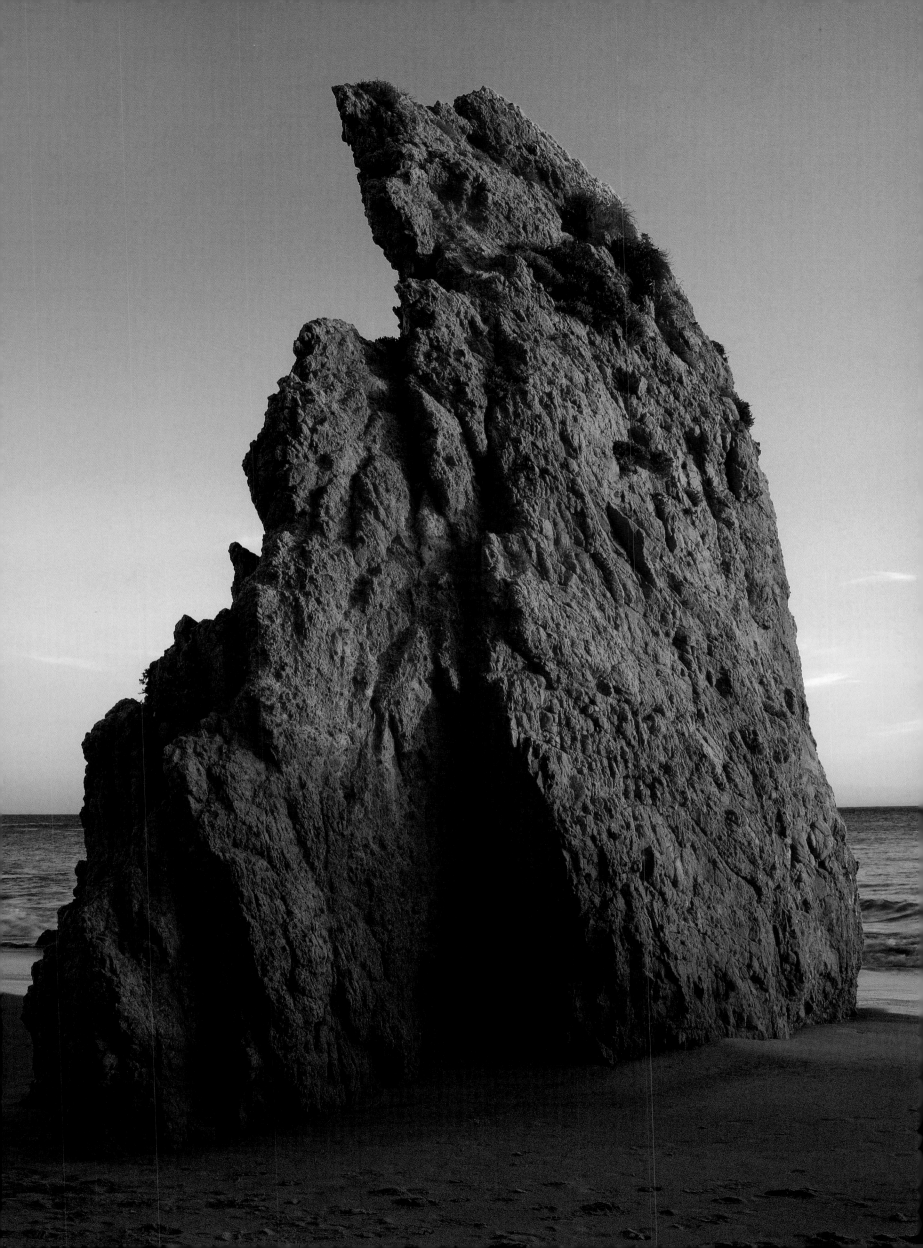

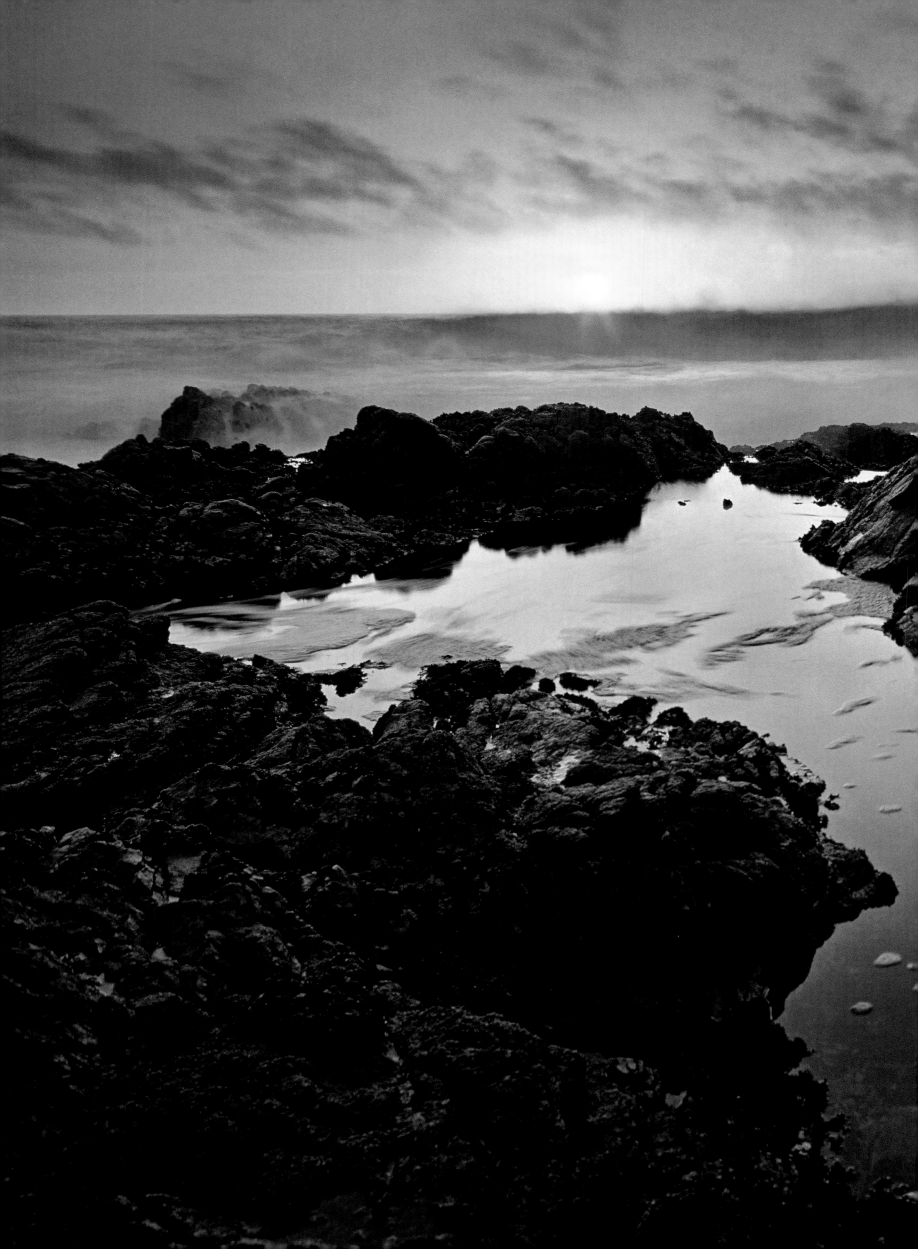

INTRODUCTION

Distinguished by its booming economy, California is internationally recognized for its entertainment industry and Hollywood glamor. Incorporated as the 31st state in 1850, California is the third largest and most populous state in the U.S. Sacramento is the state capital, and California's largest cities are Los Angeles, San Diego, San Jose, and San Francisco.

First inhabited by the American Indians, it was discovered by the Spanish in 1542, when an explorer for the King of Spain, Juan Rodriguez Cabrillo, led a European expedition and landed at what is now San Diego Bay. The Spanish later colonized the area in the 1800s, after several missions had been established along the California coast. The California gold rush of 1848 brought about significant change, drawing pioneers from all around the world and contributing to the growth, prosperity, and cultural diversity of the state today.

California's immensely productive economy relies on agriculture, electronics, the aerospace industry, film production, food processing, petroleum, computers, software, and tourism. It is the most agriculturally productive economy in the U.S. Among its most valuable exported products are grapes, cotton, almonds, wine, dairy, and oranges. A leader in the entertainment industry, its movie and television production continues to flourish and attract worldwide attention to the state. Tourism thrives year round in California: its many world-renowned tourist attractions, amusement parks, and bountiful beauty make it a popular vacation destination.

Anza-Borrego Desert State Park is
the largest state park in California.
Established in 1933, it was named
after the Spanish explorer who visited
the area in 1774, Juan Bautista de
Anza, and incorporates the Spanish
word for sheep — *borrego.*

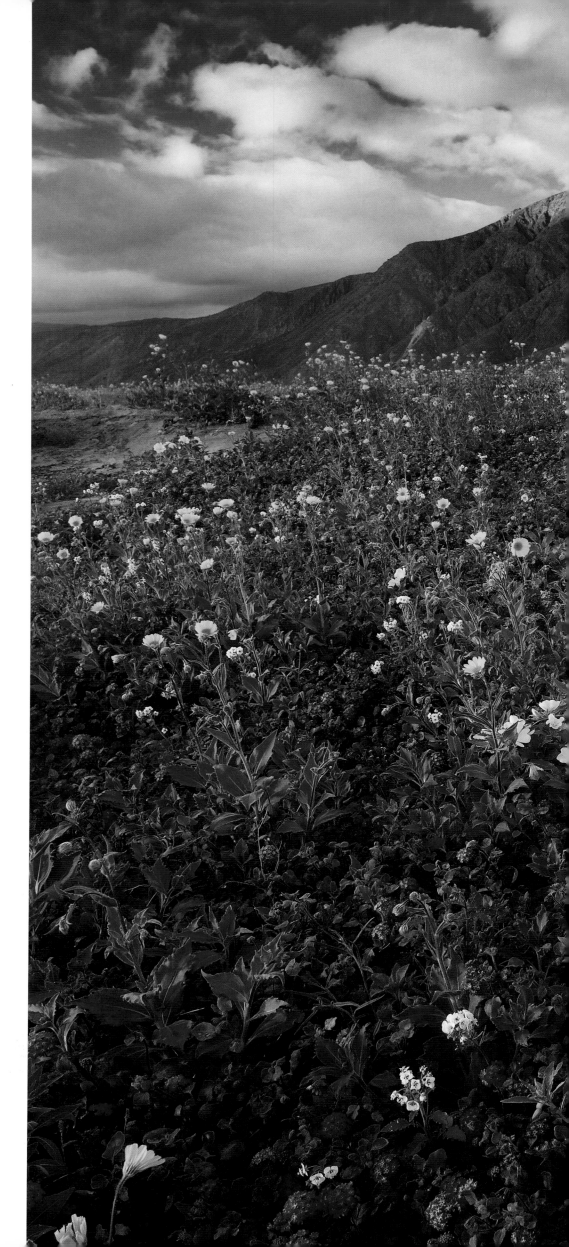

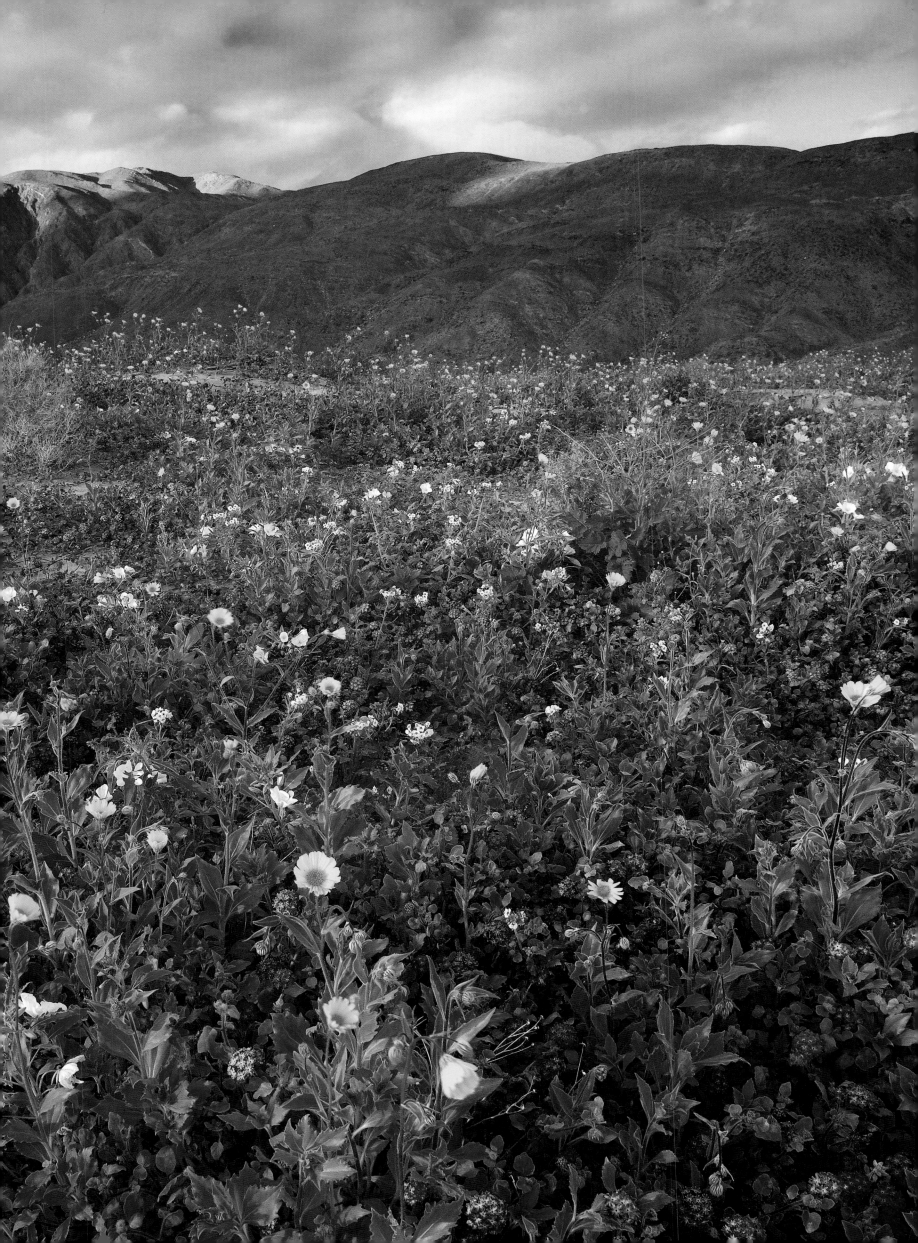

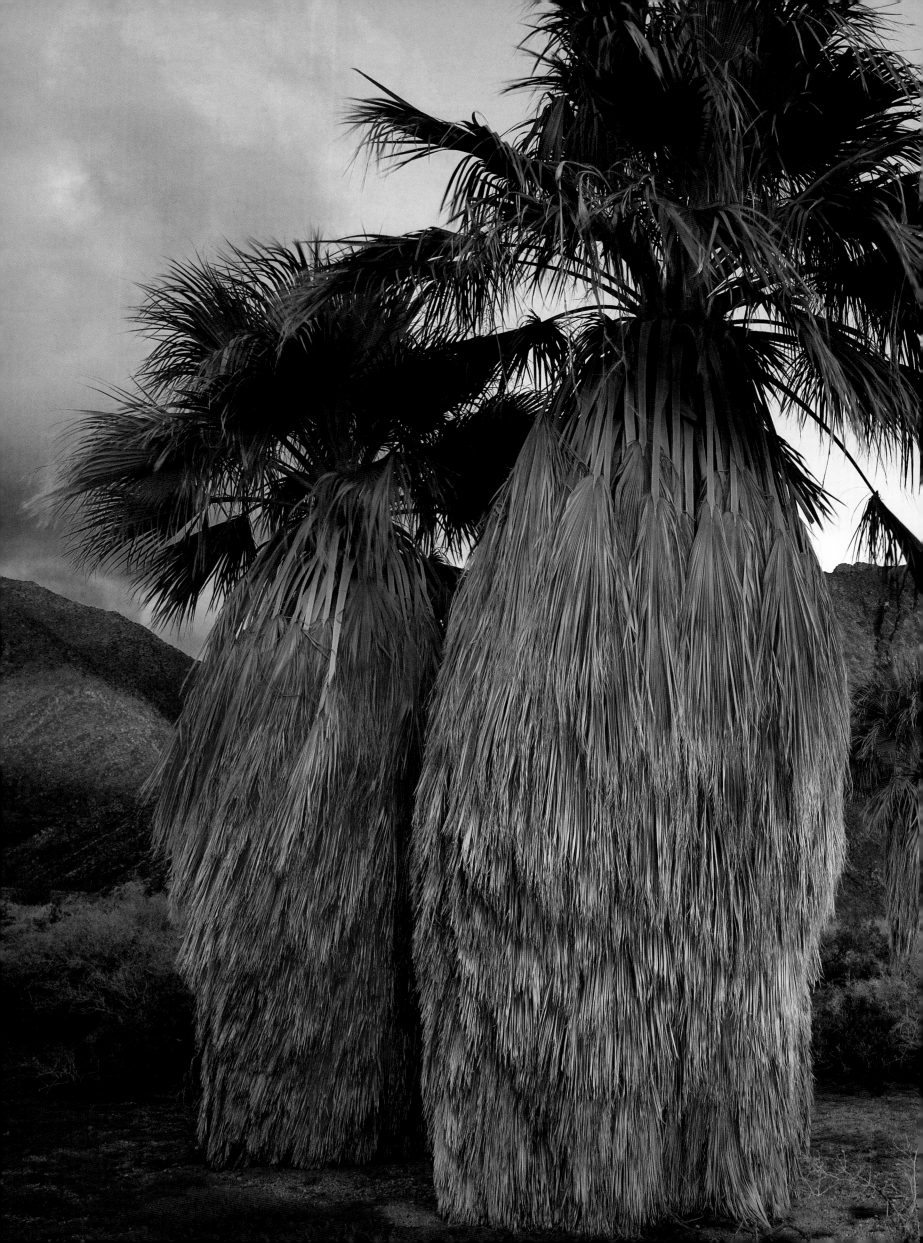

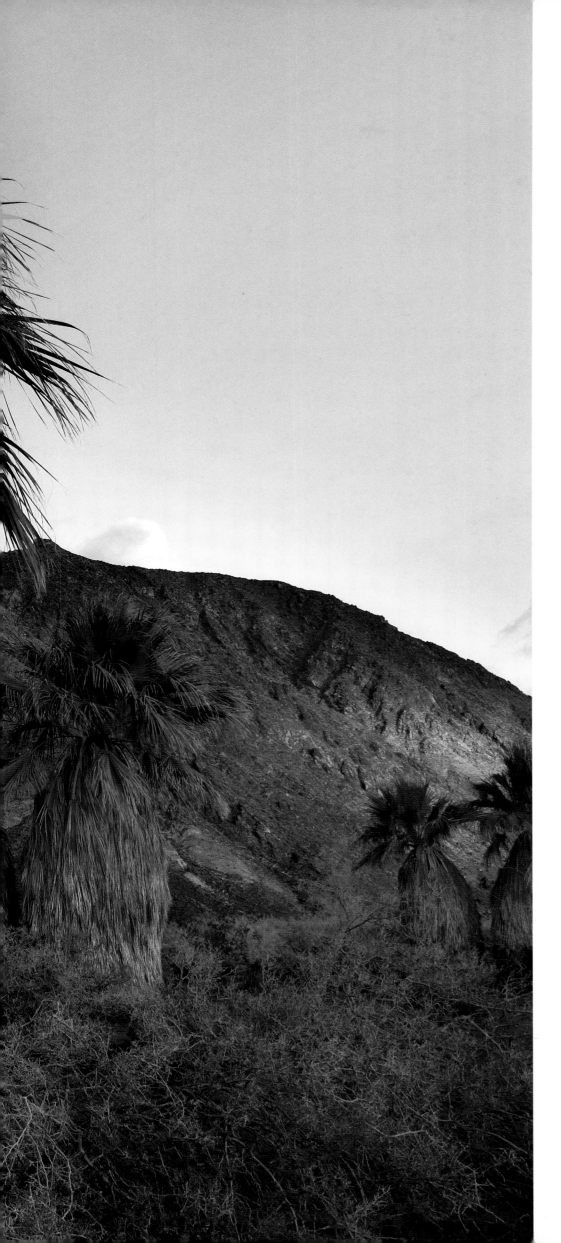

Groves of the endangered California fan palms can be found in California's Joshua Tree National Park and the Anza-Borrego Desert State Park. California fan palms are the only palms native to California.

Beautiful desert flowers like sand verbenas and evening primrose grace Anza-Borrego Desert State Park. The park features over 500 miles of dirt roads and is an excellent recreational area for auto touring, backcountry camping, hiking, mountain biking, and horseback riding.

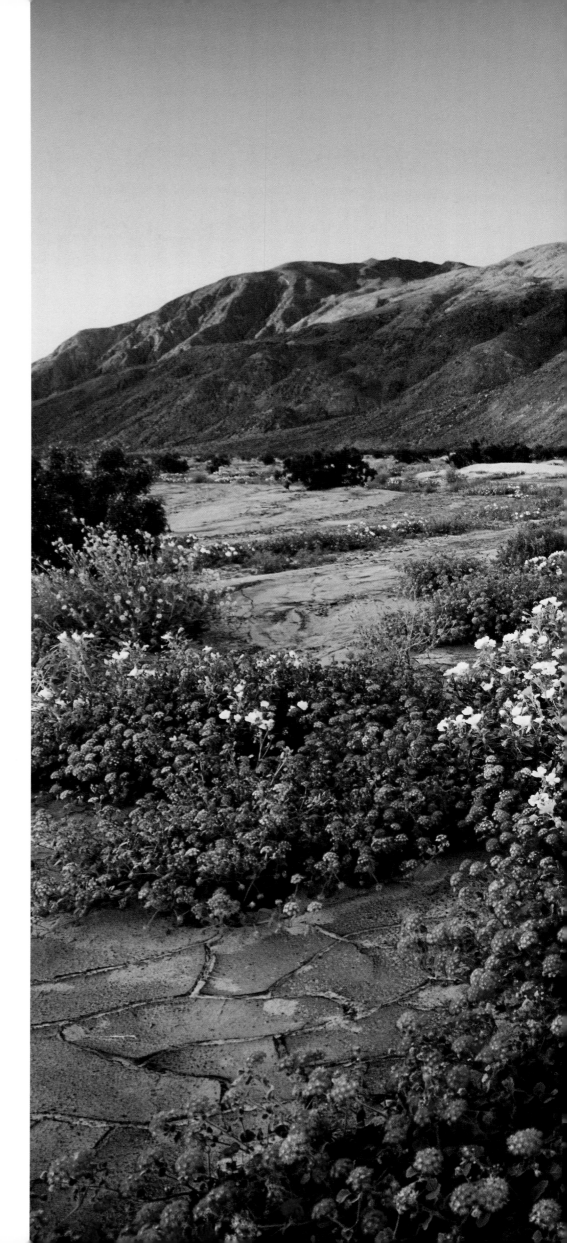

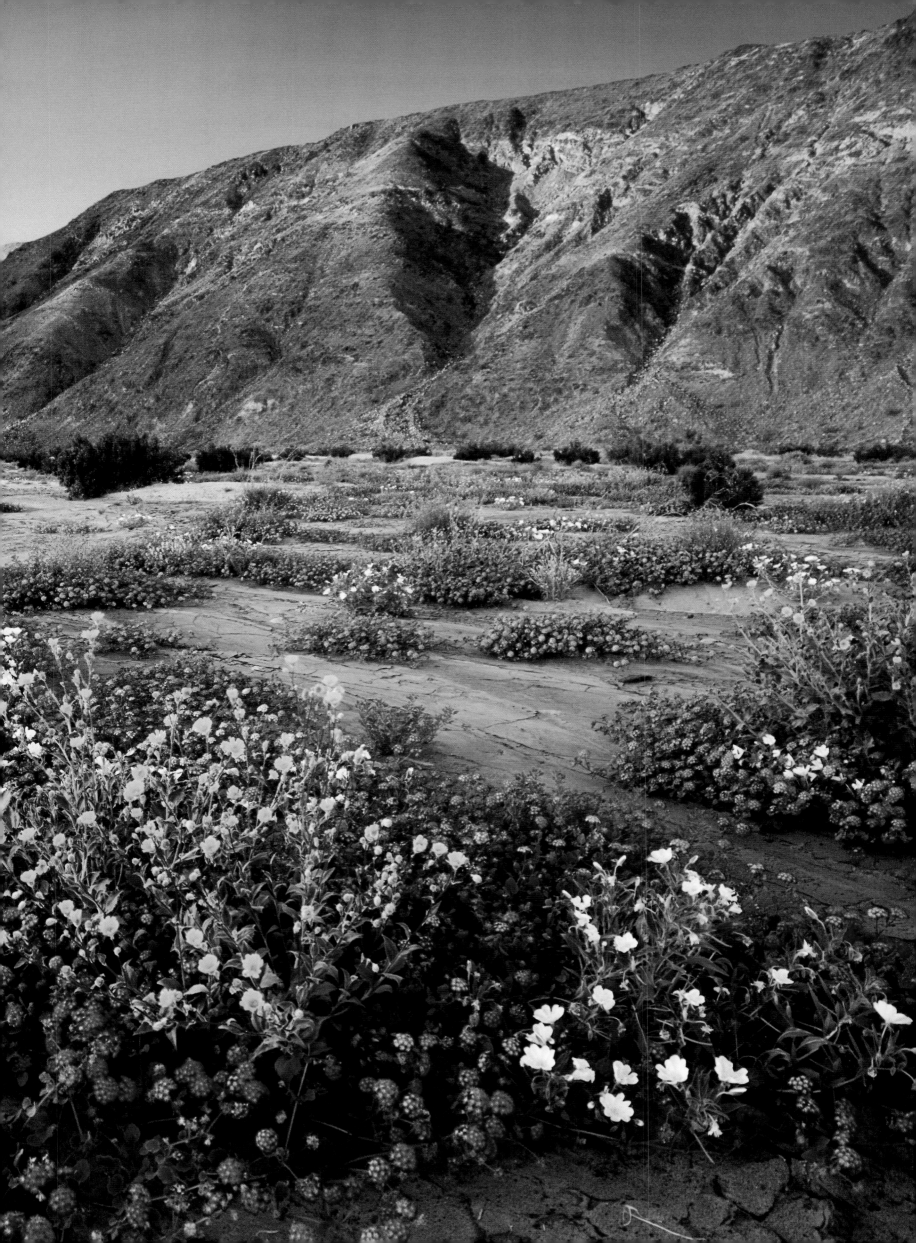

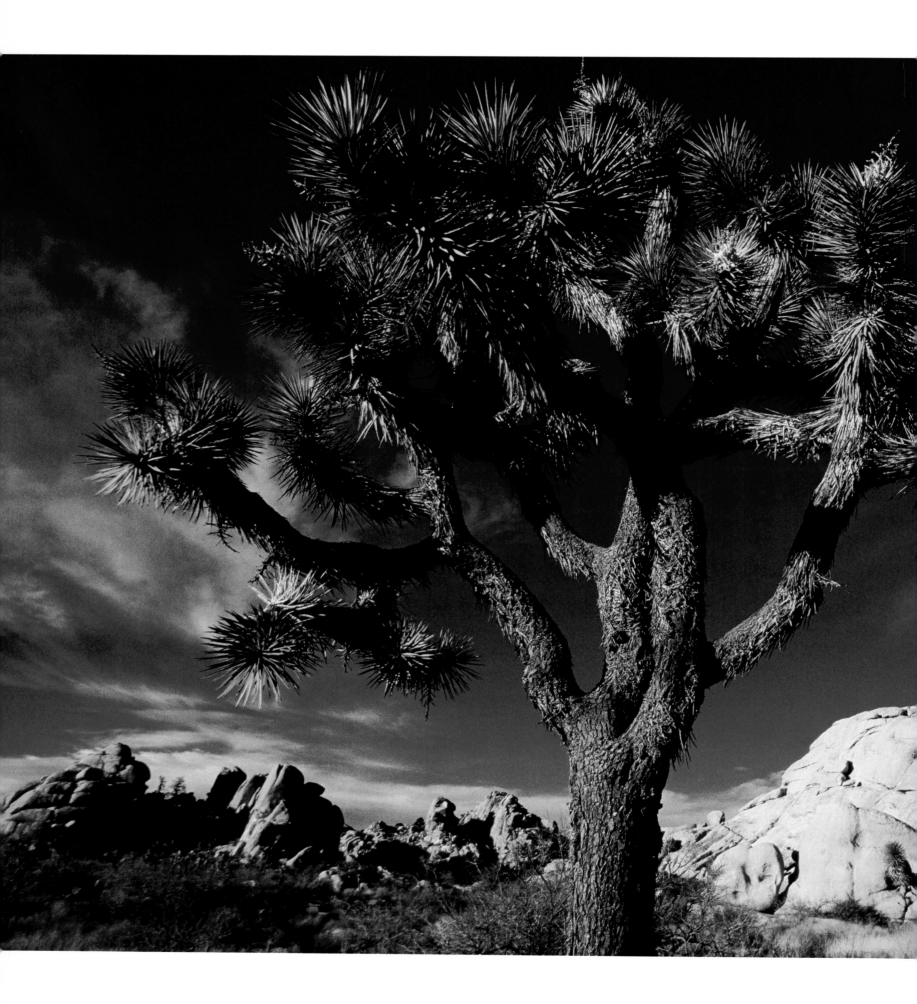

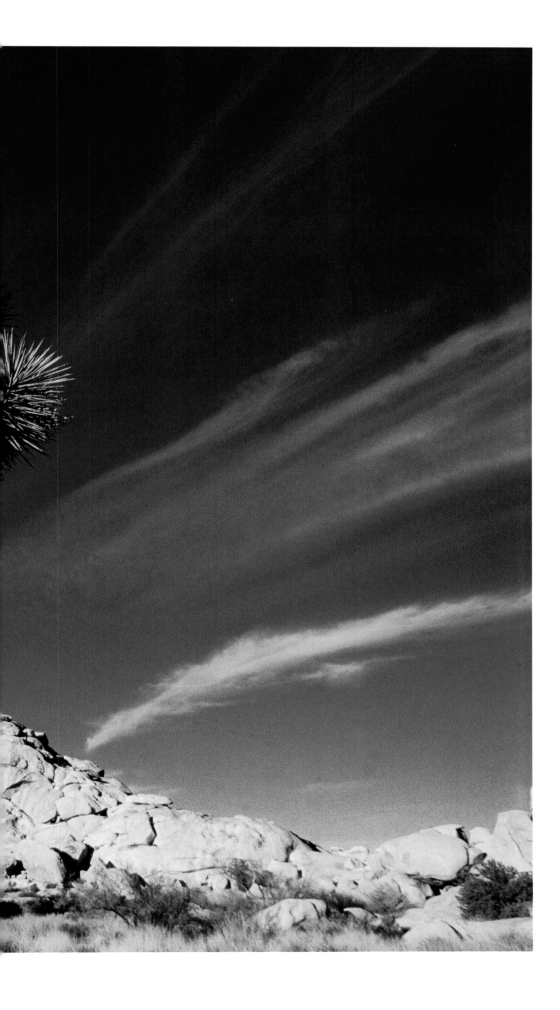

Joshua Tree National Park in southeast California was first established as a national monument in 1936 by President Franklin D. Roosevelt and became a U.S. national park in 1994. The park, consisting of two deserts, the Mojave and Colorado deserts, was named after its distinctive feature, the Joshua tree, which is actually a large yucca plant. Legend has it that the tree was named by Mormon migrants who thought its limbs resembled the upturned arms of the Biblical prophet Joshua.

With its stunning geologic features, Joshua Tree Park draws visitors from all over the world. It is an excellent recreational area for geologic tours, mountain biking, hiking, camping, but most of all rock-climbing. The park has thousands of rock-climbing routes, making it a popular year-round destination for climbers of every level.

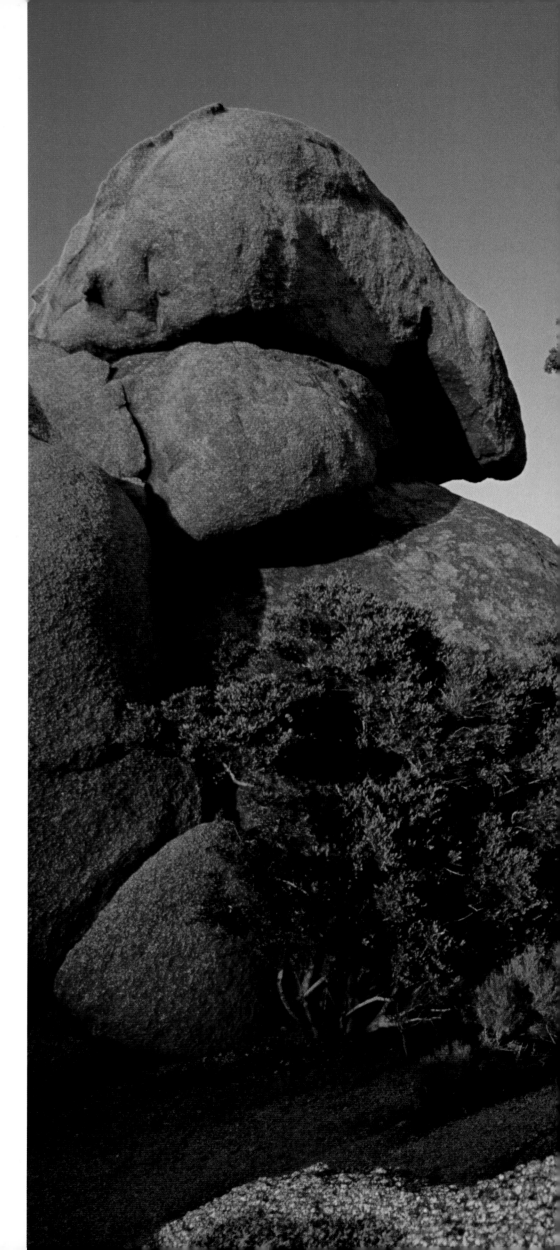

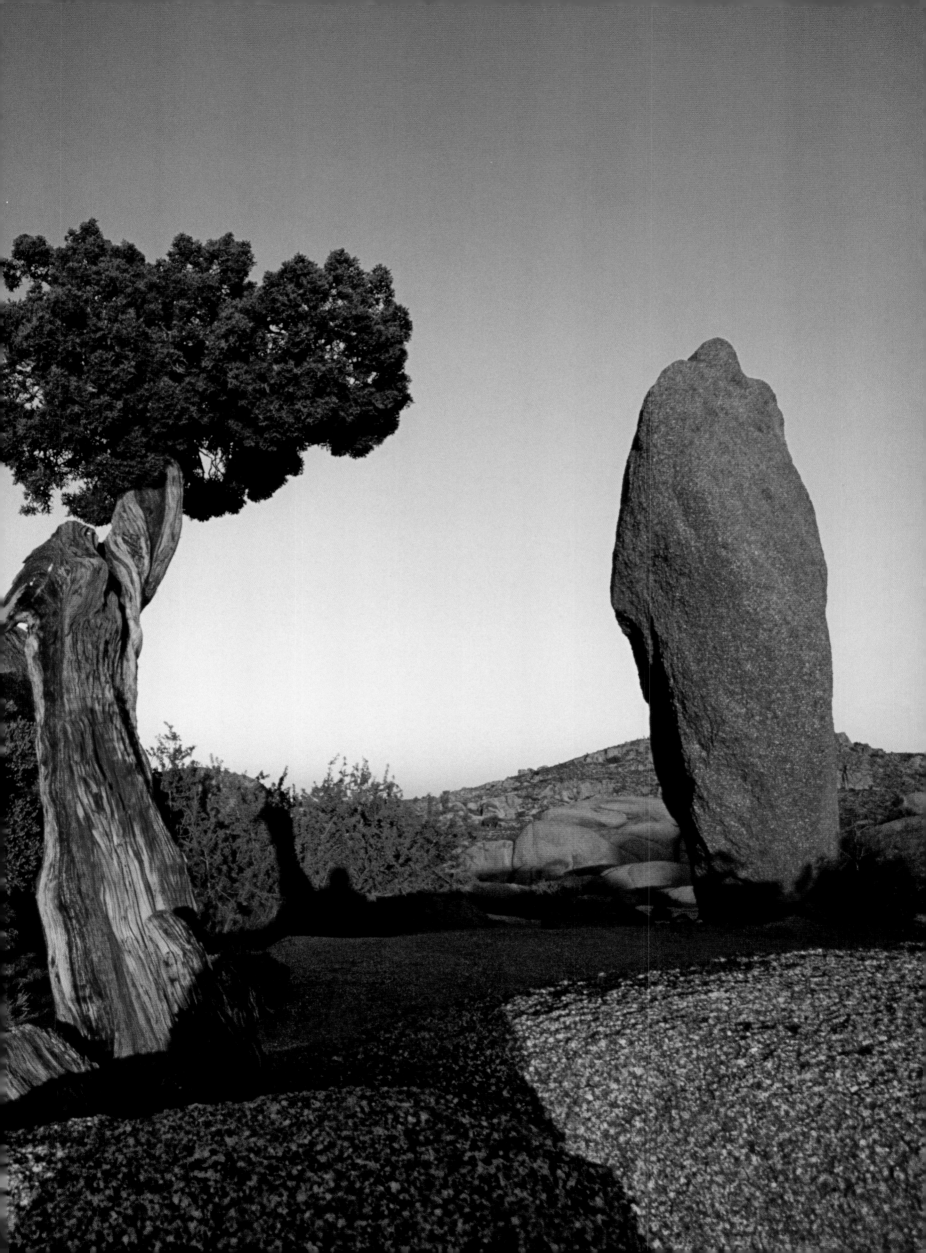

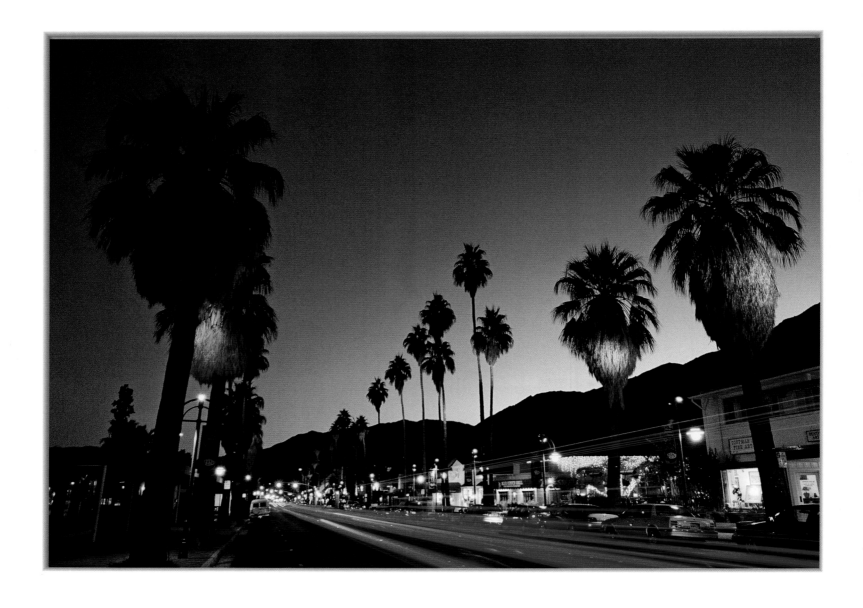

Palm Springs, a large desert city in Riverside County, is a resort sanctuary where visitors come to relax, rejuvenate, and enjoy the outdoors. It features an abundance of luxury golf courses, tennis courts, and swimming pools. Riverside County, situated in southeastern California, includes several desert cities and towns. Some of the most popular vacation destinations are Cathedral City, Rancho Mirage, Palm Desert, Indian Wells, and La Quinta.

Palm Springs has some of the world's most famous golf courses and hosts professional golf events each year. The region boasts over 80 courses, making it a golfer's paradise. *(right)*

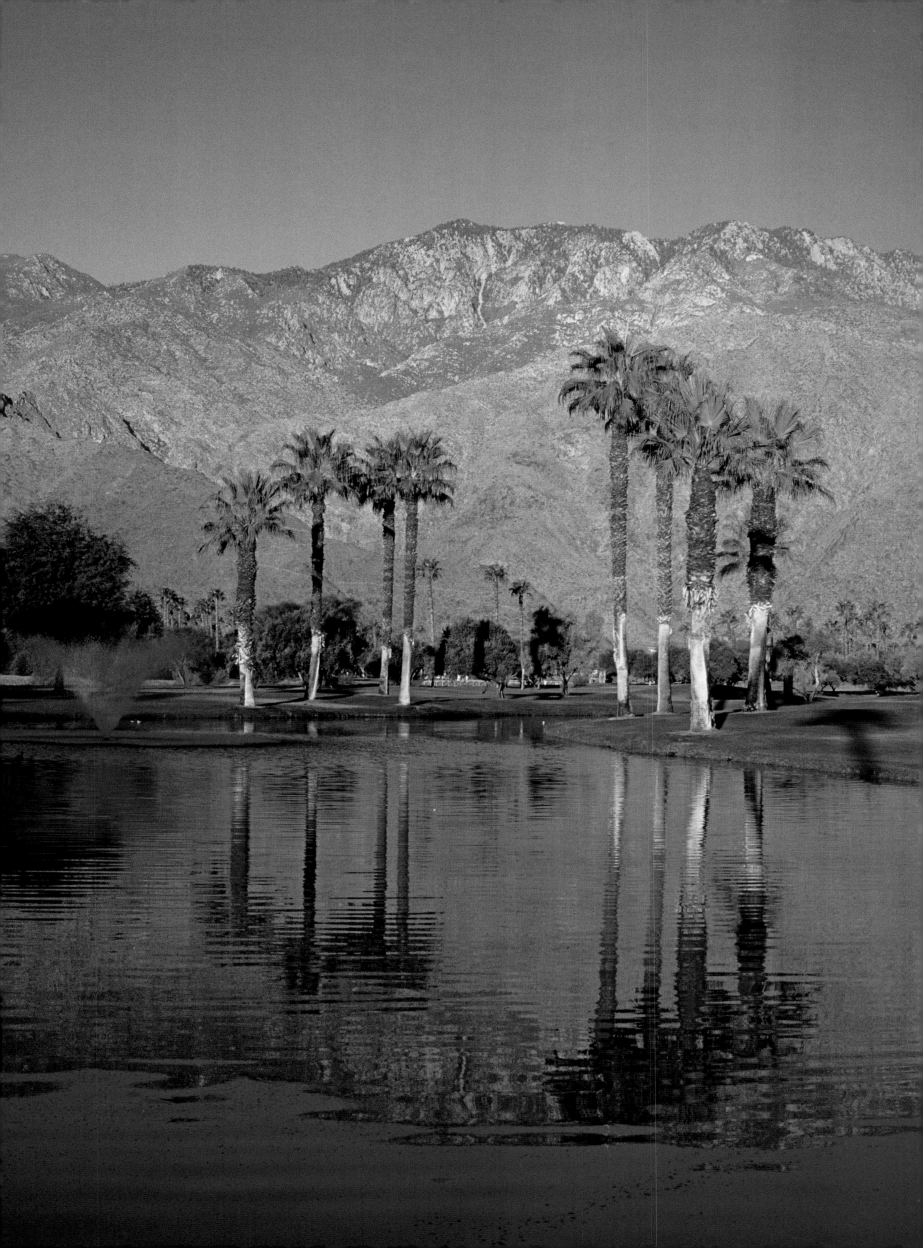

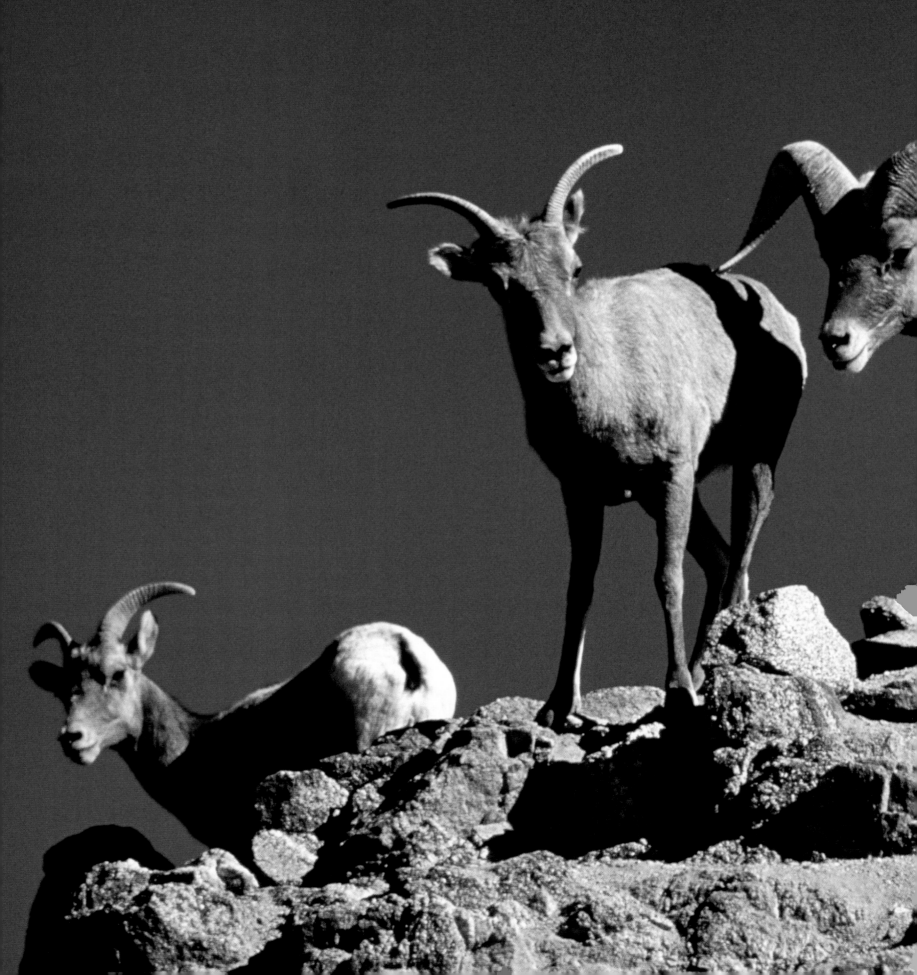

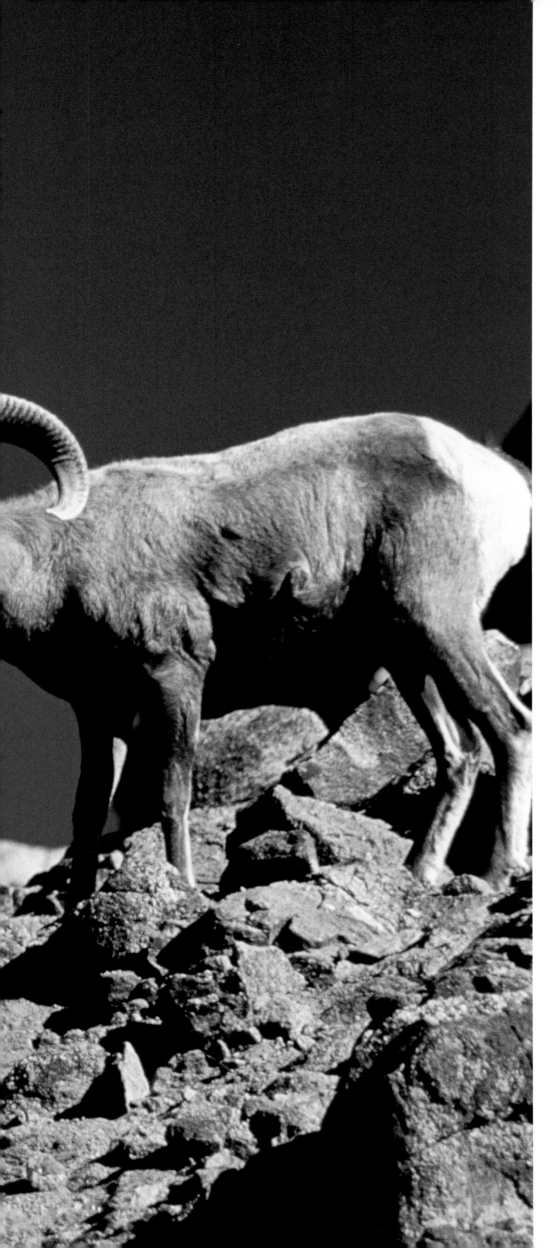

Desert bighorn sheep can be found in the Peninsular Range of Southern California. Characterized by their majestic spiraled big horns and muscular bodies, they are excellent climbers and jumpers in their rocky habitat.

The male sheep's, or ram's, rank is symbolized by the size of its horns. The rams engage in head-to-head combat that has been known to last for more than 24 hours. The female sheep, or ewes, have horns that are slender and less curved.

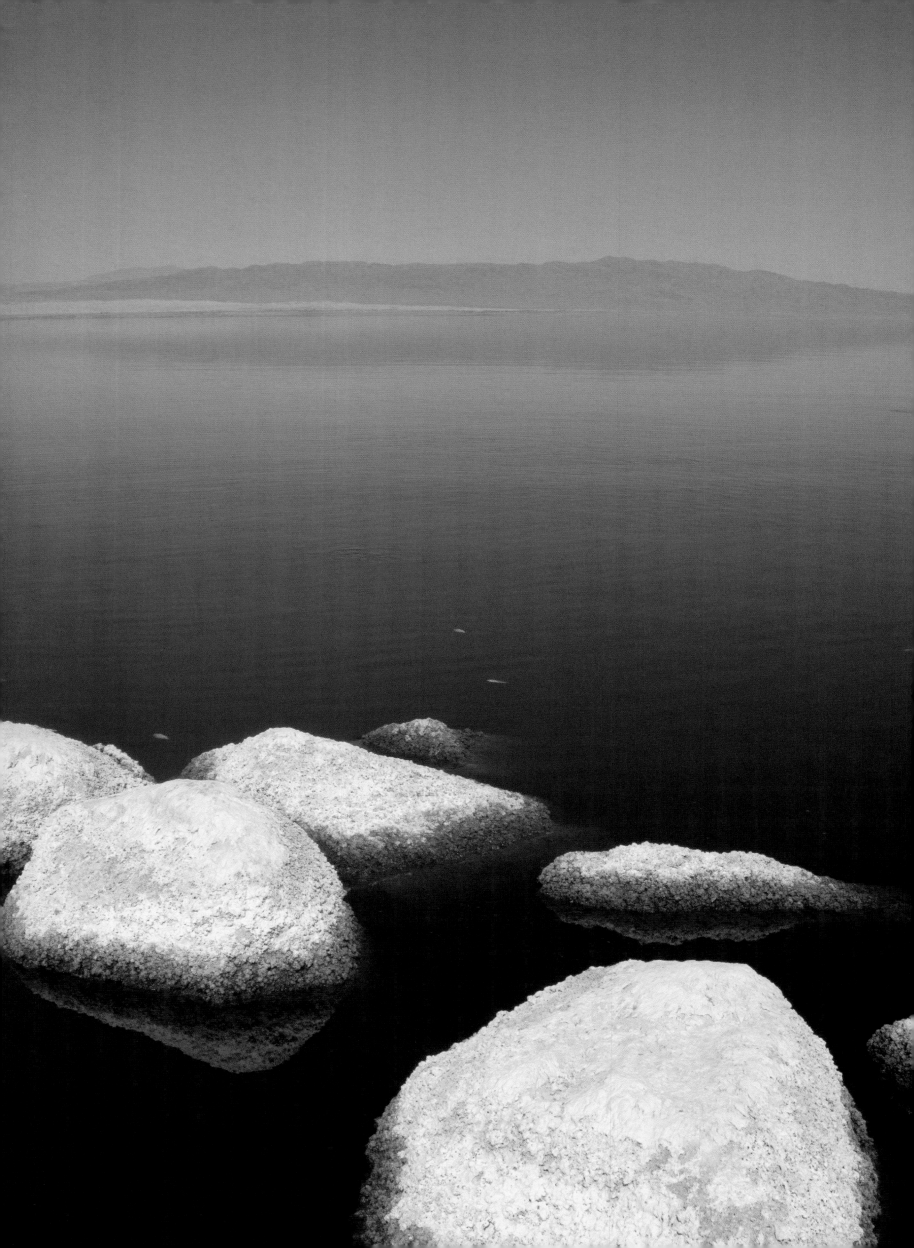

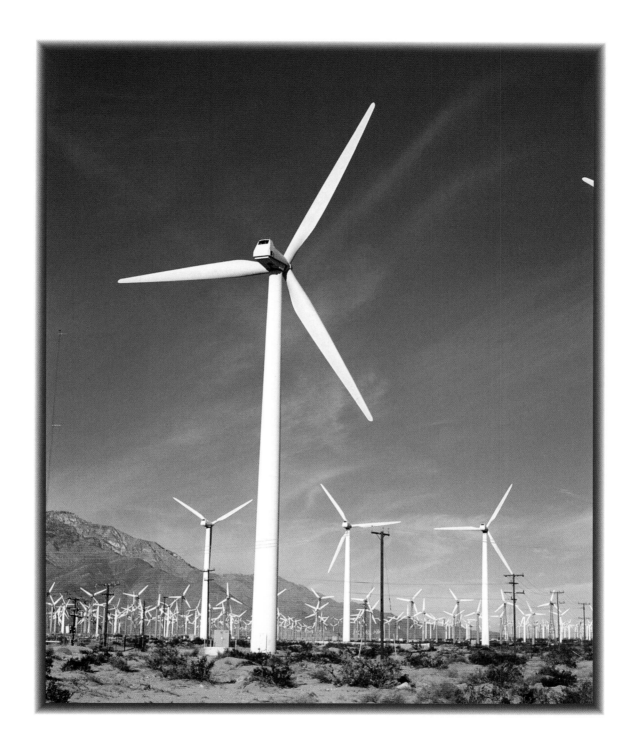

The San Gorgonio Pass wind farm, north of Palm Springs, is home to over 4,000 privately owned wind turbines. California's wind farms collectively produce enough energy to light up the city of San Francisco and play a fundamental role in energy production.

Salton Sea is California's largest lake. It was formed in 1905 when the Colorado River flooded the Salton Basin. An important inland wetland habitat in Southern California, it attracts hundreds of species of birds and wildlife. The recreational area surrounding Salton Sea has numerous campsites and provides excellent boating, fishing, and bird watching. *(left)*

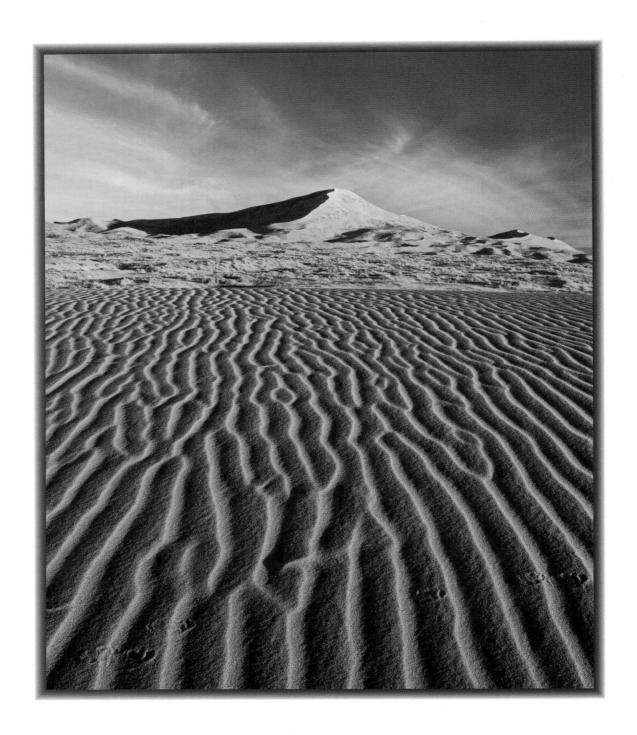

Protected by the Mojave National Preserve, the Kelso Dunes are a natural feature
of the Mojave Desert. Formed by wind-blown sand from the Mojave River sink,
these dunes have been stacking up over the past 25,000 years. Over 600 feet high,
they produce what has been described as a mysterious singing or booming-like
sound, which occurs when the sand on the dune's surface is disturbed
and avalanches.

Salt Creek, located in Death Valley National Park, is home to the rare, tiny pupfish.
These amazing fish have survived by adapting to the harsh desert environment.
They have been known to endure extreme temperatures over 100 degrees
Fahrenheit and can survive in water almost four times as salty as the sea. *(right)*

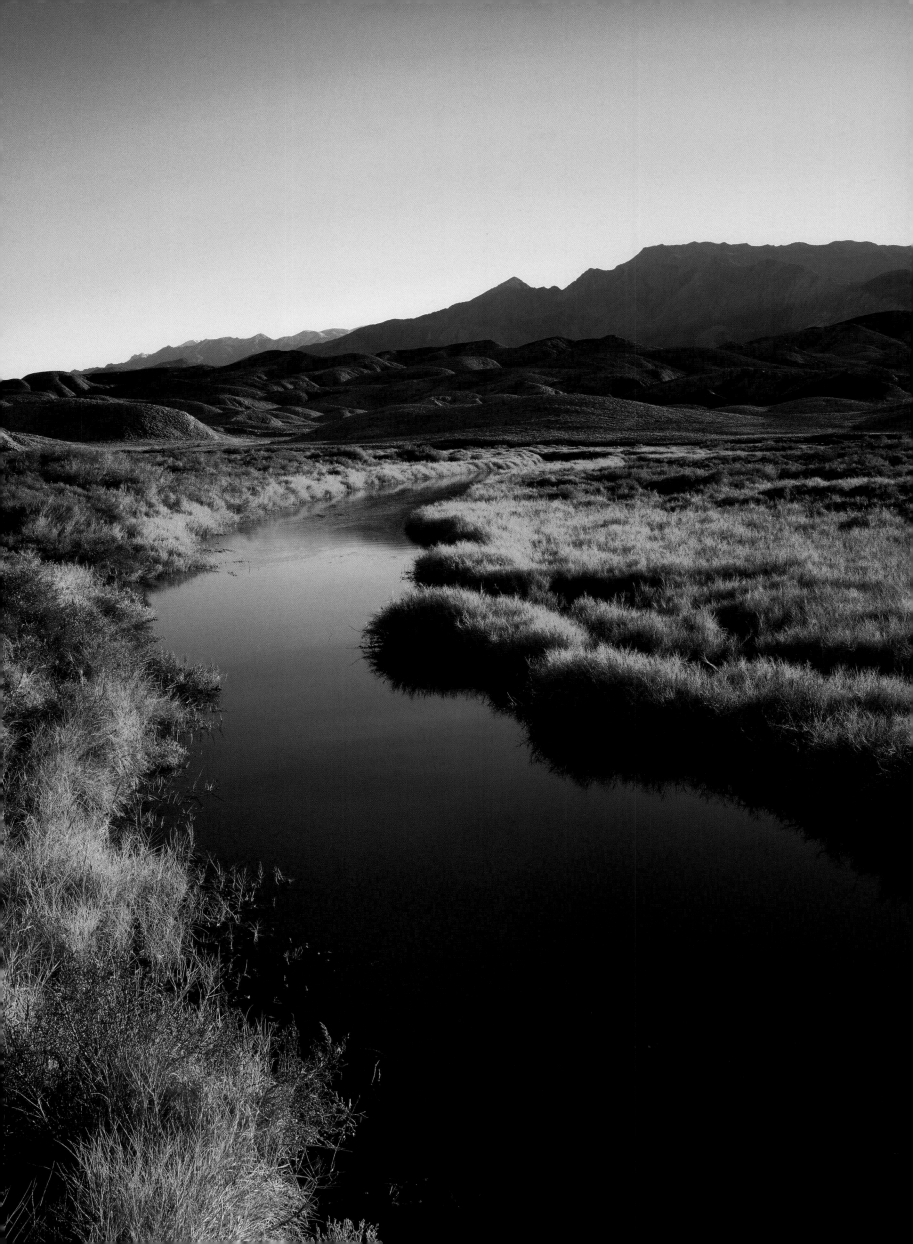

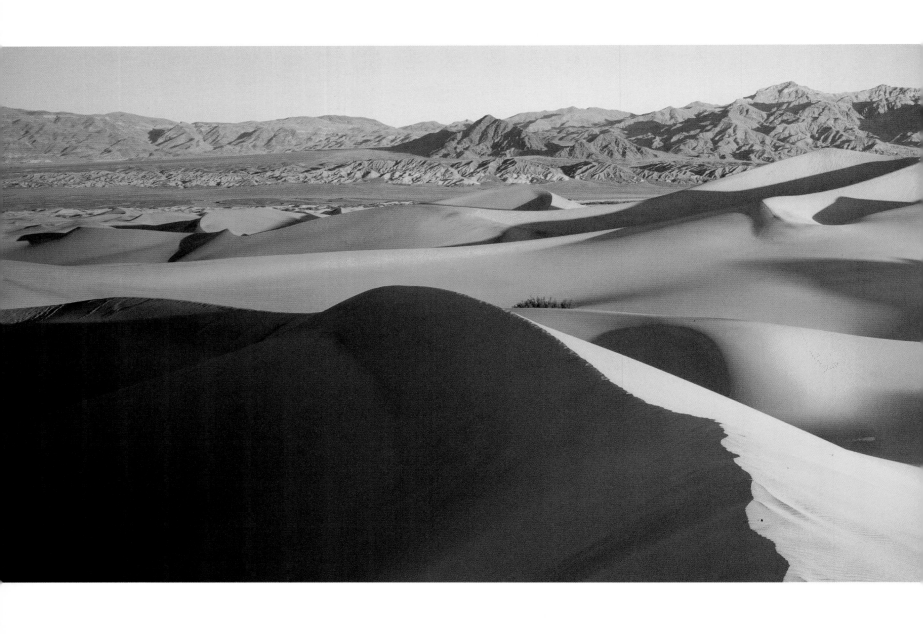

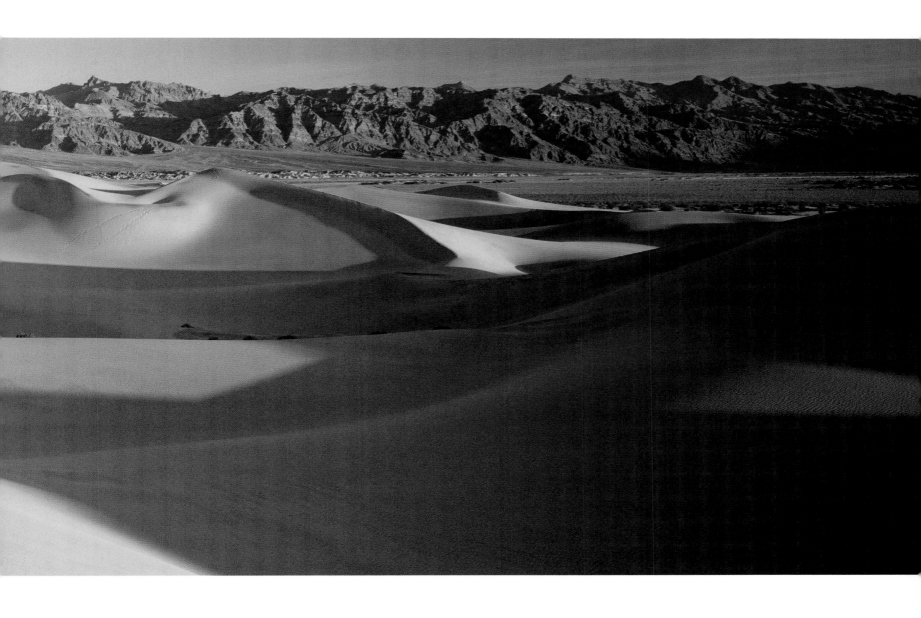

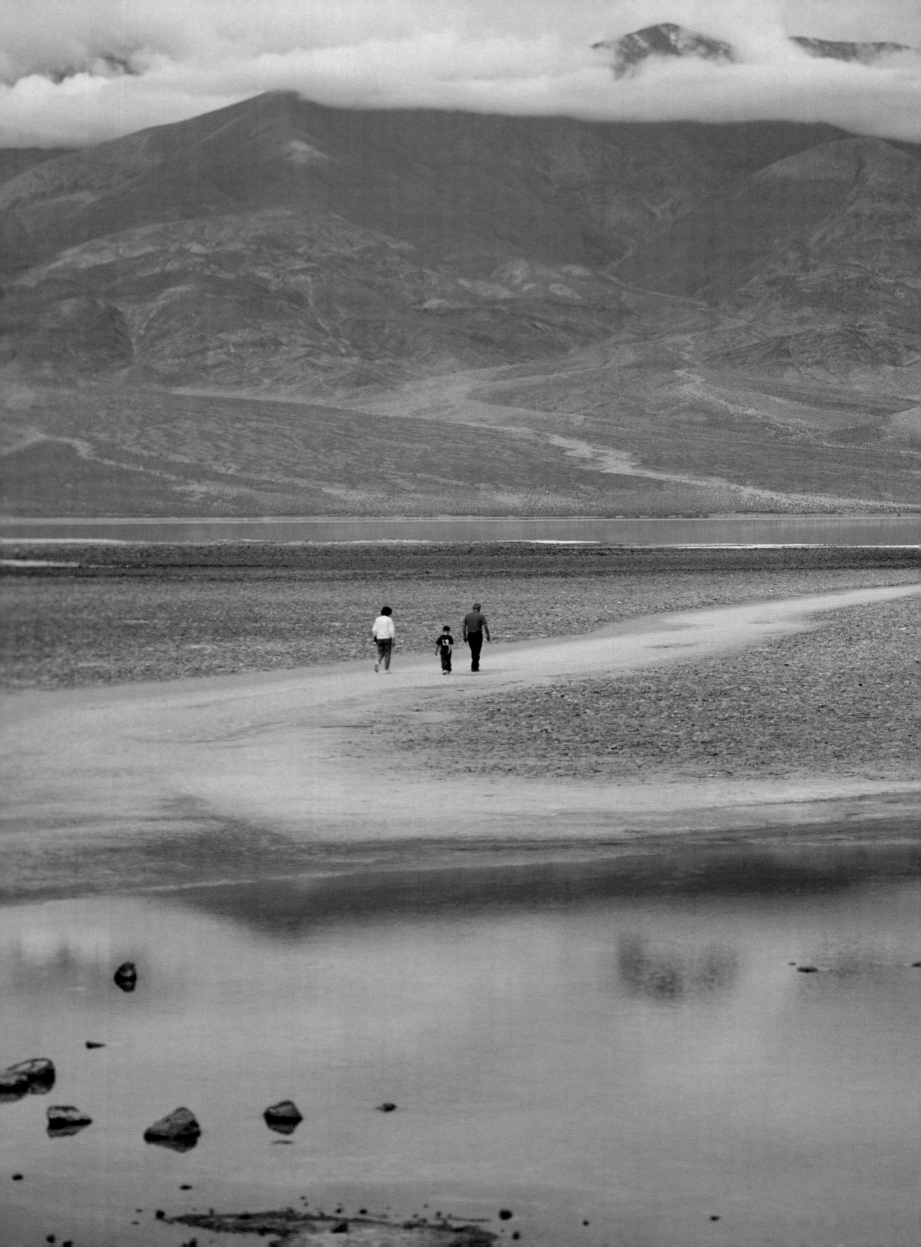

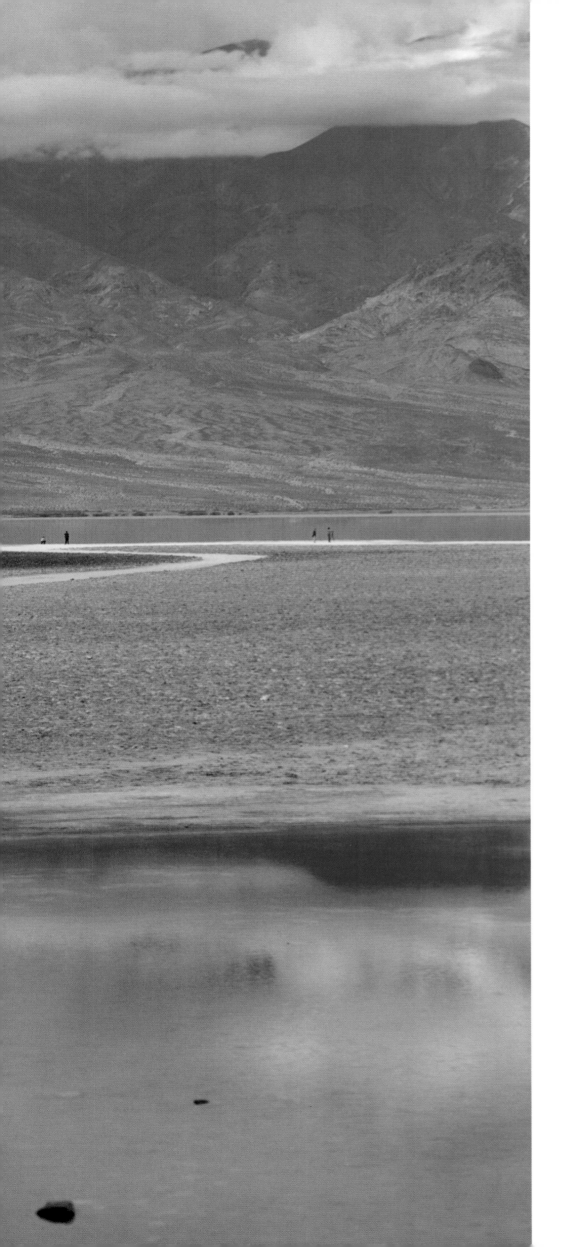

A popular place for visitors of Death Valley is the Bad Water Basin. At 282 feet below sea level, it is the lowest point in the Western Hemisphere

Death Valley National Park is one of the hottest and driest places on earth. It got its name in the winter of 1849–50 when pioneers heading for the California Gold Rush got lost crossing the desert and thought the valley was going to be their grave. After the group was rescued by two of their scouts, one of the pioneers looked back at the valley and said, "Goodbye, Death Valley." *(previous pages)*

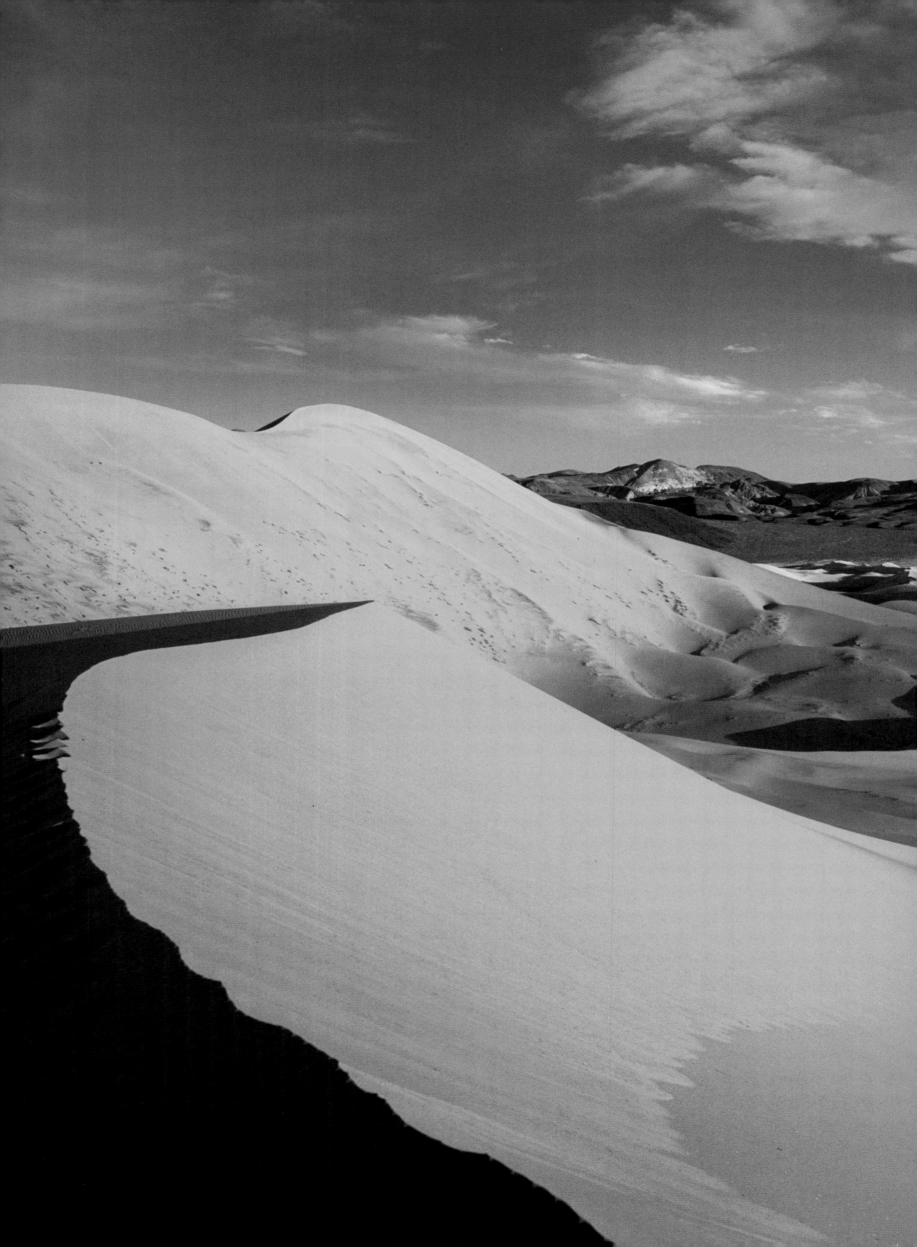

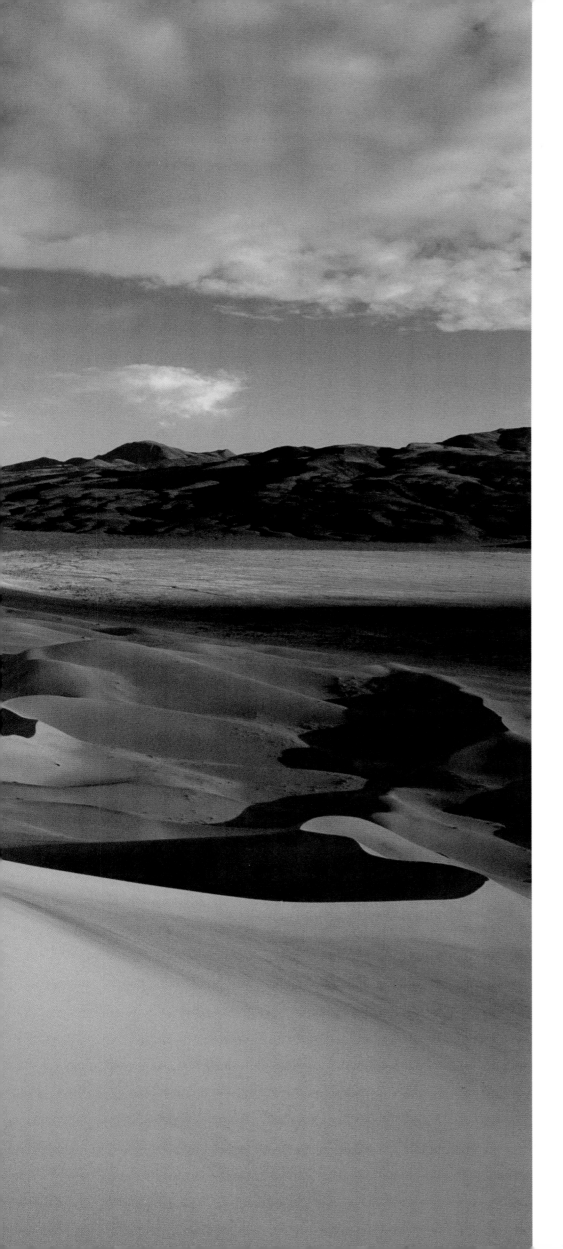

Death Valley National Park protects one of the highest dune fields in North America. The Eureka dunes in the Eureka Valley situated northwest of Death Valley rise up to 680 feet and cover an area 3 miles long and 1 mile wide.

The Furnace Creek Stables in Death Valley National Park feature horseback riding in the desolate, unspoiled beauty of the desert. Visitors can enjoy the trails sunrise to sunset on horseback or in horse-drawn carriages.

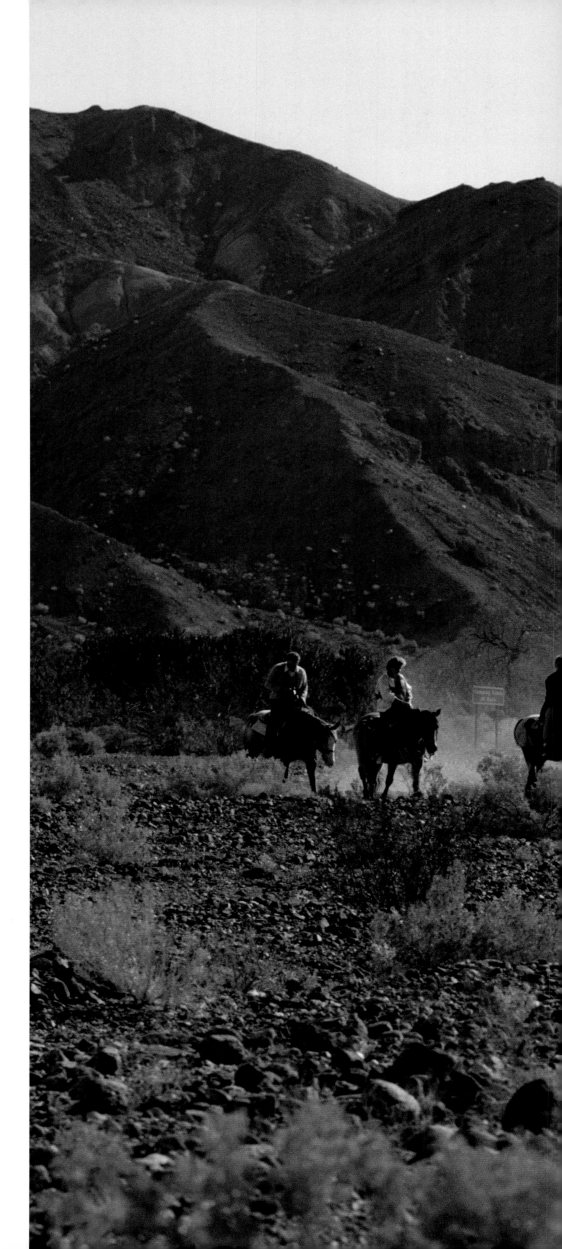

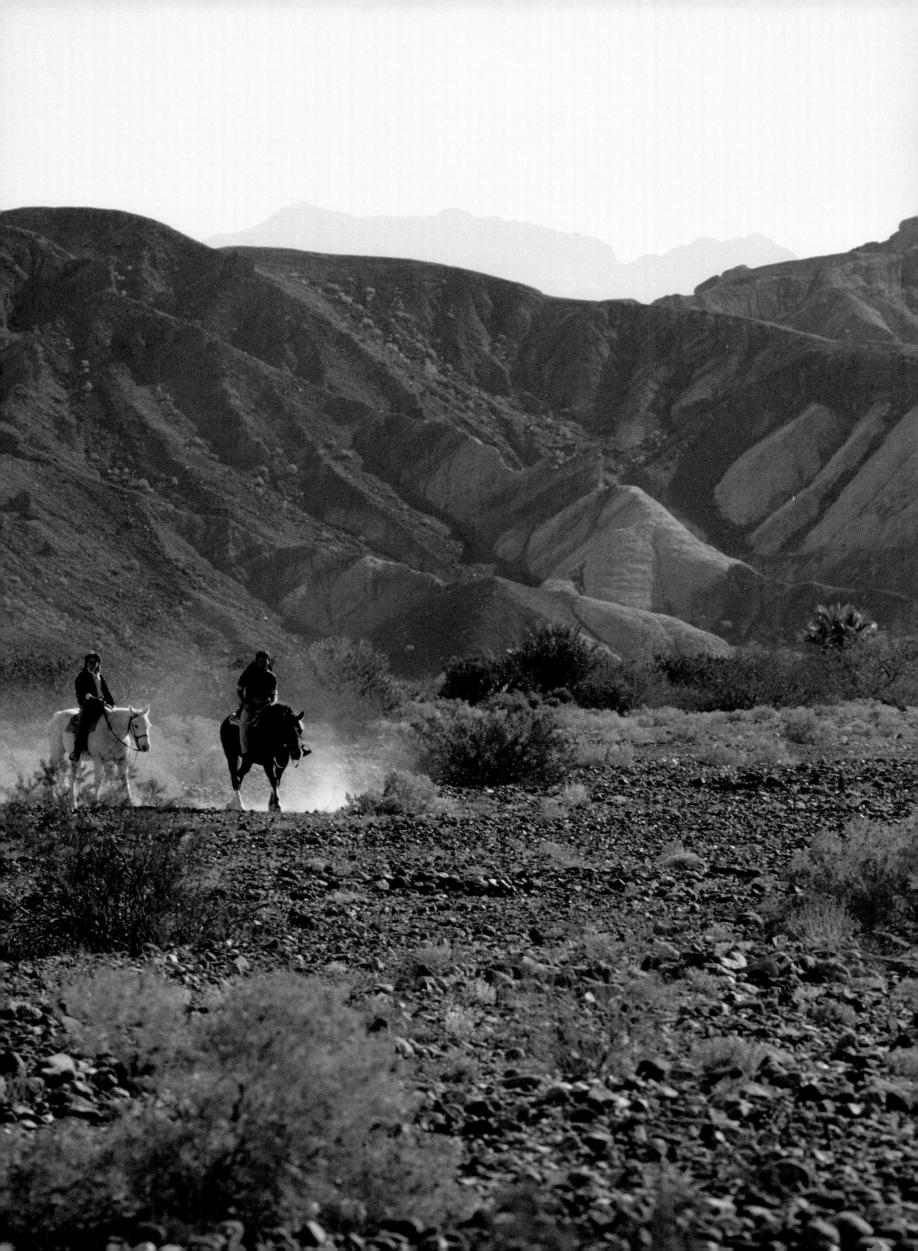

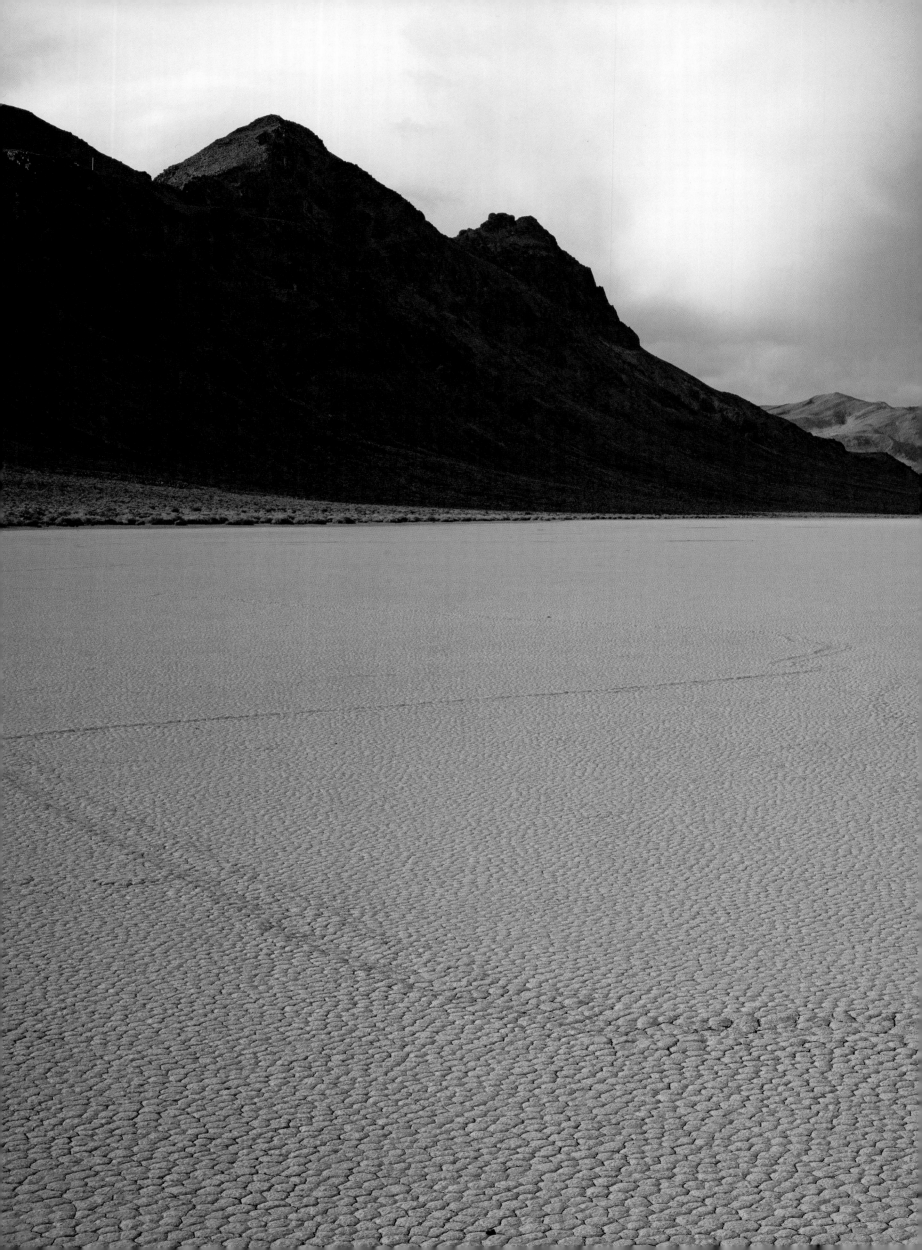

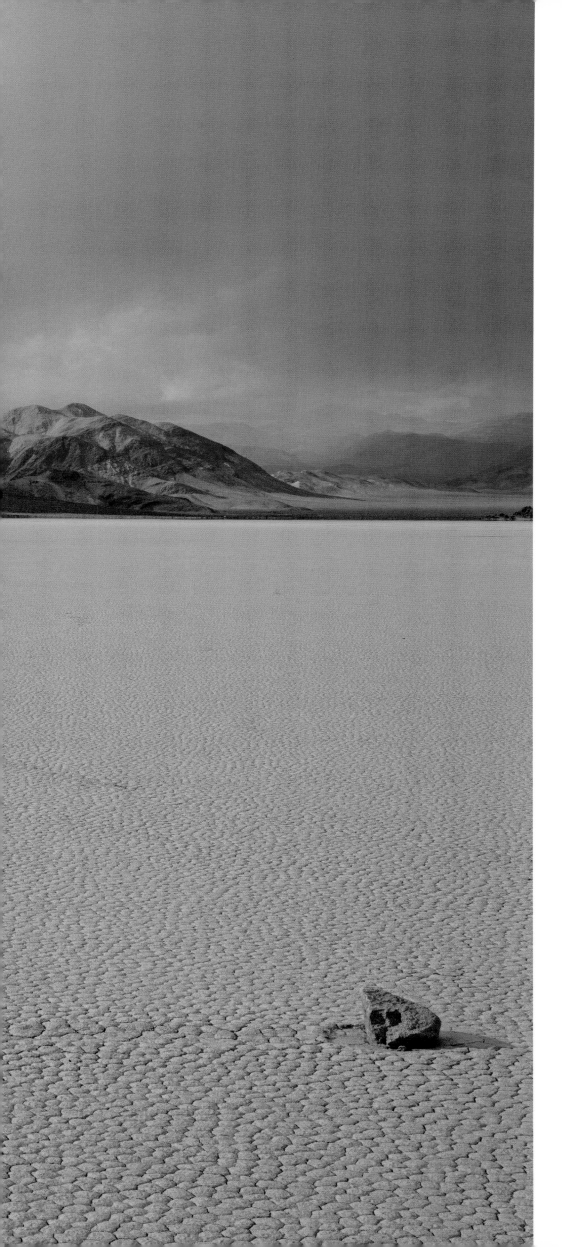

The sliding rocks of Racetrack Playa, also known as the Devil's Racetrack, are perhaps Death Valley's most mysterious feature. For no apparent reason, its pebbles and boulders slide unseen across the basin in different directions and across various distances. Years of research and investigation have resulted in many theories, but none has fully explained these mystifying moving rocks.

Located in eastern California, the Panamint Range is a group of rugged mountains that form the western border of Death Valley. In 1861, Dr. Samuel George climbed its highest point, which reaches up to 11,049 feet, and gave it the name Telescope Peak because the view resembled that seen through a telescope.

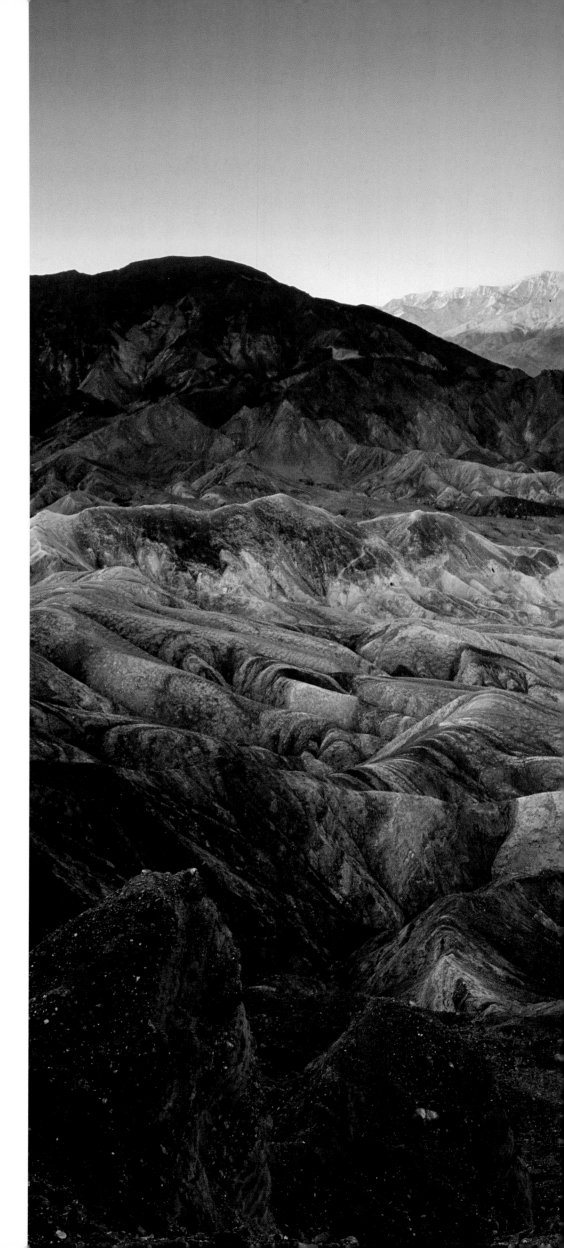

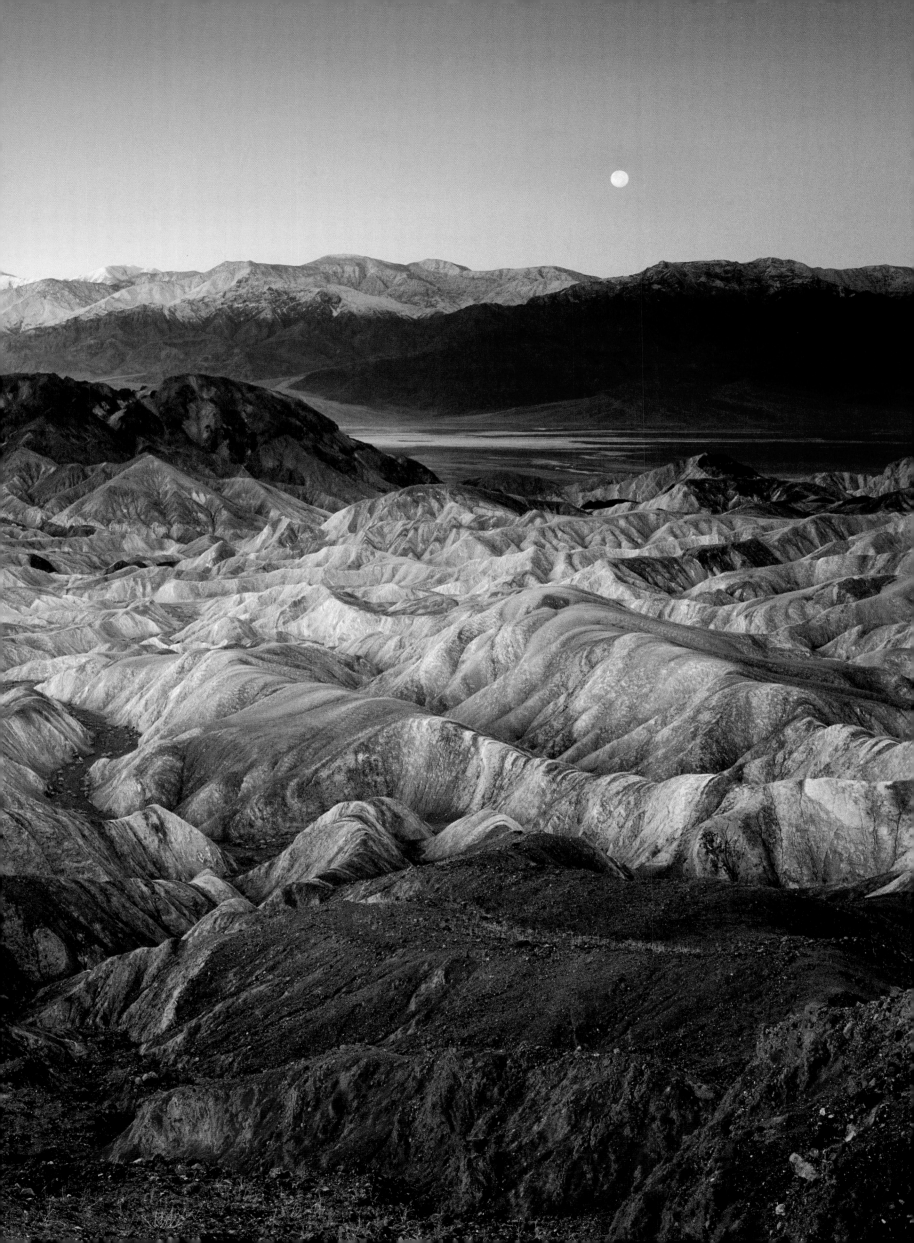

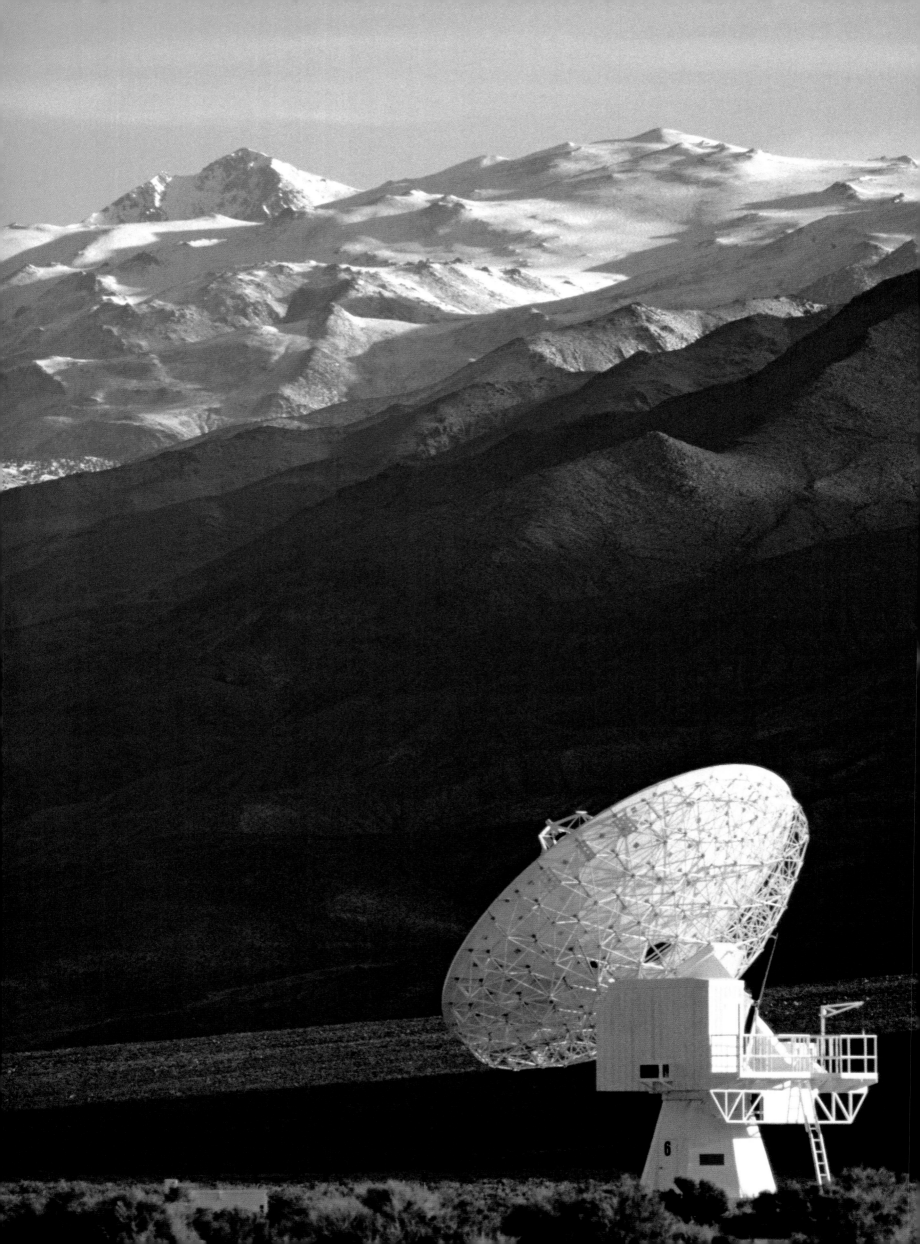

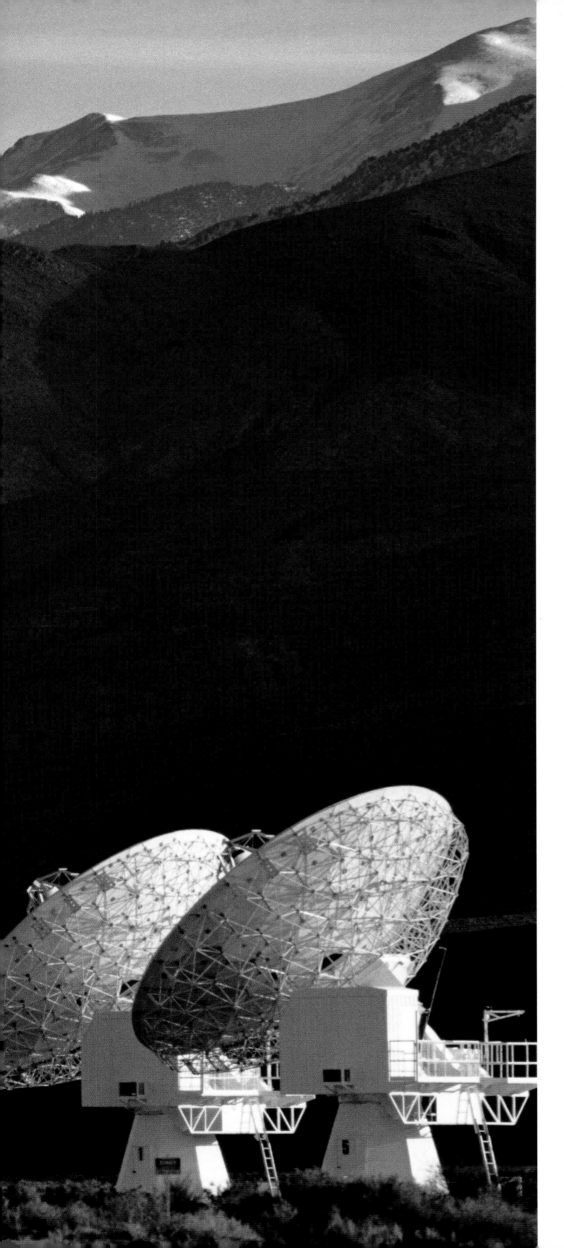

The Owens Valley Radio Observatory is the biggest university-operated radio observatory in the world. Situated near Bishop, California, it is owned and operated by the California Institute of Technology.

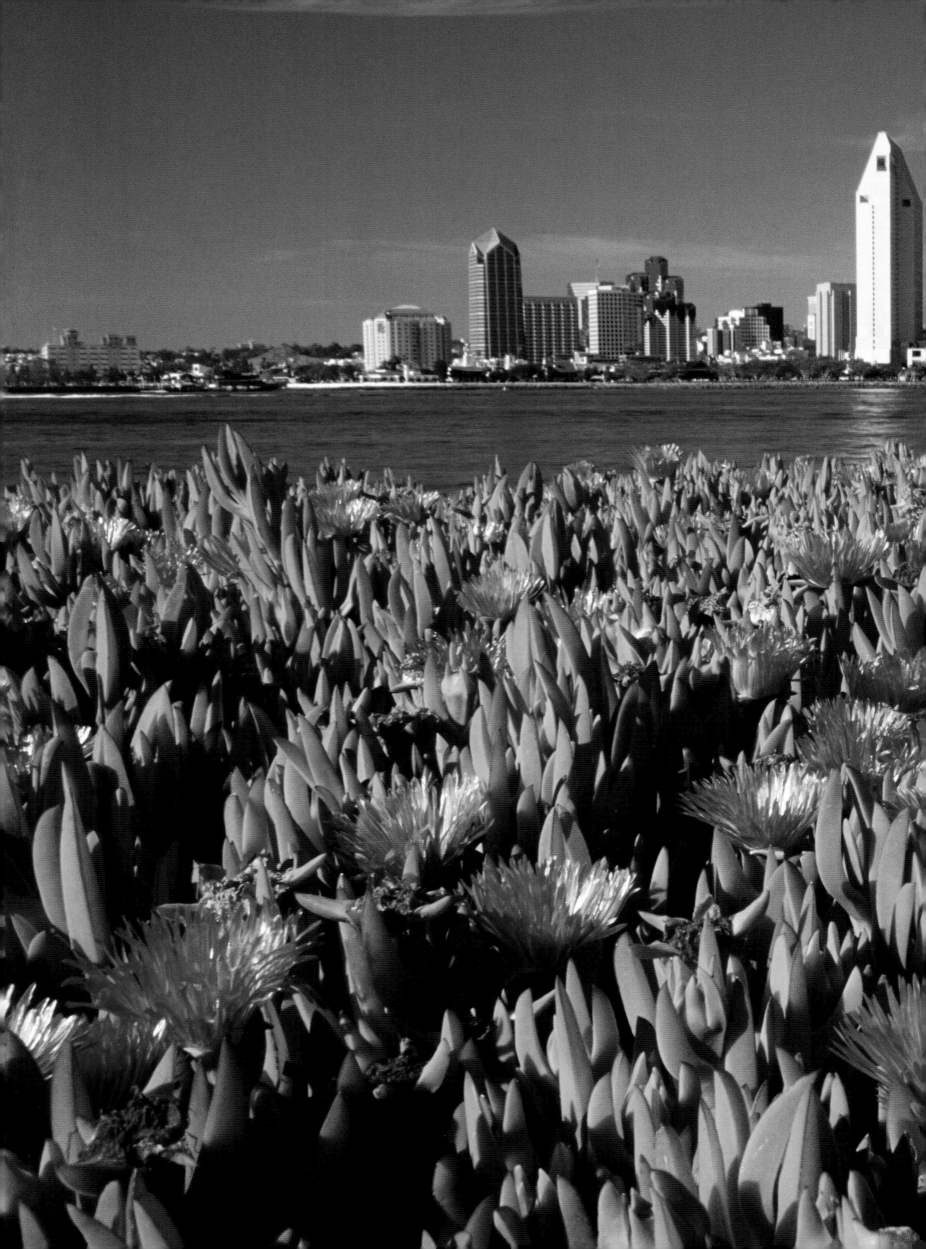

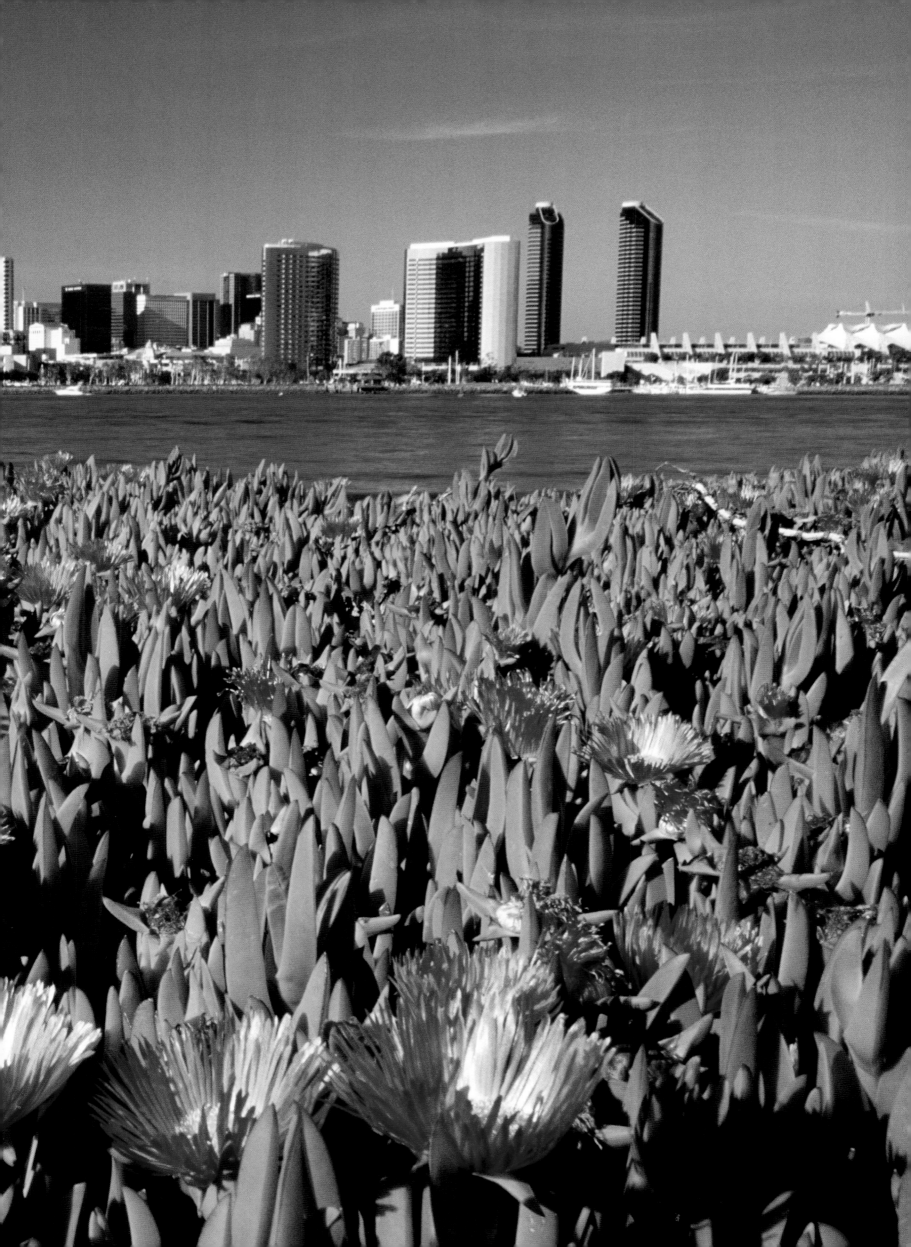

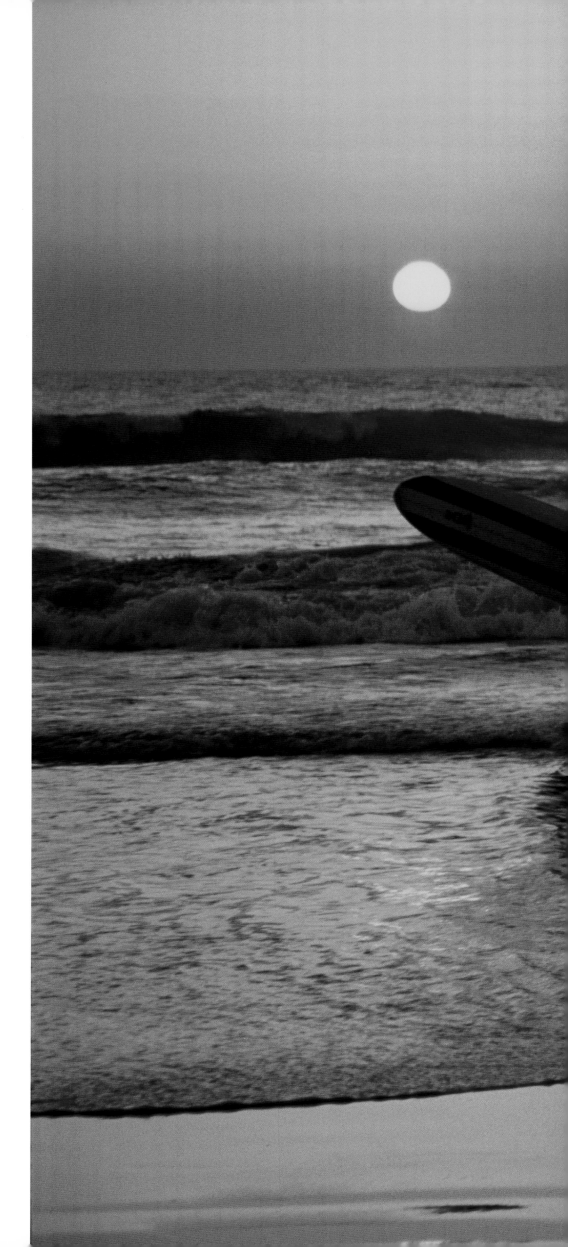

Some of the best surfing in North America can be found along the stunning beaches of the California coast. California's thriving surf culture means surfers can search for waves, rain or shine, all year round. To some it is a recreational sport, to others a way of life.

In 1542, the Portuguese explorer Juan Rodriguez Cabrillo first landed in what is now San Diego Bay. Today San Diego is California's second largest city and the seventh largest in the United States. It has a population of almost 1.3 million and encompasses about 4,200 square miles. This magnificent coastal city in southern California is blessed with a warm climate and pristine beaches. San Diego's rich cultural diversity is reflected in its performing arts, culinary arts, and neighborhoods. *(previous pages)*

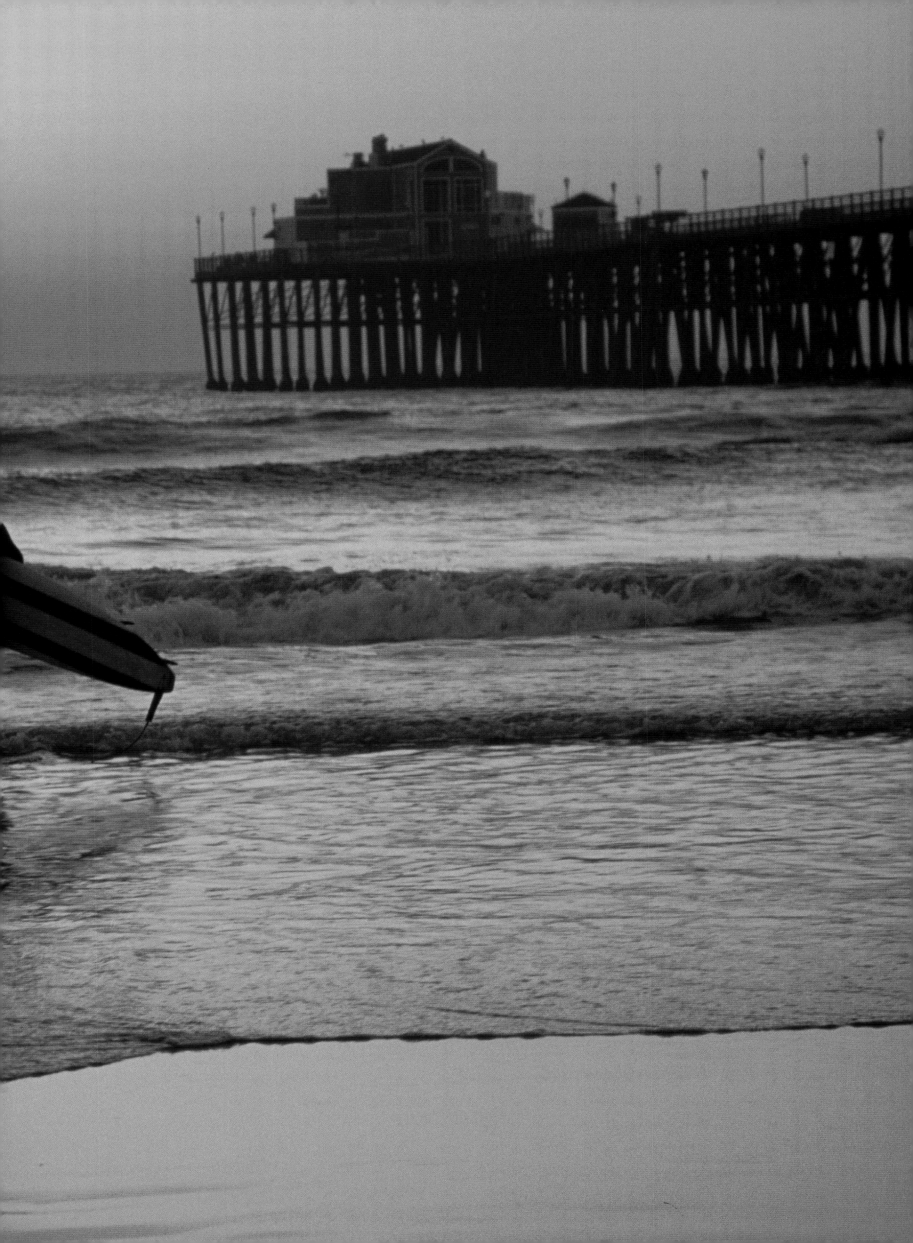

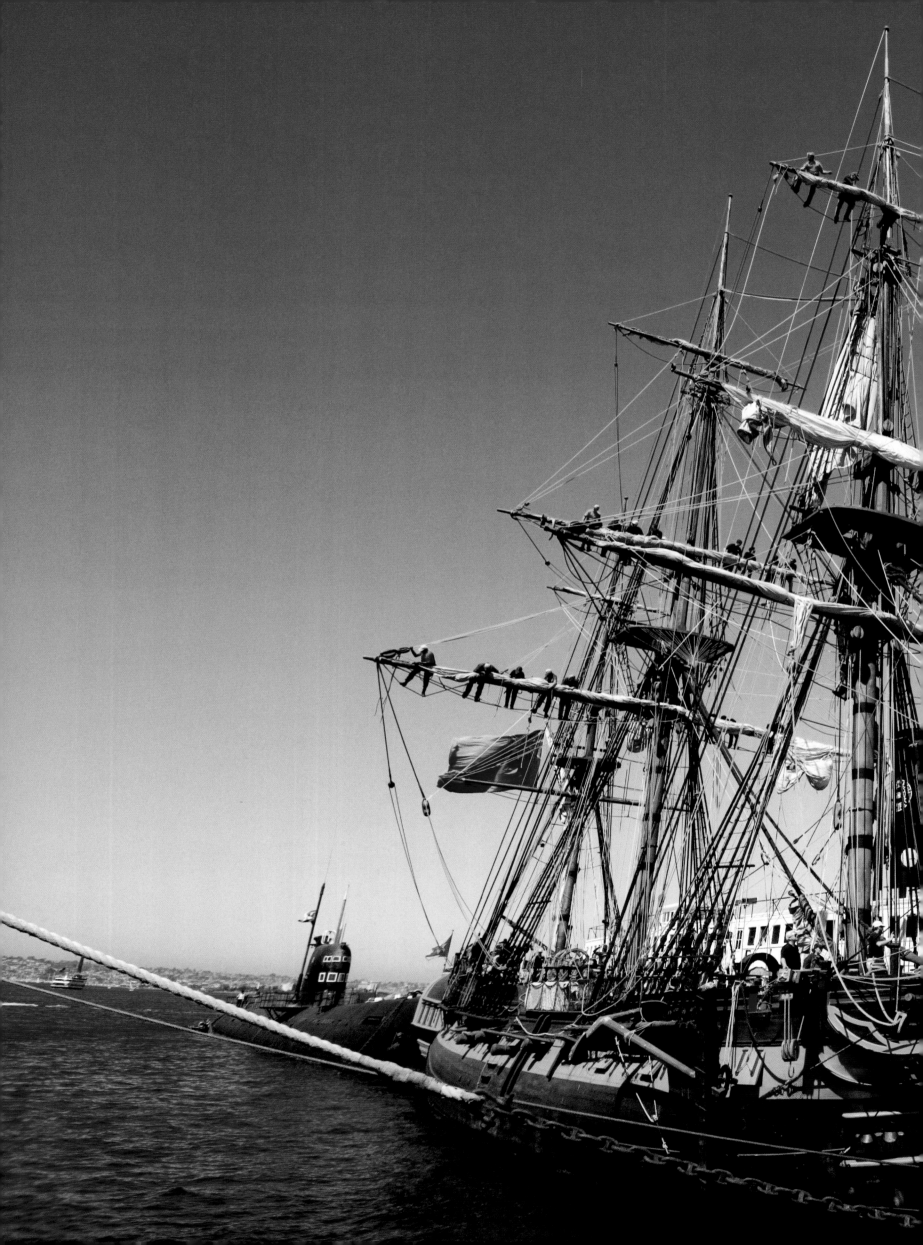

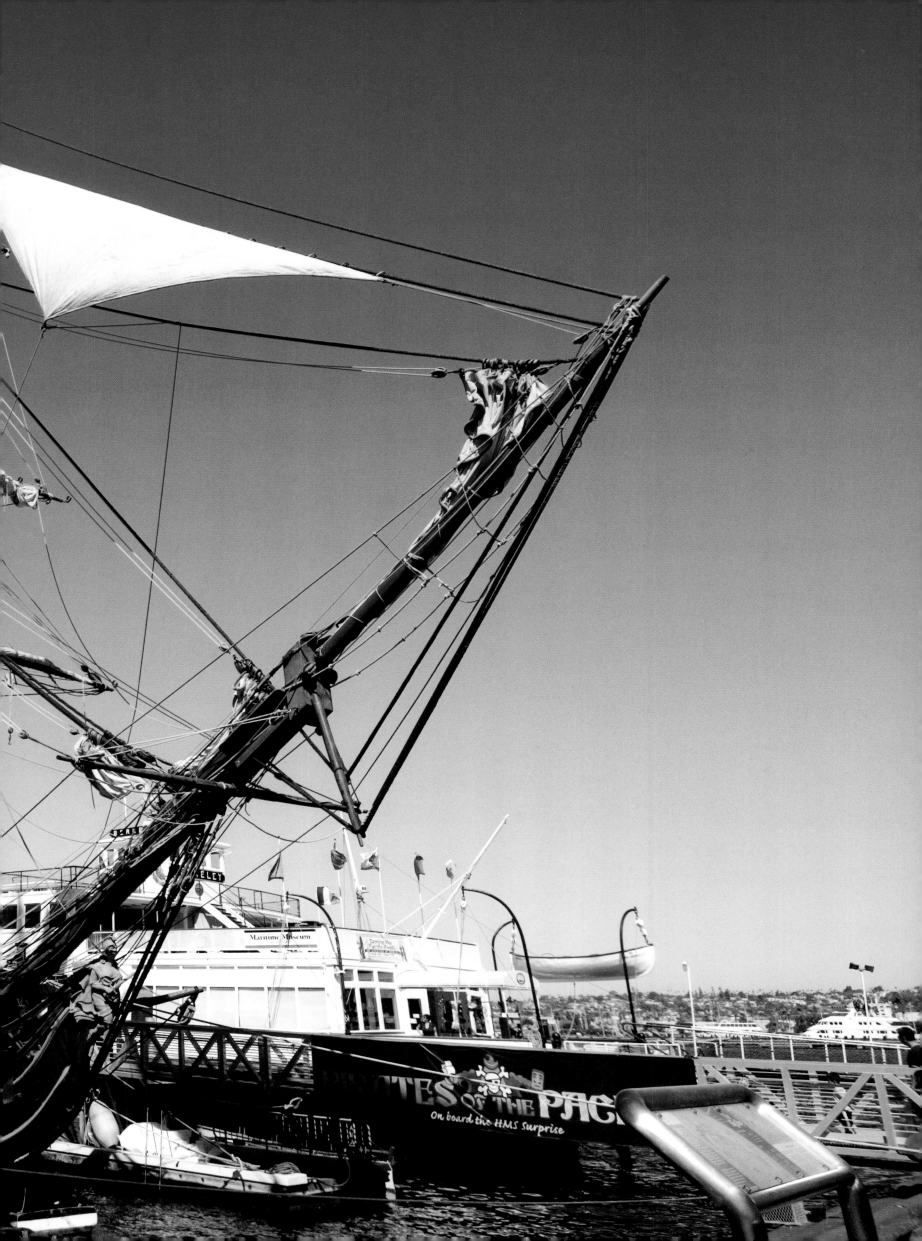

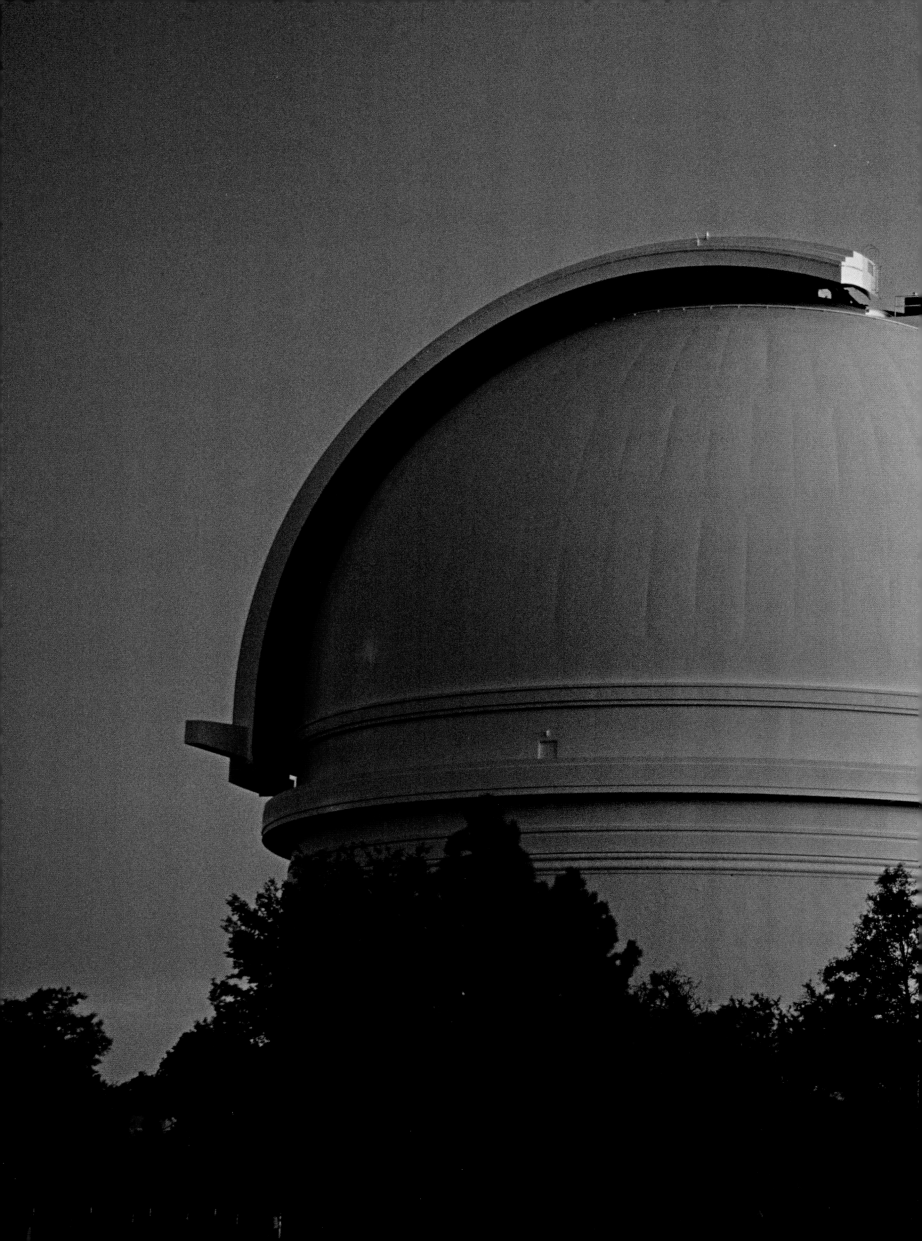

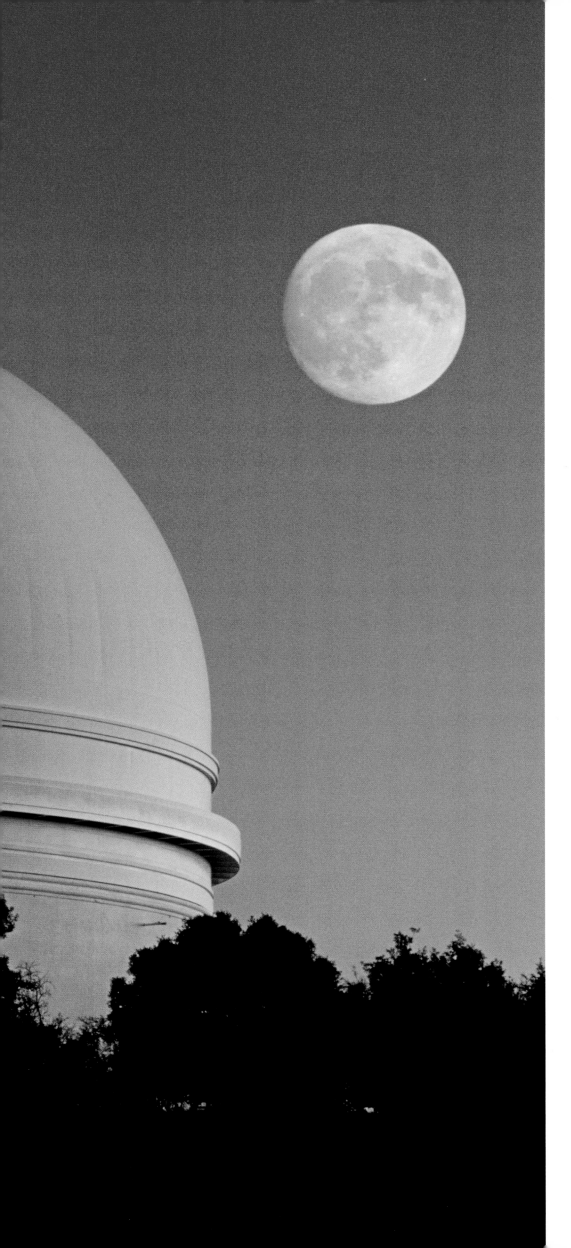

The California Institute of Technology owns and operates the Mount Palomar Observatory located in San Diego County. This world-class facility for astronomical research opened in 1948 and is home to the 200-inch Hale Telescope, one of the largest, most effective telescopes in the world.

The Maritime Museum, located in San Diego Bay, was established in 1948. It preserves and has restored one of the finest and largest collections of historic sea vessels — most notably the world's oldest active sailing ship, the famous *Star of India. (previous pages)*

Beautiful San Diego Harbor hosts many different tours all year round. Visitors come to enjoy narrated harbor excursions, scenic ferry boat rides, and dinner-dance cruises. (*overleaf*)

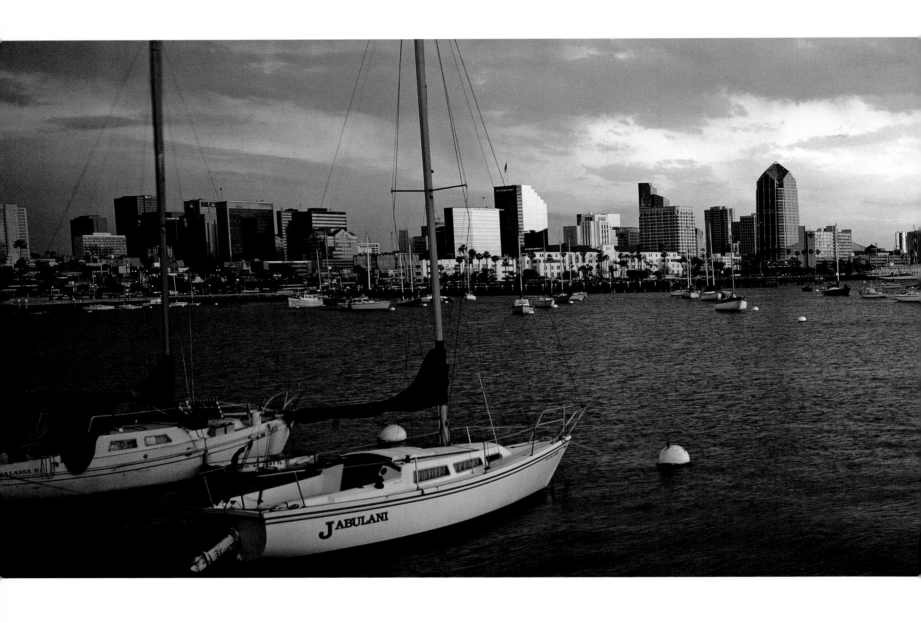

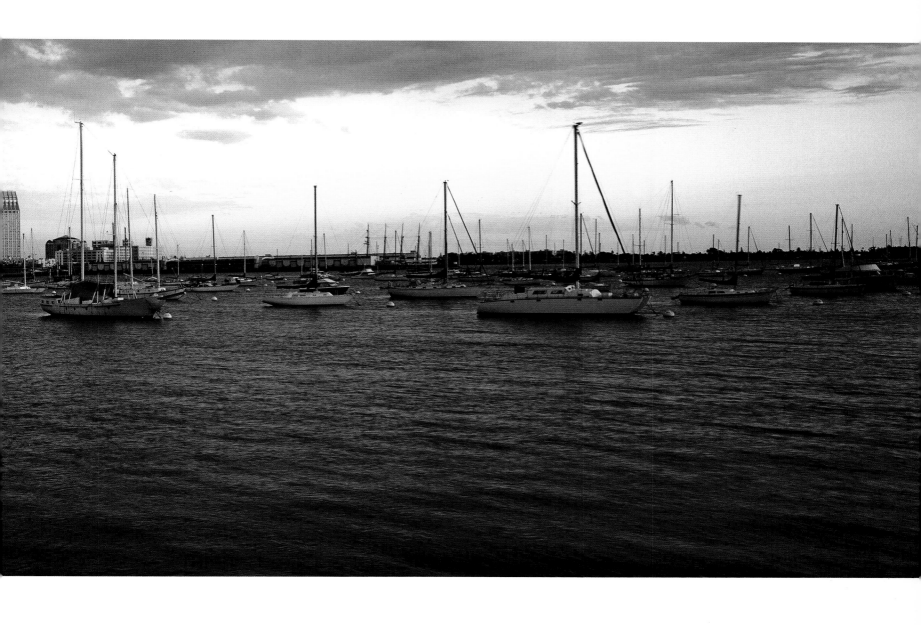

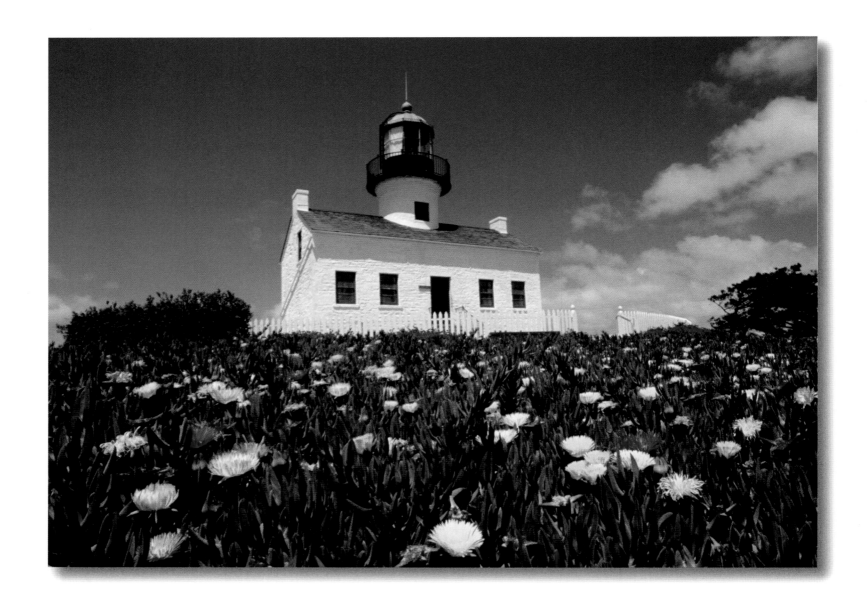

The Old Point Loma Lighthouse towers 422 feet above sea level in San Diego Bay.
First lit by the light keeper on November 15, 1855, it guided sailors safely into the
harbor for 36 years. It marks the site of the Cabrillo National Monument, which
memorializes the landing in 1542 of the Portuguese explorer Juan Rodriguez
Cabrillo — the first European to set foot on the
California coast.

San Diego's Balboa Park is a large cultural complex and National Historic
Landmark. Its 1,200 acres feature the world-famous San Diego Zoo, stunning
gardens, museums, and theatres. *(right)*

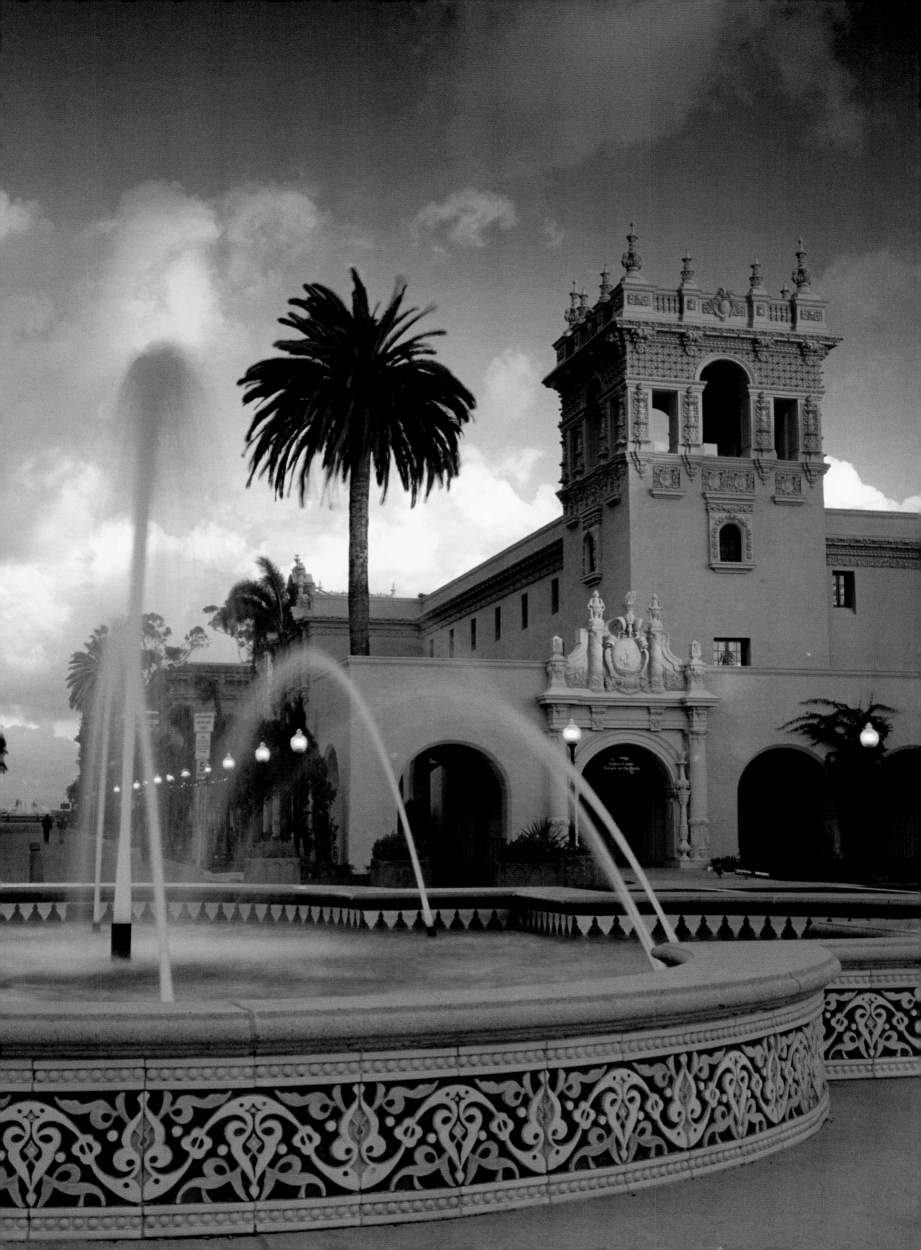

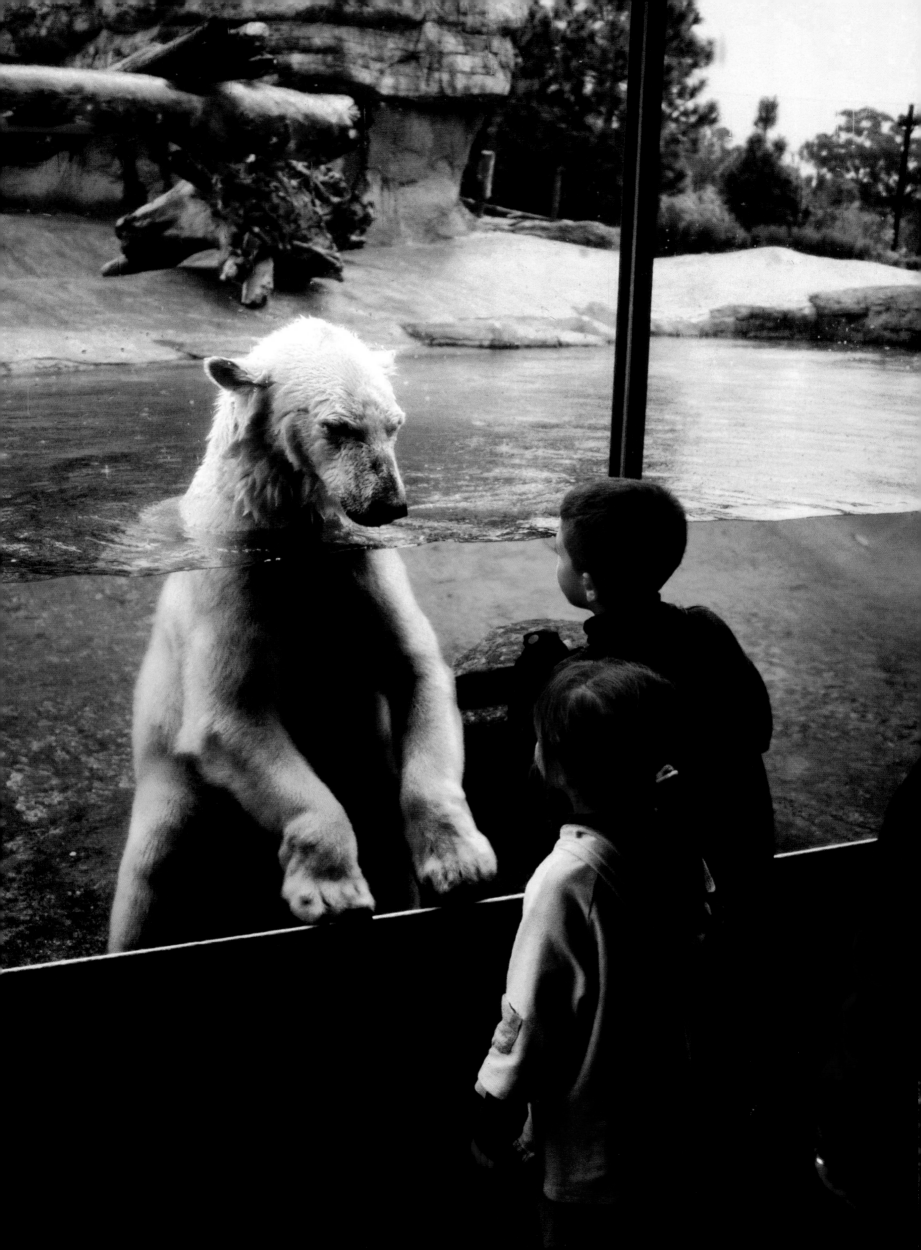

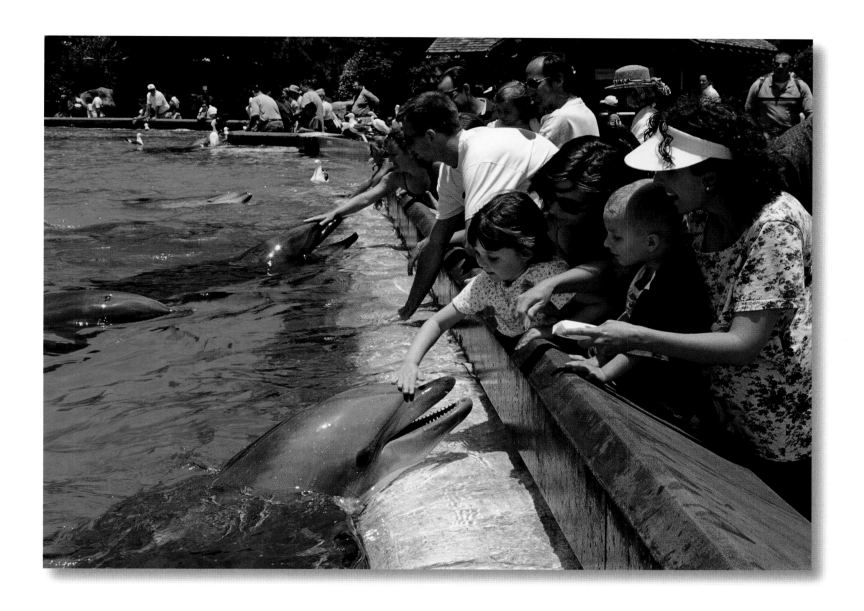

The initial idea to open an underwater restaurant and marine life exhibit led four UCLA graduates to build what is known today as Sea World. Established in 1964, this theme park of magnificent marine mammals has a variety of exciting rides and attractions for all ages — most notably the amazing killer whale, pilot whale, and bottlenose dolphin shows.

In 1916, Dr. Harry Wegeforth established the San Diego Zoo because of his concern for the welfare of the animals that were displayed at the Panama-California exhibition. This 100-acre world-class animal facility located in Balboa Park, San Diego, is known for its grotto "cageless" exhibitions and is home to over 4,000 animals and 800 species. *(left)*

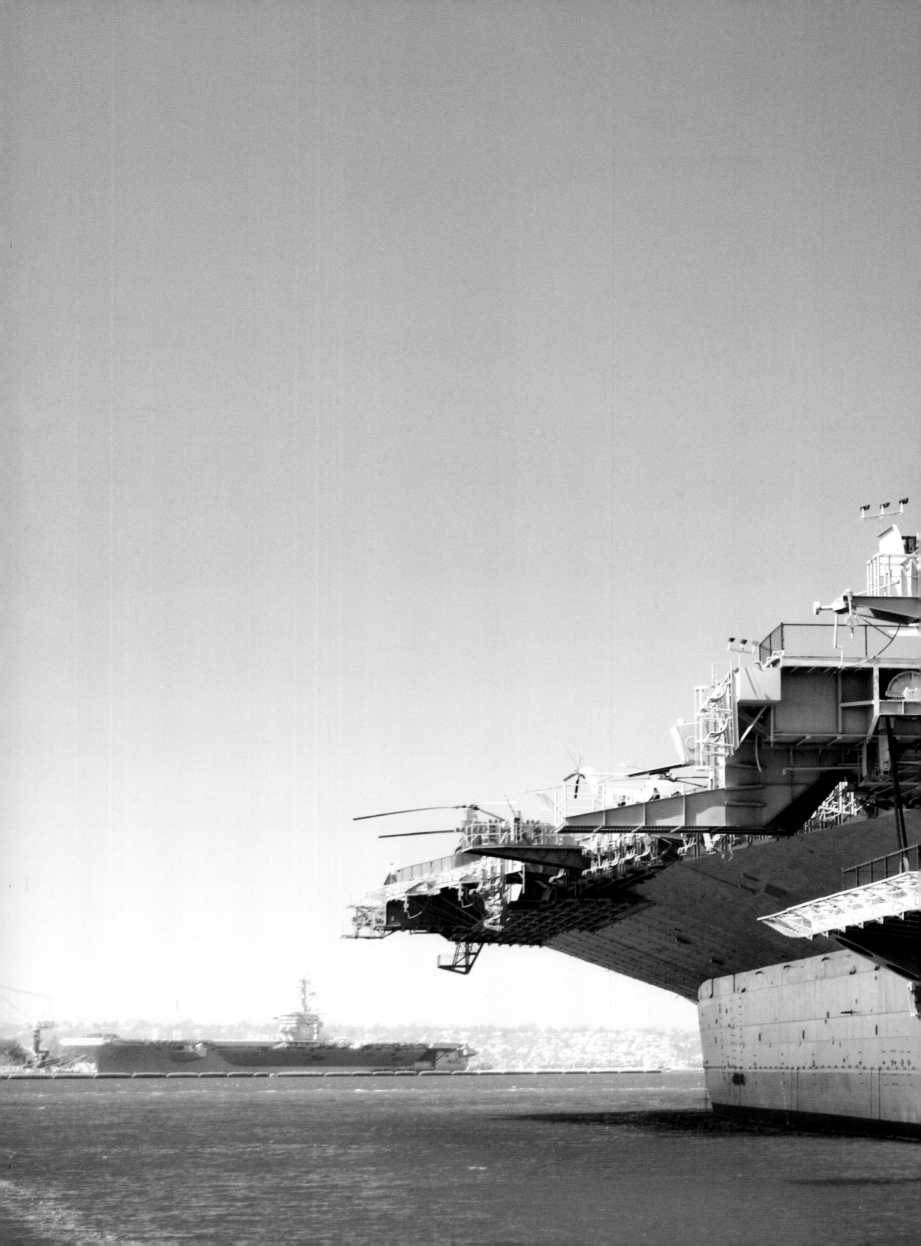

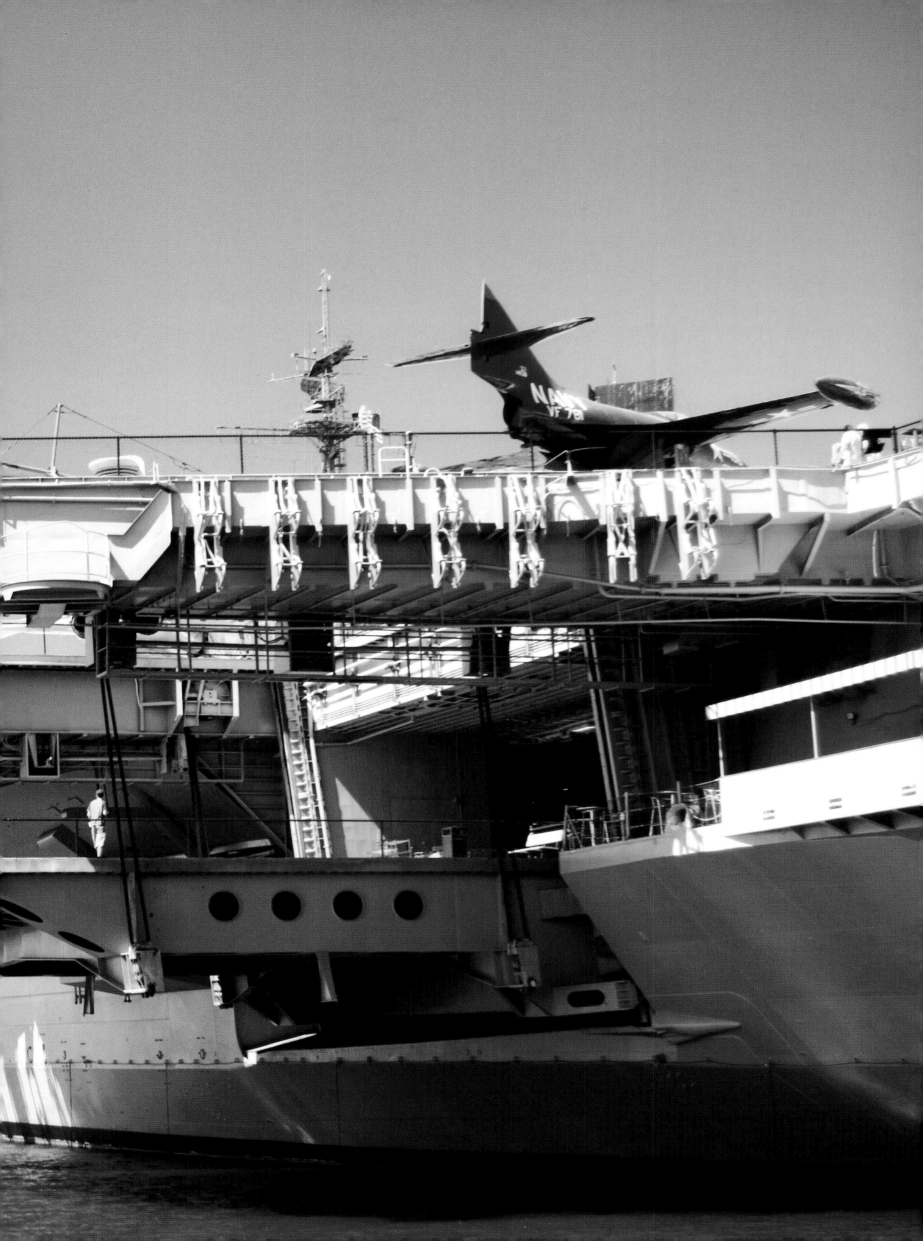

The California poppy was designated the official state flower in 1903. Native to California, these poppies blanket vast hillsides with their radiant orange blooms.

The San Diego Aircraft Carrier Museum, featuring more than 35 exhibits, is home to the USS *Midway* — the longest serving United States Navy aircraft carrier. Its exciting naval aviation life can be experienced through the museum's virtual-reality flight simulator and a self-guided audio tour. (*previous pages*)

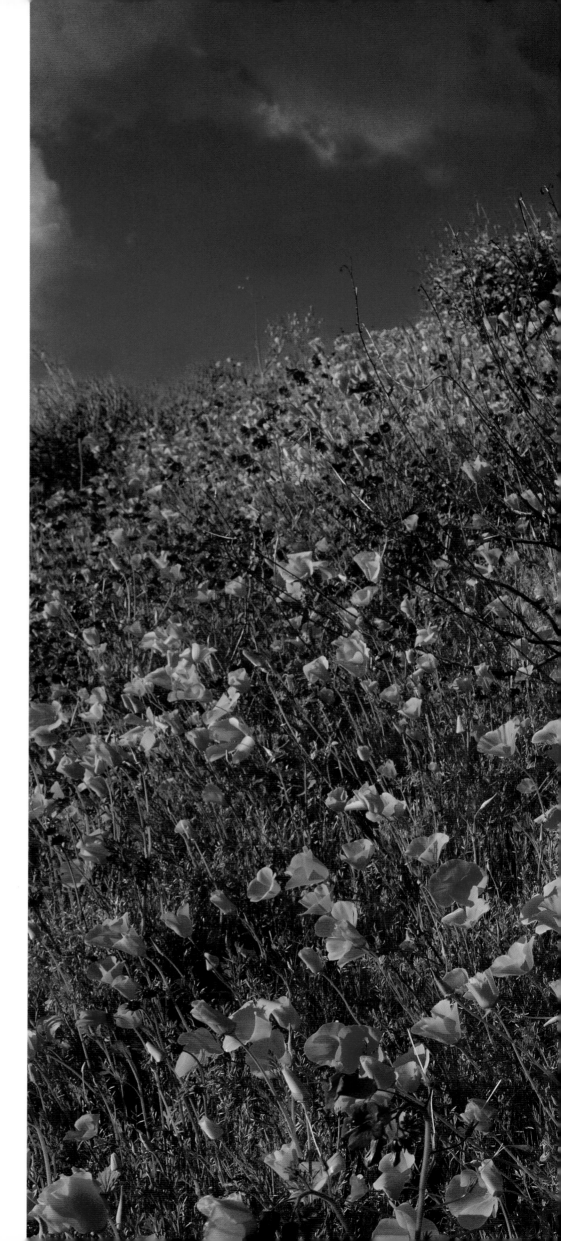

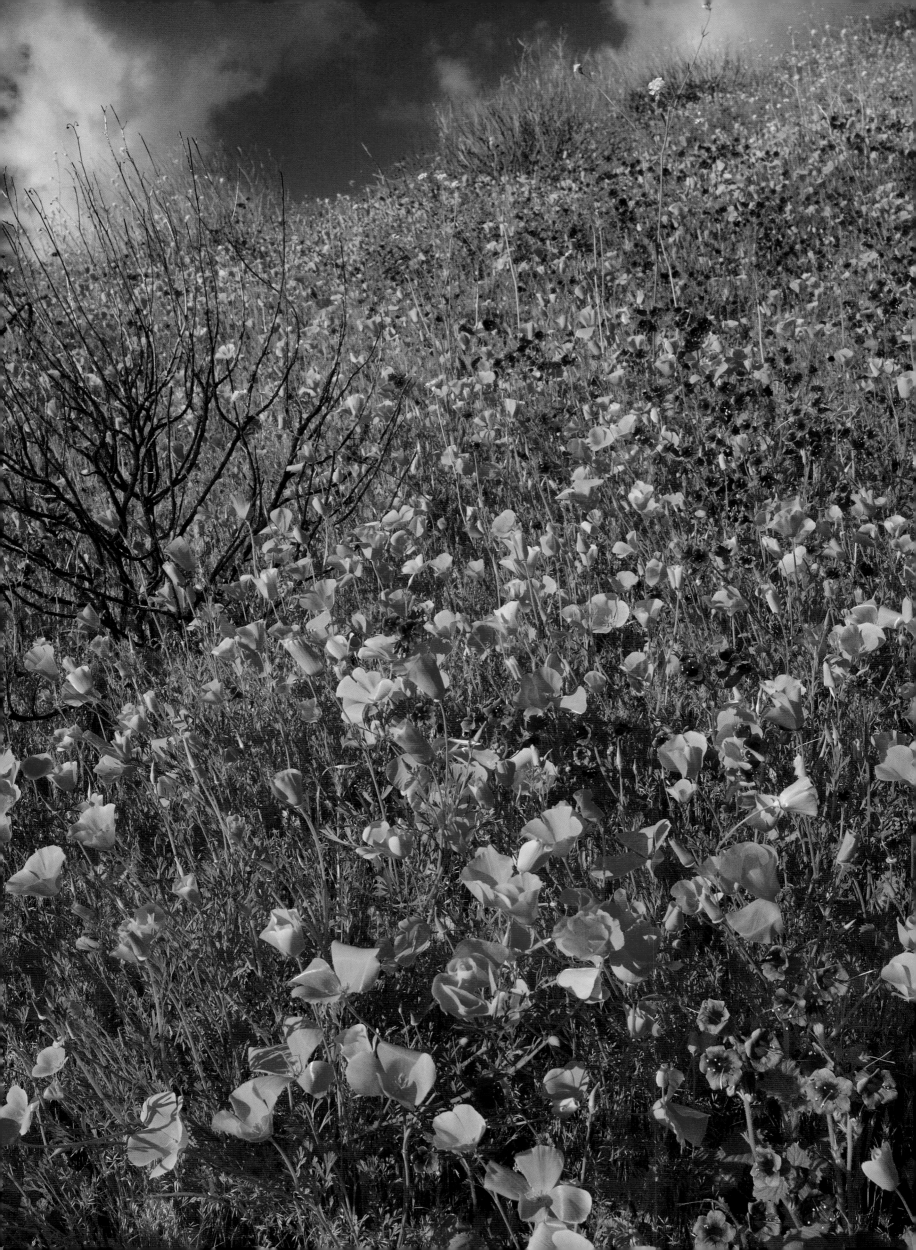

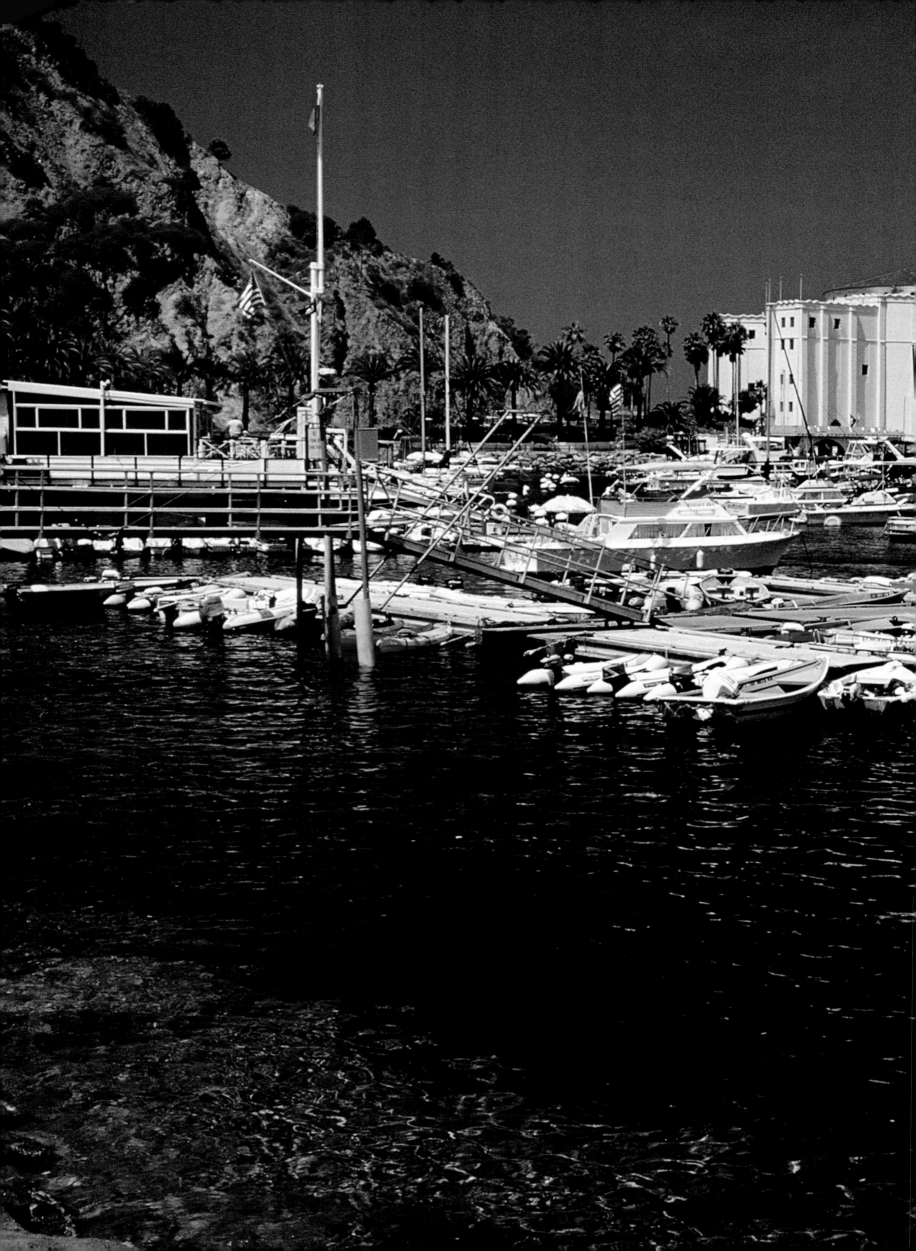

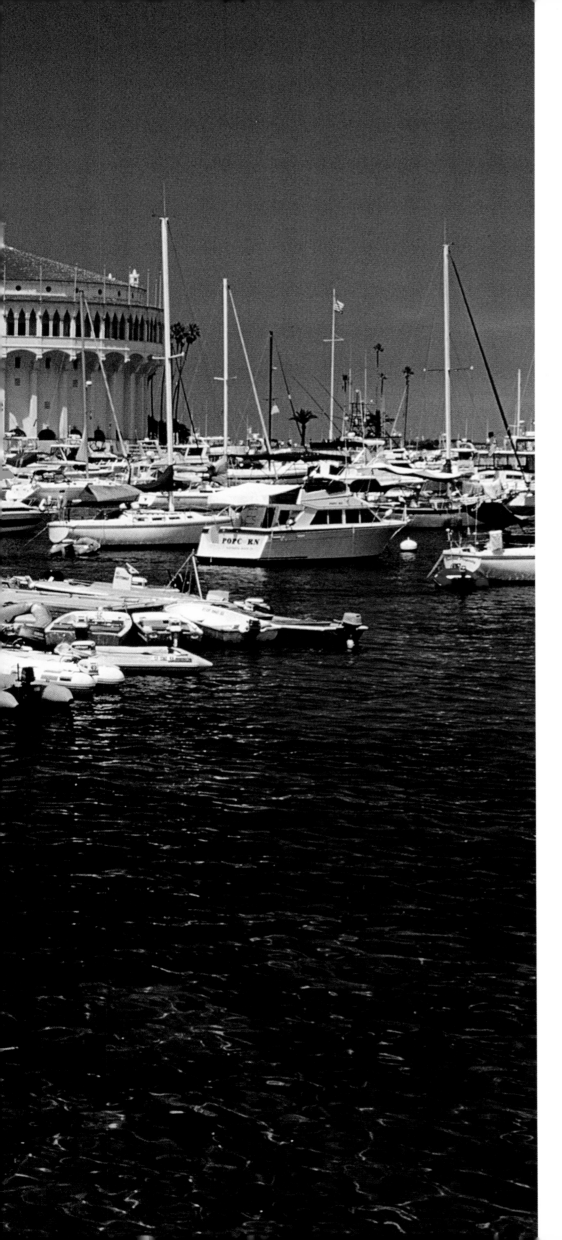

Santa Catalina Island is located off the coast of southern California. This pristine island features a casino, hotels, fine restaurants, a golf course, a museum, and botanical gardens, attracting millions of tourists each year.

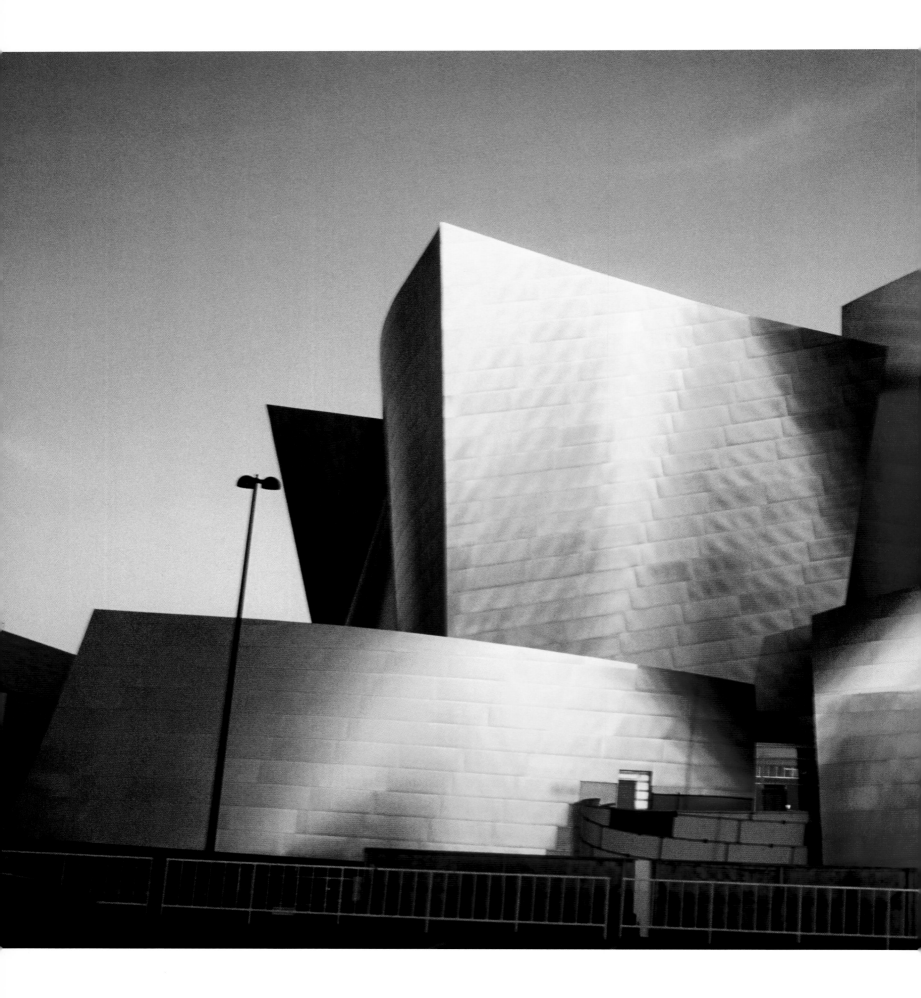

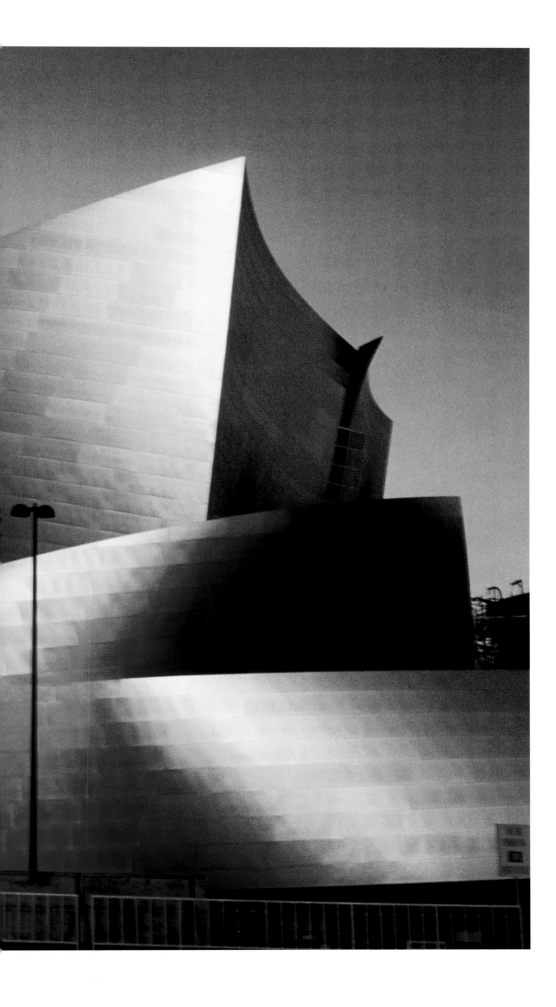

The stunning Walt Disney Concert Hall was designed by renowned architect Frank Gehry. This world-class architectural spectacle boasts acoustic sophistication, a beautiful auditorium, and a gleaming stainless-steel exterior.

Leo Carrillo State Park consists of 3,000 acres and one and a half miles of pristine beach. It was named after Leo Carrillo who served on the California Beach and Park Commission for 18 years. A conservationist, preservationist, and actor, Leo Carrillo is perhaps best remembered for his character Pancho on the 1950's TV series "The Cisco Kid."

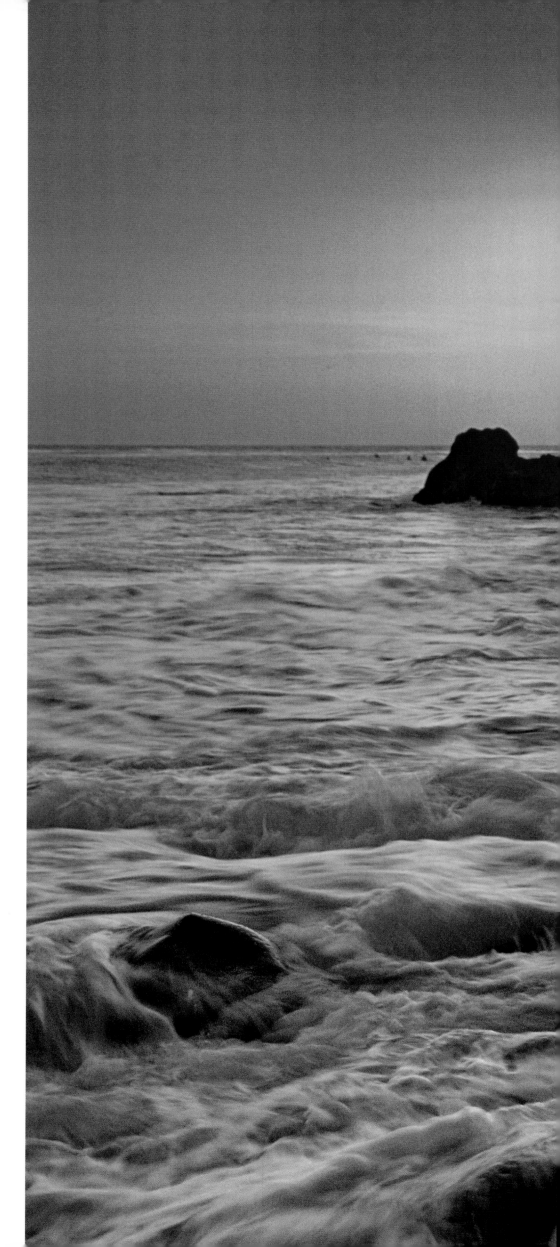

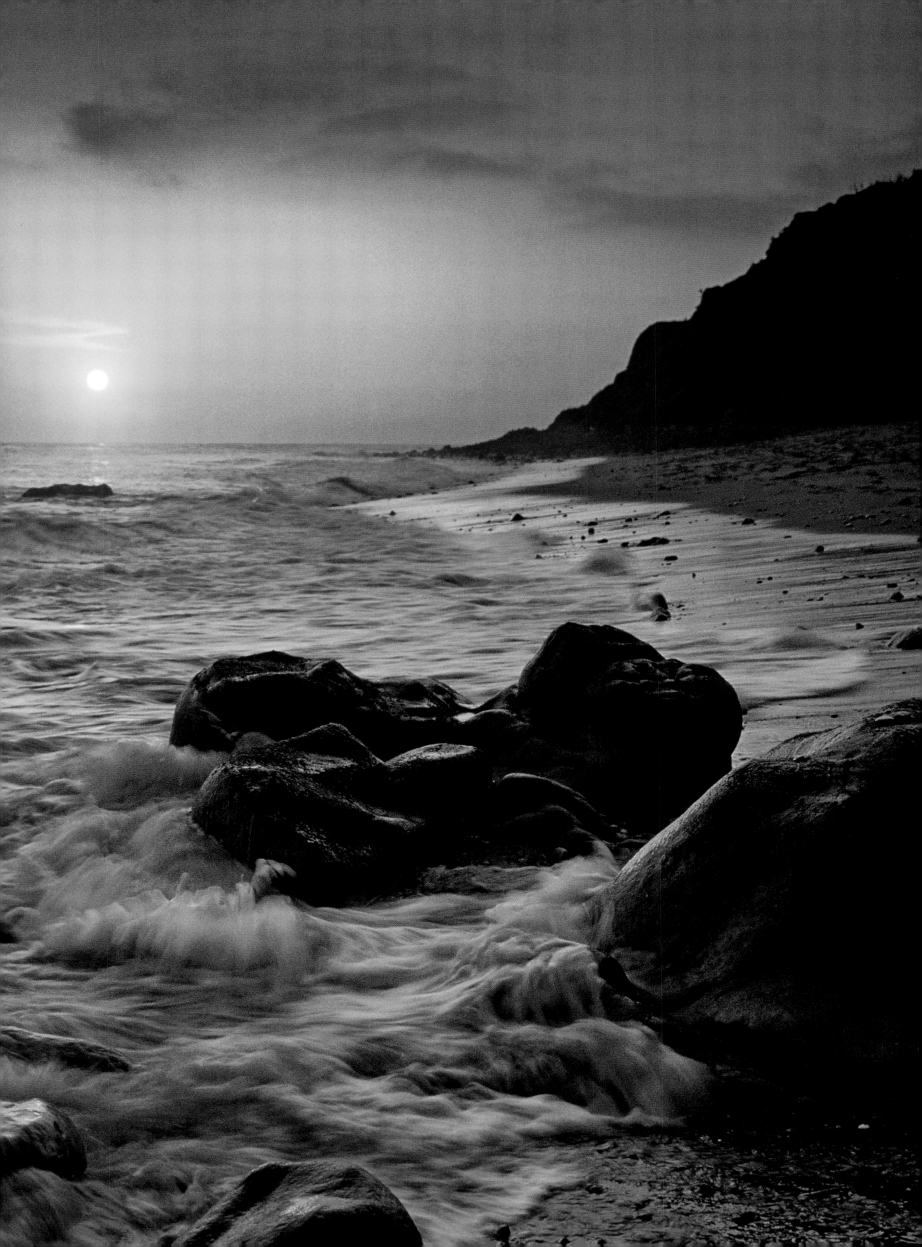

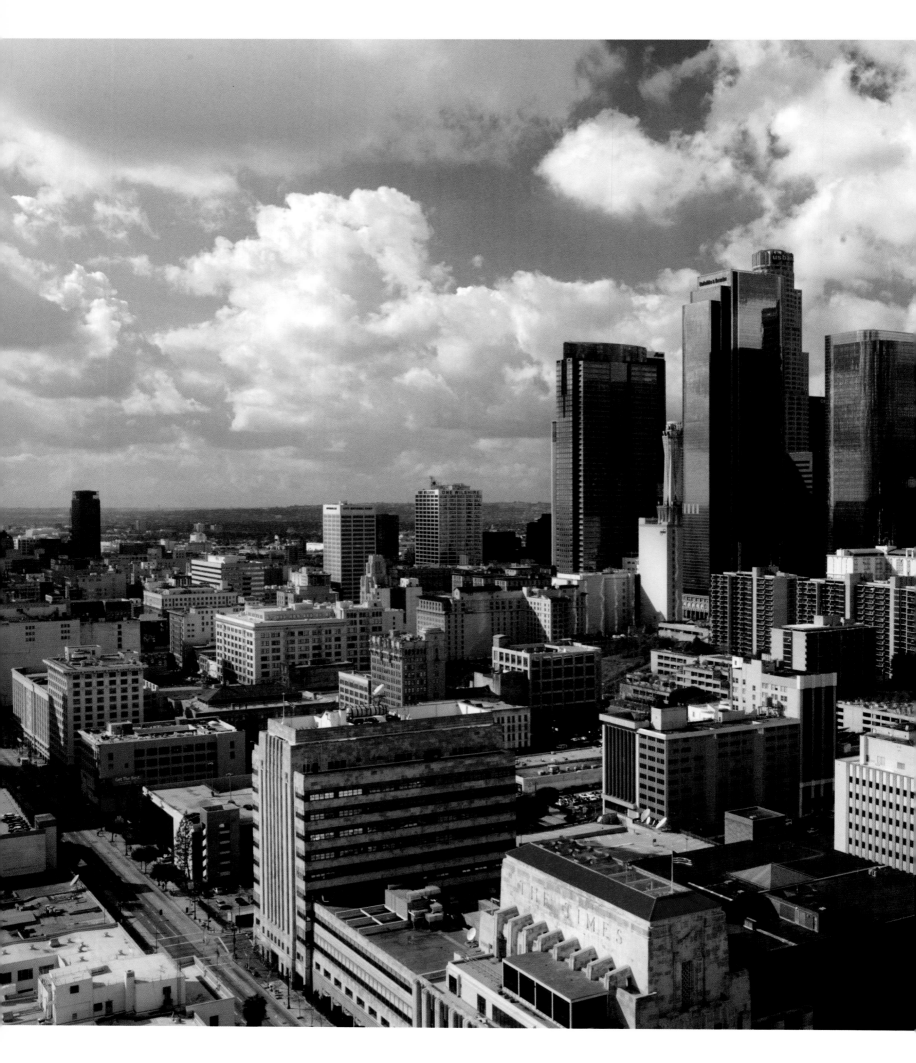

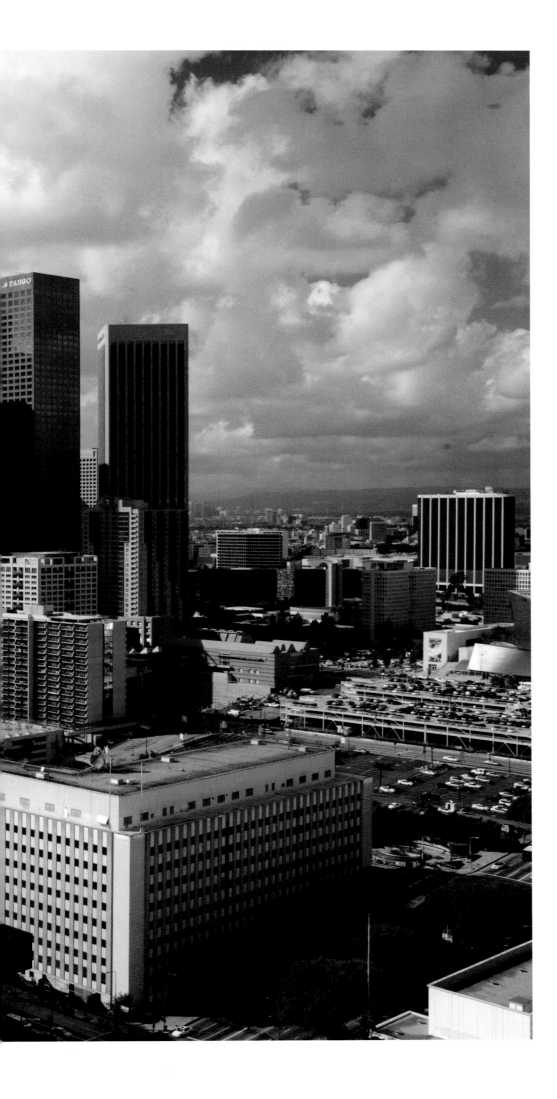

Southern California's metropolitan city of Los Angeles, also known as the City of Angels, was founded by the Spanish Captain Fernando Rivera y Moncada in 1781 and incorporated in 1850. Today it is the largest and most populous city in California, and the second largest in the U.S. It is a cultural melting pot that is internationally recognized for its economy and world renowned for its entertainment industry.

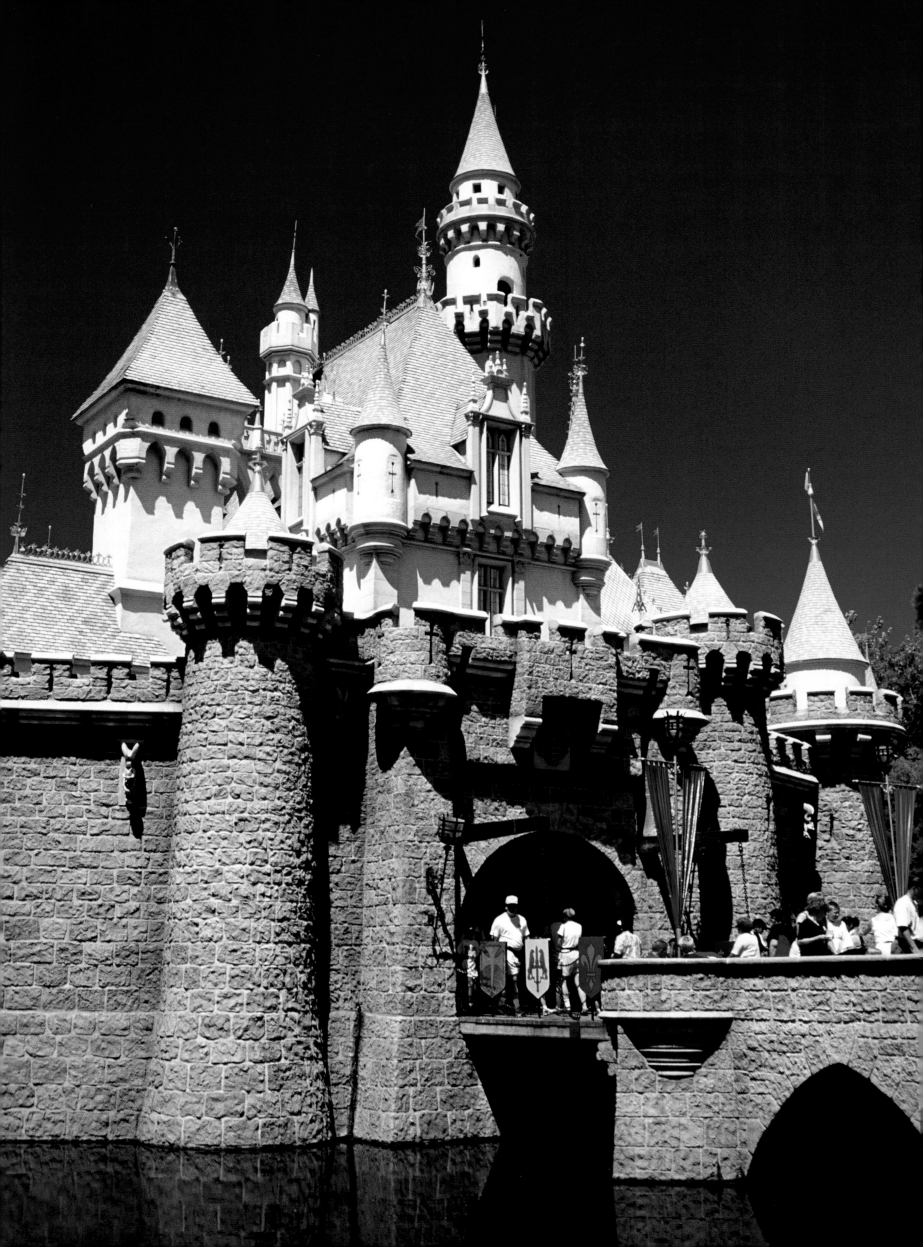

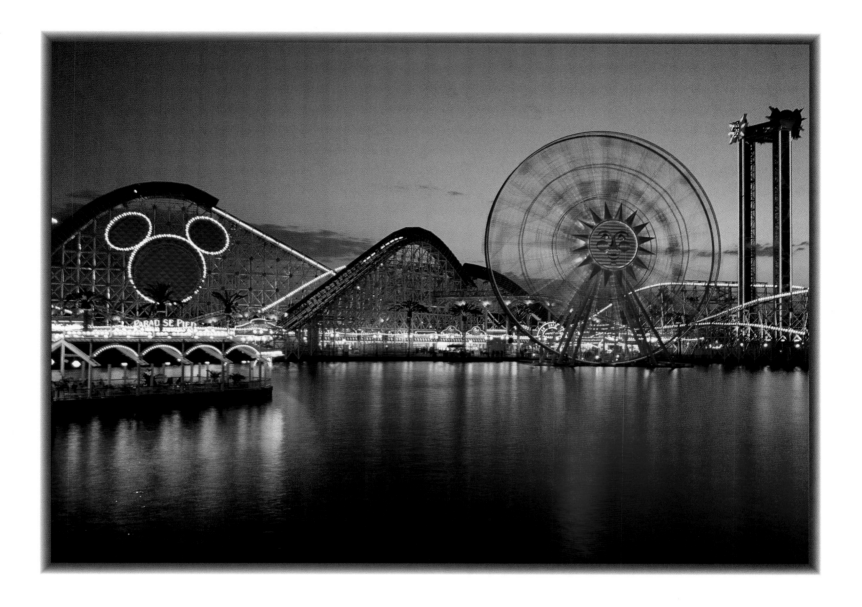

The Disneyland Resort, near Disneyland Park in Anaheim, California, is a fun recreational destination that features Disney's California Adventure Park. One of its many alluring attractions, called the Sun Wheel, is a giant ferris wheel created with a sun theme.

Disneyland Park is a world-famous amusement park in Anaheim, California. Created by visionary entrepreneur Walt Disney, it opened in 1955 and is owned and operated by the Walt Disney Company. Its many features include rides, theme lands, live shows, and a monorail, attracting millions of visitors from all around the world. *(left)*

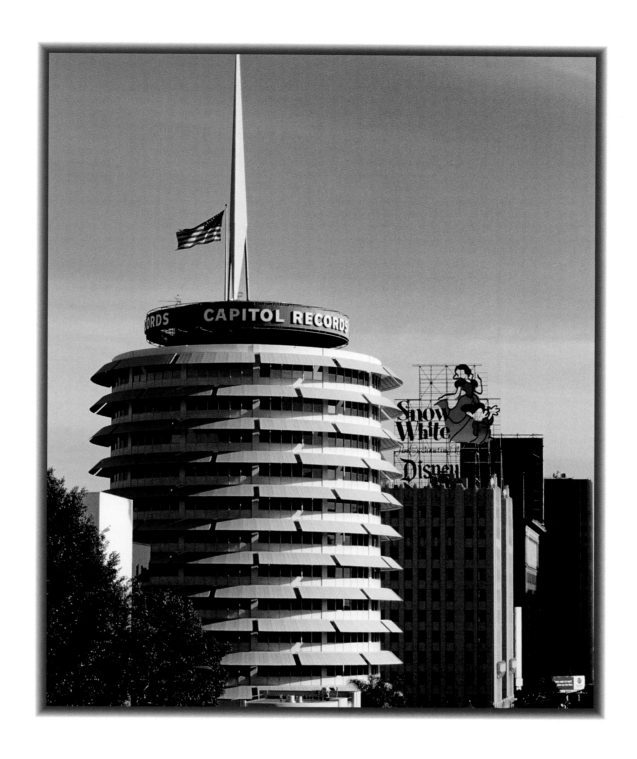

Resembling an immense stack of vinyl 45s on a turntable, the Capitol Records Tower is a 13-storey Hollywood landmark and beacon to the music business. A pioneer in the industry, Capitol Records was, in 1942, the first record company established on the West Coast.

The Arco Plaza Towers and the Aon Tower are located in downtown Los Angeles. The two Arco Plaza buildings are almost identical, with 52 floors rising up 699 feet. At the time of their completion in 1972, they were the tallest buildings in Los Angeles, until the Aon Tower, the tallest building in Los Angeles until 1989, was built in 1973. The Aon Tower's 62 floors rise up 858 feet. *(left)*

Laguna Beach, a classic southern California beach city located in Orange County, is a popular tourist destination and home to many celebrities and artists. It is perhaps most famous for its annual event, The Festival of Arts. Its feature attraction is the Pageant of the Masters in which classical and contemporary paintings come to life with music, narrators, and real people posing.

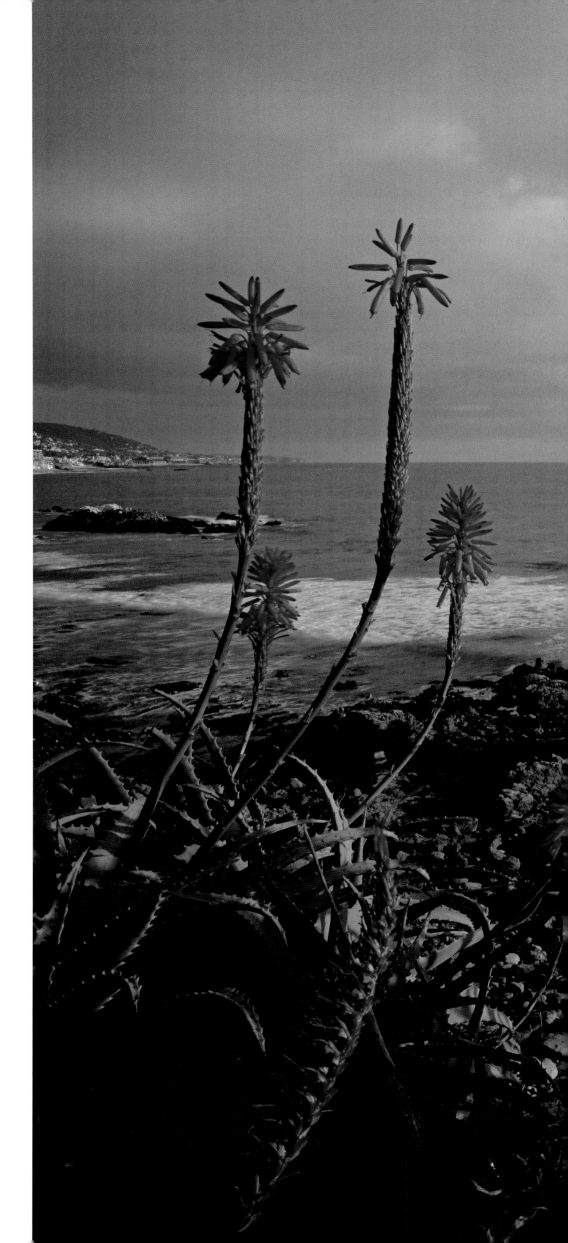

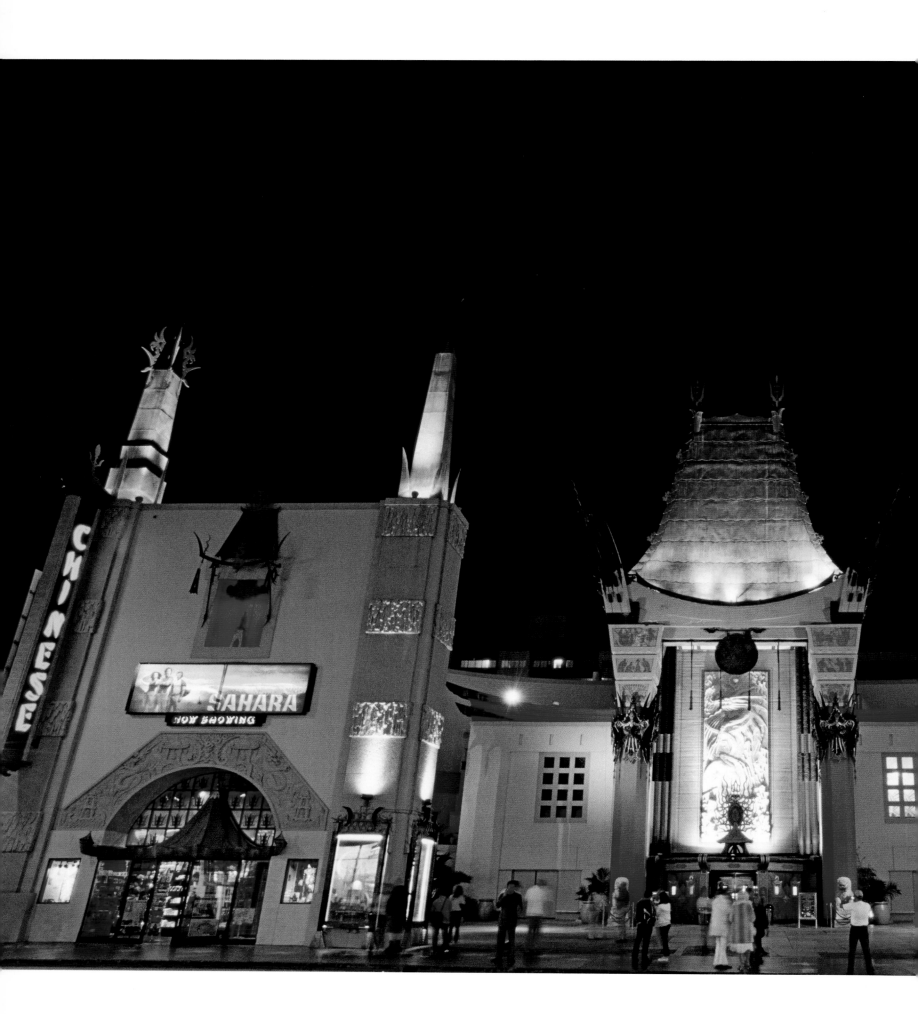

Hollywood's world-famous Sid Grauman Chinese Theatre opened in 1927 and was built at a cost of $2 million. The theatre features a sidewalk of celebrity handprints, footprints, and autographs, marked into the cement. In 1968, it was declared a historic, cultural landmark and is still one of the most favored places for Hollywood movie premieres.

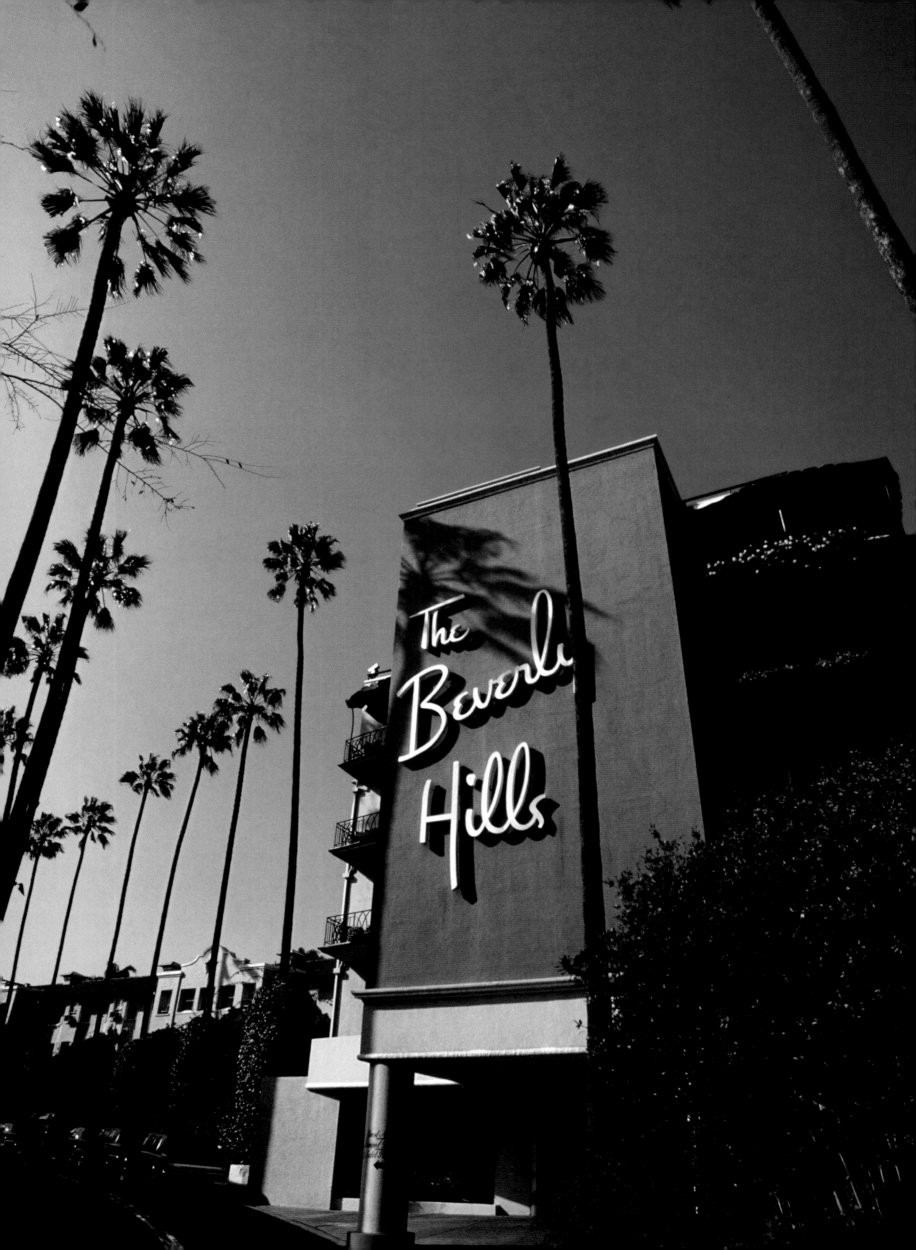

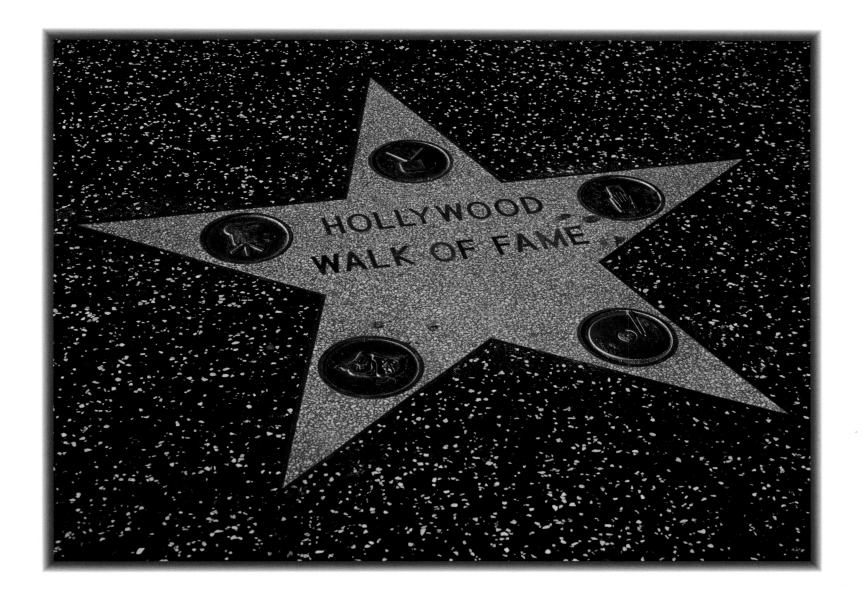

In 1958, artist Oliver Weismuller created the Hollywood Walk of Fame along Hollywood Boulevard. It pays tribute to celebrities who have made momentous contributions to Hollywood's entertainment industry, which includes film, television, radio, music recording, and live theatre.

The renowned Beverly Hills Hotel is situated on Sunset Boulevard. Built in 1912, its 21 bungalows and 12 acres of lush gardens have hosted several celebrity legends, such as Marilyn Monroe, Elizabeth Taylor, and Clark Gable. *(left)*

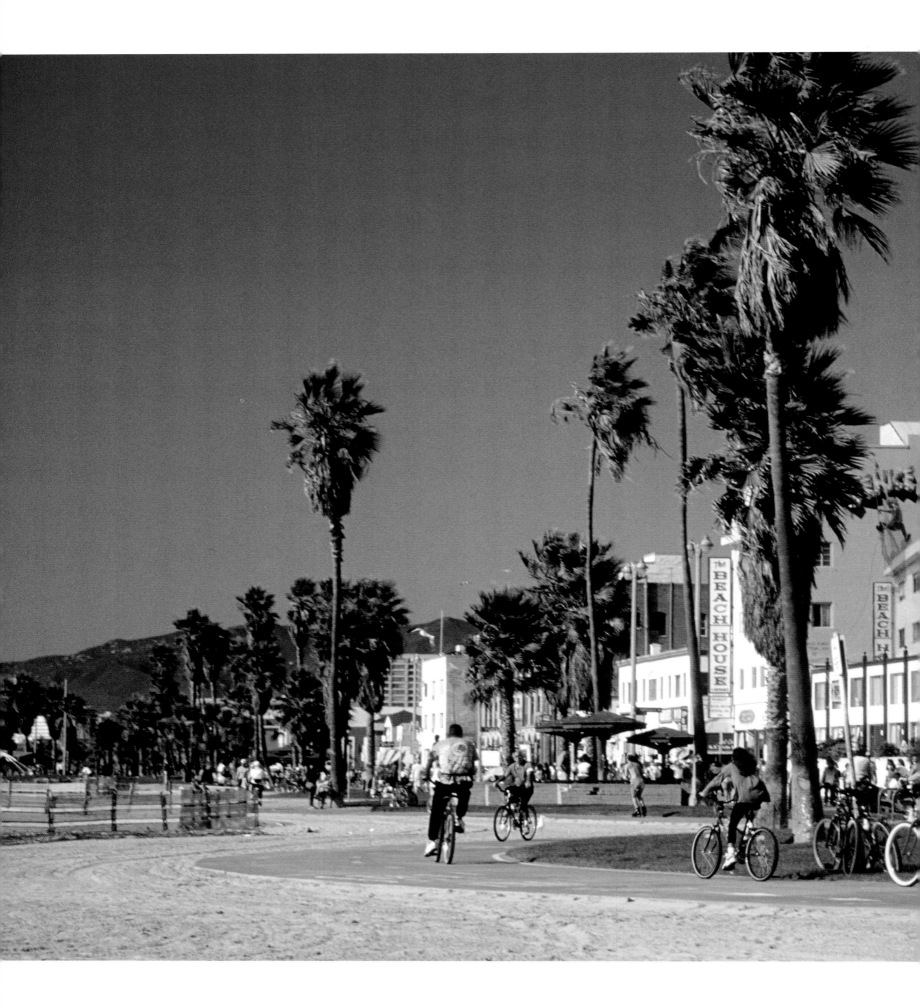

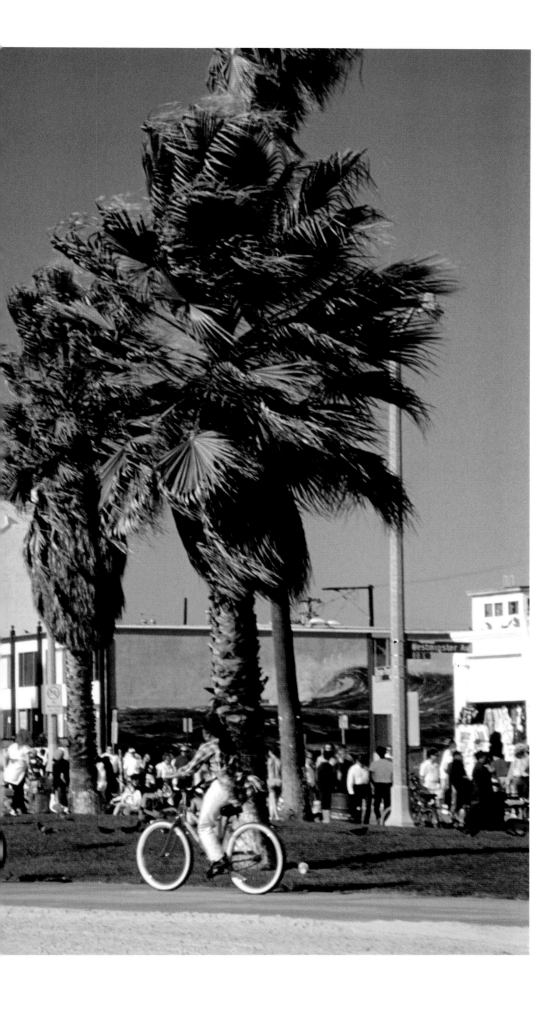

Venice Beach in west Los Angeles is perhaps best known for its colorful bohemian community. Its famous boardwalk, which runs parallel to the beach, bustles on the weekends with bikers, skaters, tourists, and street performers.

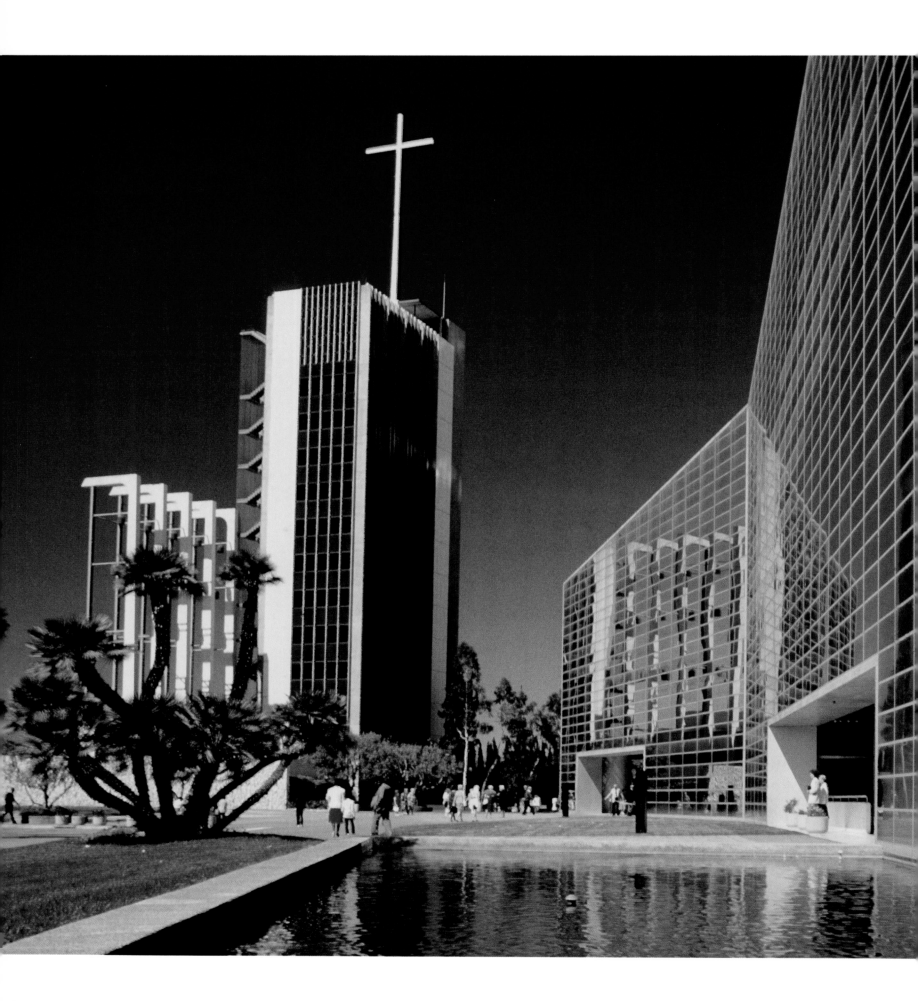

The Crystal Cathedral, located in the city of Garden Grove, is a world-famous spiritual shrine and church. A shimmering architectural work of art, it was designed by American architect Philip Johnson.

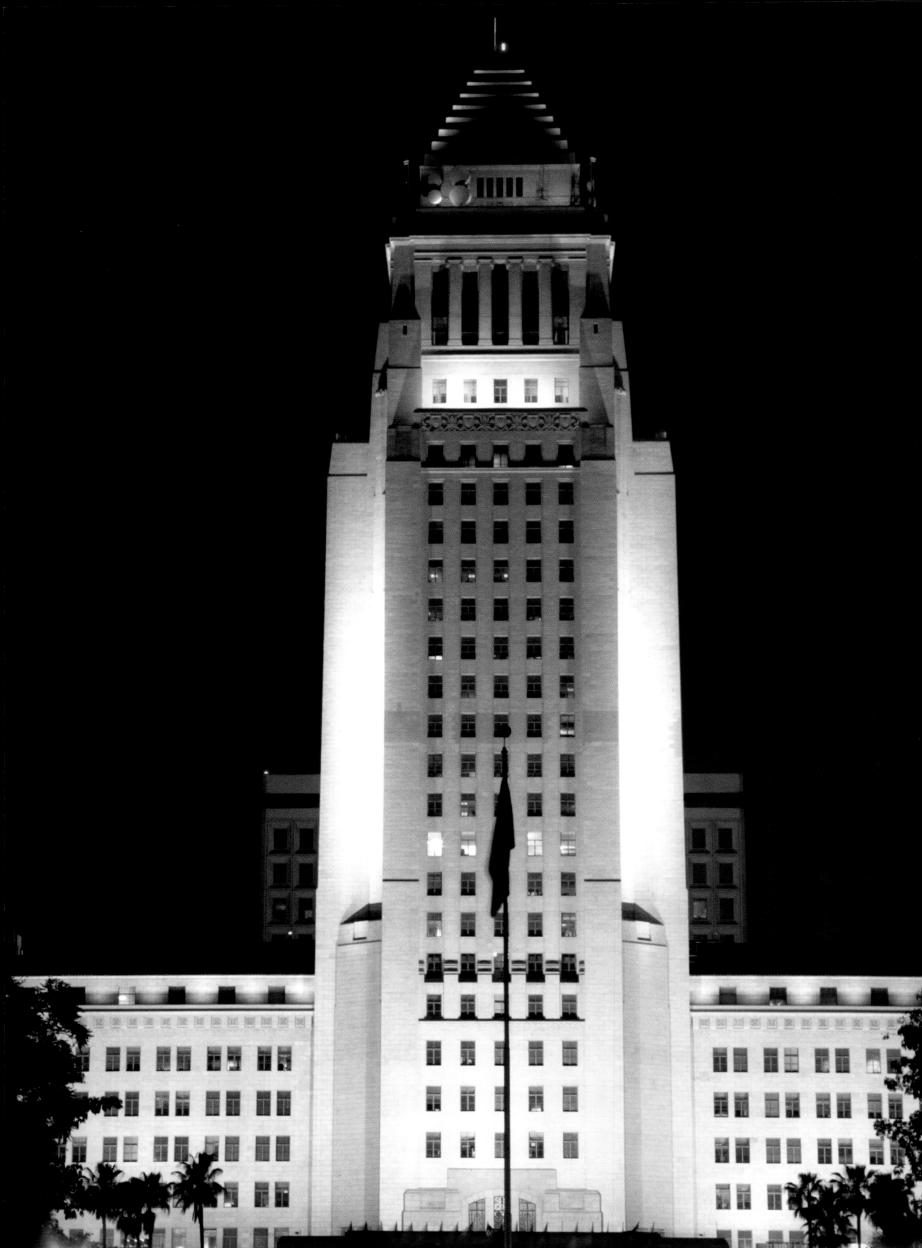

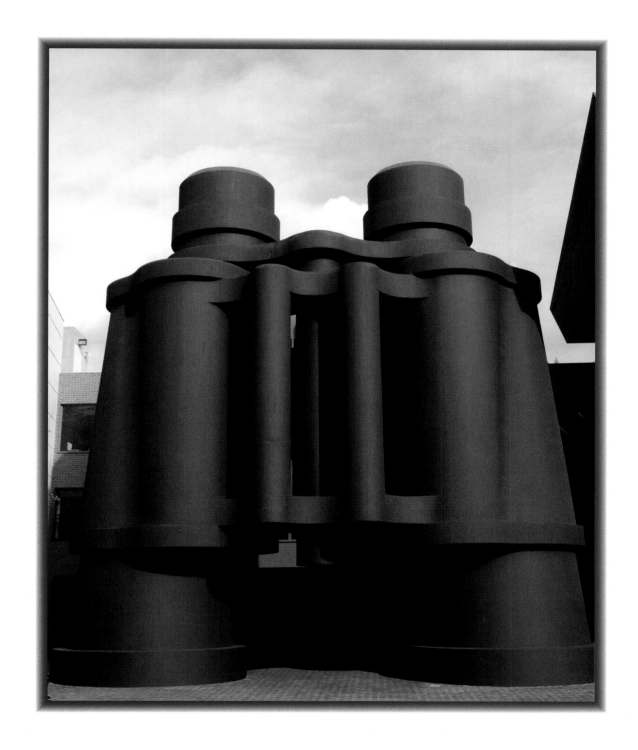

The unique binocular building in Venice, California, was designed by architect Frank Gehry in collaboration with artists Claes Oldenburg and Coosje van Bruggen. These monumental binoculars that serve as the entranceway to the building have become a Venice landmark.

Los Angeles City Hall, located in downtown Los Angeles, was built in 1928. At 454 feet, it was the tallest building in Los Angeles from 1928 to 1964. Its concrete tower was constructed with water from California's 21 historic missions and sand from its 58 counties. It was designed to resemble one of the Seven Wonders of the Ancient World, the Mausoleum at Halicarnassus. *(left)*

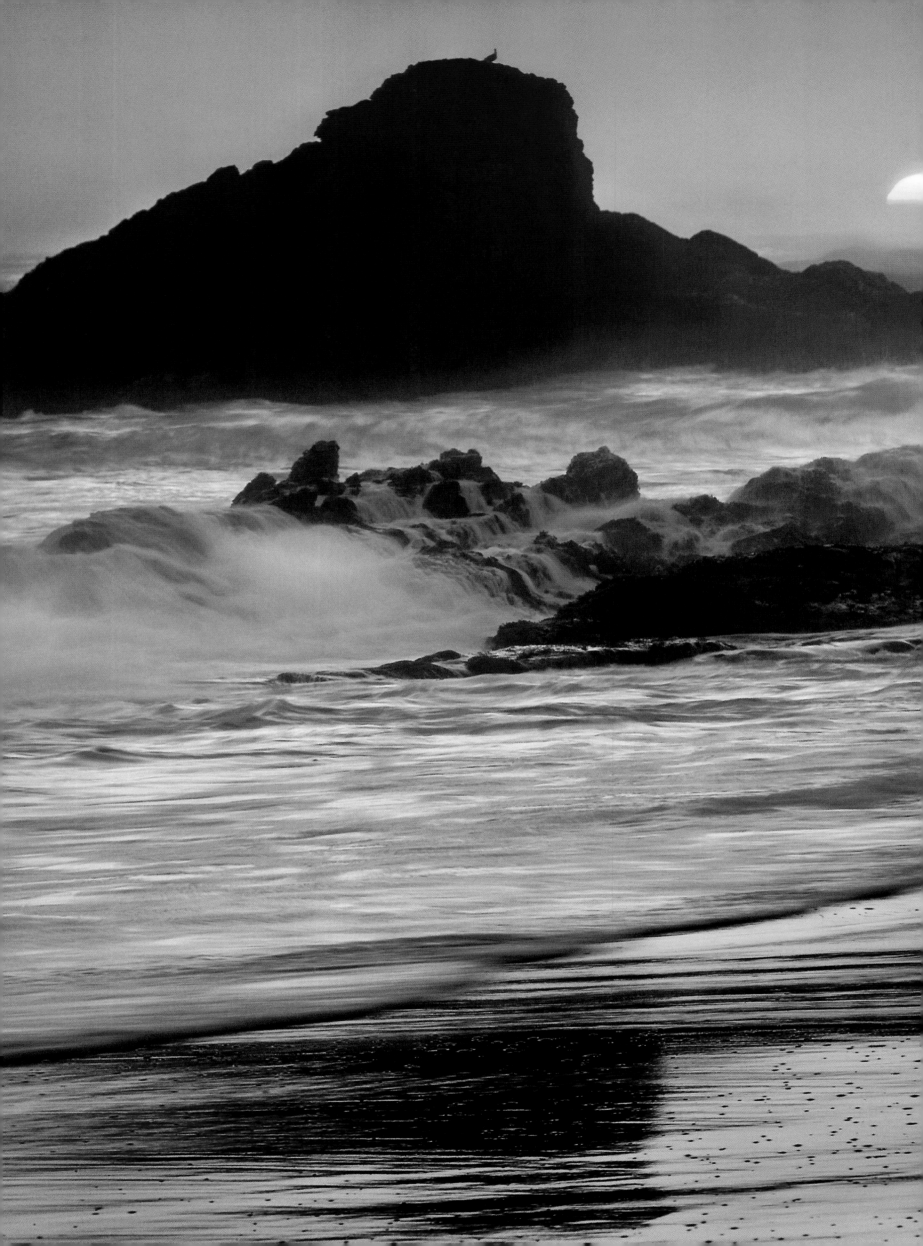

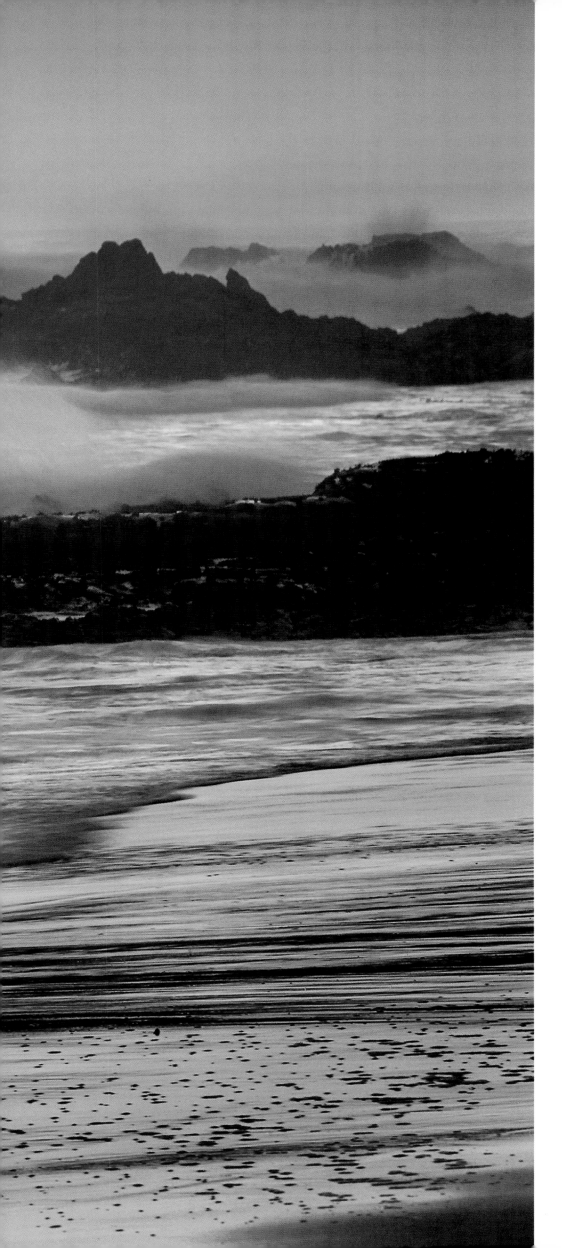

El Matador Beach is one of the most beautiful in Malibu. It has a long, sandy shoreline with a series of intimate coves, sea caves, stacks, and rock outcroppings. Its upper cliffs provide views of the deep blue water below.

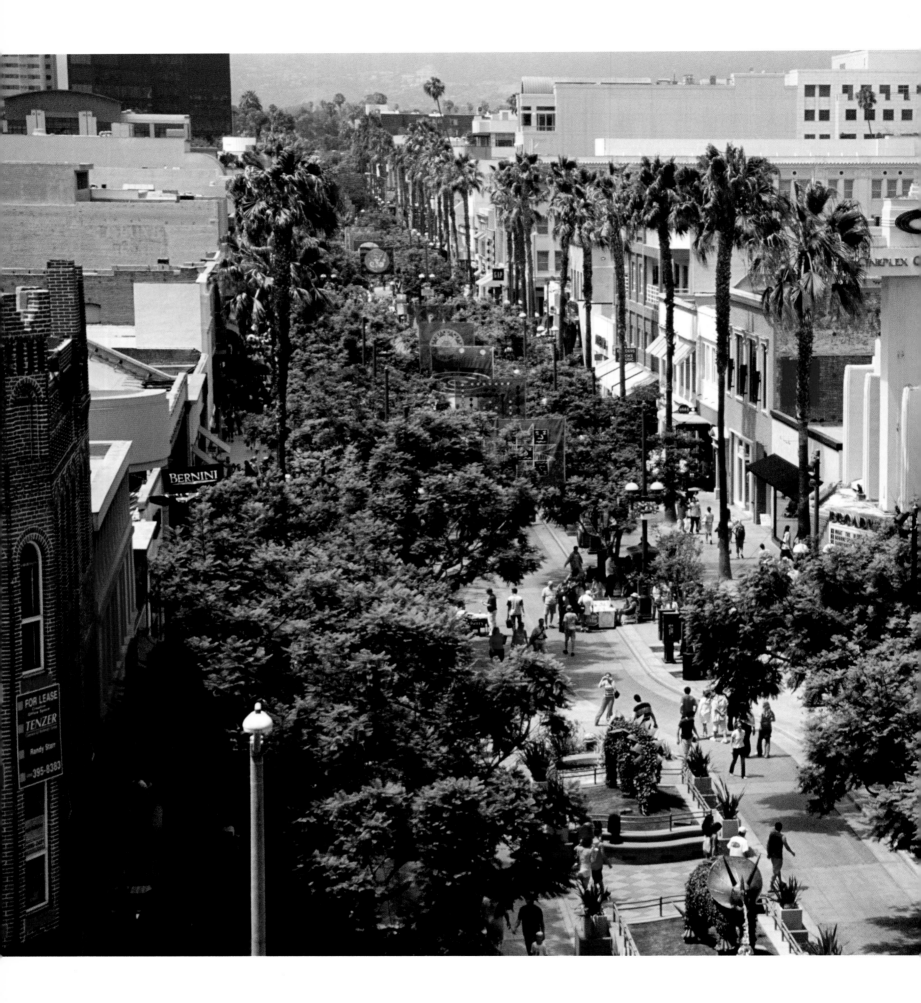

The renowned Third Street Promenade, located in Santa Monica, is a popular three-block stretch that attracts shoppers, tourists, and celebrities. It features trendy restaurants, upscale shopping, antique stores, bookstores, and movie theatres. In the evenings the sidewalks bustle with people and various street performers.

The Getty Center in Los Angeles was designed by American architect Richard Meier. It is home to the J. Paul Getty Museum, which opened in 1997. The museum collects and displays classical art, illuminated manuscripts, drawings, sculpture, European paintings, and photographs.

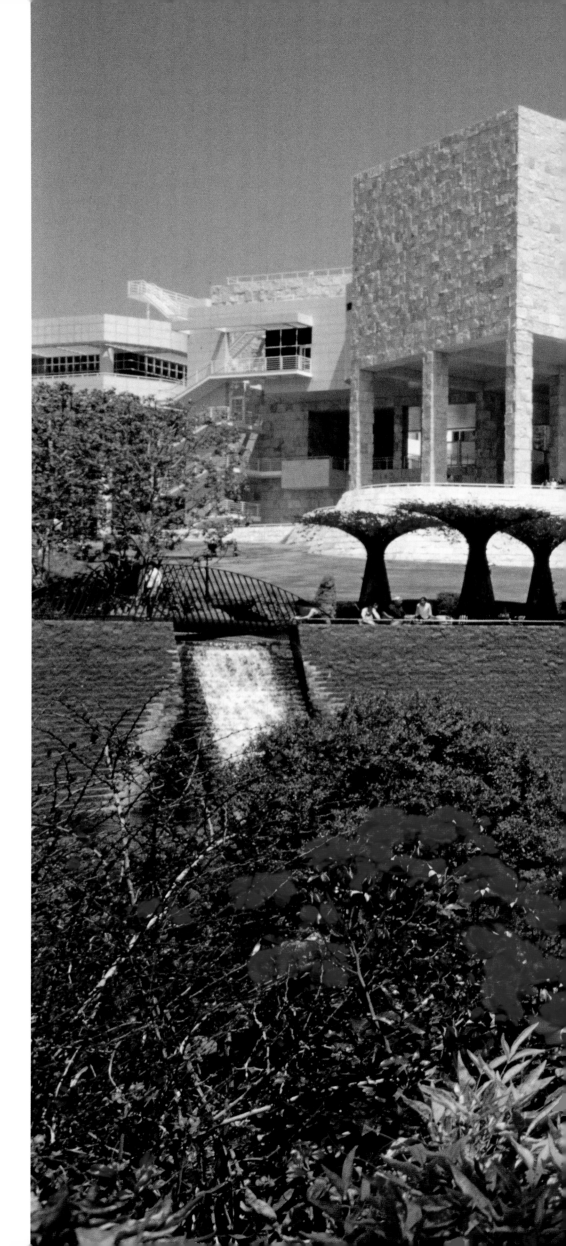

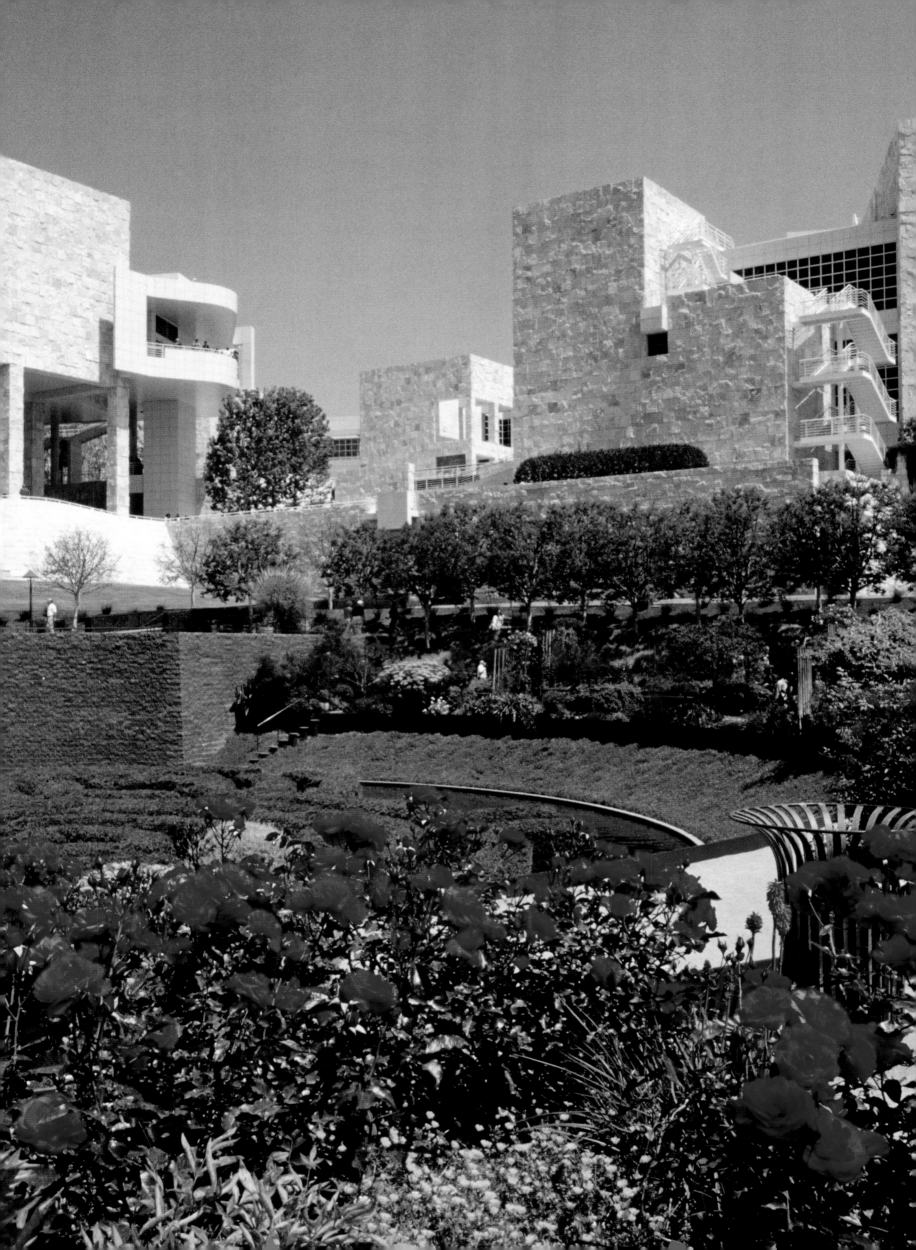

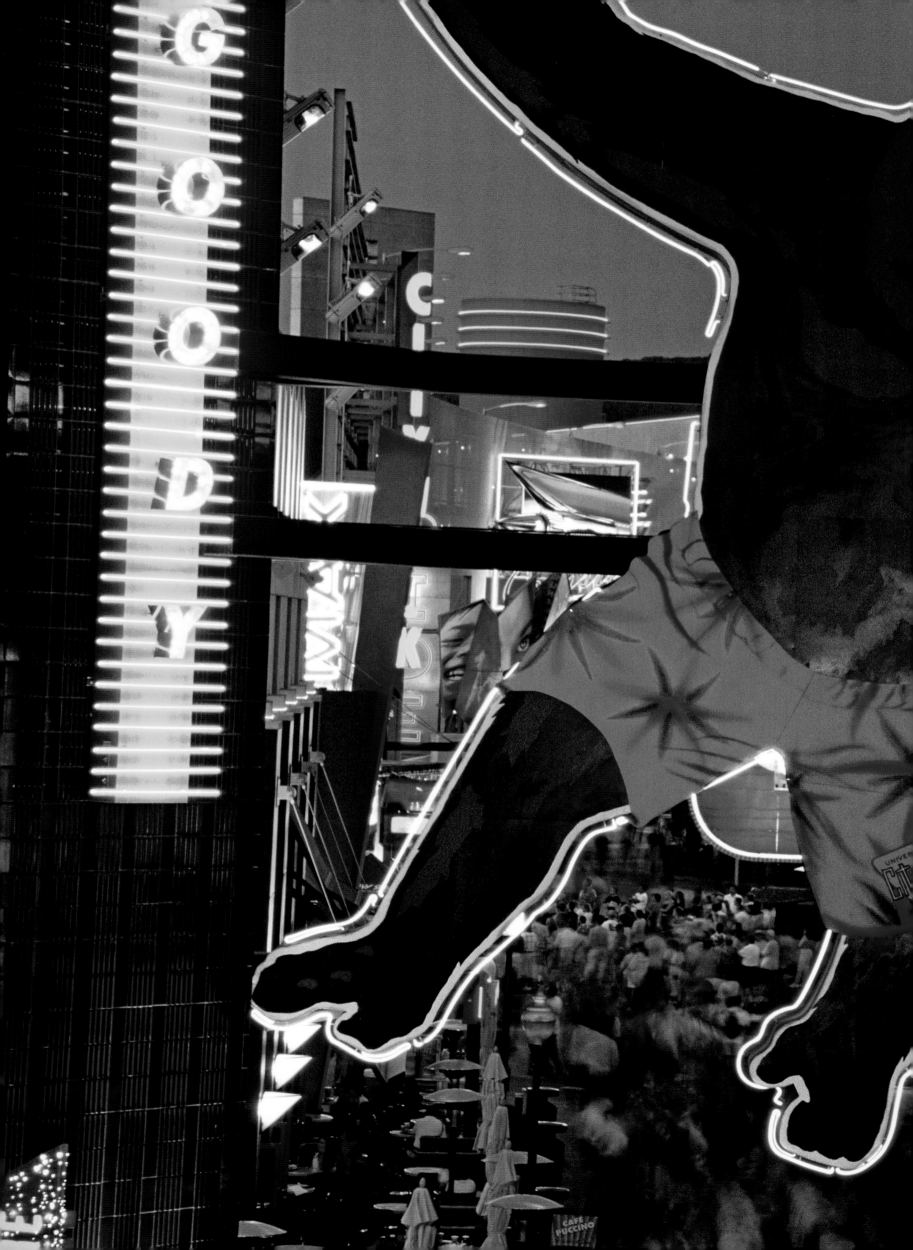

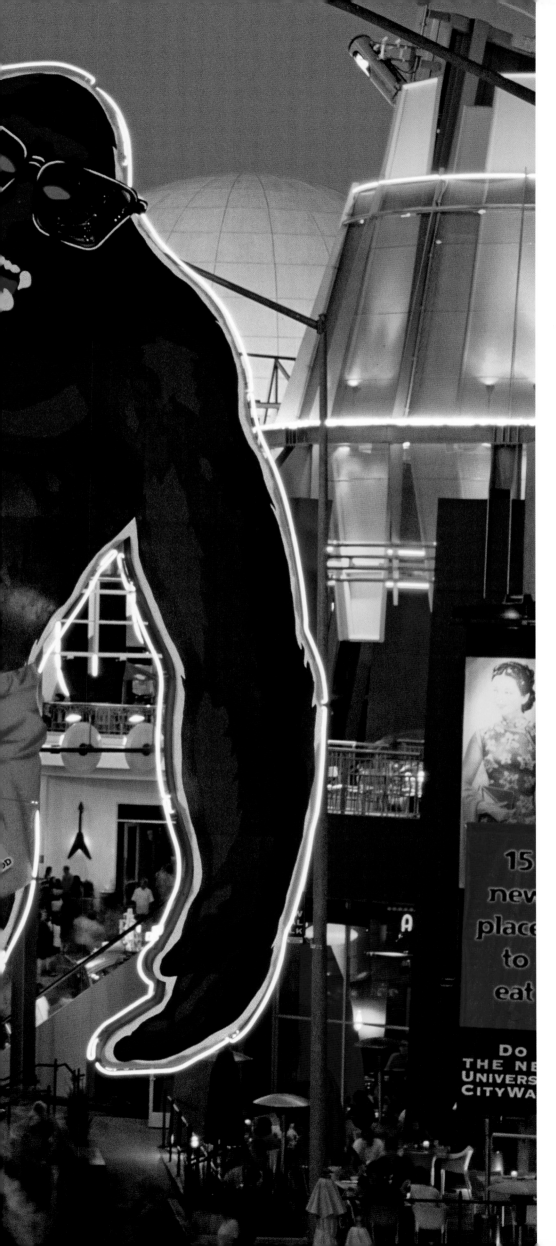

Universal Studios Hollywood is a theme park in Los Angeles, California. Visitors can experience the exciting movie industry through studio tours, live shows, behind-the-scenes movie sets, and exciting rides.

89

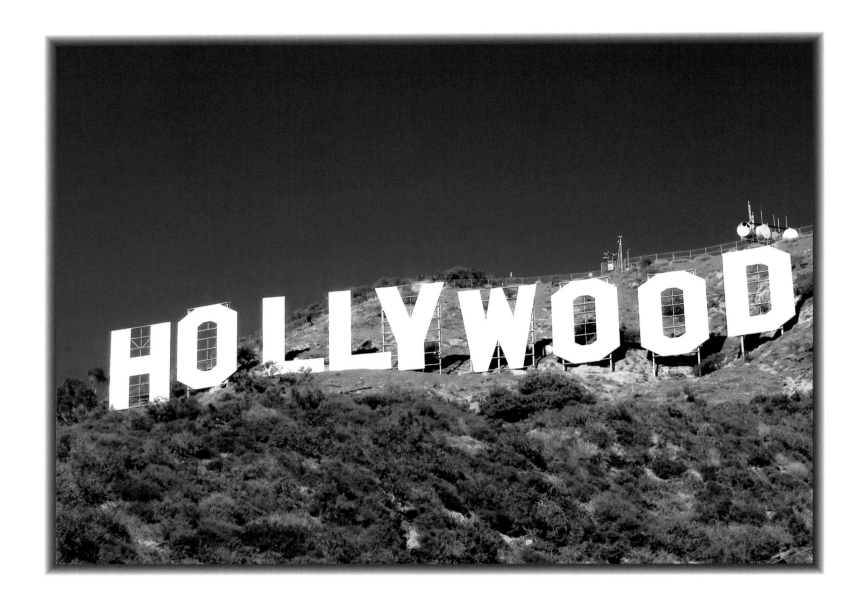

The famous Hollywood sign was built in 1923 as an advertisement for *LA Times* publishing tycoon Harry Chandler's new housing development. It originally read Hollywoodland, but the "land" was removed from the sign in 1949. Today it stands as a world-renowned landmark and symbol for the film industry.

Situated at the foot of Colorado Boulevard in Santa Monica is the well-known Santa Monica Pier. Built in 1909, the pier features a ferris wheel, a carousel, an aquarium, an arcade, restaurants, and the famous landmark Hippodrome building. *(right)*

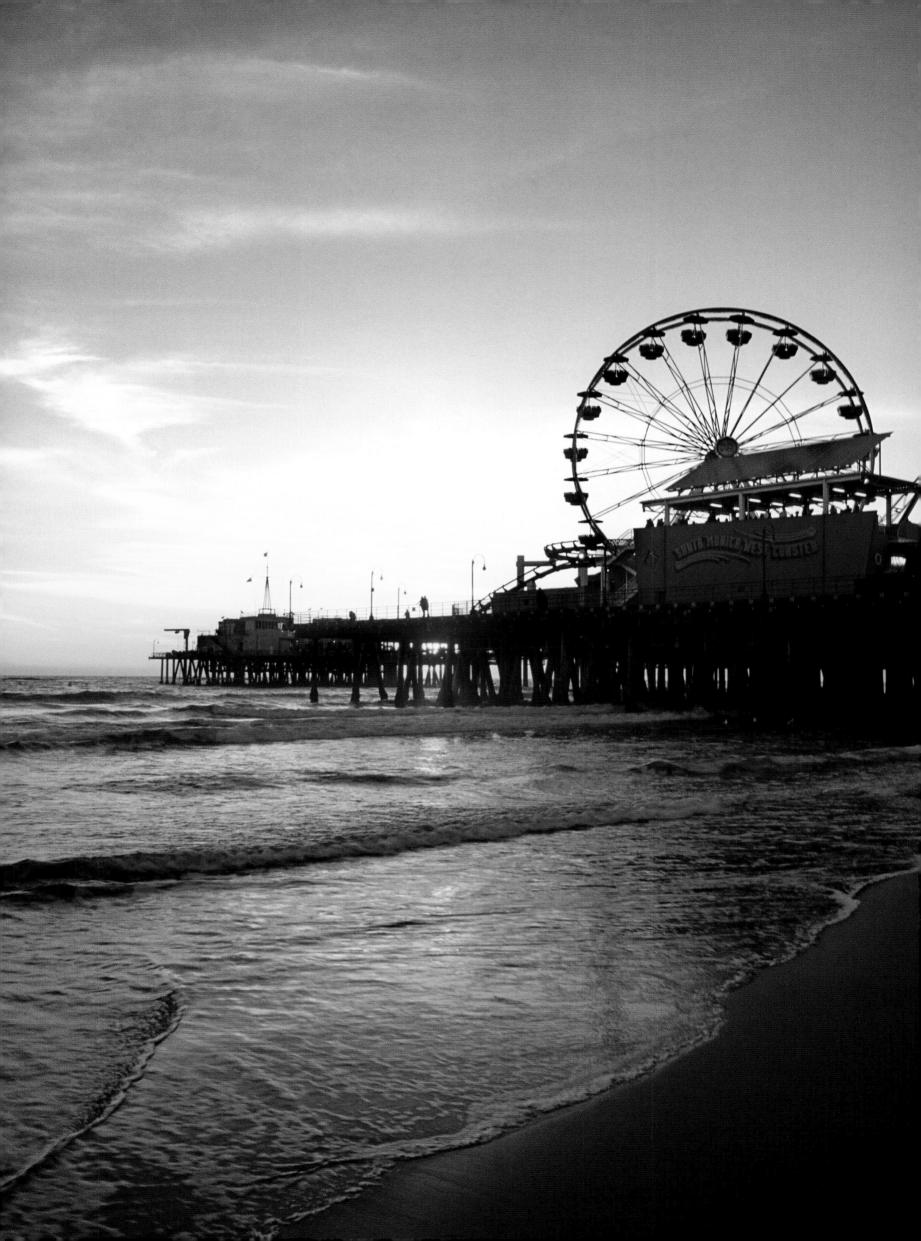

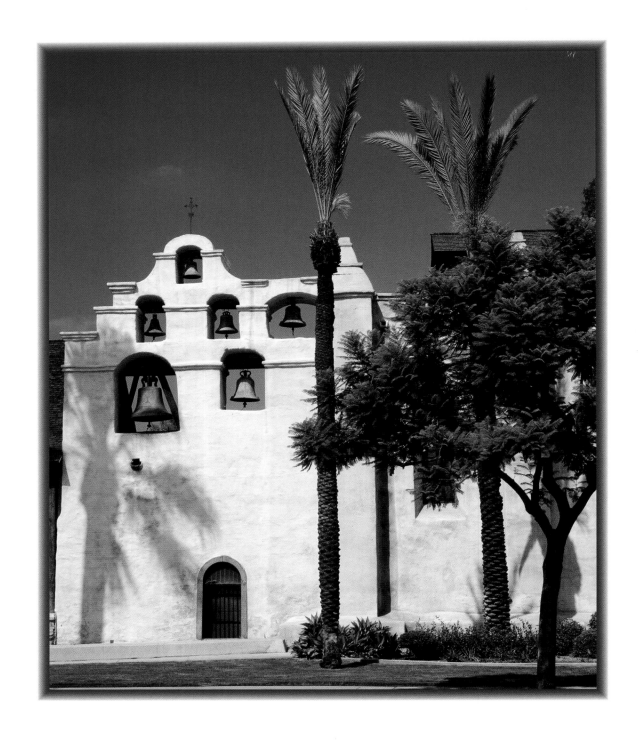

Located in LA County and often referred to as the "Godmother of the Pueblo of Los Angeles," the San Gabriel Mission was founded on September 8, 1771. Named for the Archangel Gabriel, it was the fourth of 21 California missions. Due to its large crops, and trade in both cattle hides and wine, San Gabriel prospered and was nicknamed "the pride of missions."

Mission Santa Barbara was the 10th of the California missions, founded in 1786 by the Spanish on the Feast Day of Saint Barbara. Its original purpose was to convert the Chumash Indians and has been in continuous use since. Today it is one of the most visited missions in California. *(right)*

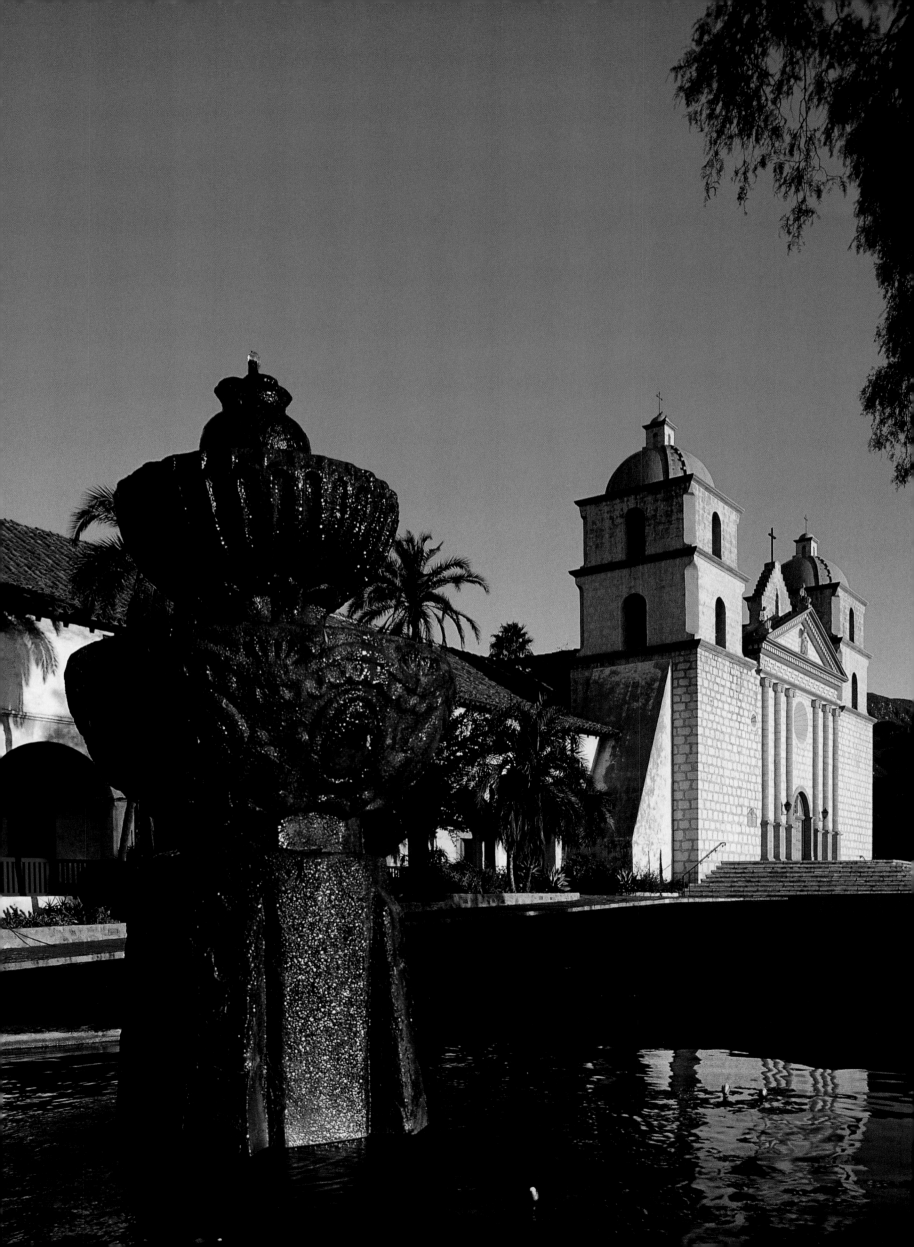

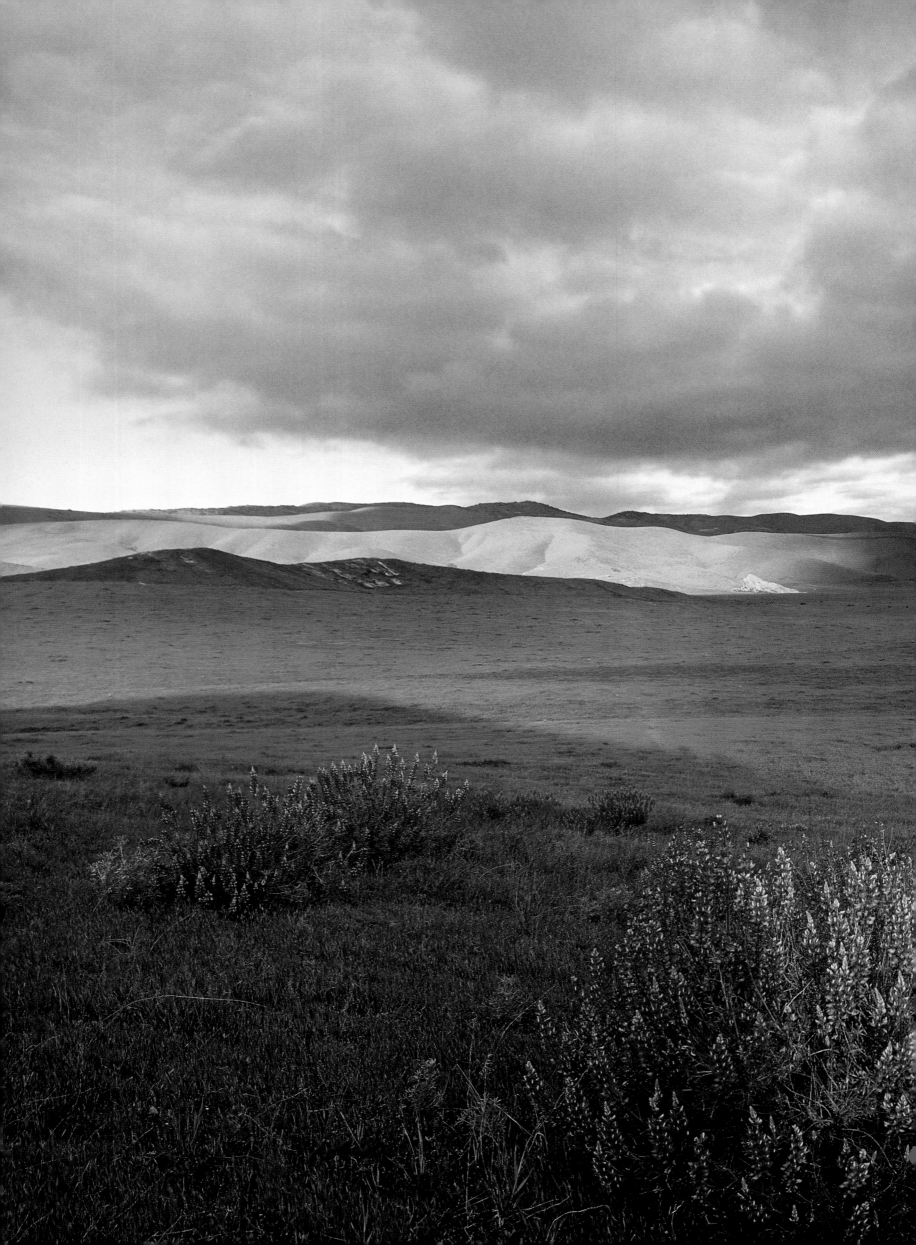

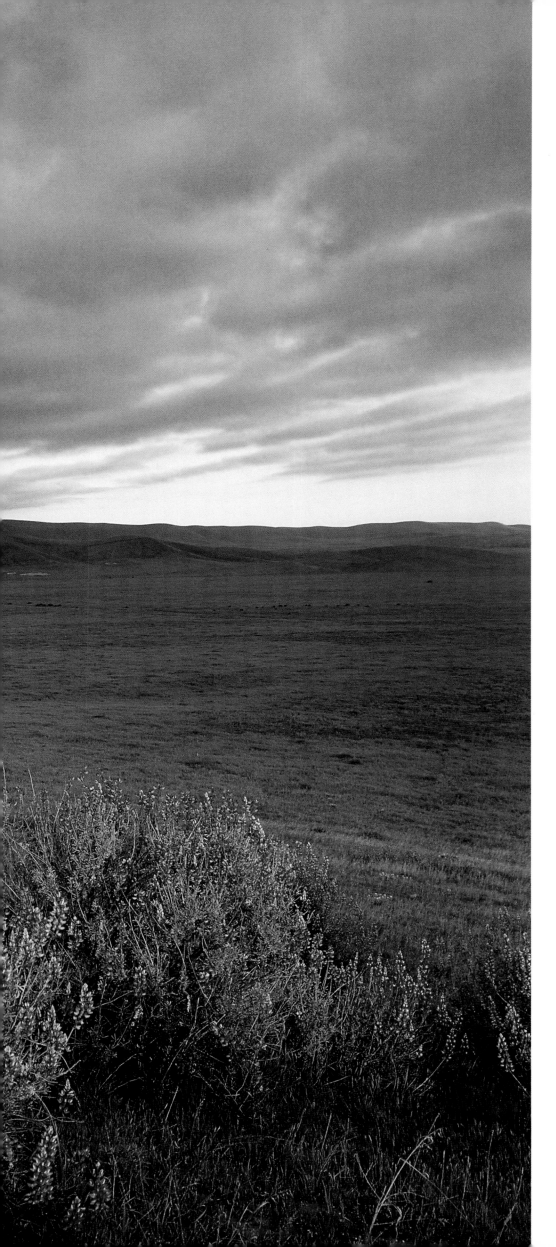

In San Luis Obispo County, the Carrizo Plains National Monument is the largest native grassland remaining in California, an area of cultural importance to Native Americans. The Chumash and Yokuts peoples once gathered food, traded, and held ceremonies on this land.

Almost 250,000 acres, Carrizo is rich with diverse communities of wildlife and plant species. It is home to 13 species of threatened or endangered plants and animals.

On the eastern edge of the plain, the rugged ridges and mountain ranges reveal the San Andreas fault, a geological fault that runs more than 800 miles through western and southern California.

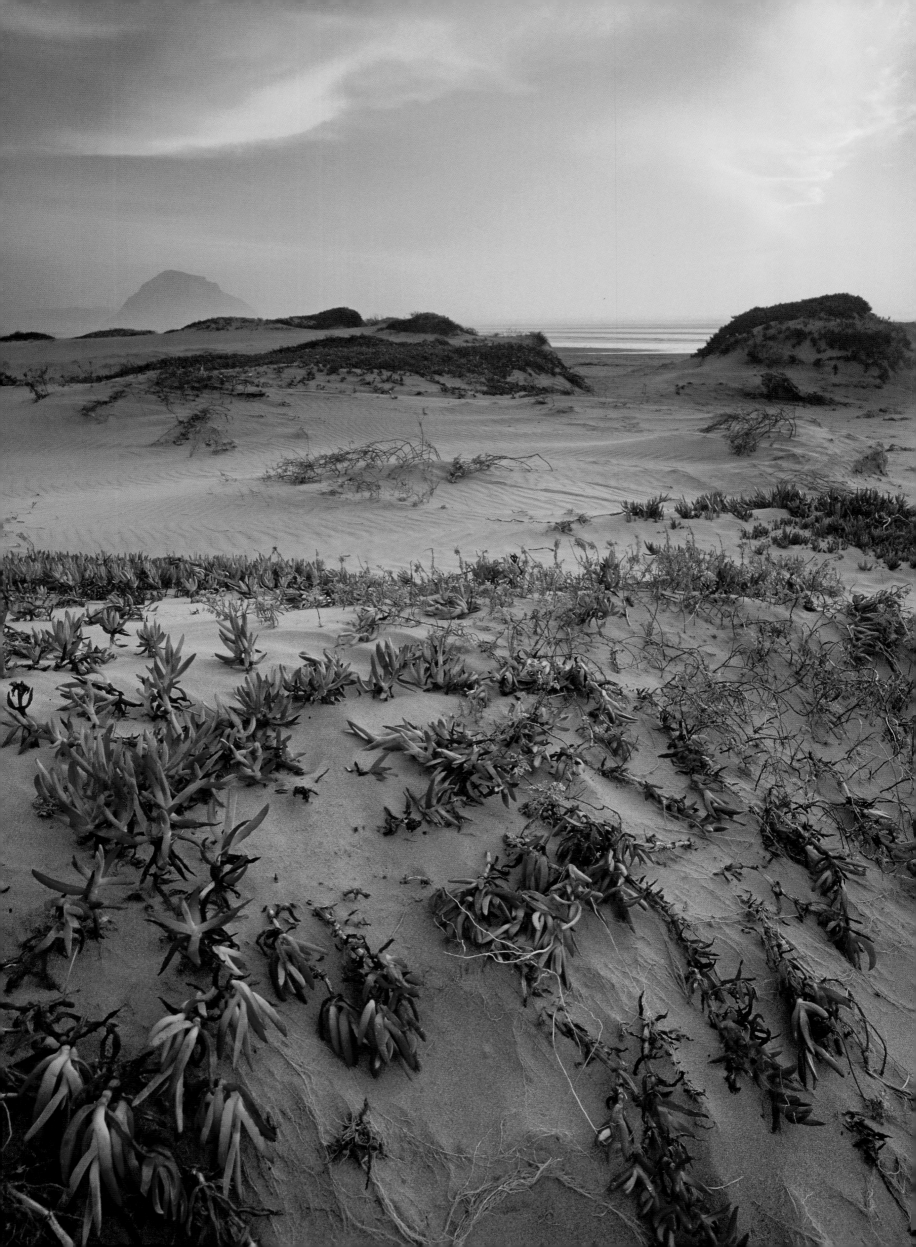

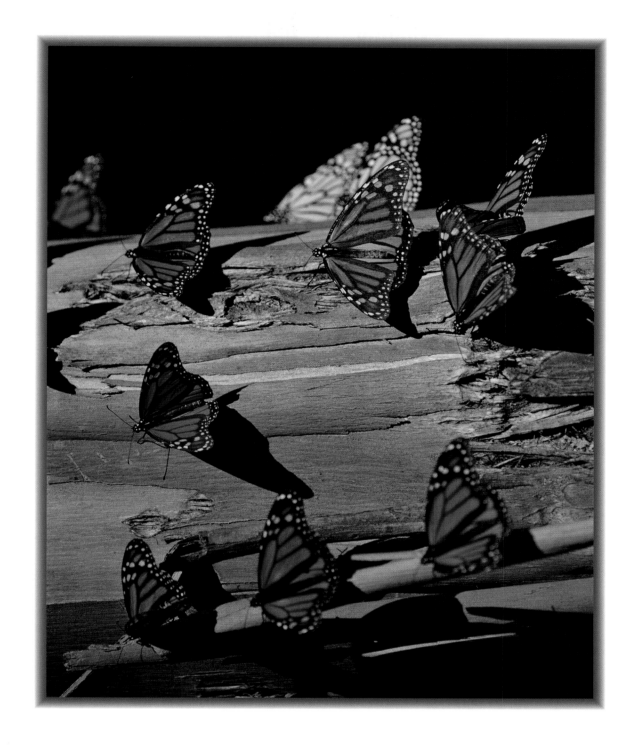

The vibrant orange and black monarch butterfly can be seen along the Big Sur Coast from mid-October to February. These gorgeous creatures have been known to migrate as far as 3,000 miles, much farther than other butterflies.

Morrow Bay is a quaint coastal fishing village on California's central coast characterized by sandy beaches, the beautiful Pacific coastline, and its famous landmark Morrow Rock, an enormous dome-shaped rock situated offshore. *(left)*

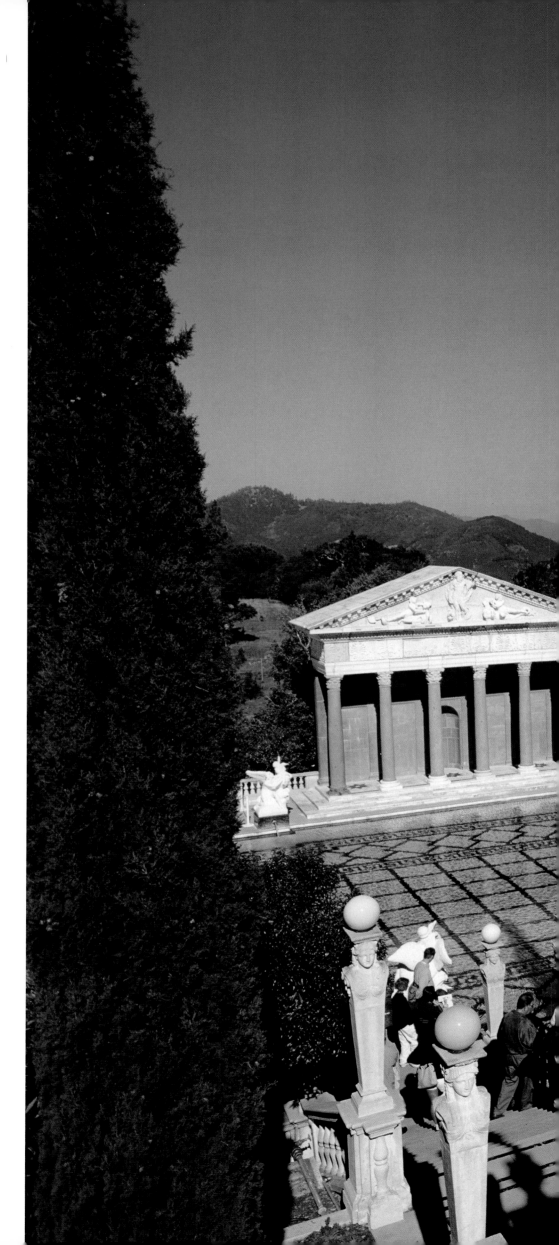

Hearst Castle, located near San
Simeon, was once known as
Camp Hill. Its history began when
a wealthy miner named George
Hearst bought 40,000 acres of
ranchland in 1865. By the time his
only son, newspaper tycoon William
Hearst, inherited the land in 1919,
it had grown to 250,000 acres. Fond
of his time spent camping there
as a child, William decided to add
something more accommodating
and grand. Over many years, he
built a dream estate inspired by
Spanish cathedrals. The Hearst
Corporation donated it to the
state in 1957 and today stands as
a magnificent National and State
Historic Monument.

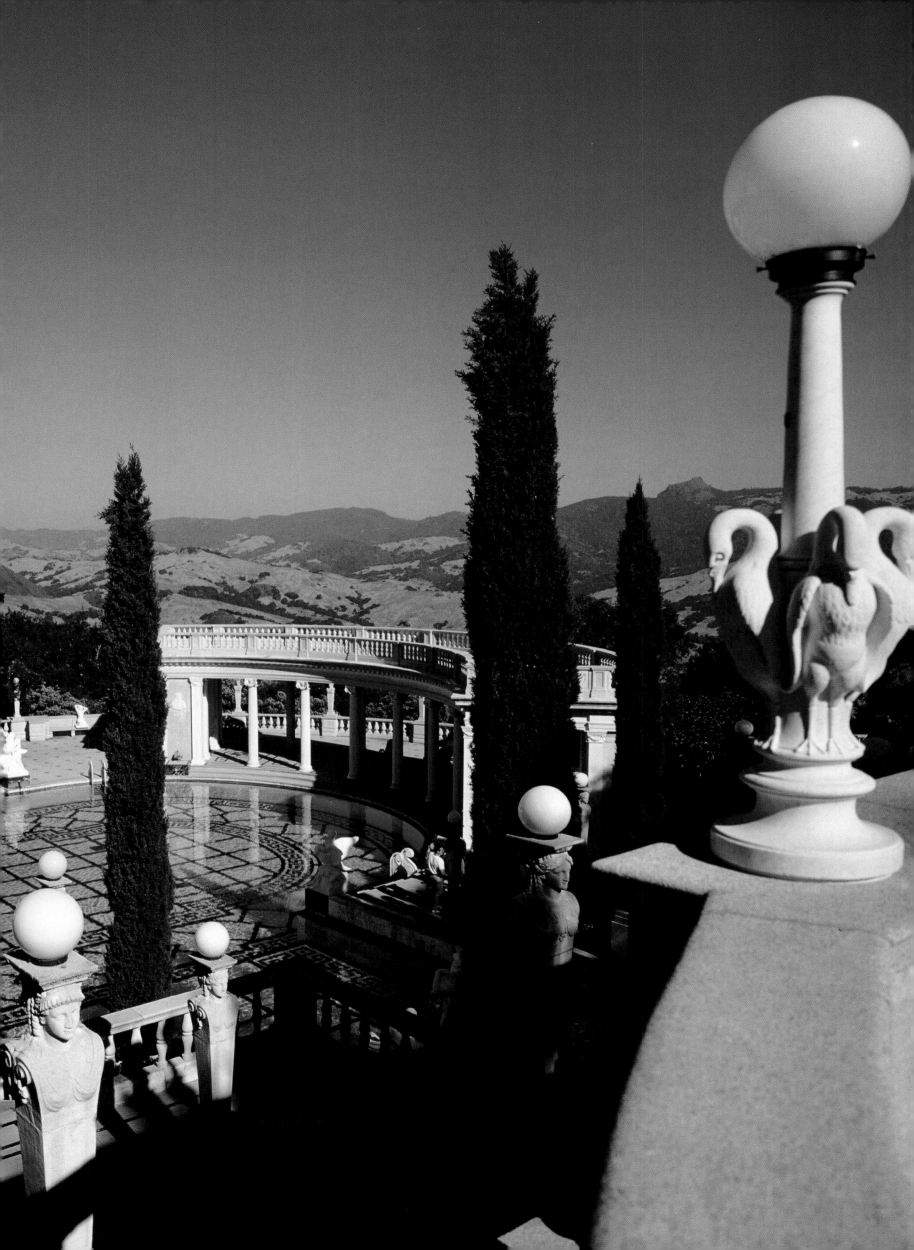

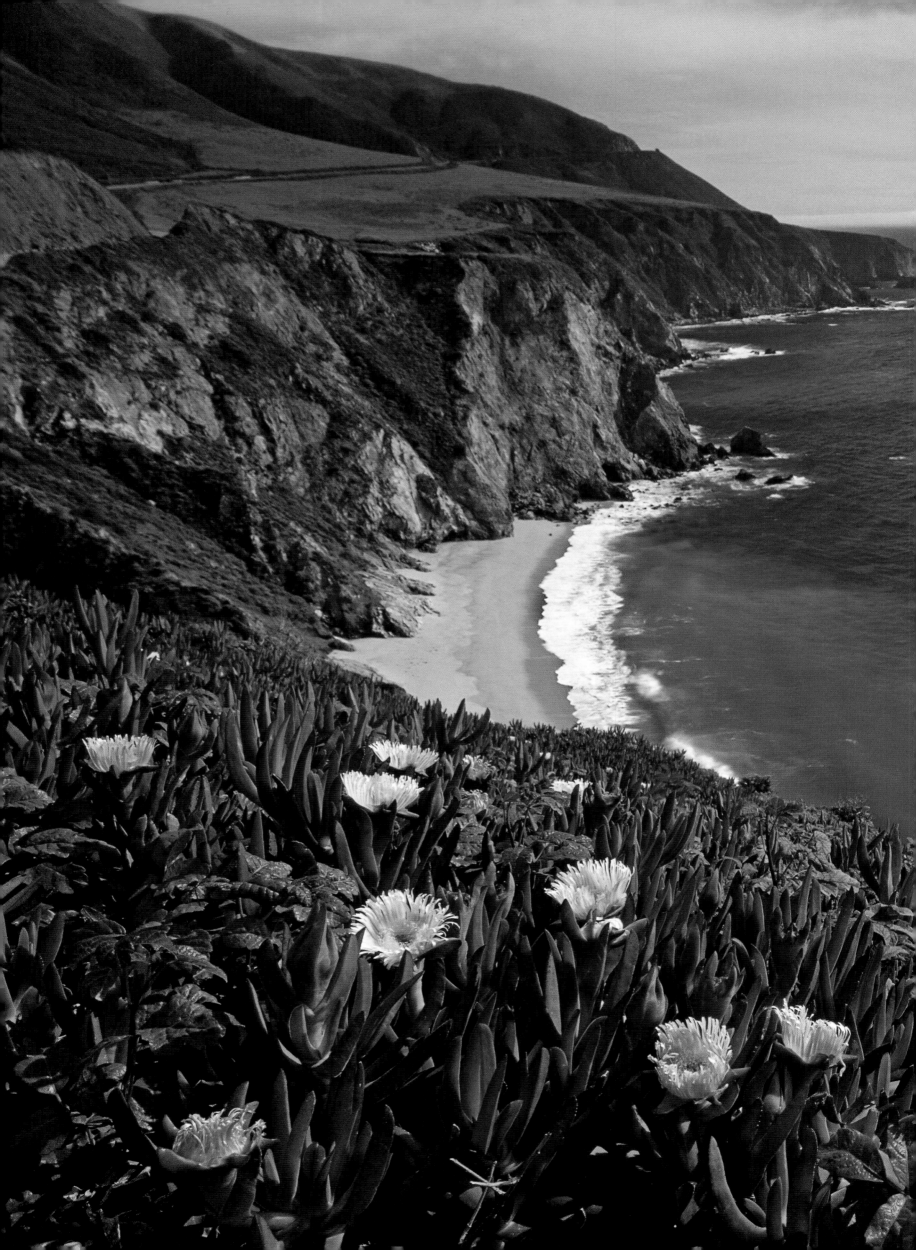

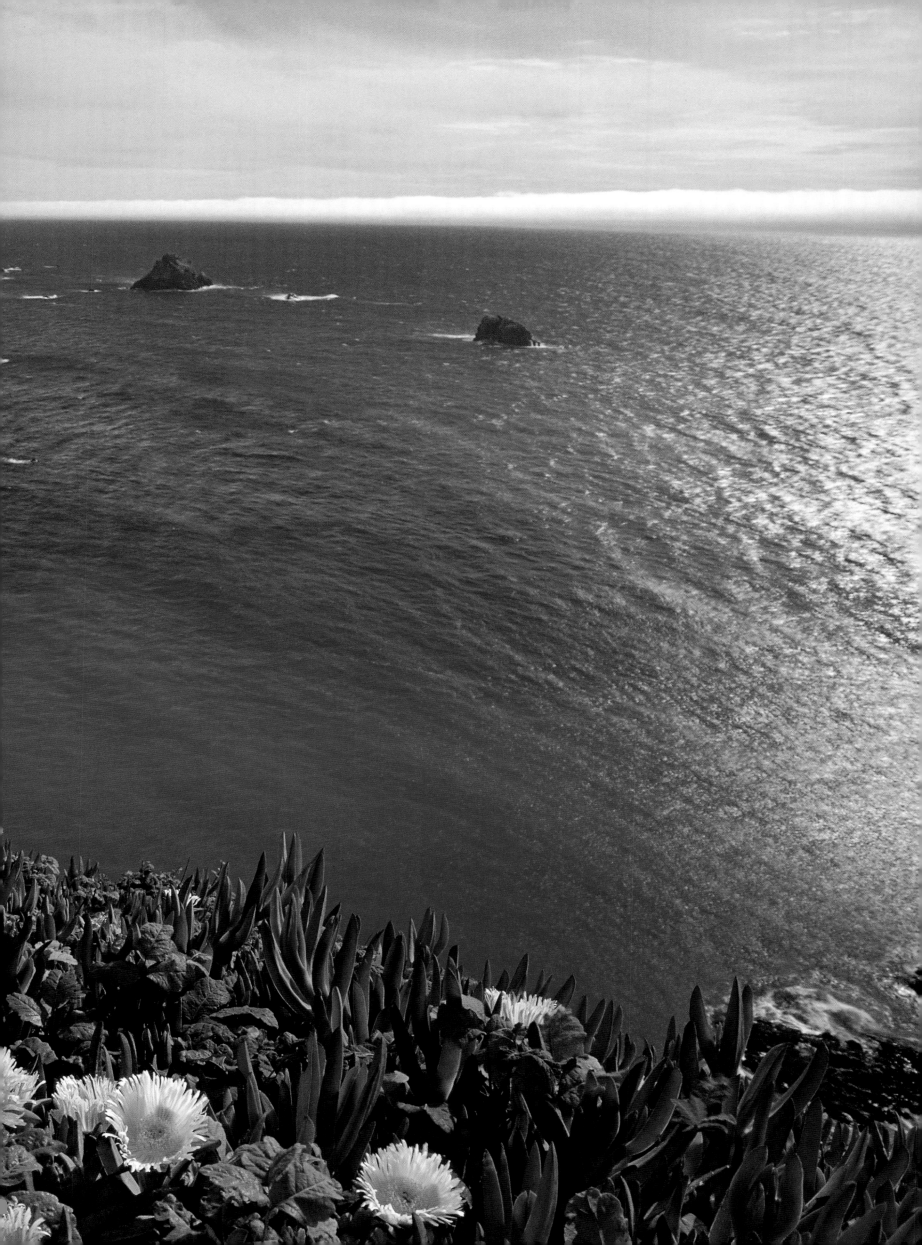

Pfeiffer Beach is one of many magnificent beaches along the Big Sur coast. It is characterized by rugged coastal beauty, white sand, sea caves, caverns, and offshore rocks.

A coastal wilderness of magnificent scenery, Big Sur encompasses about 90 miles of the California Coast. In 1542, Juan Rodriguez Cabrillo, a Portuguese sailor for the King of Spain, sailed here and wrote: "All the coast passed this day is very bold; there is a great swell and the land is very high. There are mountains which seem to reach to the heavens, and the sea beats on them." *(previous pages)*

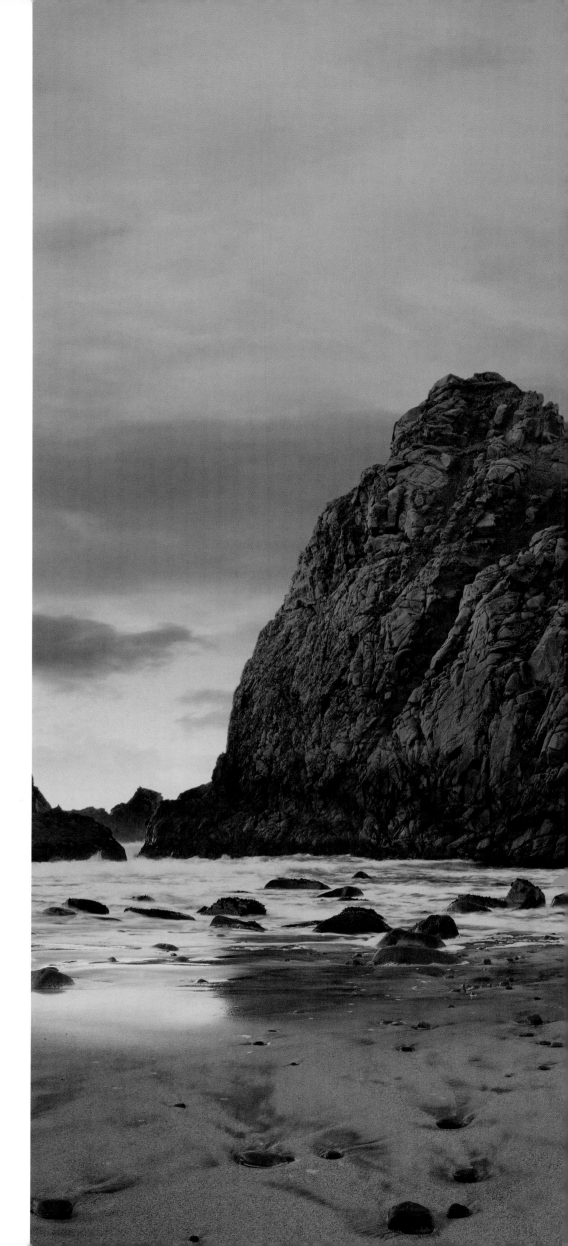

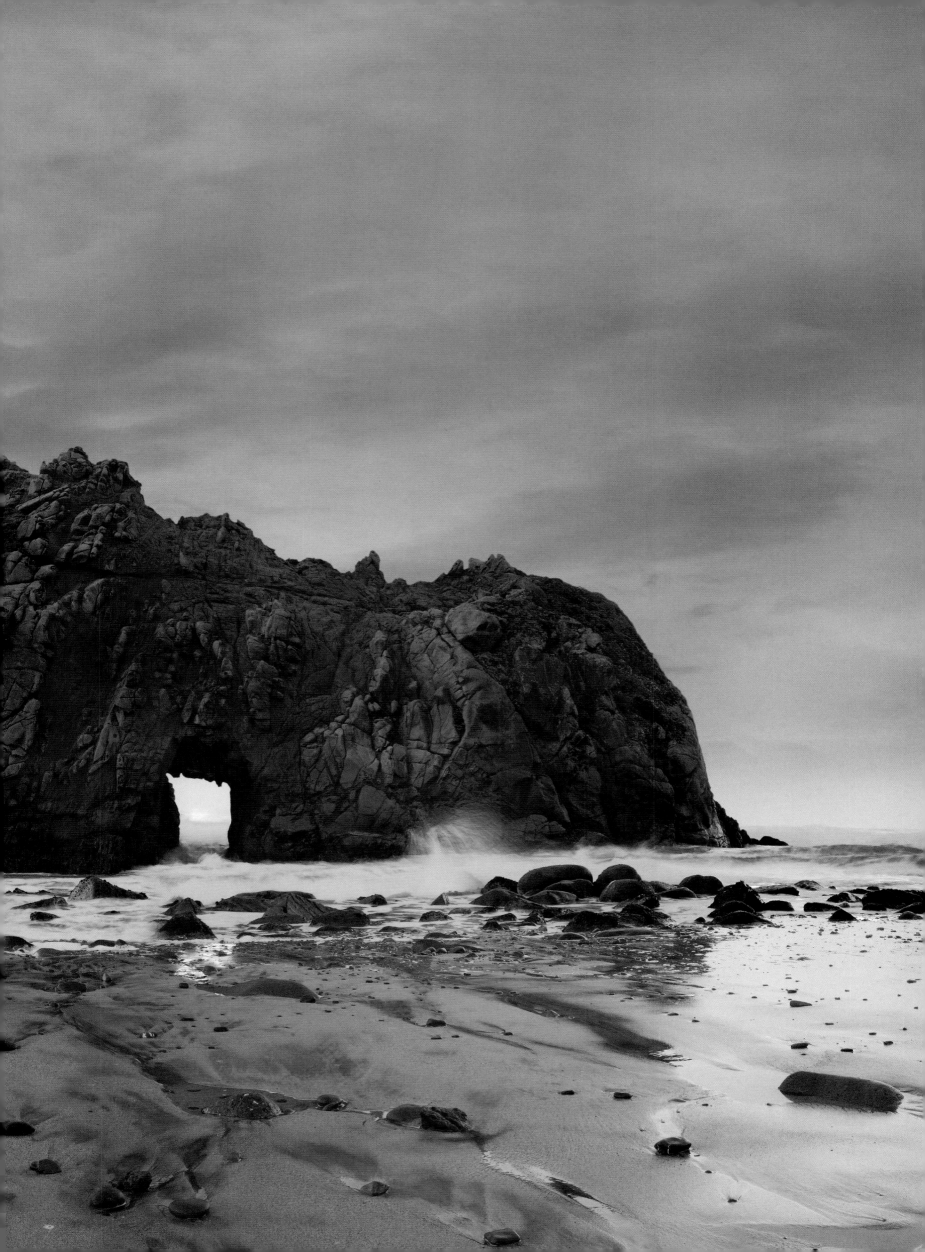

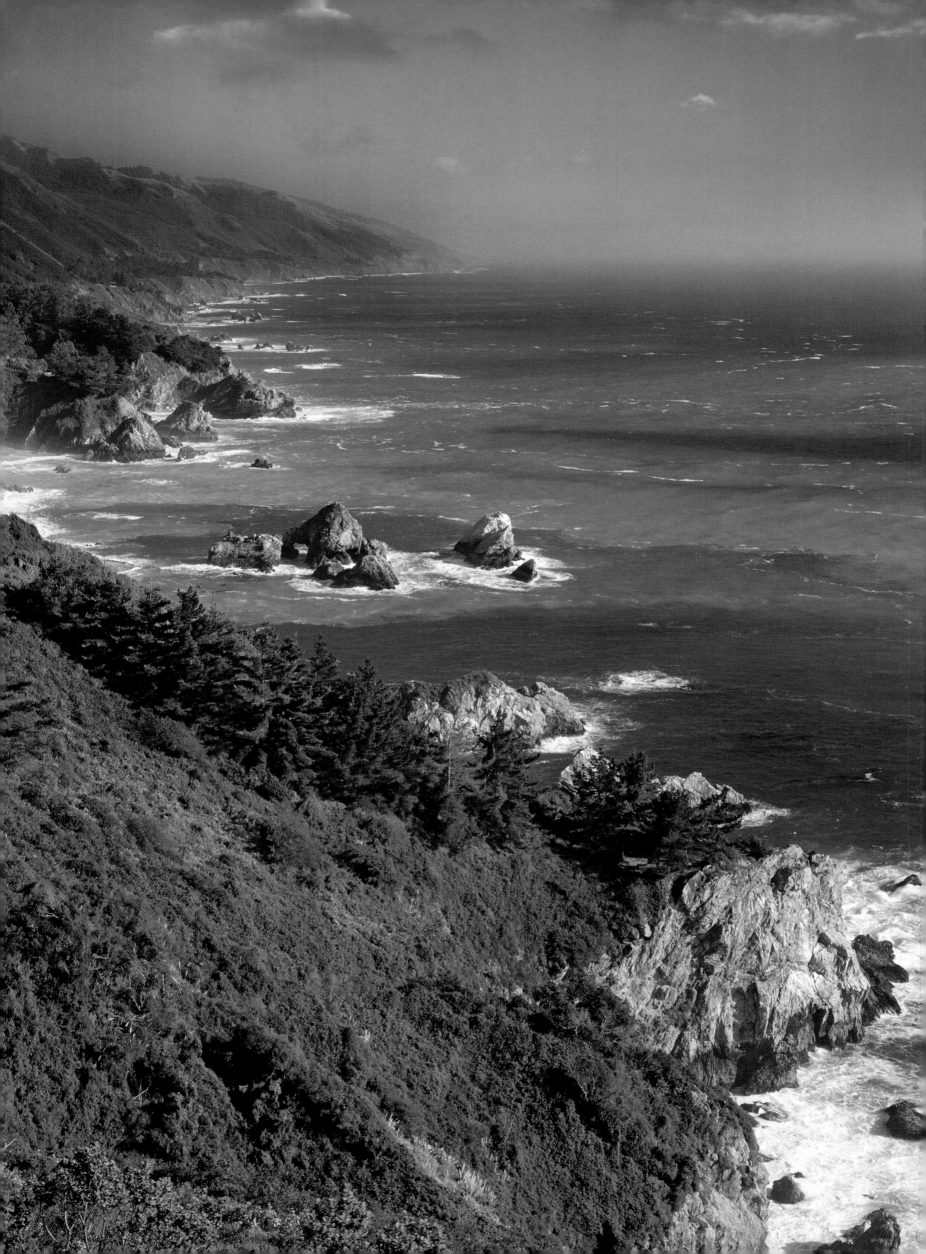

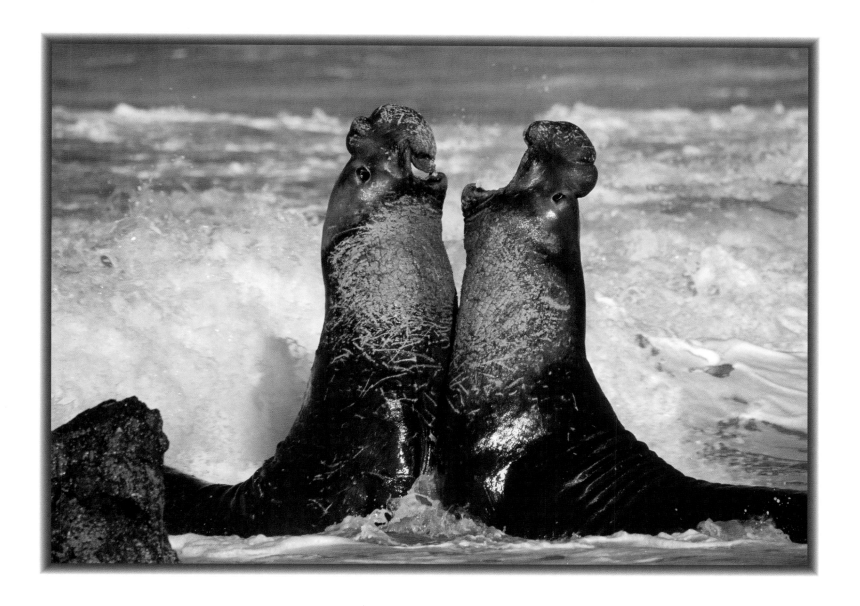

Once thought extinct, elephant seals have made an incredible comeback. They now colonize select beaches and coves — such as Piedras Blancas — of the southern range of Big Sur. Elephant seals are named after their giant size and the male's long noses. Migrating thousands of miles each year, they come ashore for only a few months to breed, give birth, and molt.

Big Sur's spectacular natural beauty is its feature attraction. Visitors come from all over to enjoy its natural grandeur through scenic drives, hiking, biking, horseback riding, and camping. *(left)*

The historic Fisherman's Wharf is located on the Monterey Peninsula. This once bustling commercial fishing area has become a popular attraction that features incredible seafood restaurants, galleries, whale-watching tours, fish markets, and a theatre.

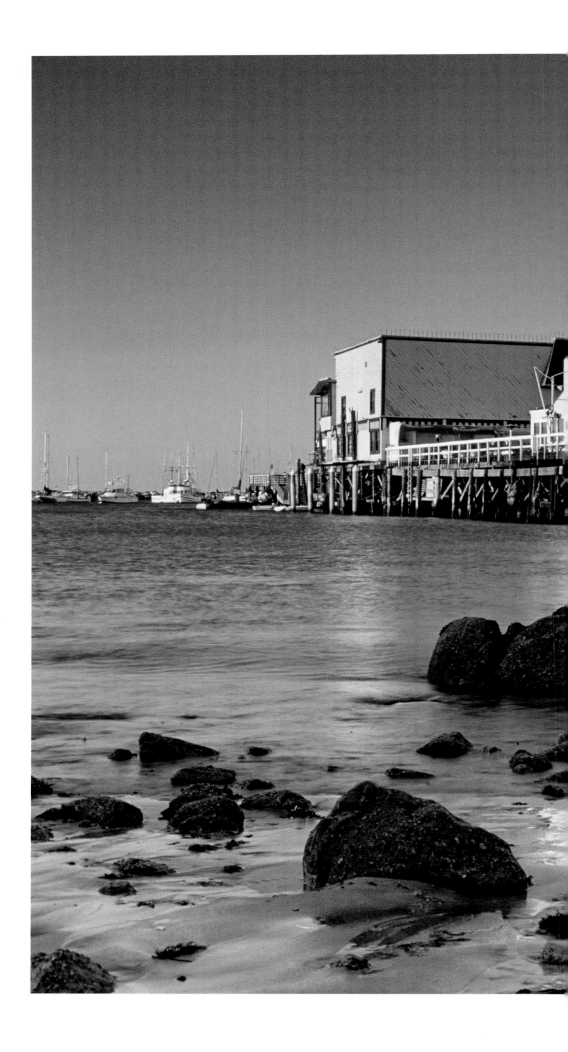

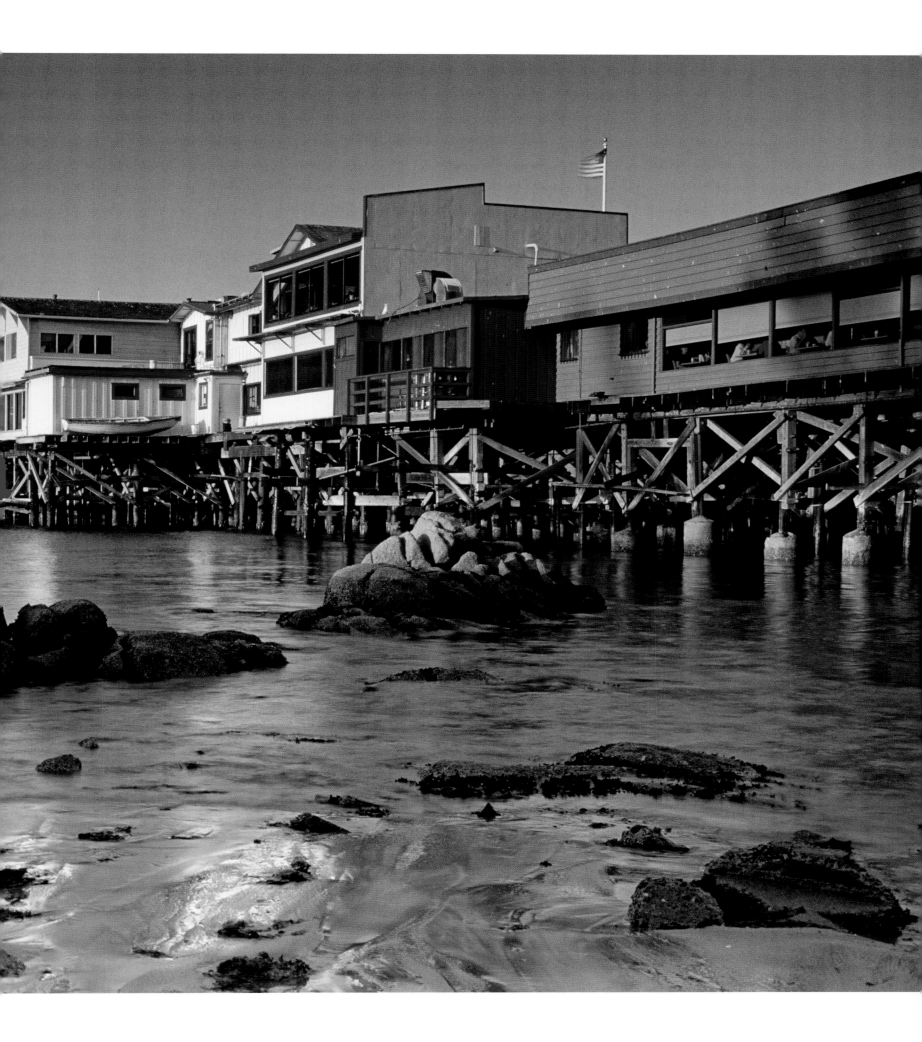

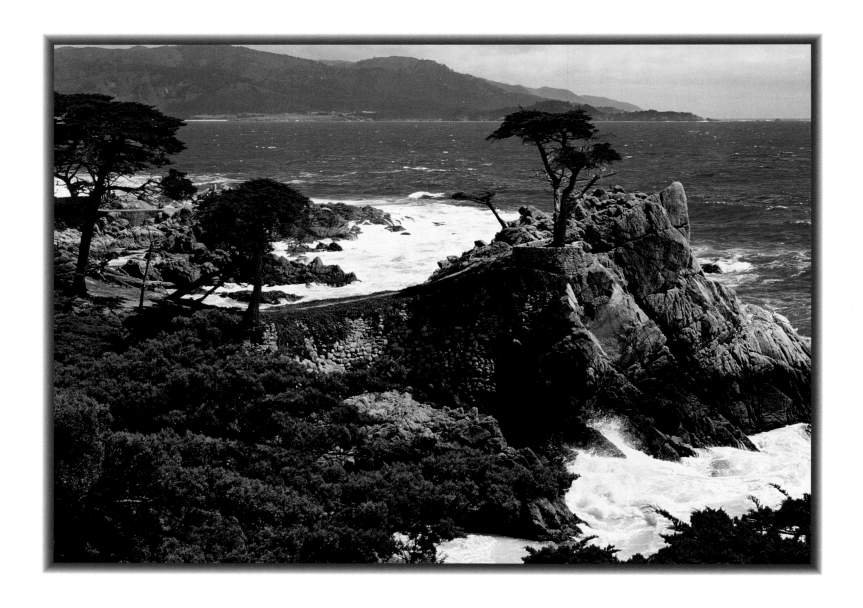

The picturesque seaside town of Carmel, located in Carmel Bay, is perhaps best known for its artistic community. Home to poets, writers, and other artists, this quaint little region features an array of galleries, shops, exhibitions, and festivals.

Mission Borromeo, situated in Carmel, was named after the Archbishop of Milan. It was the second of California's missions, founded on June 3, 1710. Today it is a National Historic Landmark and active parish, and attracts visitors from all over the world, including Pope John Paul II during his 1987 U.S. tour.

Native to California is the Monterey cypress tree on California's central coast near the Monterey and Carmel regions. These unique gnarled trees occur naturally in only two groves, which are protected inside the Del Monte Forest and Point Lobos State Reserve.

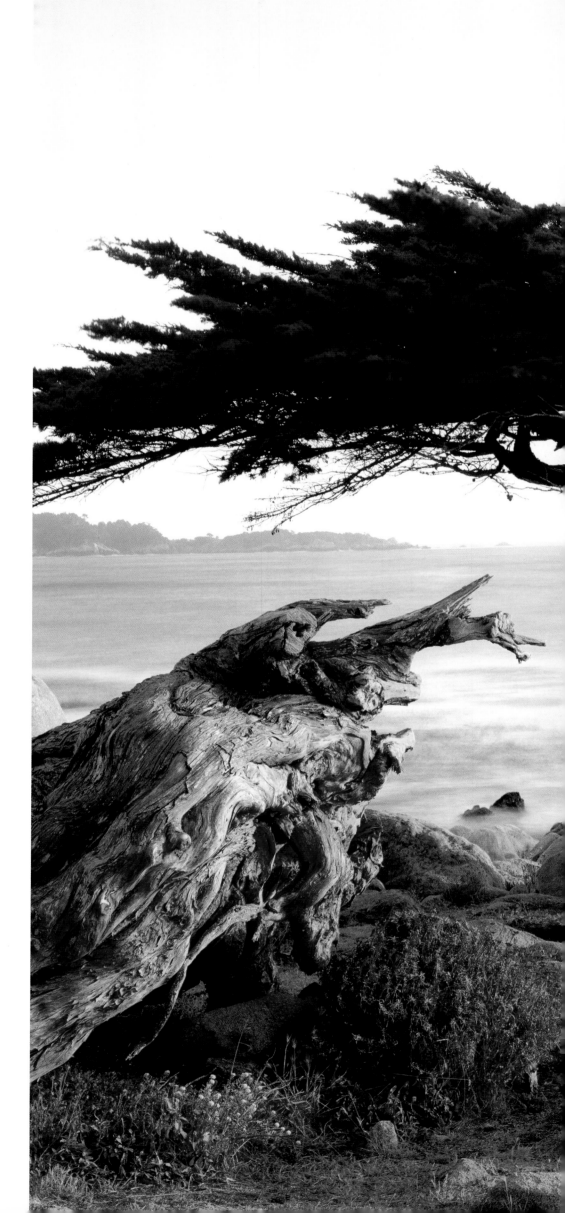

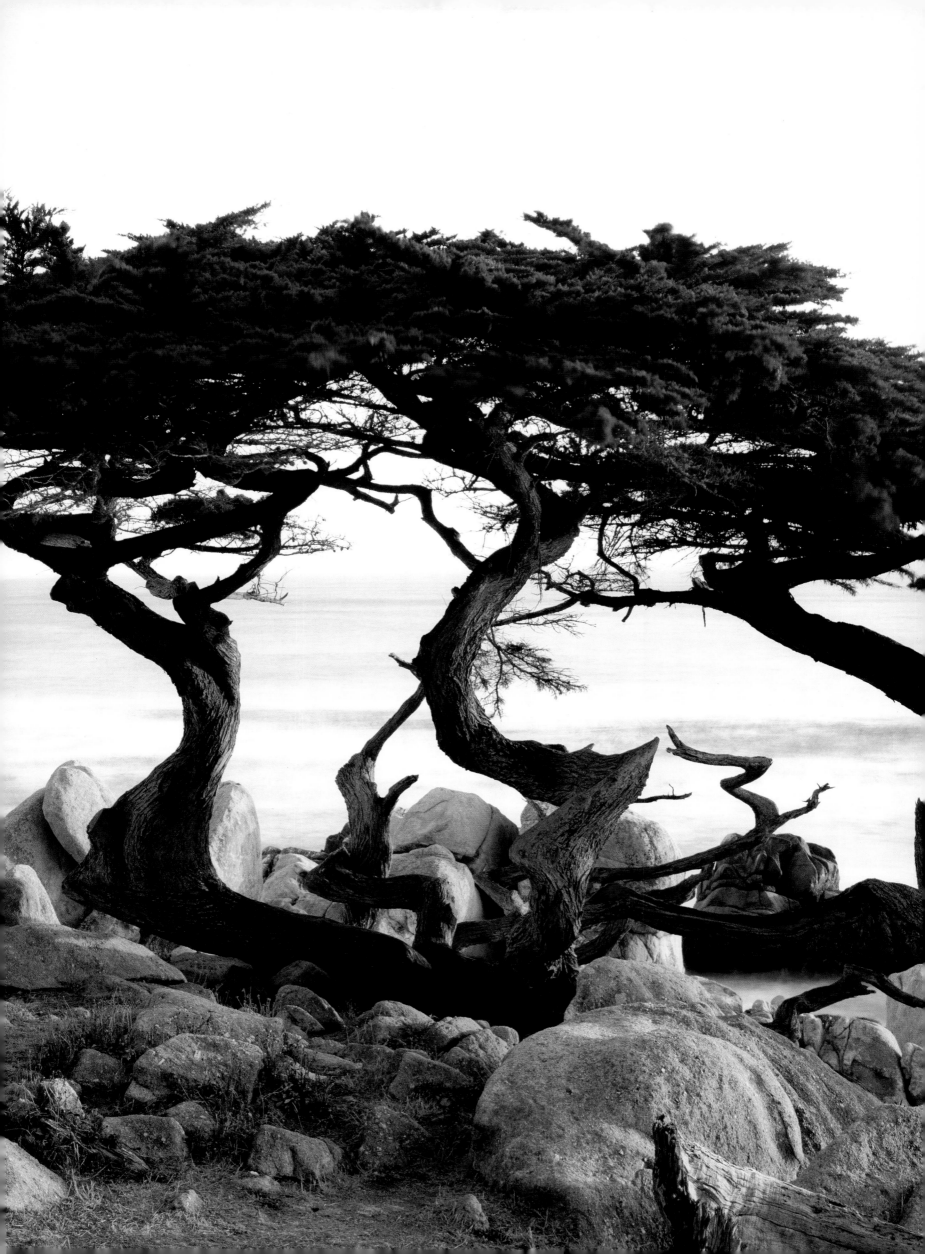

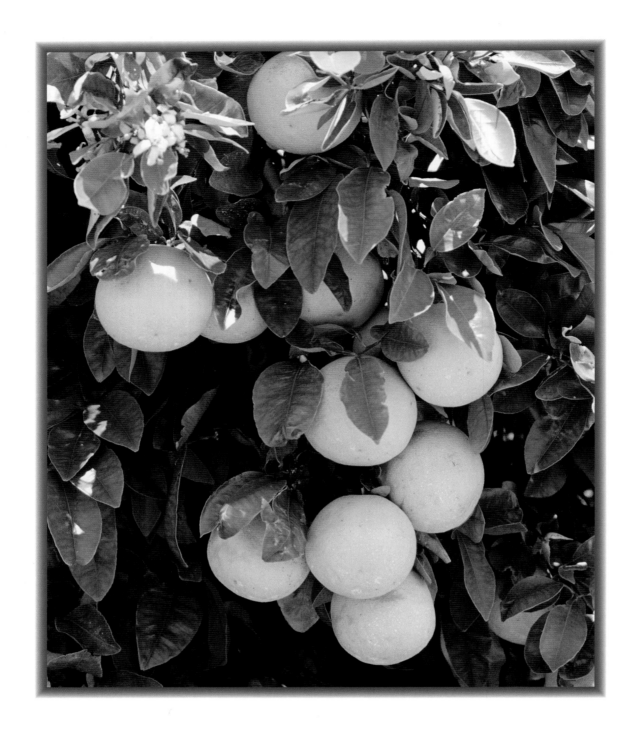

Oranges first appeared in the Western Hemisphere in 1493, when Christopher Columbus brought seeds on his second voyage and planted an orange grove. California is the top food and agricultural producer in the United States. Oranges are among its leading agricultural exports, along with cotton, almonds, wine, and grapes.

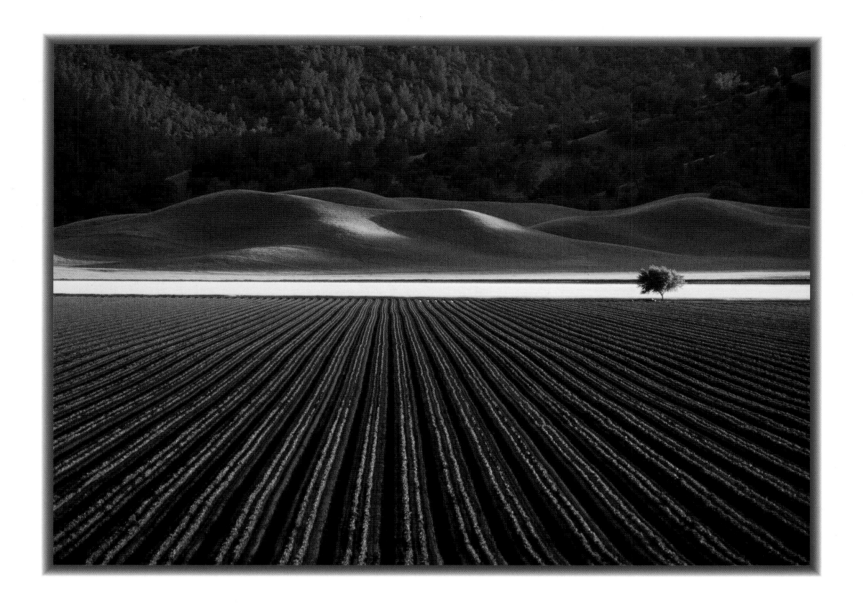

The agricultural center of Salinas, also known as "the salad bowl of the world,"
is situated in California's Monterey County. Its moderate climate and rich soil
are ideal for significant amounts of vegetable crops. It is the largest producer of
lettuce in the U.S.

Financed by Sarah L. Winchester, the widow of wealthy gun tycoon William Wirt Winchester, the construction of the famous "haunted" Winchester Mystery House began in 1884. She believed she was cursed by those who had been killed by Winchester rifles and her only way to make peace was through continuous construction of the house. Construction continued for 38 years until her death. Today it is a Historic Landmark, which visitors tour for its many bizarre features.

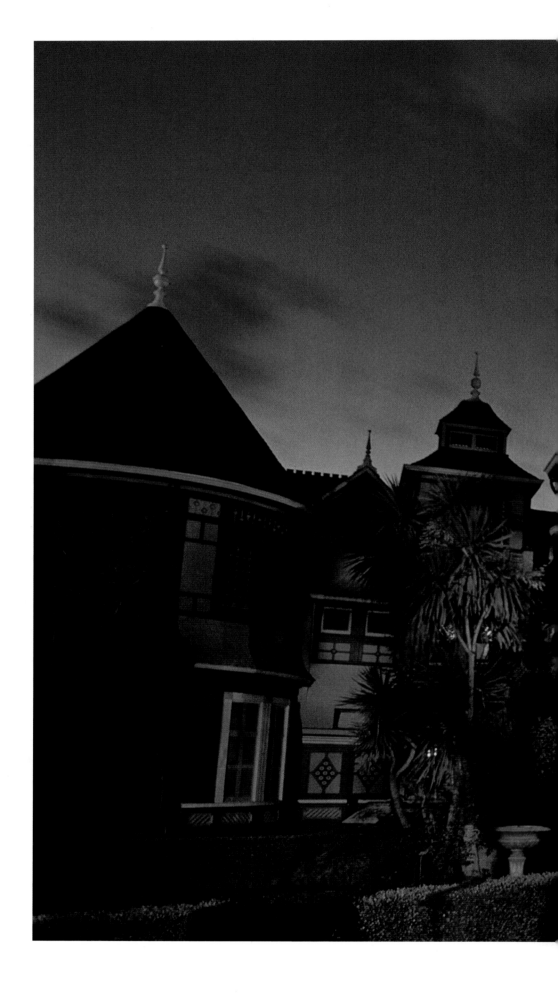

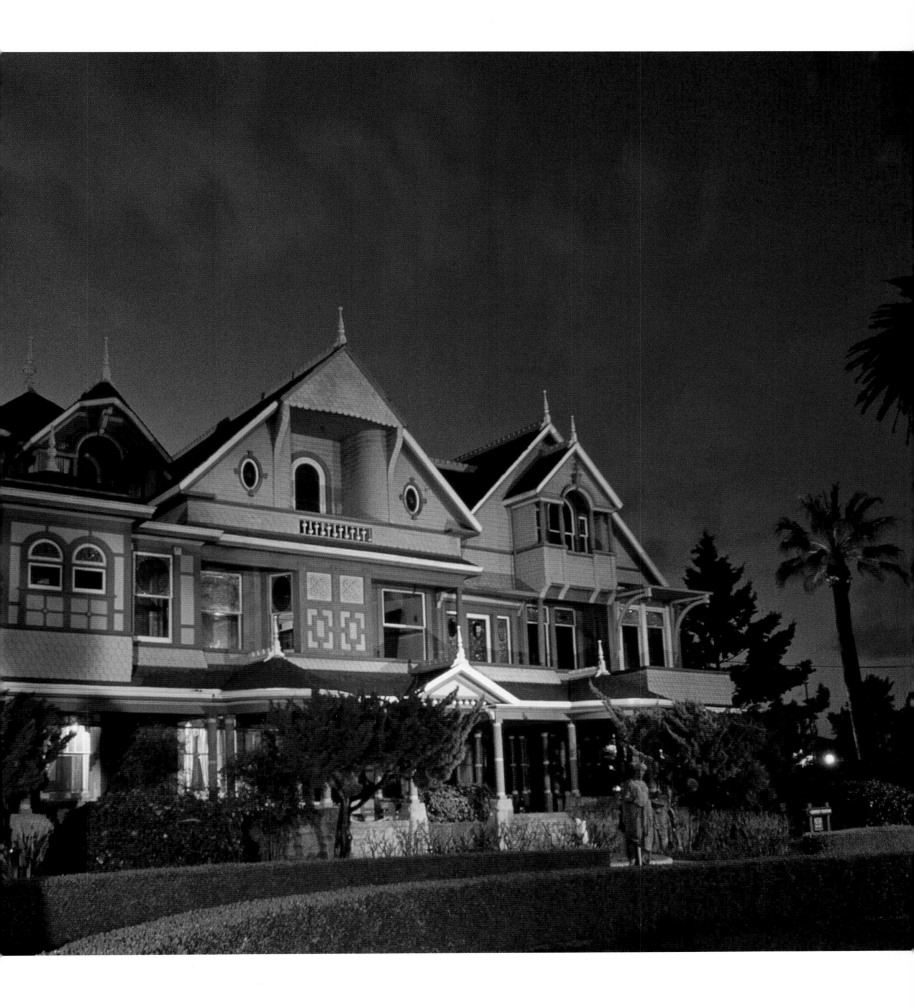

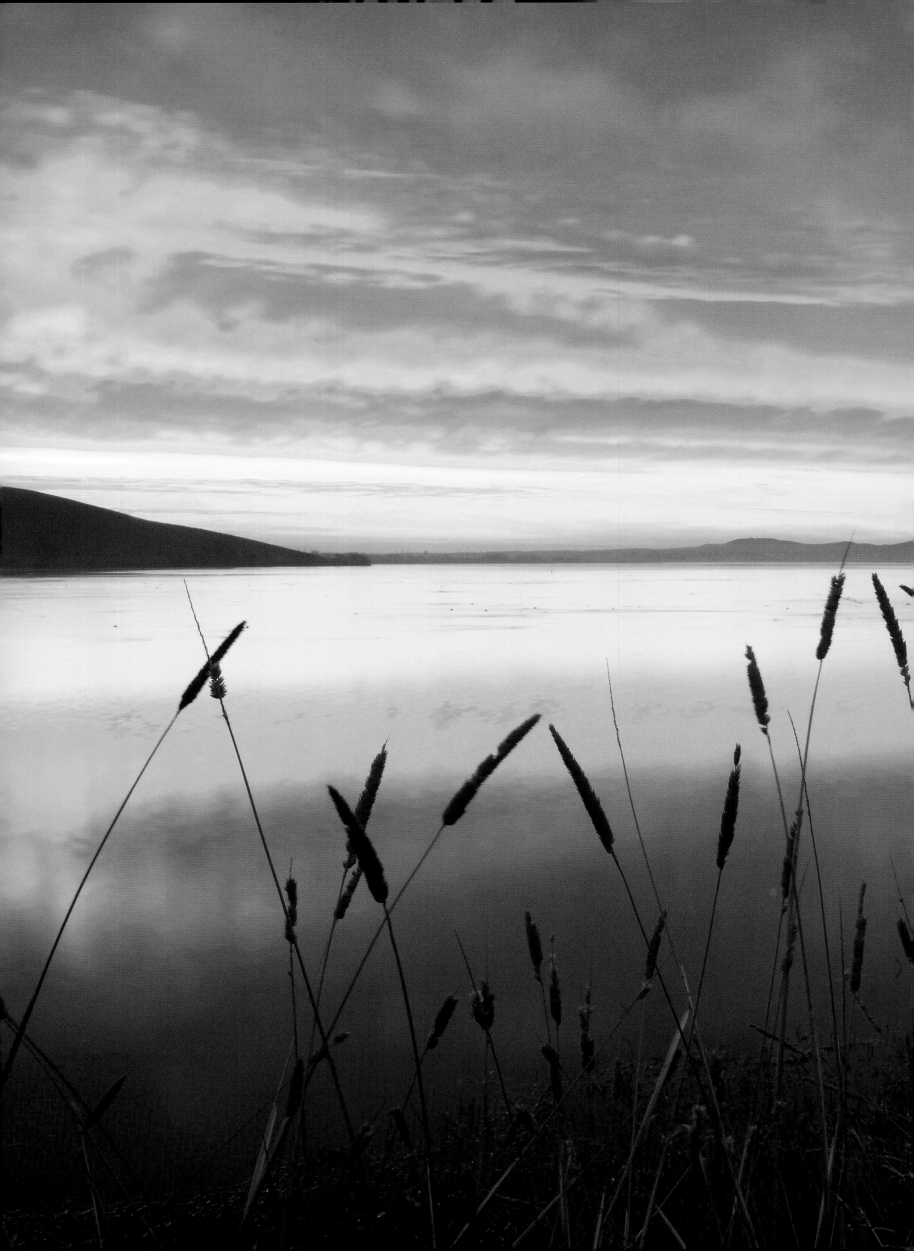

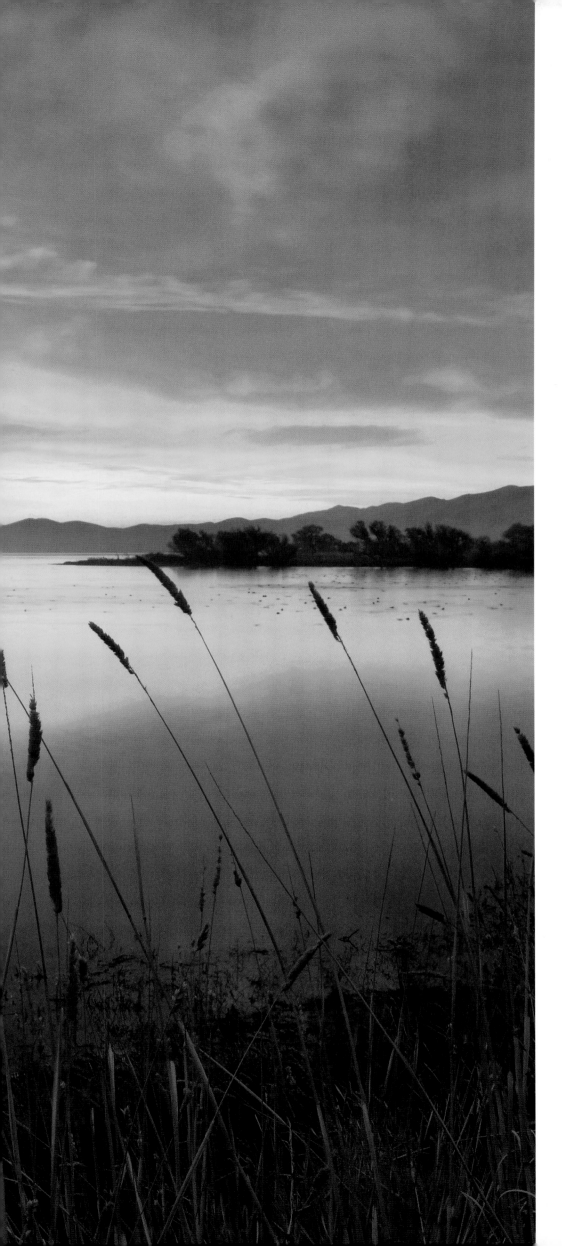

The San Luis Reservoir is a water reservoir that collects runoff from the San Joaquin-Sacramento River Delta. It is part of the San Luis State Recreation Area located in the western San Joaquin Valley — a popular area for boaters, campers, and fishermen.

The picturesque Bridalveil Falls in Yosemite National Park plummets 620 feet into the Yosemite Valley. Flowing year round, this magnificent waterfall is at its peak in the spring months, when warmer temperatures melt the winter snow.

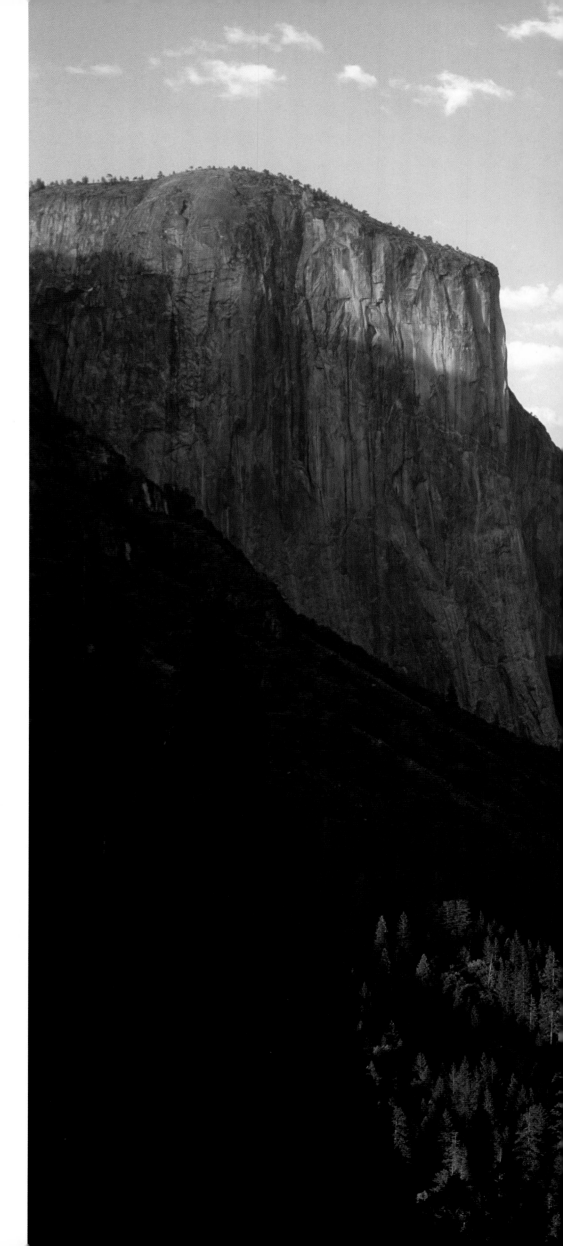

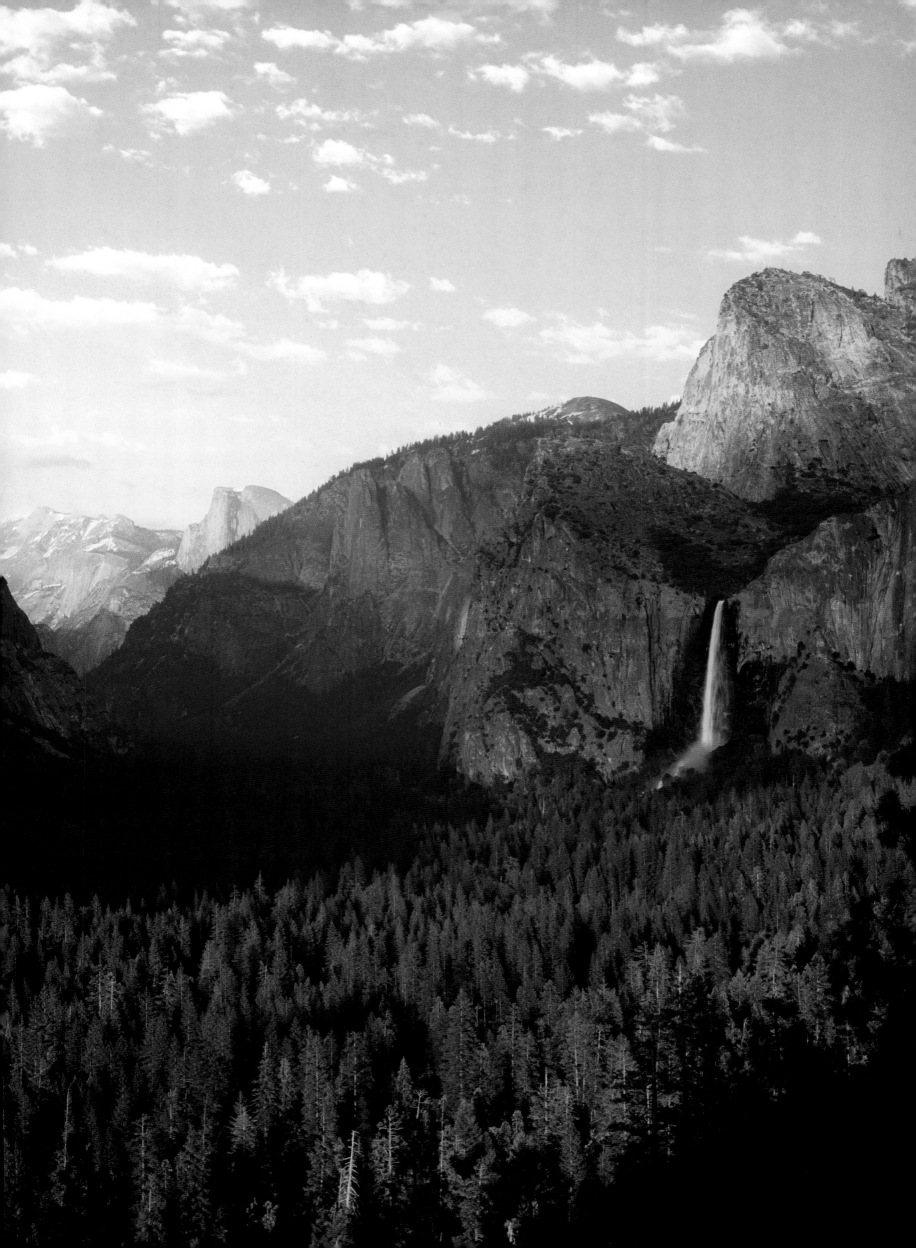

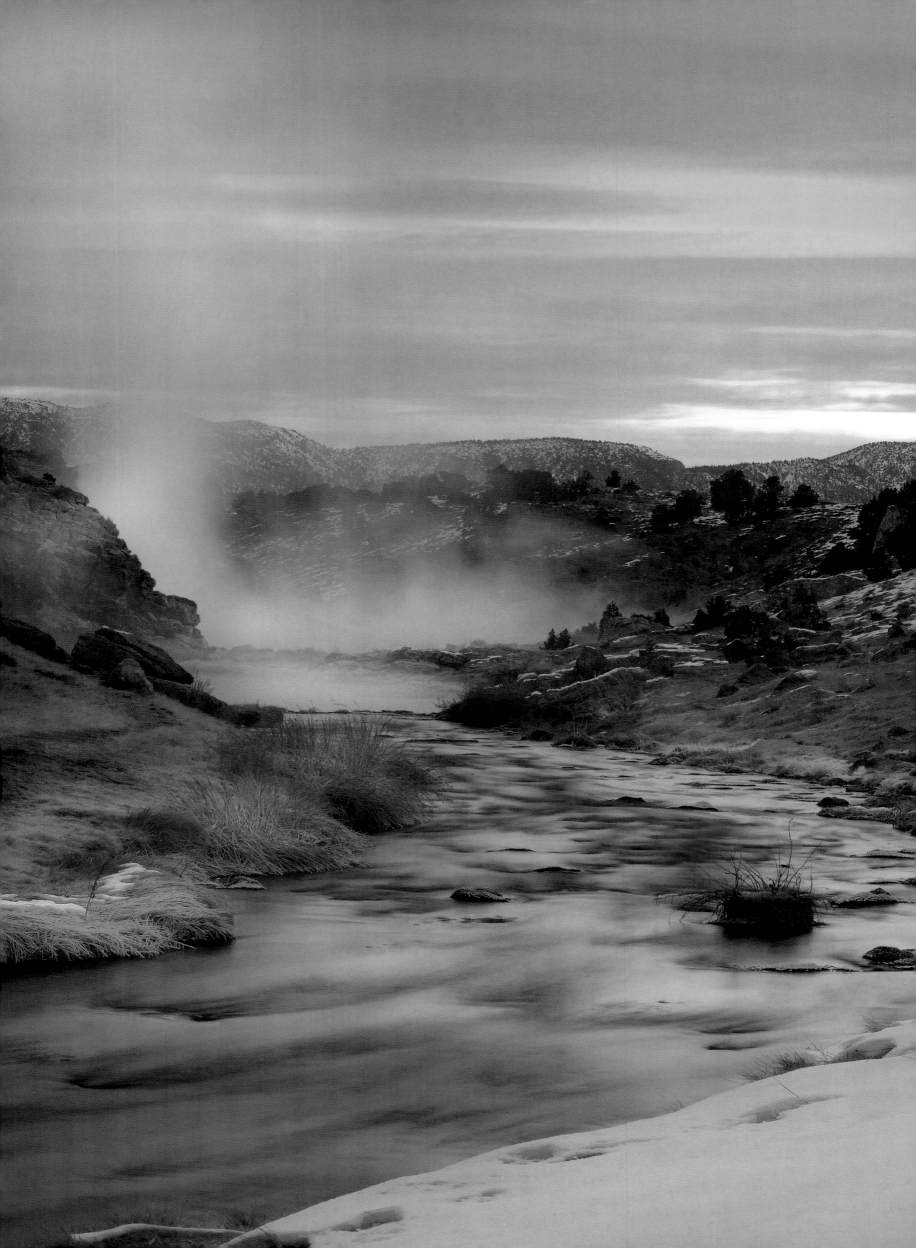

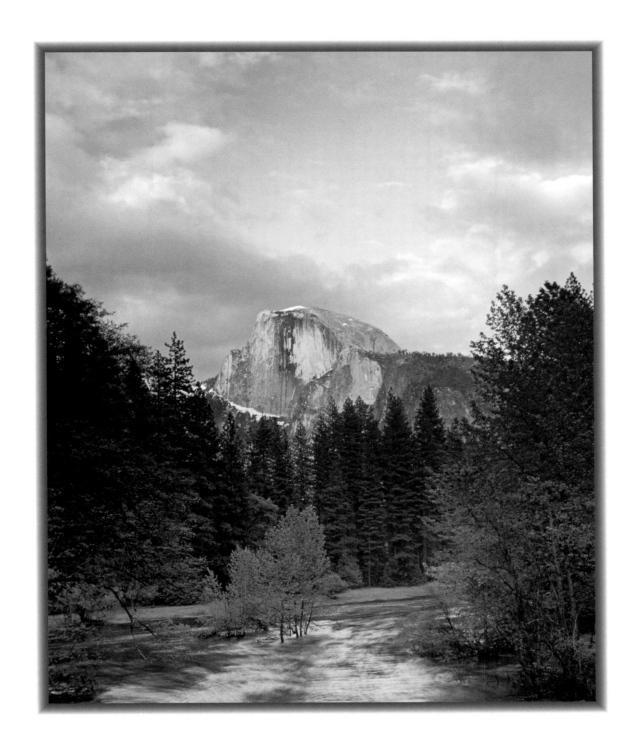

Yosemite National Park was designated a World Heritage Site in 1984. Its 750,000-acre park encompasses magnificent granite cliffs, spectacular waterfalls, and immense sequoia groves. Half Dome is one of Yosemite's most recognizable sights. Rising more than 4,737 feet, its granite crest towers over the Merced River.

Hot Creek, a hot spring situated in California's eastern Sierra Nevada Mountains, is maintained by the National Park Service and surrounded by a spectacular natural setting. Hot Creek's hot springs have become a popular family tourist destination. *(left)*

Yosemite Falls in California's Yosemite National Park is the highest waterfall in North America. Rising up to 2,425 feet, it consists of two giant drops and several small ones in between. The first of the two drops, called Upper Yosemite Falls, plunges 1,430 feet and the second, called Lower Yosemite Falls, plunges 320 feet, together making it one of the park's most magnificent features.

Lake Tahoe, located in the Sierra Nevada, is one of the largest and deepest freshwater lakes in the U.S. It features spectacular ski resorts, summer vacation homes, and natural pristine beauty, providing visitors with recreational activities all year round. *(overleaf)*

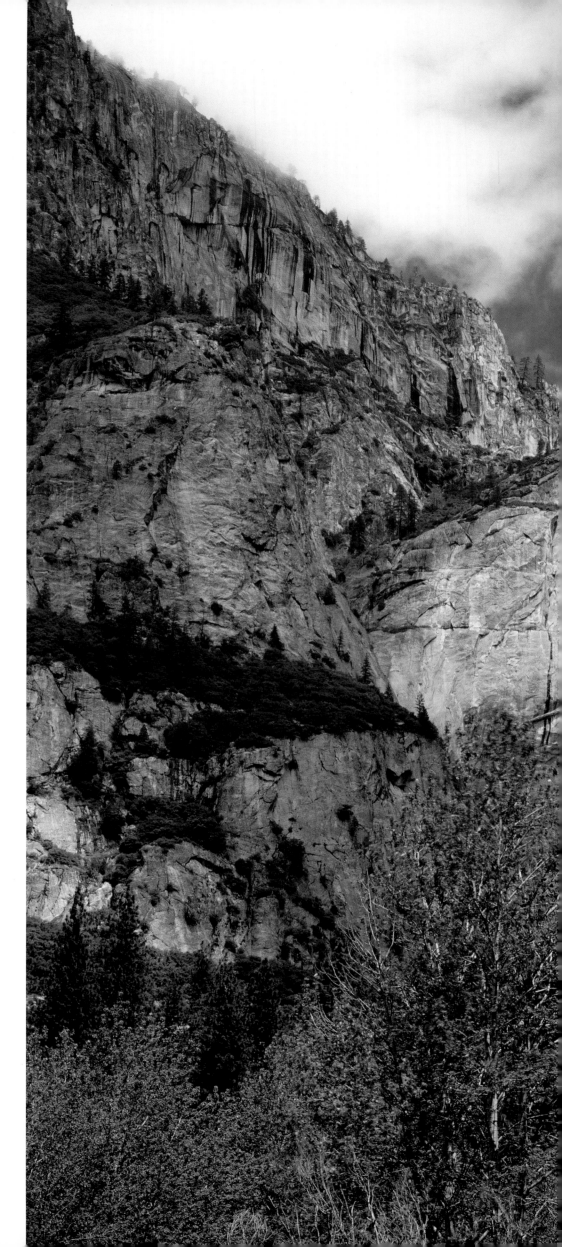

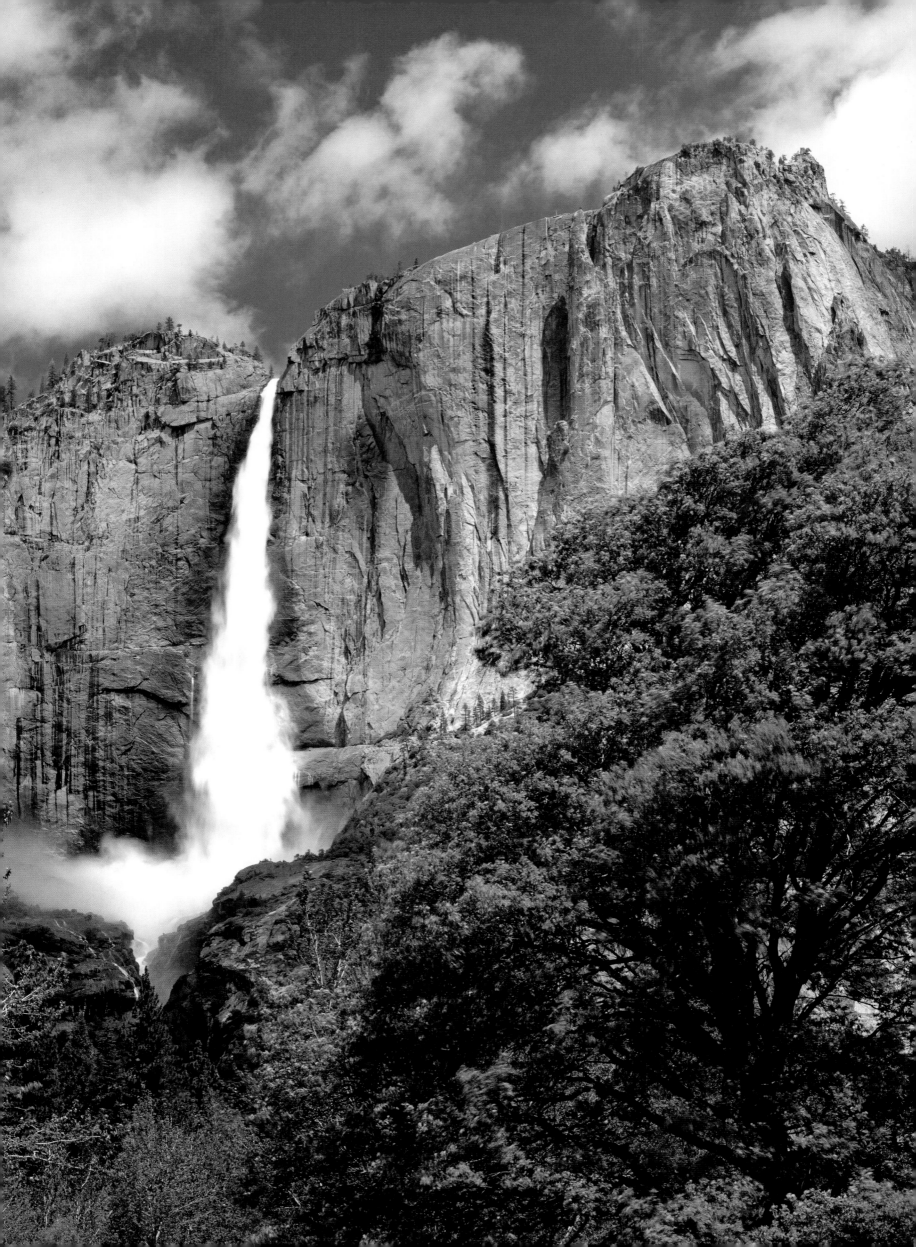

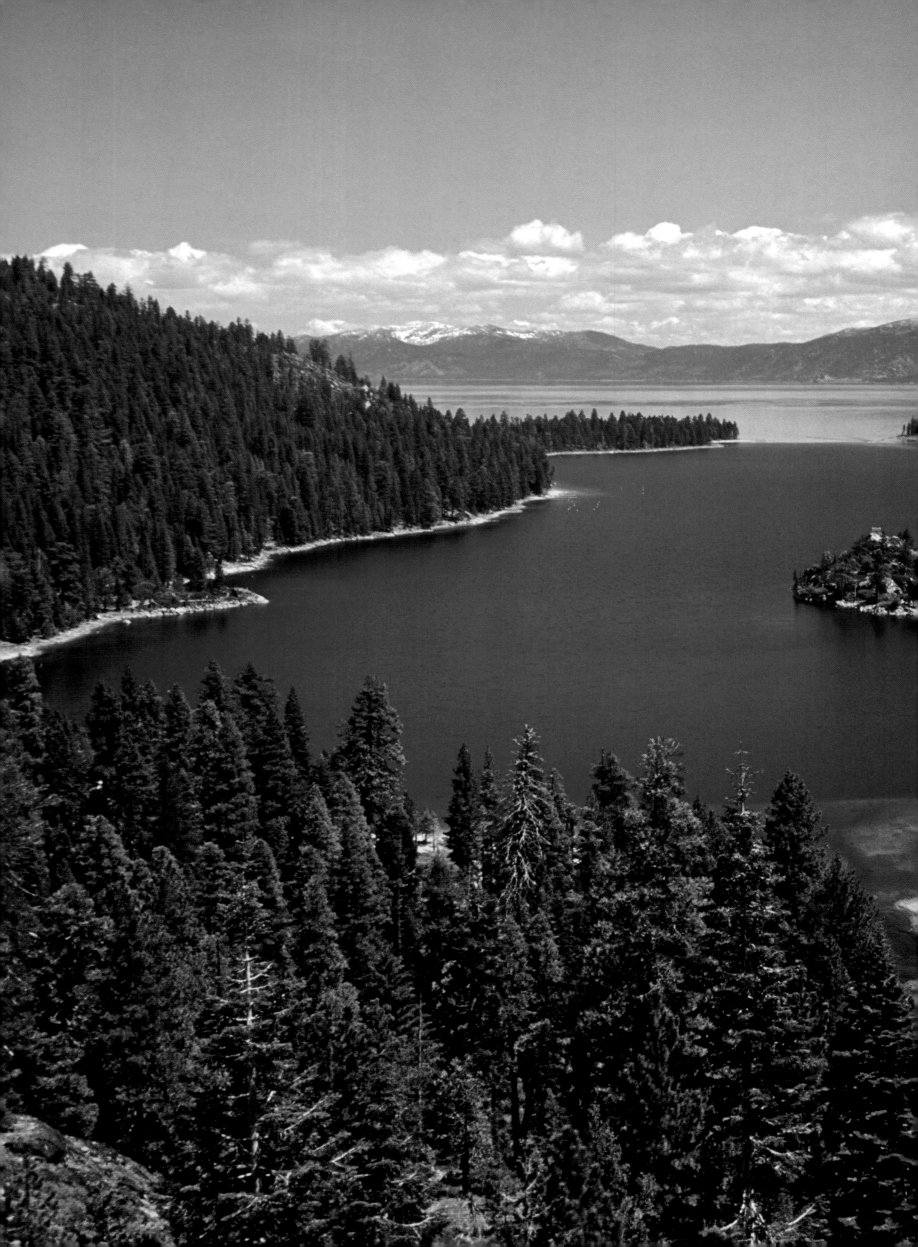

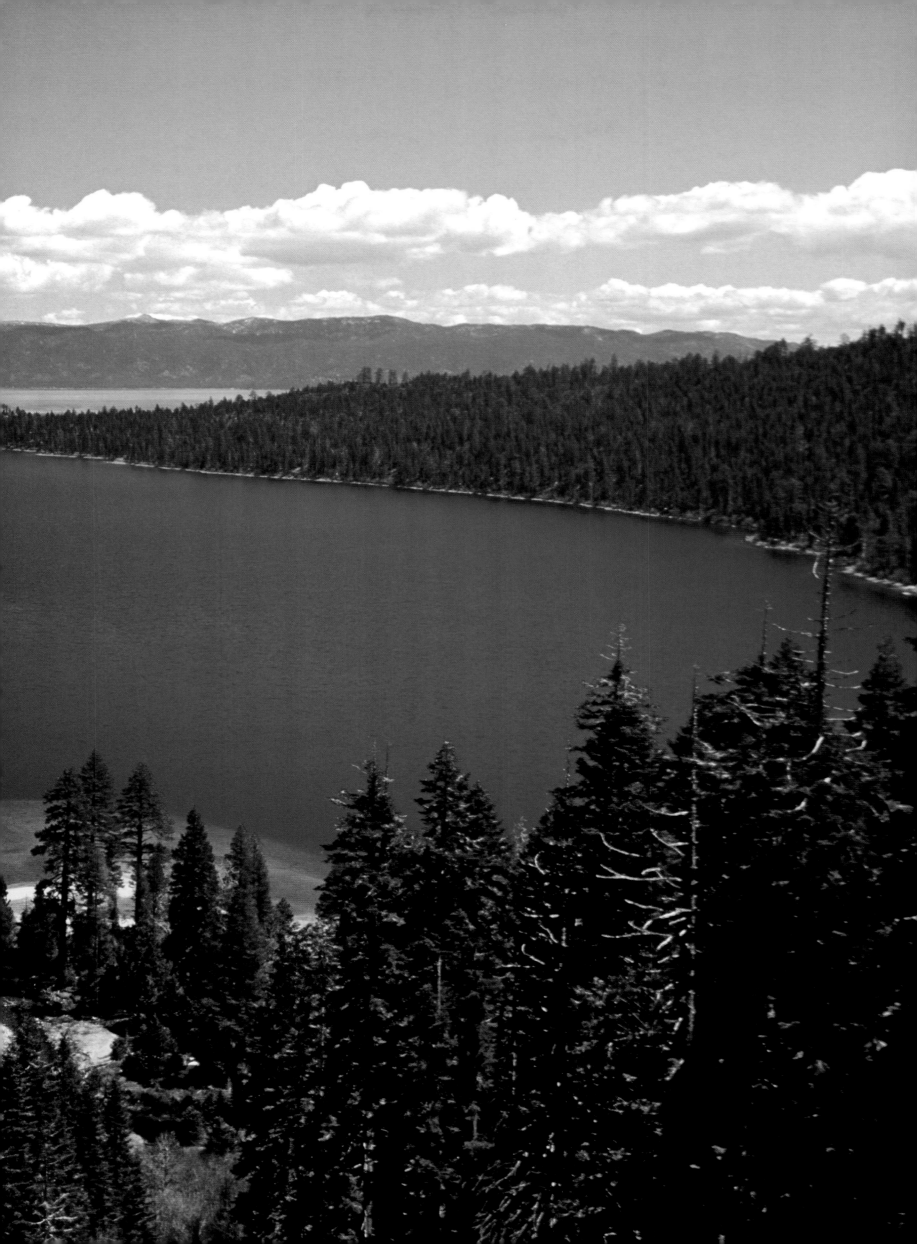

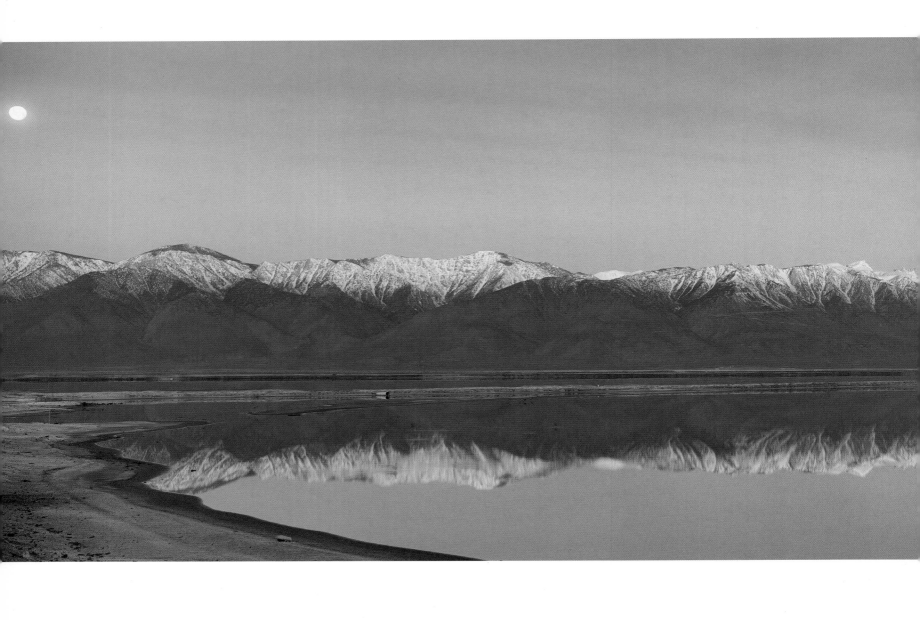

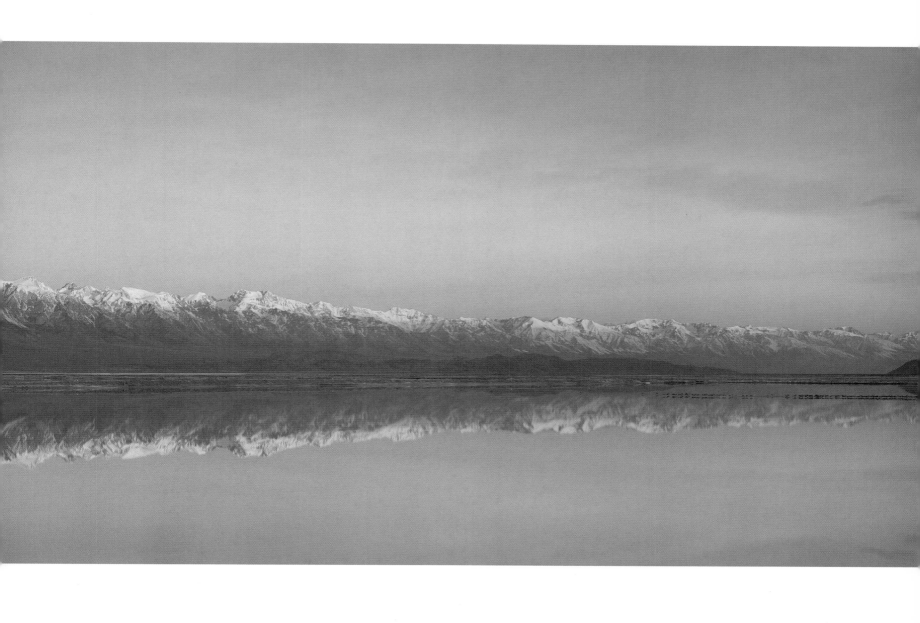

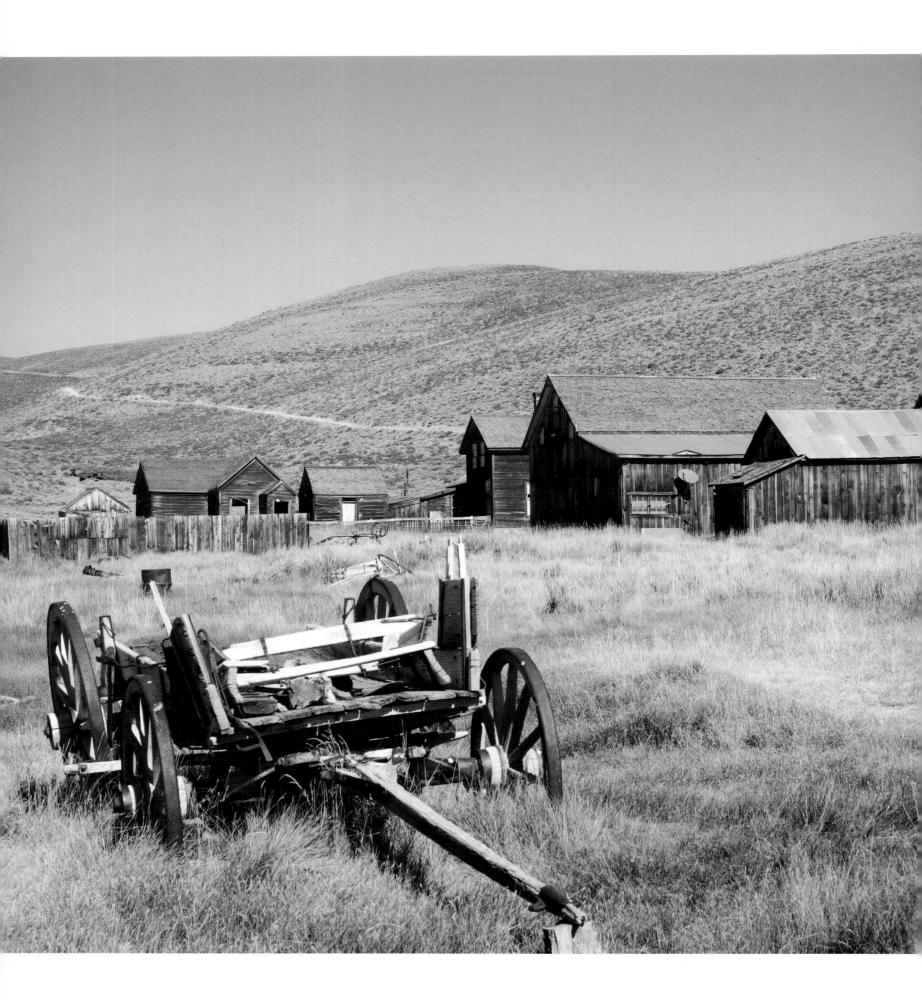

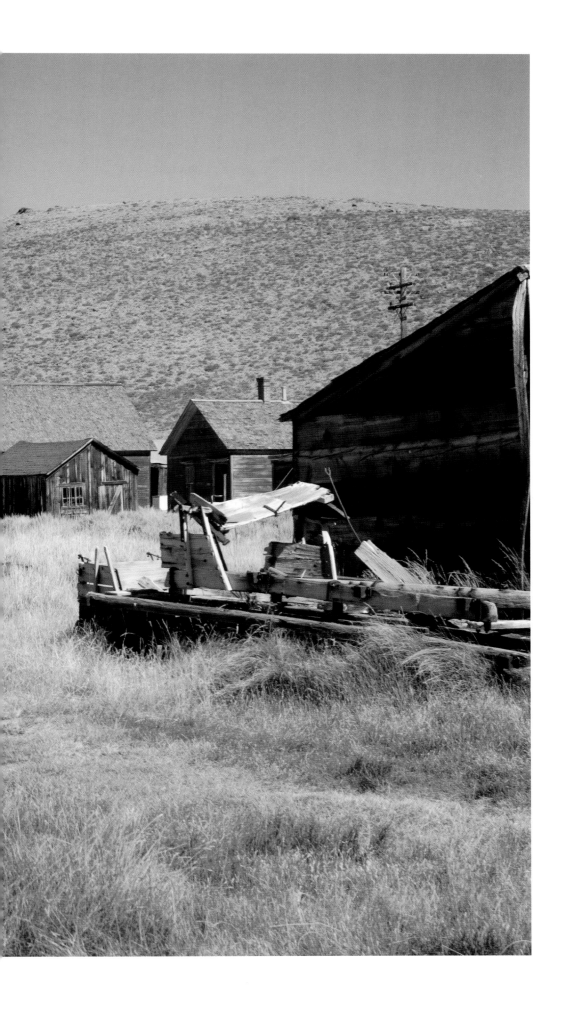

Situated in the Sierra Nevada, Bodie Ghost Town was once a booming gold-mining town. It was named after W.S. Bodey (whose name was later spelled incorrectly), a prospector who in 1859 discovered gold. His discovery ignited a gold rush, creating the town of Bodie. At one time this town had a thriving population of 10,000 and even had its own Chinatown. In 1962, Bodie was designated a National Historic Site and State Historic Park.

Owens Lake is a dry lake in Owen Valley, which lies between the Mojave Desert and the Sierra Nevada Mountains. Once a magnificent blue lake, it gradually dried up after the water from the Owens River was diverted by the Los Angeles Aqueduct in 1913. *(previous pages)*

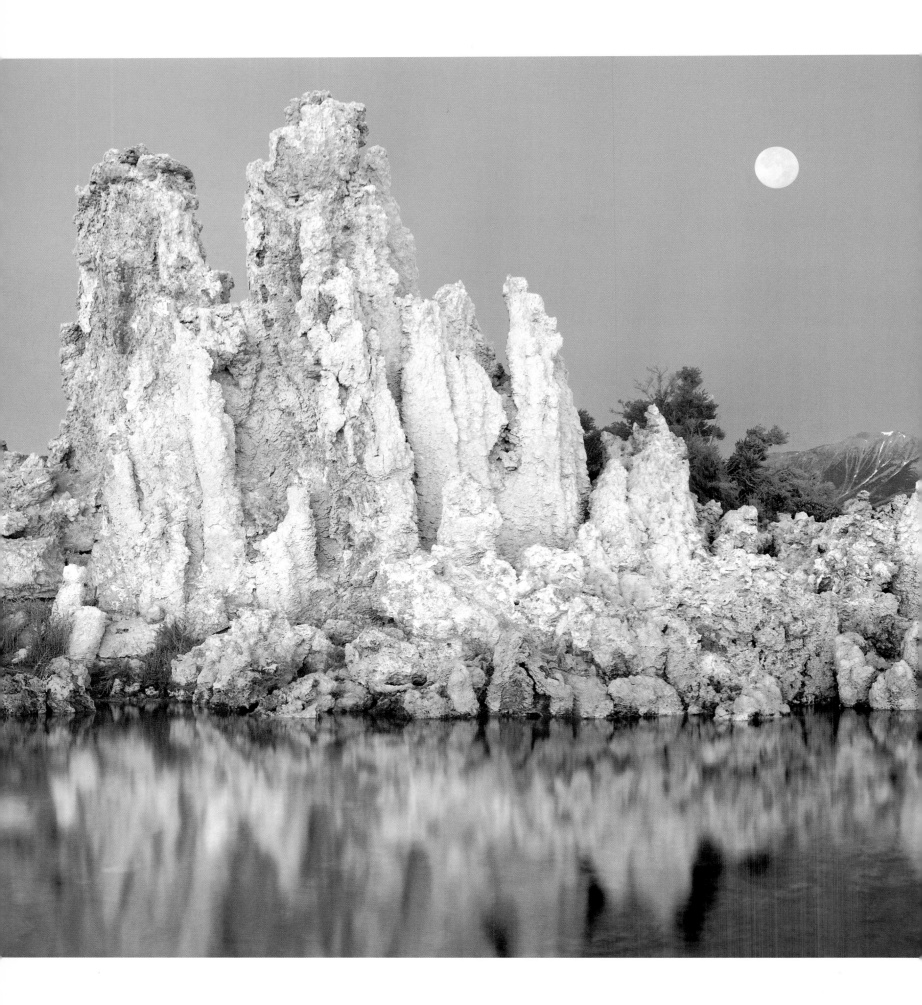

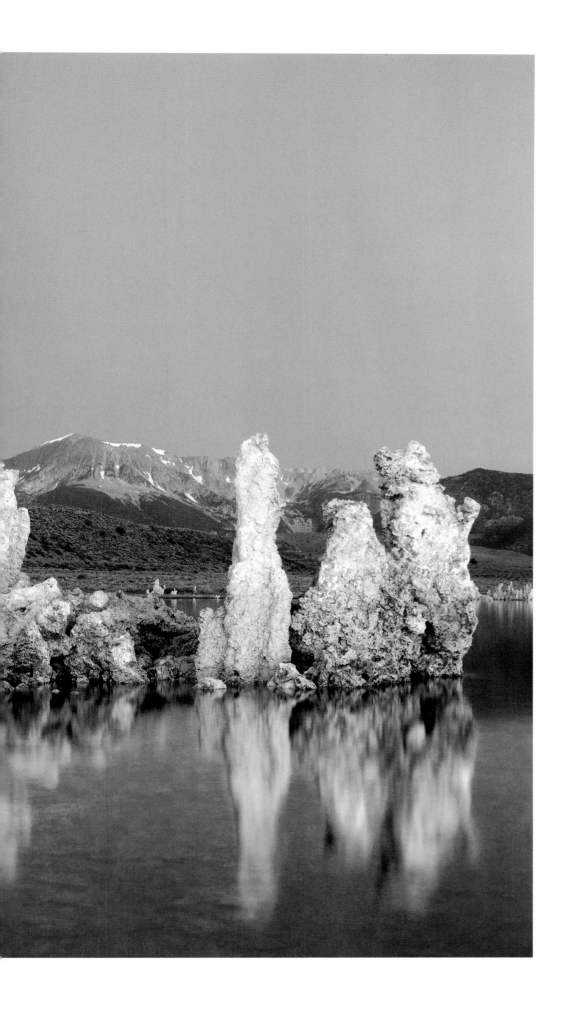

Mono Lake is one of the oldest lakes in North America. This ancient lake is characterized by the unusual formations of a porous rock called tufa — majestic towers formed by the interaction of the alkaline lake with the fresh-water springs.

The streams of the Eastern Sierra Nevada Mountains wash salts and minerals into the lake, but the lake has no outlets. Over time, as the freshwater evaporates, the minerals remain, making the lake about two and half times as salty as the ocean.

California is home to the highest point in the contiguous United States, Mount Whitney. Named in honor of the American geologist Josiah Whitney, it towers 14,505 feet over the town of Lone Pine. Three local fishermen — Al Johnson, Charley Begole, and Johnny Lucas — first climbed this vast mountain in 1873.

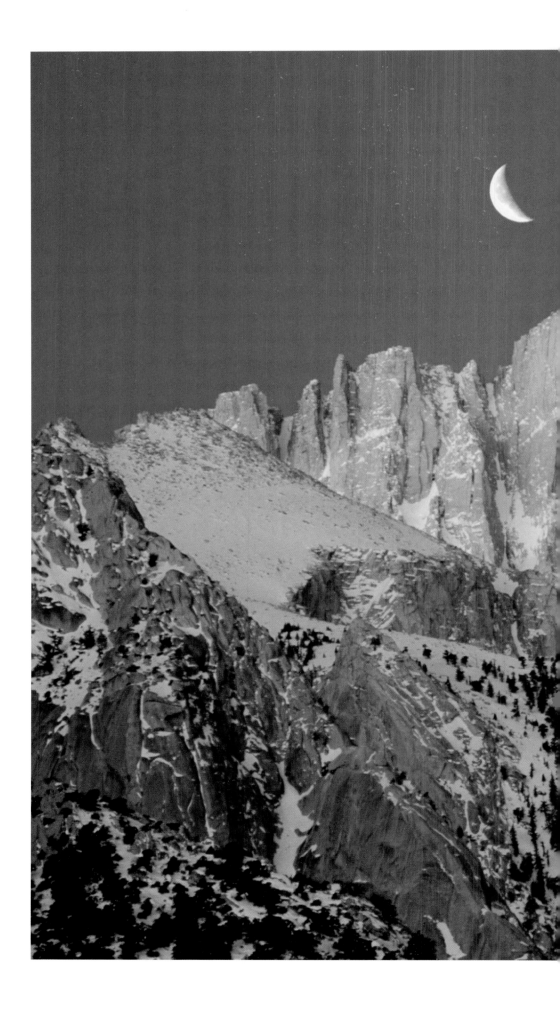

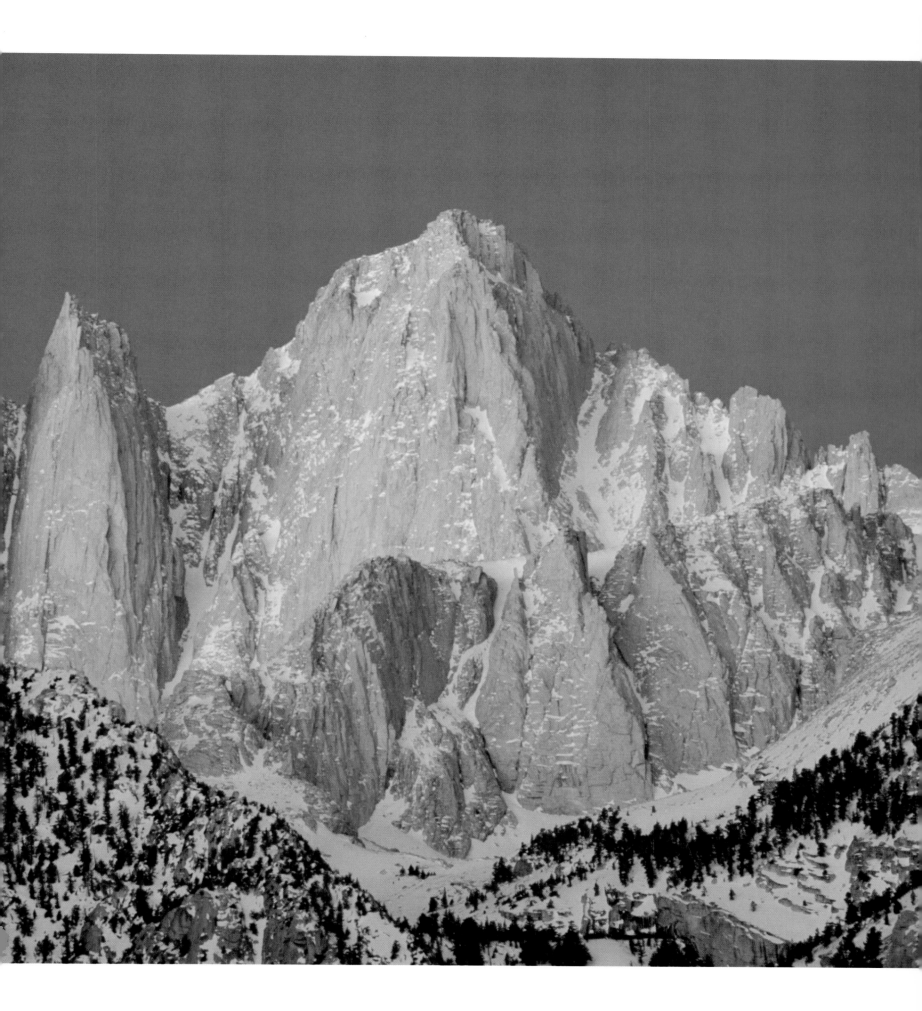

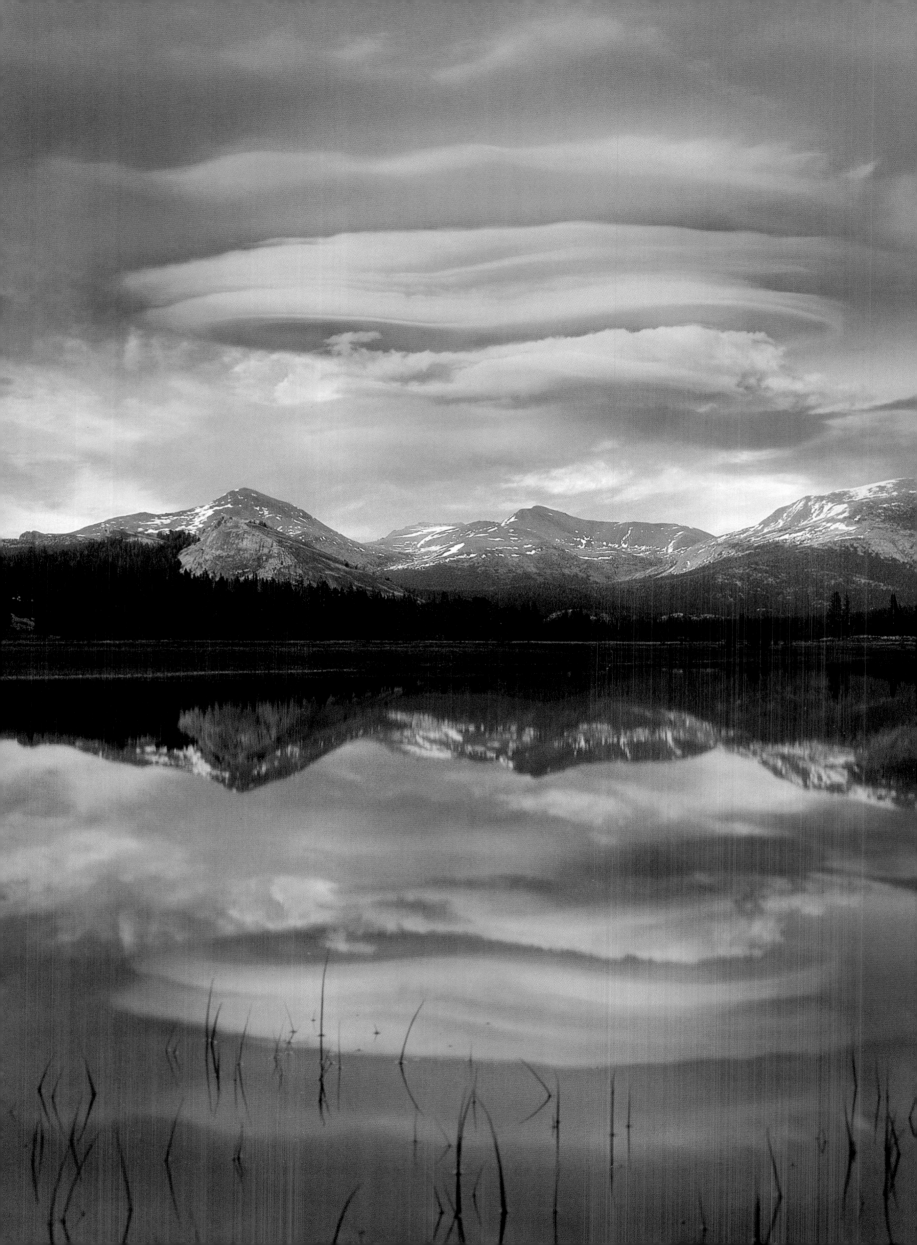

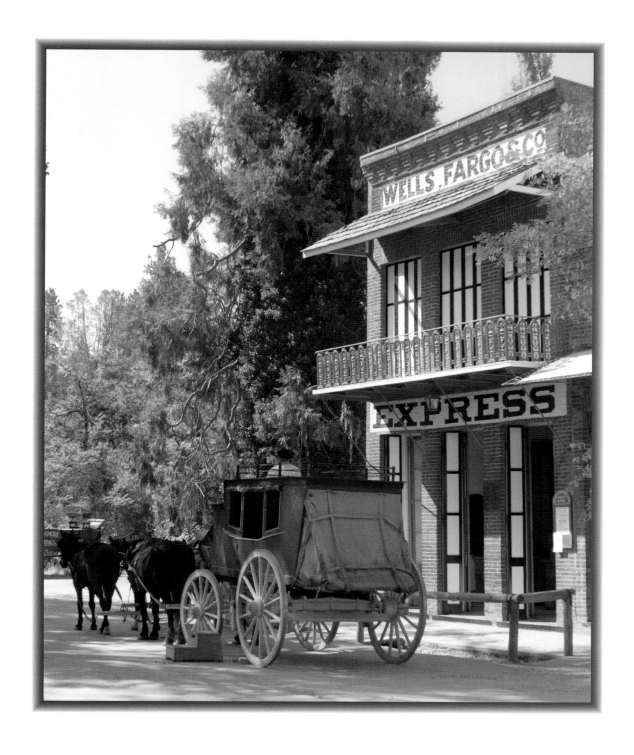

The Columbia State Historic Park in the Sierra Nevada preserves the 1850s California gold rush era. It features a large assortment of mid-1850s brick buildings, historic saloons, hotels, restaurants, as well as guided tours. One of its highlights is a 100-year-old stagecoach.

Tuolumne Meadows is a sub-alpine meadow situated at an elevation of about 8,600 feet in the eastern region of Yosemite National Park. Alongside the meandering Tuolumne River, Tuolumne Meadows is an excellent recreational area for hiking, backpacking, rock-climbing, and camping. *(left)*

Ottaway Lake is one of the many serene areas in Yosemite National Park where hikers can enjoy the solitude and tranquility of nature. The park provides several scenic trails in the wilderness backcountry for hiking, backpacking, and horseback riding.

Greenstone Lake is located in the Hoover Wilderness Twenty Lakes Basin. Its High Sierra pristine beauty is a heavenly paradise for hikers. *(overleaf)*

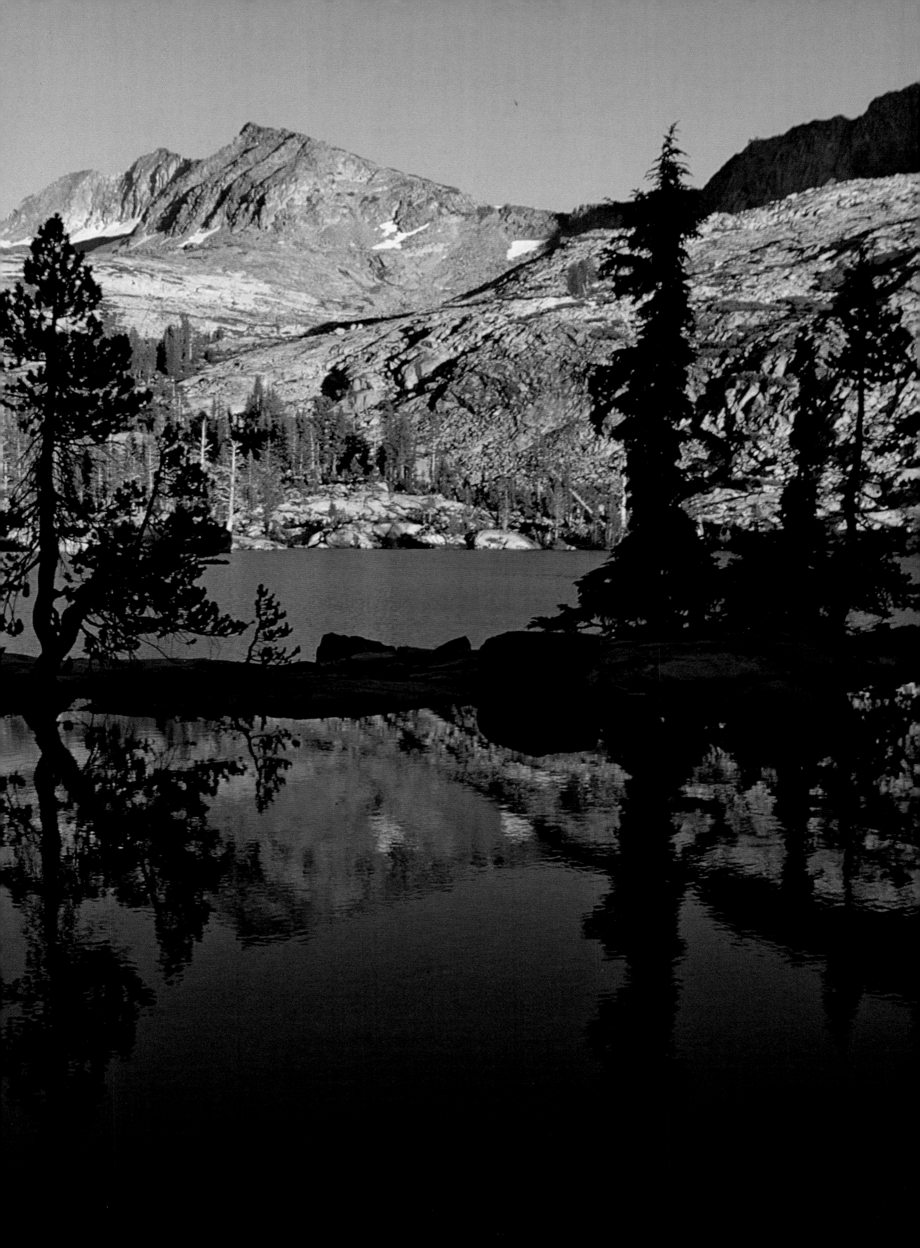

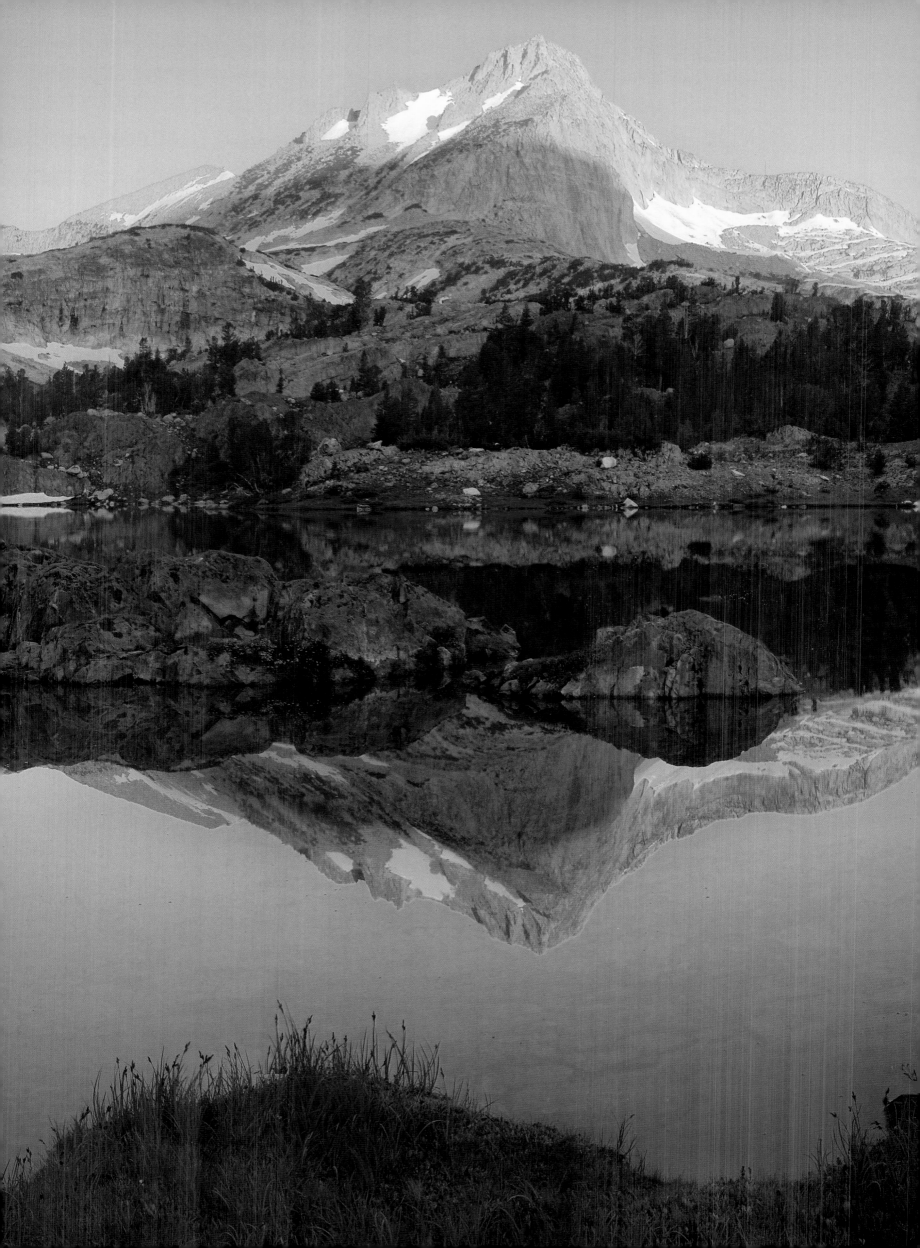

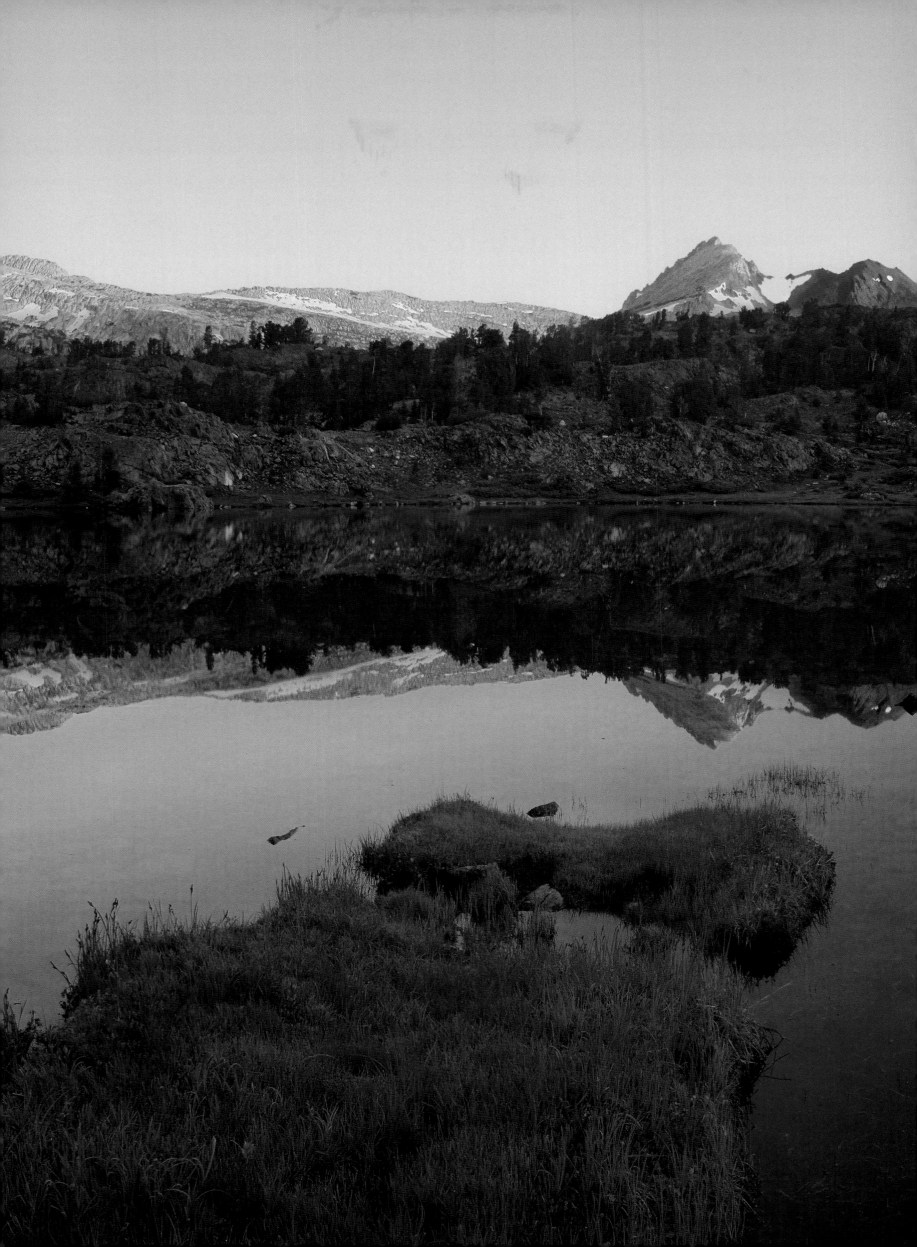

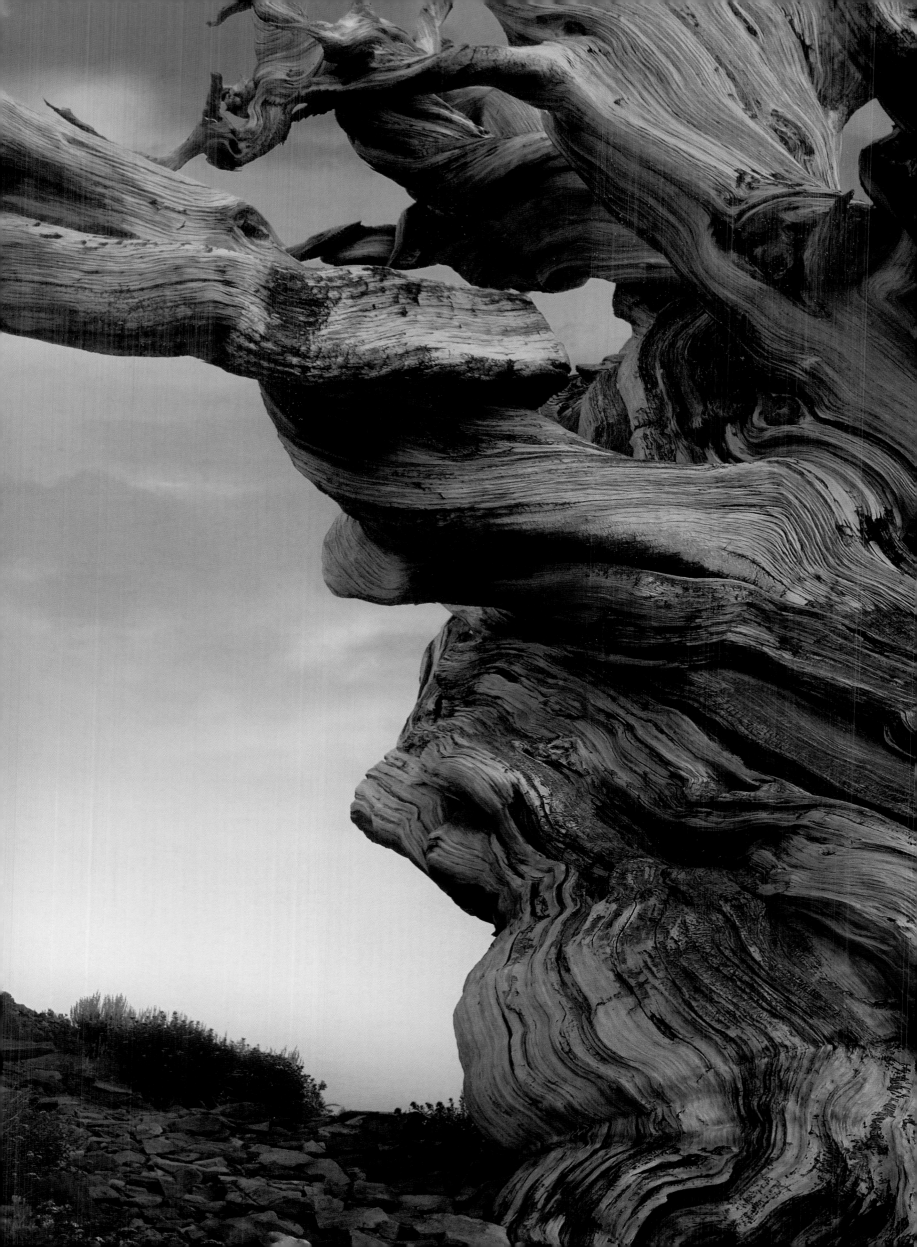

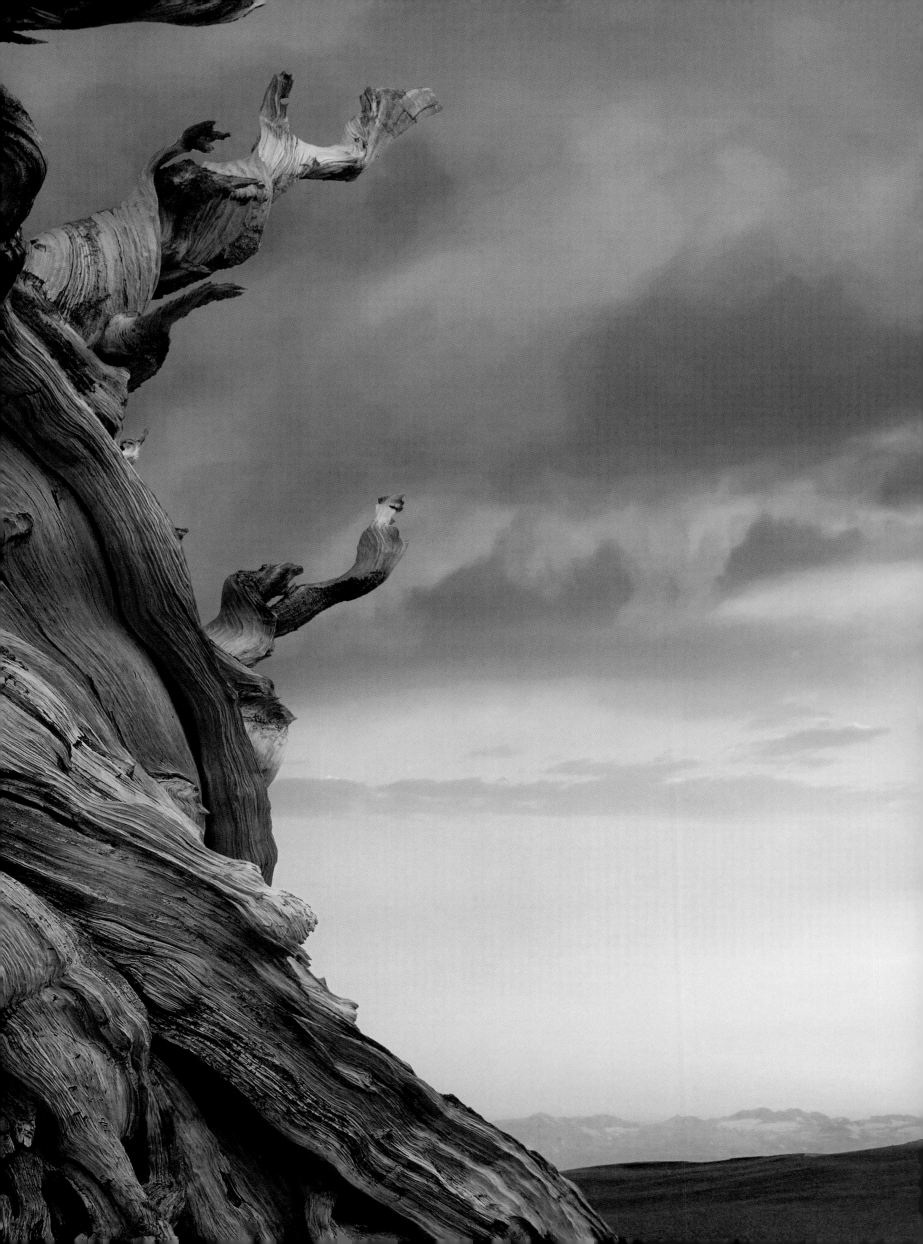

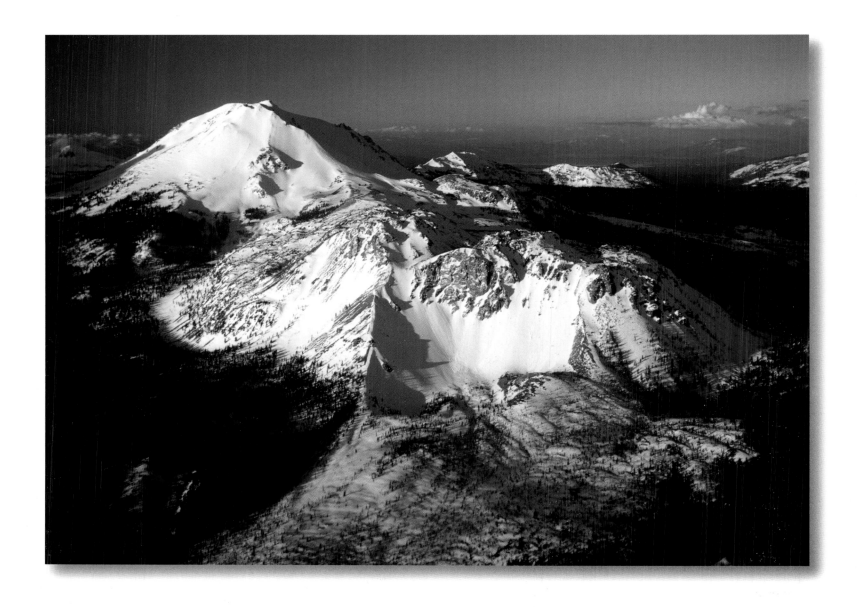

Lassen Peak, also known as Mount Lassen, is an active volcano at the southern end of the Cascade Range in northern California. It rises up 10,457 feet and was named after Peter Lassen, a Danish explorer and guide who led immigrants through the area in the 1800s.

Located in the White Mountains, the Ancient Bristlecone Pine Forest is home to the oldest bristlecone pines in the world. The oldest living trees known on earth, they have survived more than 40 centuries. In 1957, Dr. Schulman, an American scientist, discovered the world's oldest living tree in the Ancient Bristlecone Pine Forest. Named after the longest-lived person in the Bible, Methuselah was determined to be about 4,700 years old. *(previous pages)*

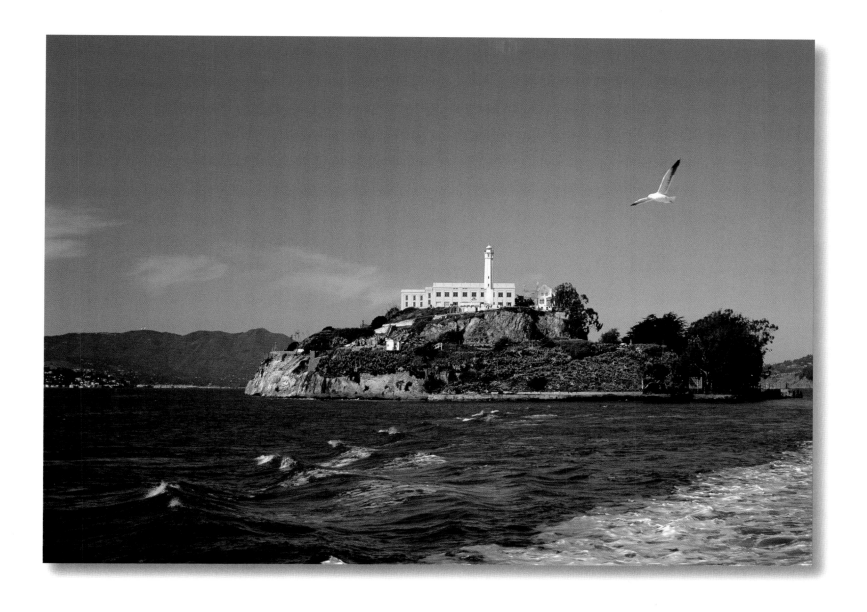

Located in San Francisco Bay, the renowned Alcatraz Island was named after
the Spanish word for pelican, one of the island's first inhabitants. This island is
home to a now abandoned maximum security federal prison, retired military
fortification, and the oldest operating lighthouse on the California coast. Today it is
a National Historic Landmark and part of the Golden Gate Recreation Area.

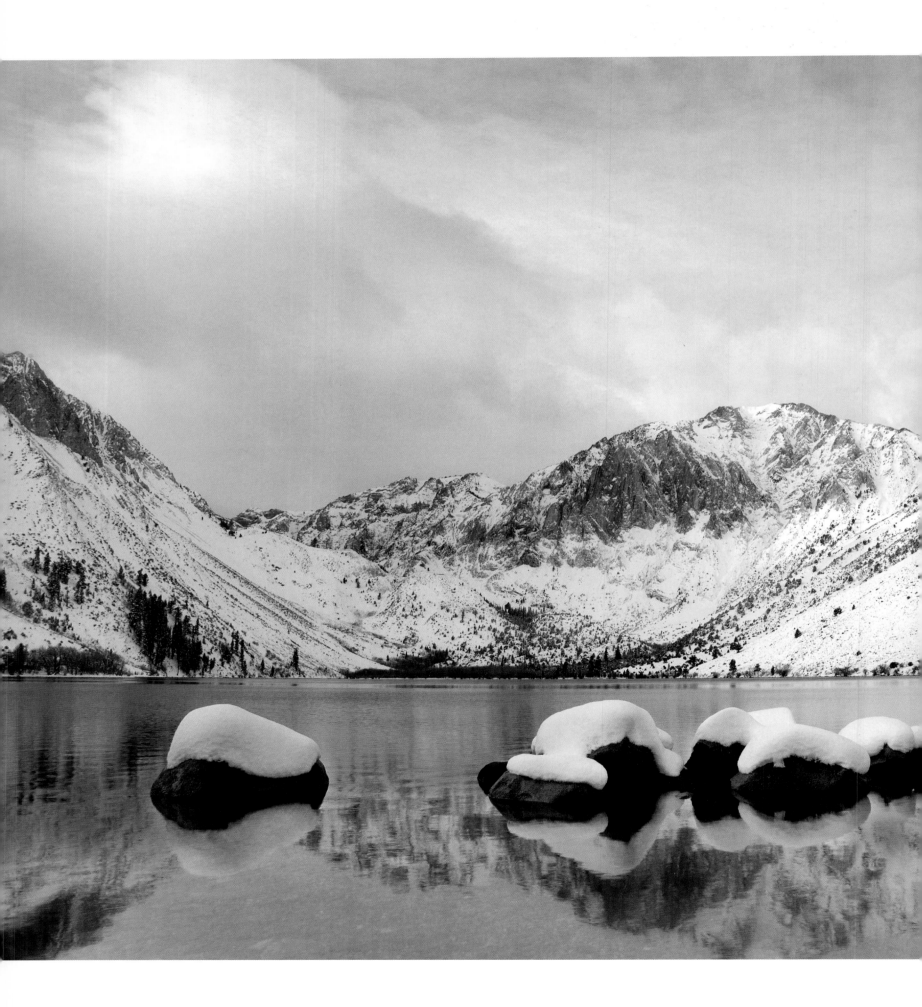

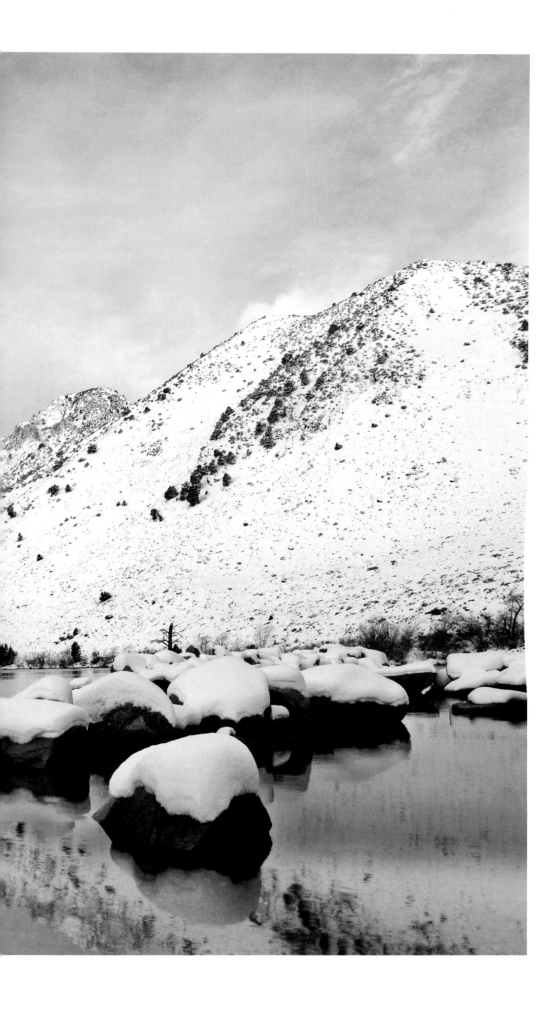

Convict Lake in the eastern Sierra Nevada mountain range got its name after a group of escaped convicts from Carson City, Nevada, took on the law near the lake in the late 1800s. Surrounded by a magnificent backdrop of majestic mountains and natural beauty, this lake has a resort nearby and has become a popular fishing destination.

San Francisco, situated at the northern end of the San Francisco Peninsula, was inhabited by Spanish settlers in 1776 and incorporated in 1850. Today this densely populated city is the fourth largest in California and is characterized by its steep hills, Victorian architecture, historic landmarks, tourism, and rich ethnic mix.

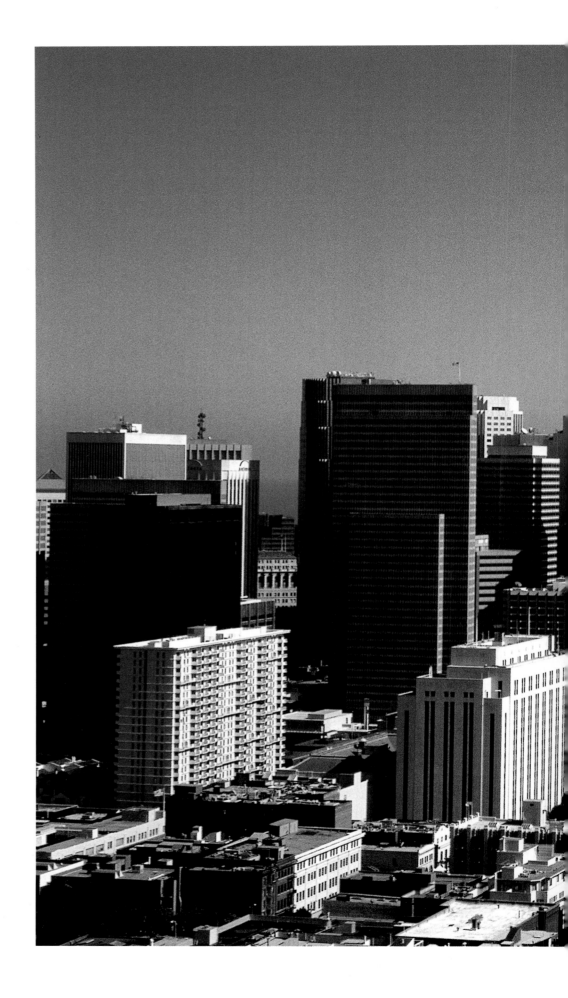

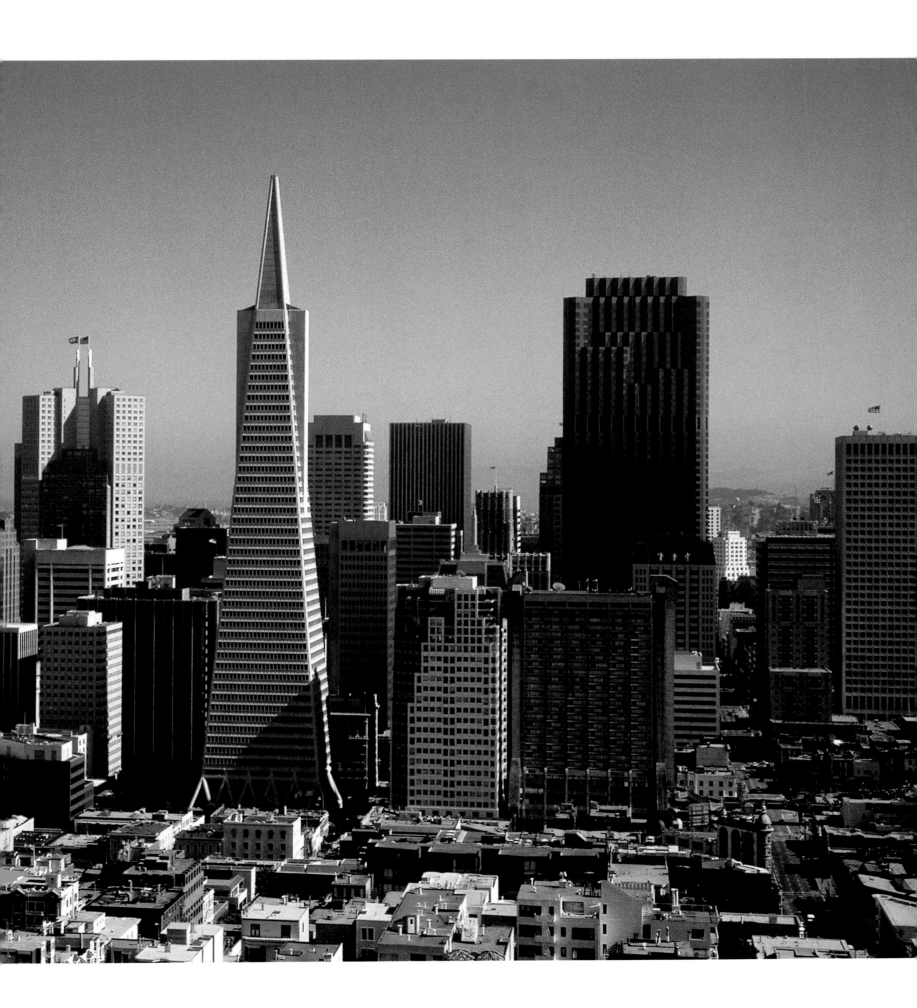

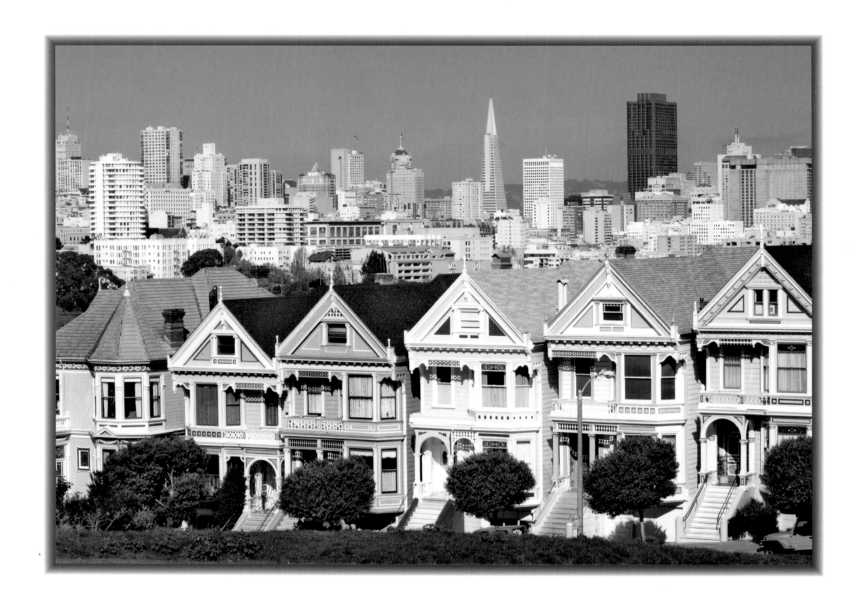

The beautiful wooden Victorian architecture of several San Franciscan homes, dubbed the Painted Ladies, is one the city's most distinctive features. Most notable are the famous Six Sisters, a row of six pastel-colored Victorian homes located across Alamo Square Park.

San Francisco's Lombard Street is famous for its steep, winding hill. One block of this roadway has eight switchbacks that meander past beautiful Victorian architecture and well-tended gardens. It is often billed as one of the "crookedest" streets in the world. *(right)*

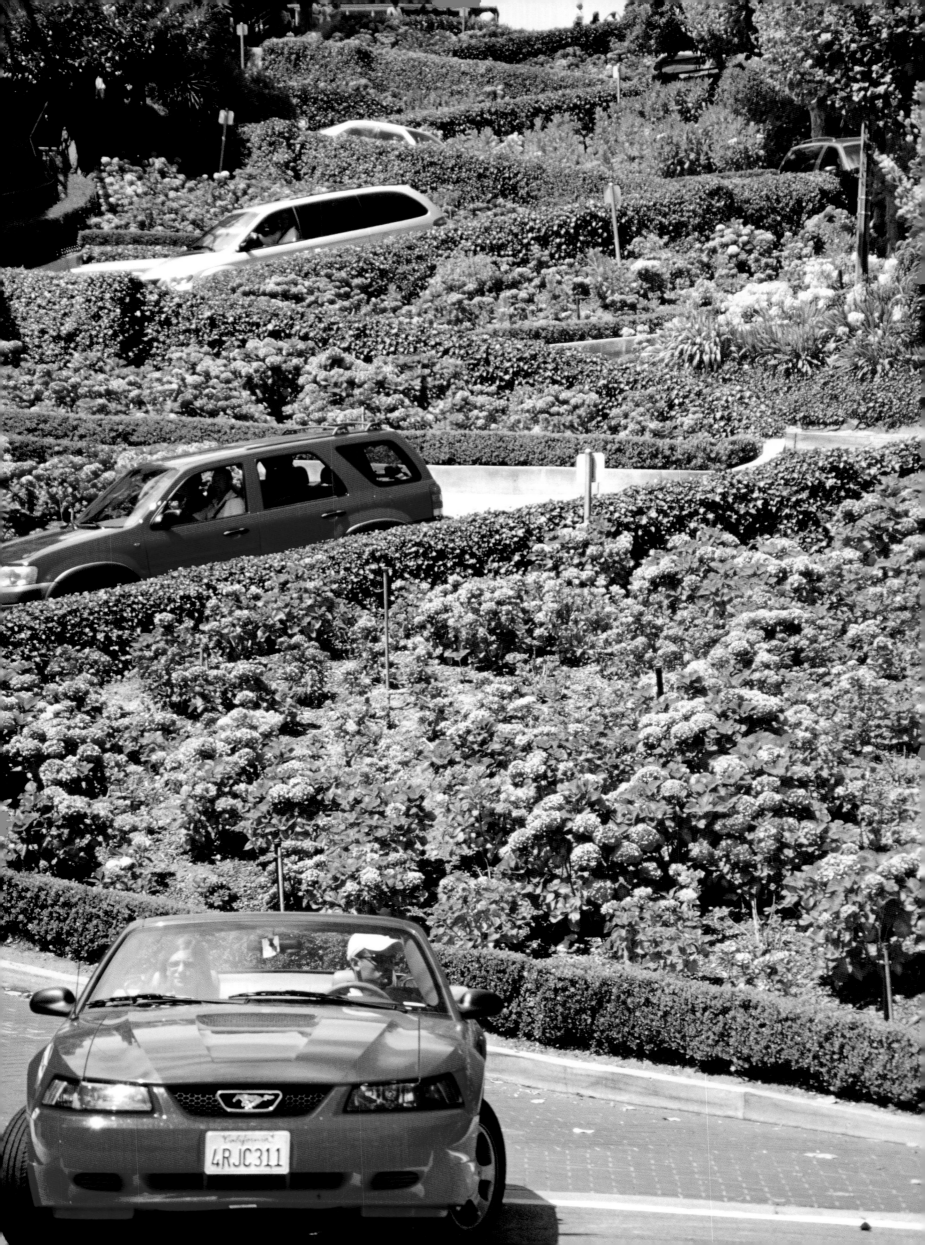

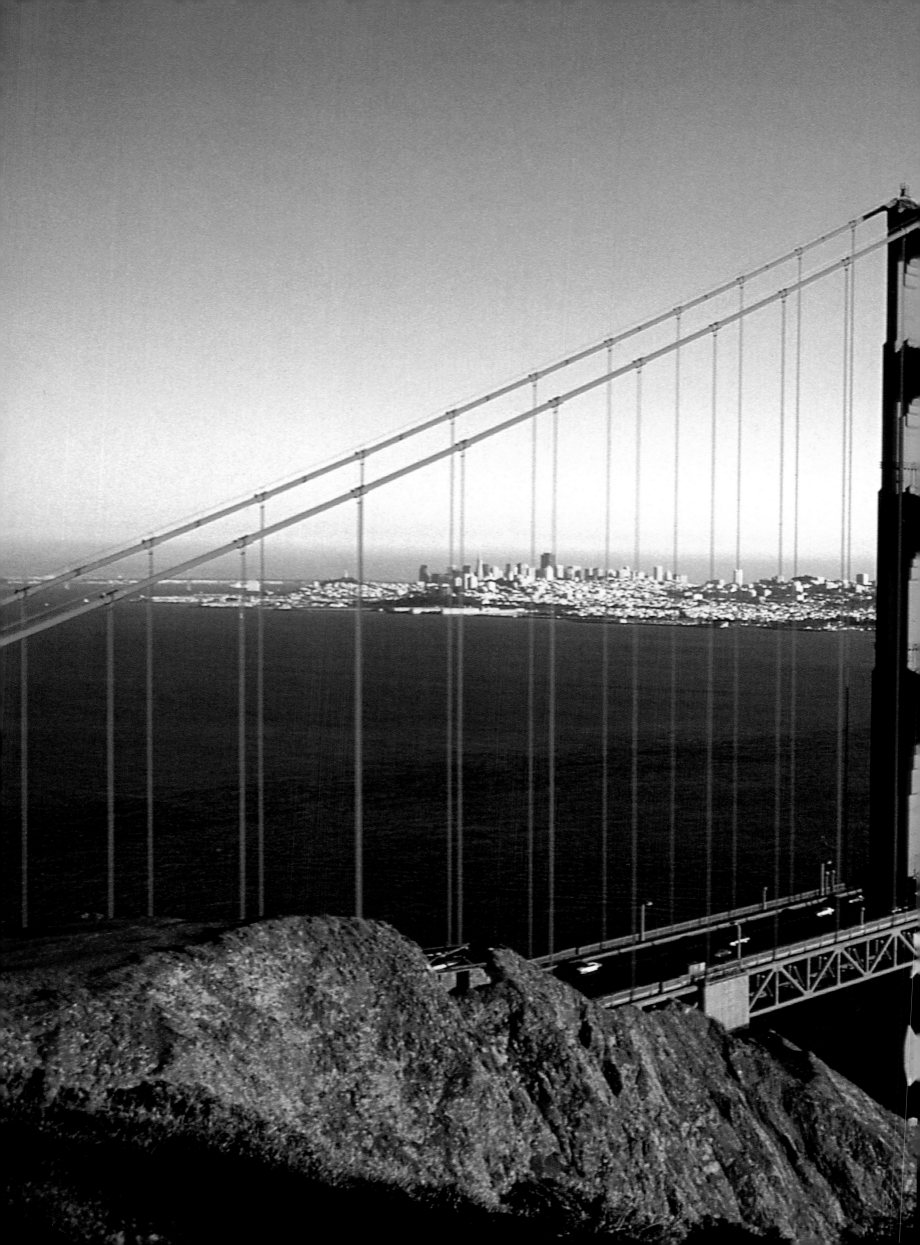

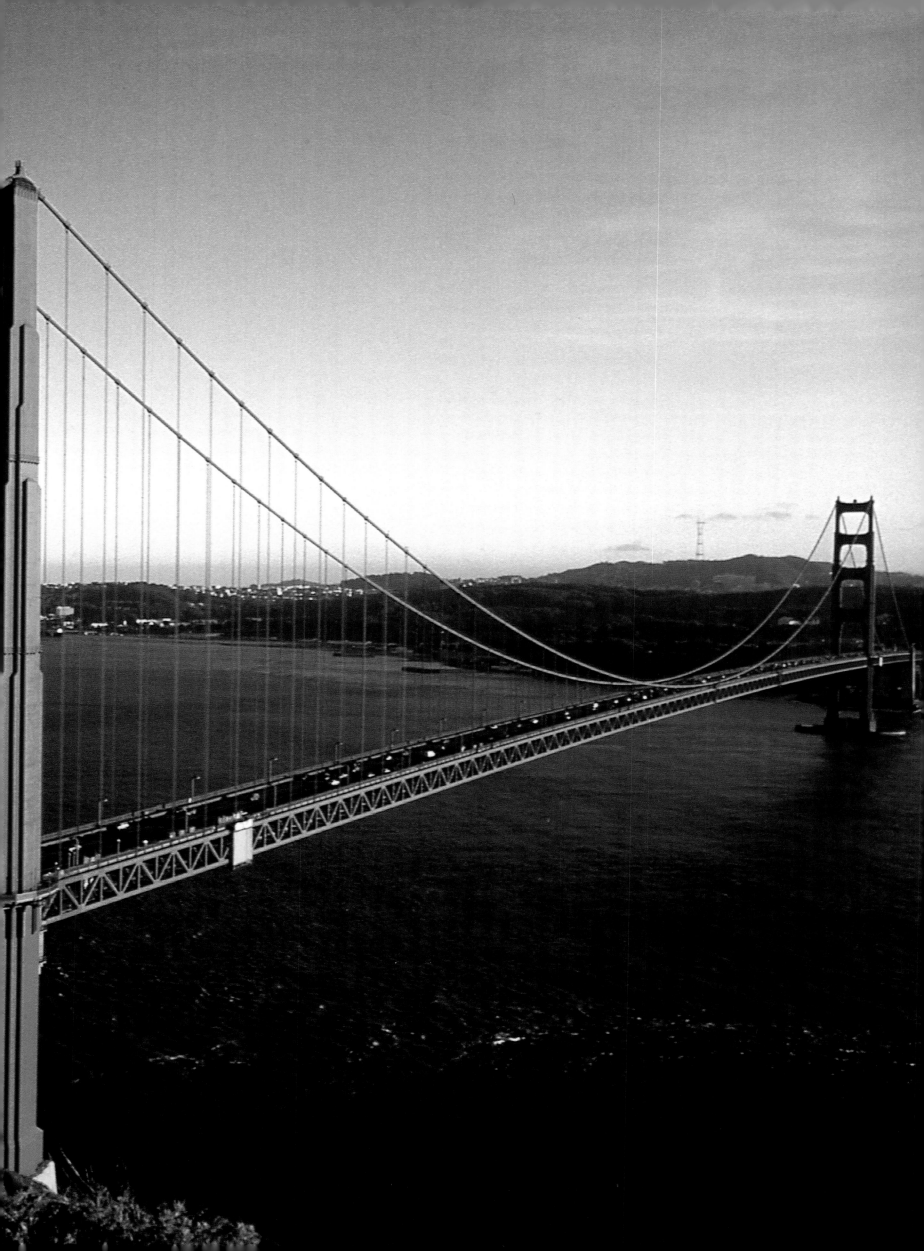

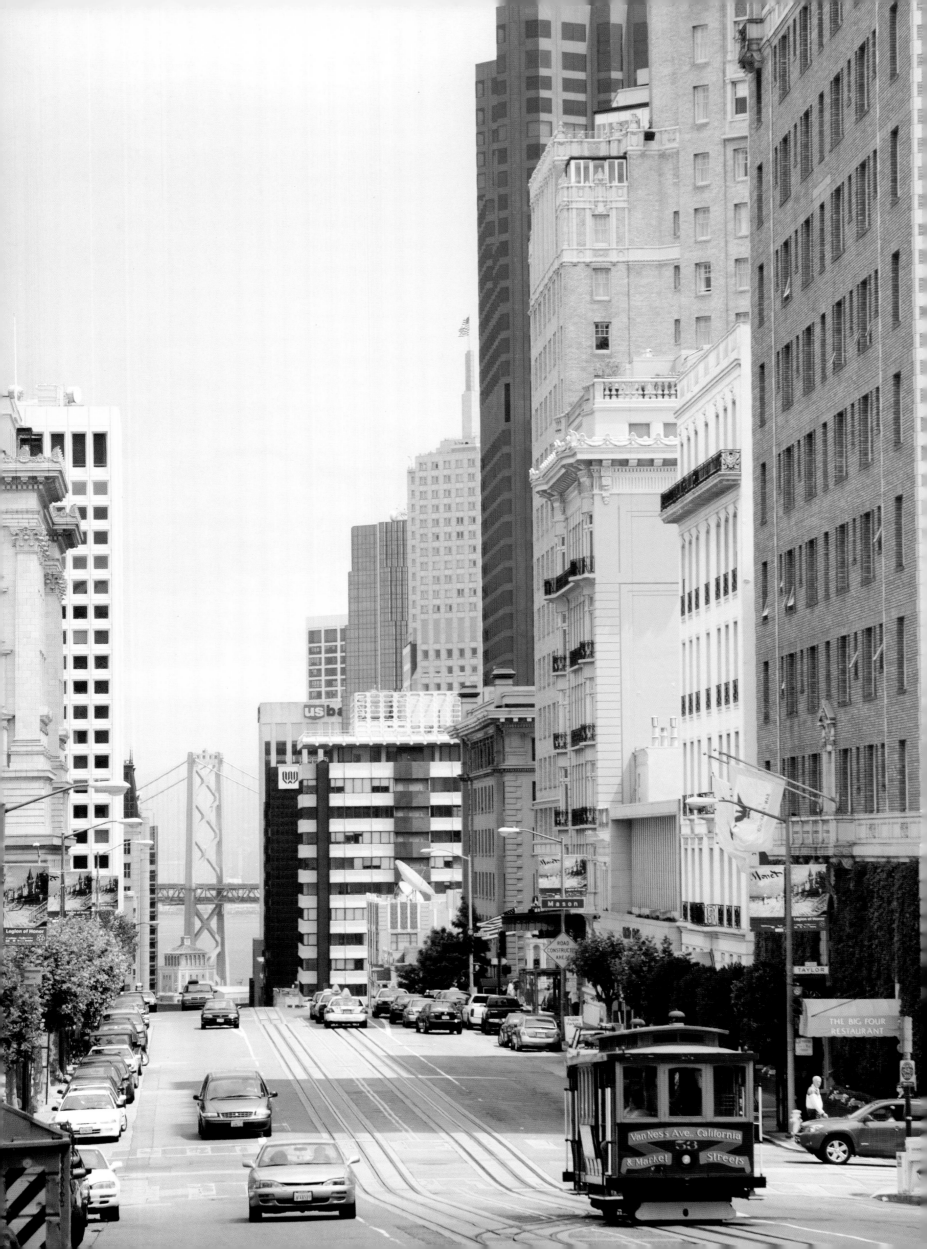

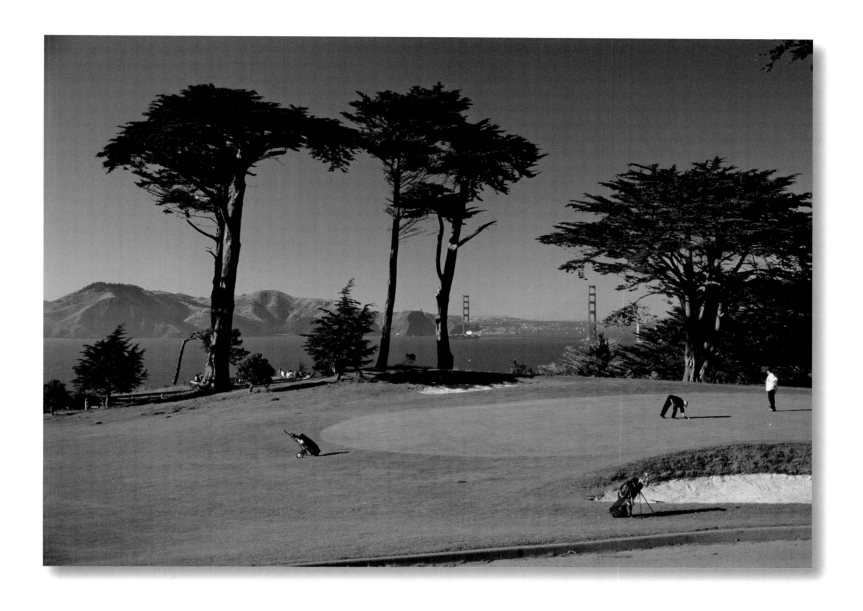

Opened in 1928, San Francisco's Lincoln Park golf course was created by designer Tom Bendelow. Golfers on this 68-par, 149-yard-long course enjoy spectacular views of the Golden Gate Bridge and the city of San Francisco itself.

San Francisco is renowned for its cable cars. The first cable car began public service on September 1, 1873. Today this manually operated urban transport system is the last operational one of its kind in the world. *(left)*

Opened in 1937, the Golden Gate Bridge's 4,200-foot main suspension span was the longest in the world at the time of its construction. It was named after the Golden Gate Strait, which links San Francisco Bay to the Pacific Ocean. The bridge hangs 220 feet above the water, reaches 746 feet high, and can withstand winds up to 100 miles per hour. *(previous pages)*

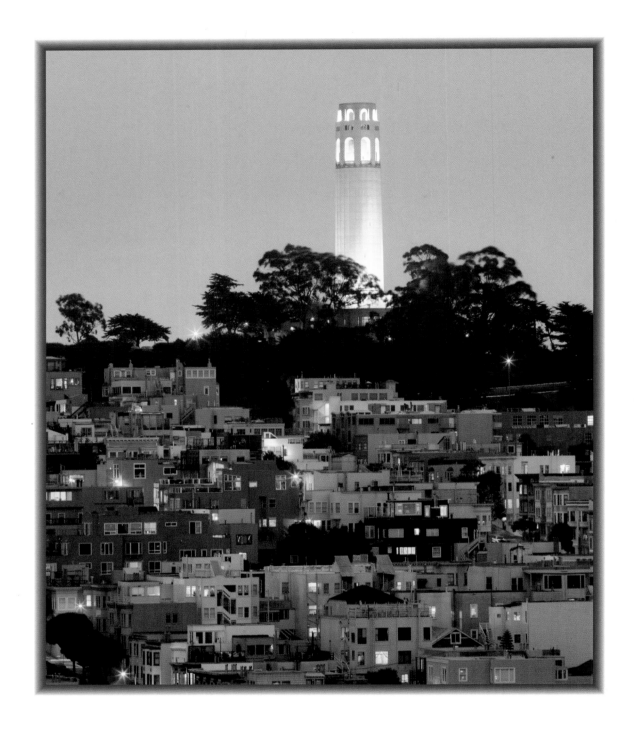

Lillie Hitchcock Coit, an eccentric local citizen, financed San Francisco's landmark Coit Tower to beautify the city. Overlooking the 284-foot Telegraph Hill, the tower, designed by architect Arthur Brown, rises up 210 feet, with an observation deck atop that provides stunning city views.

The Legion of Honor is a fine arts museum in San Francisco. Inspired by the beauty of the Palais de la Legion d'Honneur in Paris, Alma de Bretteville Spreckels, wife of sugar tycoon Adolph Spreckels, had the museum constructed in the 1920s. Designed by architect George Applegarth, it features French art, and displays great works by European artists like Monet, Rembrandt, and Rubens. *(right)*

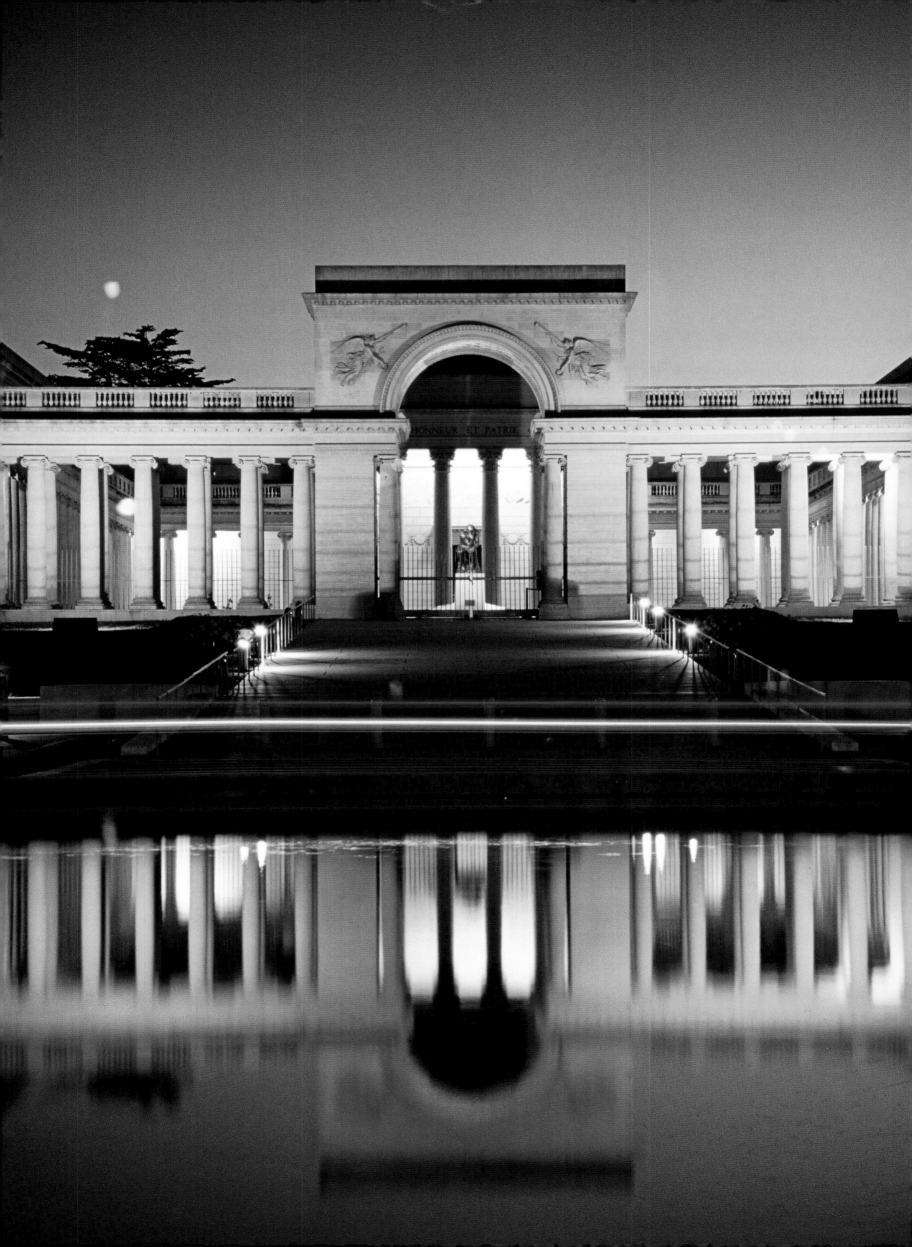

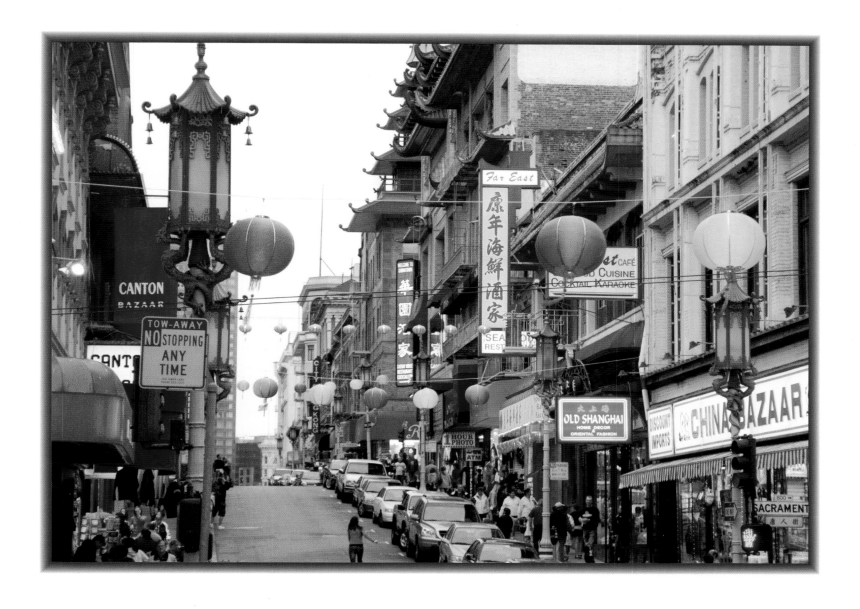

Established in the 1850s, San Francisco's Chinatown is one of the largest and oldest cultural centers in North America. This large, bustling Chinese community features authentic restaurants, herbal shops, bakeries, markets, a museum, and a fortune cookie factory.

A pioneer in the art world and a world-renowned landmark, the innovative Museum of Modern Art in San Francisco opened in 1935 under the supervision of director Grace L. McCann Morley. Exclusively featuring modern and contemporary art of the 20th century, it was the first museum of its kind on the West Coast. *(left)*

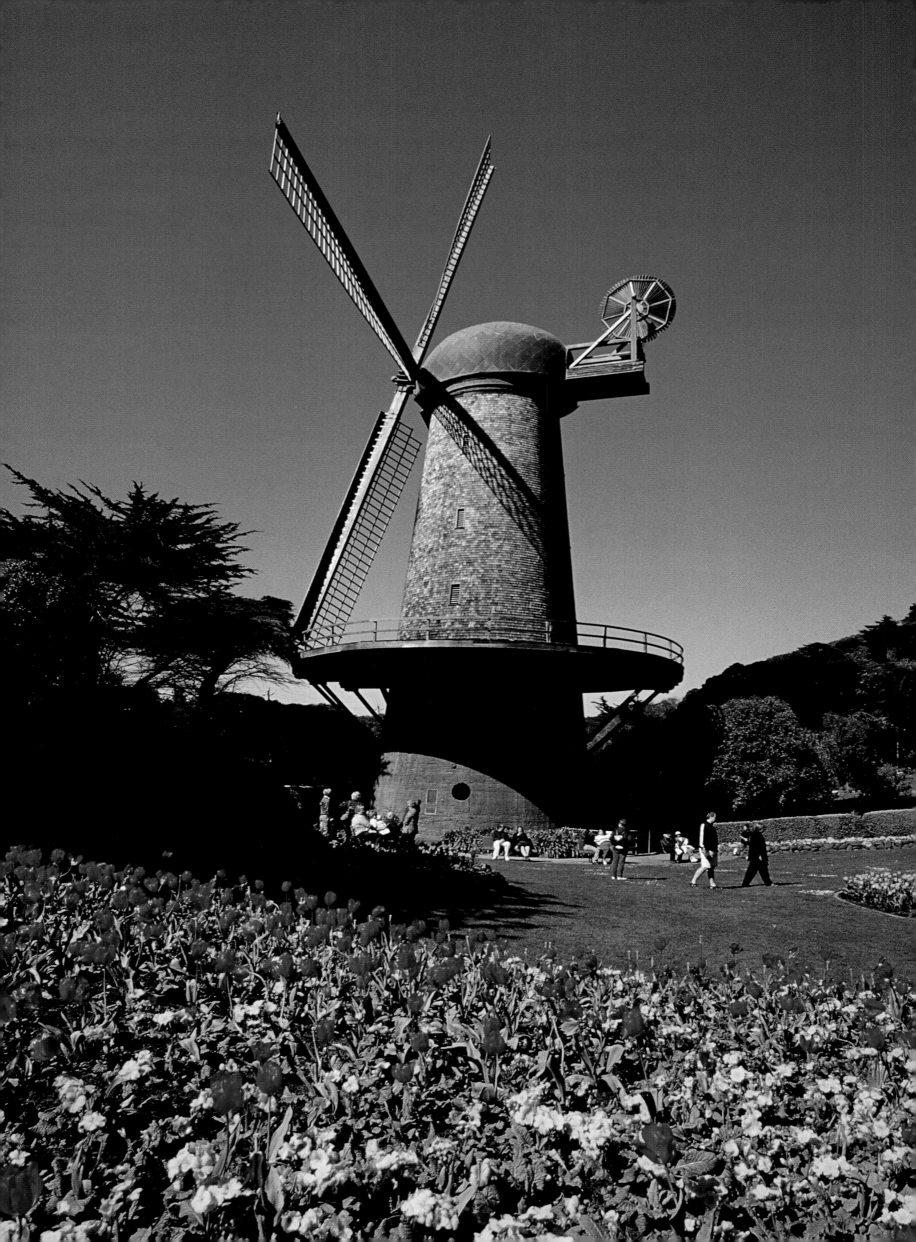

The Russian Ridge Open Space Preserve, located in the Santa Cruz Mountains, is a magnificent place to view California's native grasslands and spring wildflowers. It encompasses about 1,800 acres and includes 8 miles of trails, making it a popular destination for hiking, biking, and horseback riding.

Golden Gate Park is one of the largest urban parks in the world. Created out of sand dunes in the 1890s, this 1,017-acre park has an abundance of unique features that attract thousands of visitors each weekend. Some of its most popular attractions are the Japanese Tea Garden, the De Young Museum, the Academy of Sciences, the Strybing Arboretum, and the Conservatory of Flowers. *(left)*

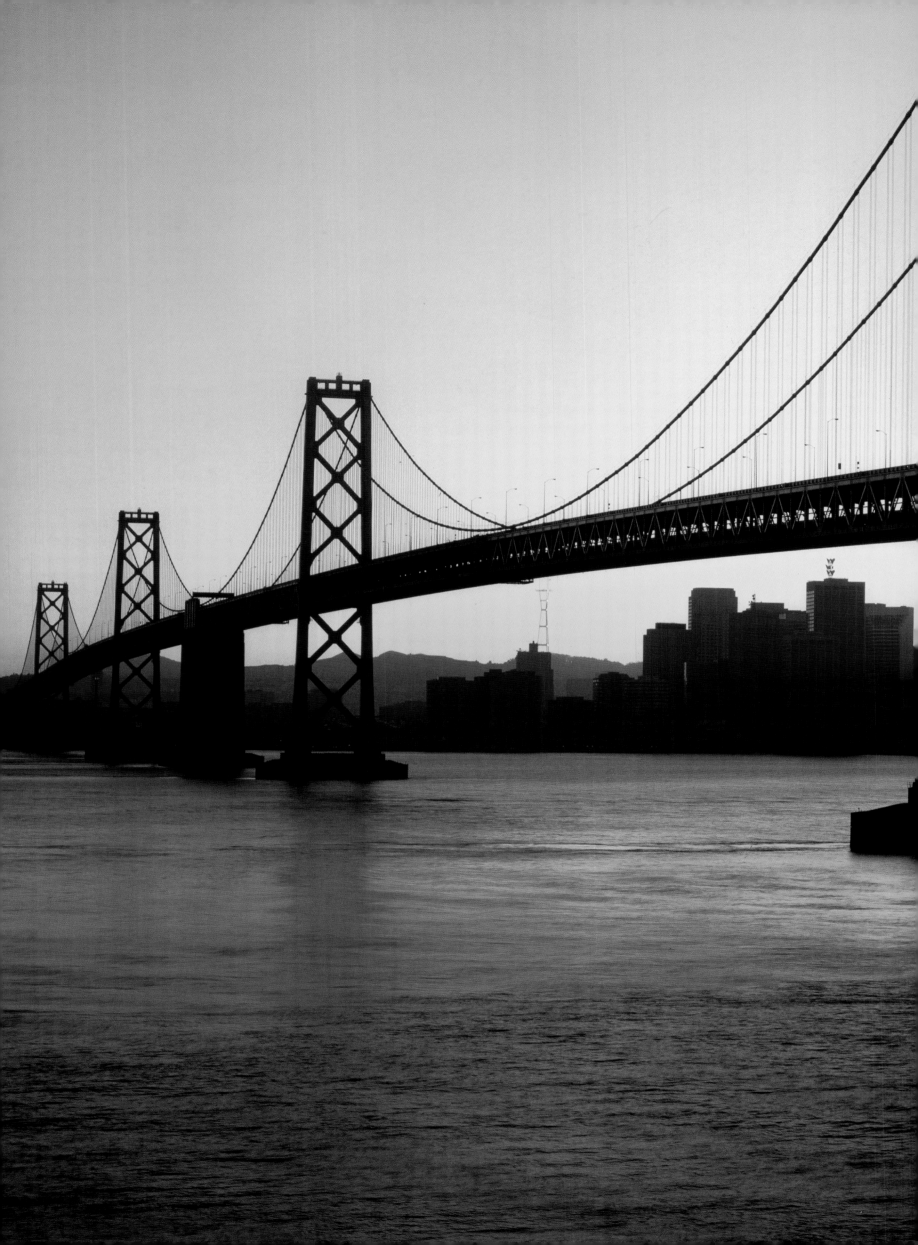

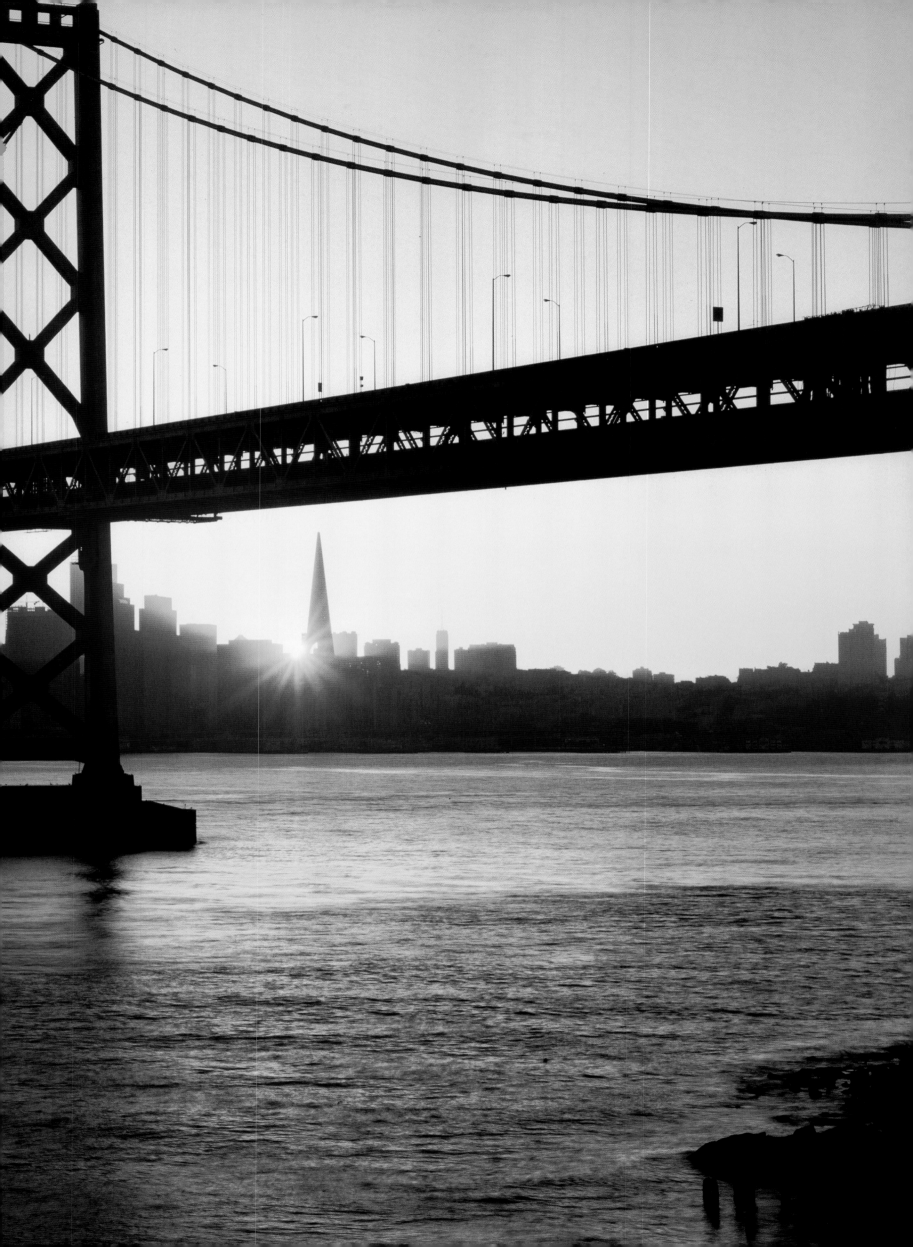

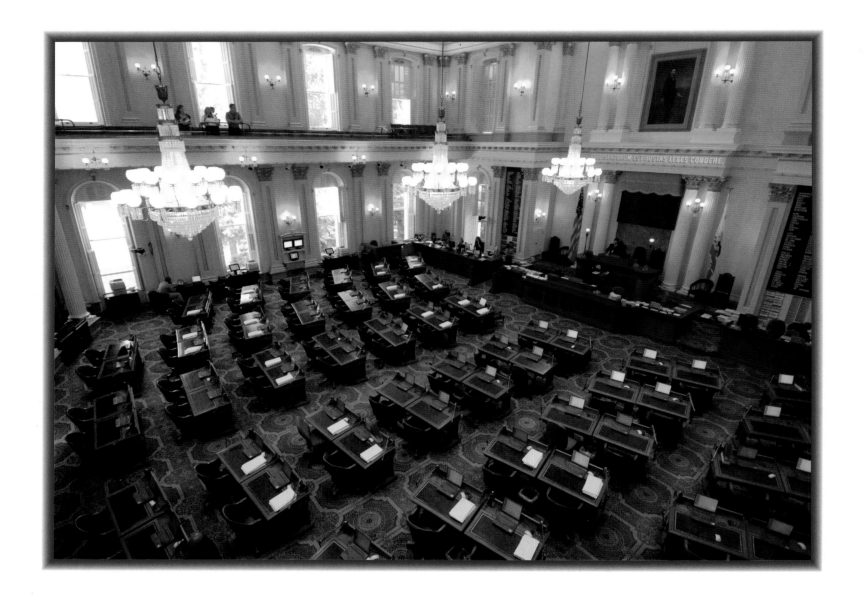

The State Capitol provides visitors with guided tours of the main building and its chambers of the state legislature. It also features a museum that highlights the political history of California.

Sacramento County was established and designated the state capital in 1850, during the California Gold Rush. The magnificent State Capitol building was designed in a Roman Corinthian style by architects Miner F. Butler and Reuben Clark. Its construction took almost 15 years, at a cost of $245 million. It was renovated and restored in the 1970s. *(right)*

The San Francisco–Oakland Bay Bridge opened in 1936, connecting California's two cities, San Francisco and Oakland. It has two major spans that are linked in the middle by a tunnel at Yerba Buena Island. One of the busiest bridges in the United States, it spans over eight miles across San Francisco Bay. *(previous pages)*

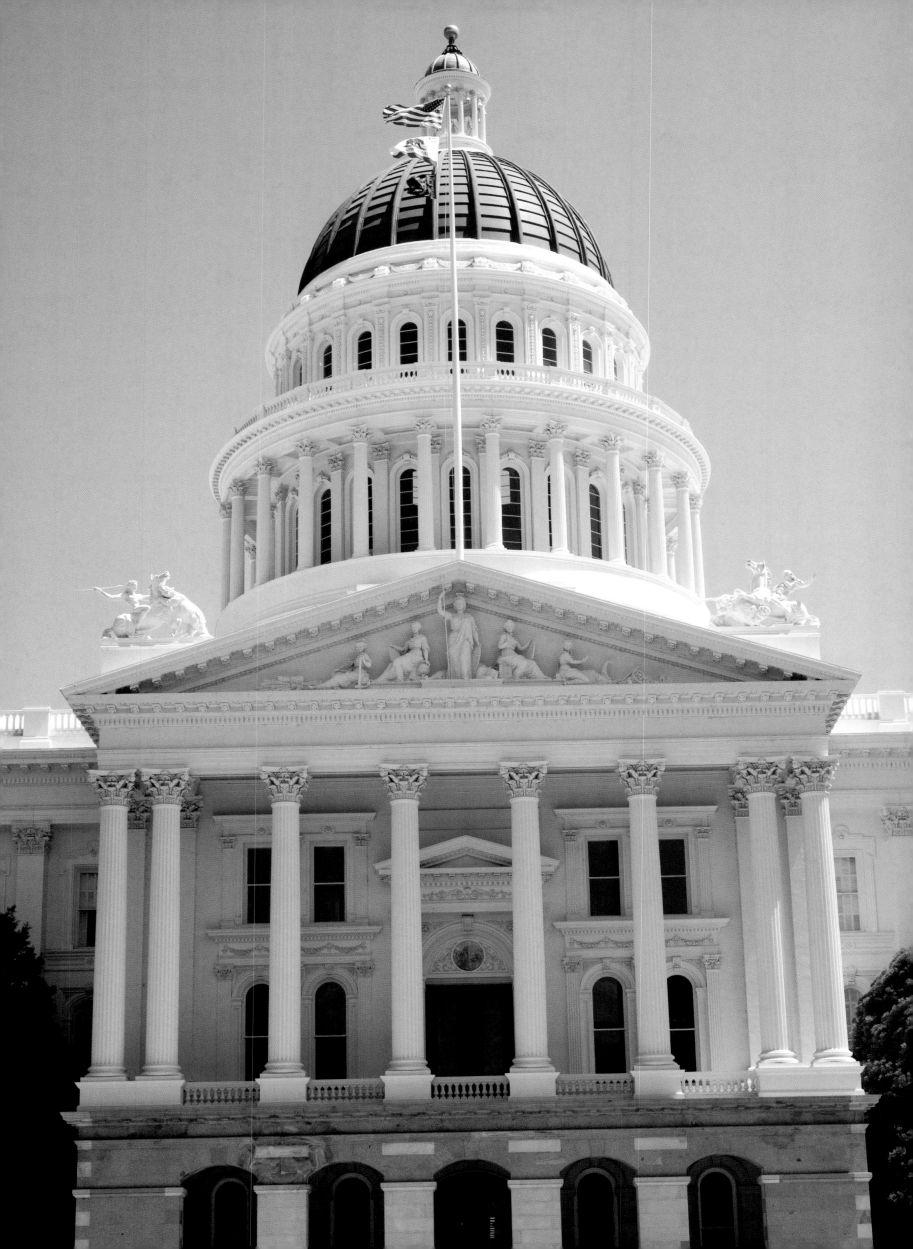

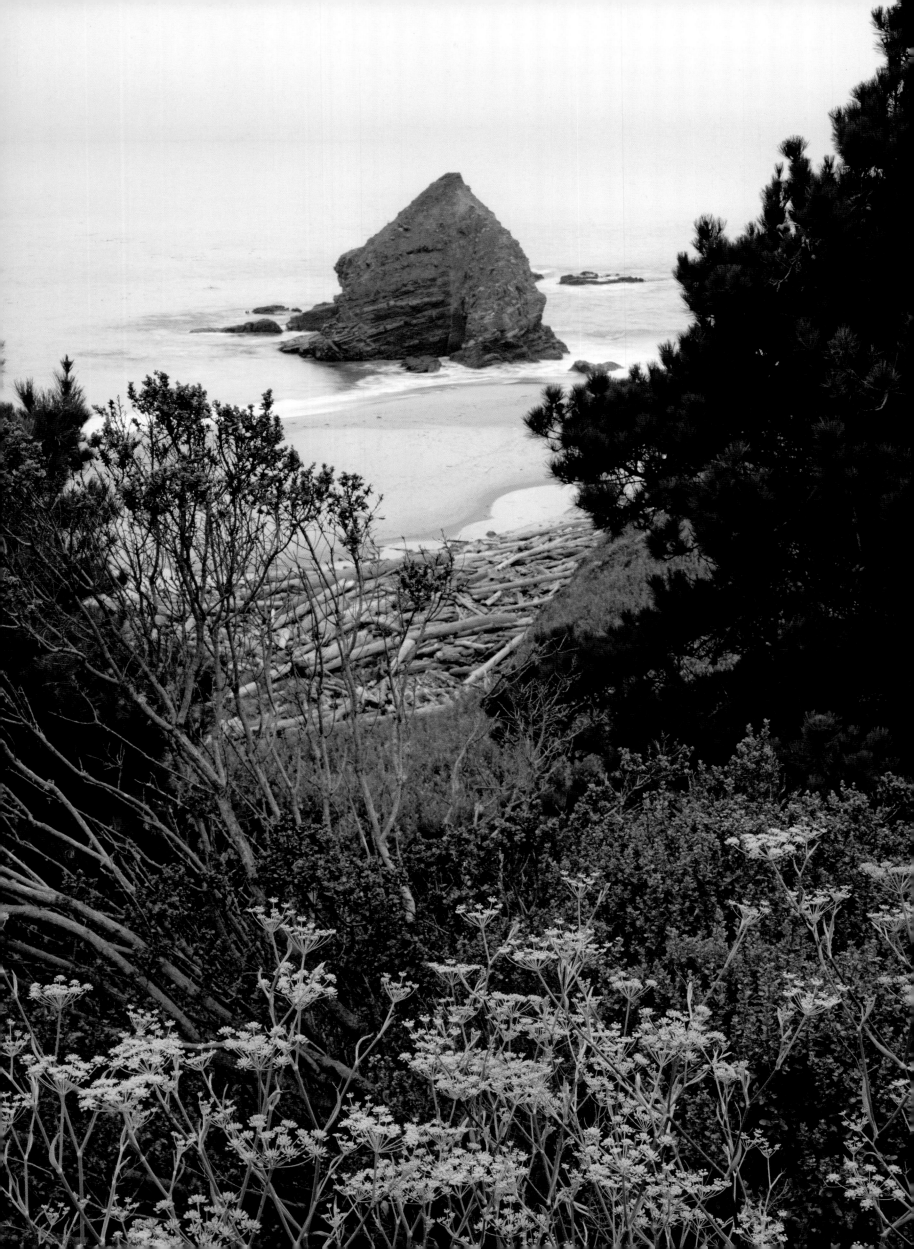

Mendocino Headland State Park is a charming park in northern California's Mendocino County. Visitors can enjoy scenic hikes along its trails, particularly in the spring when the meadows bloom with beautiful wildflowers.

Albion is a quaint coastal town in northern California's Mendocino County. Bordering on the beautiful Pacific Coast, it has become a popular weekend getaway. *(left)*

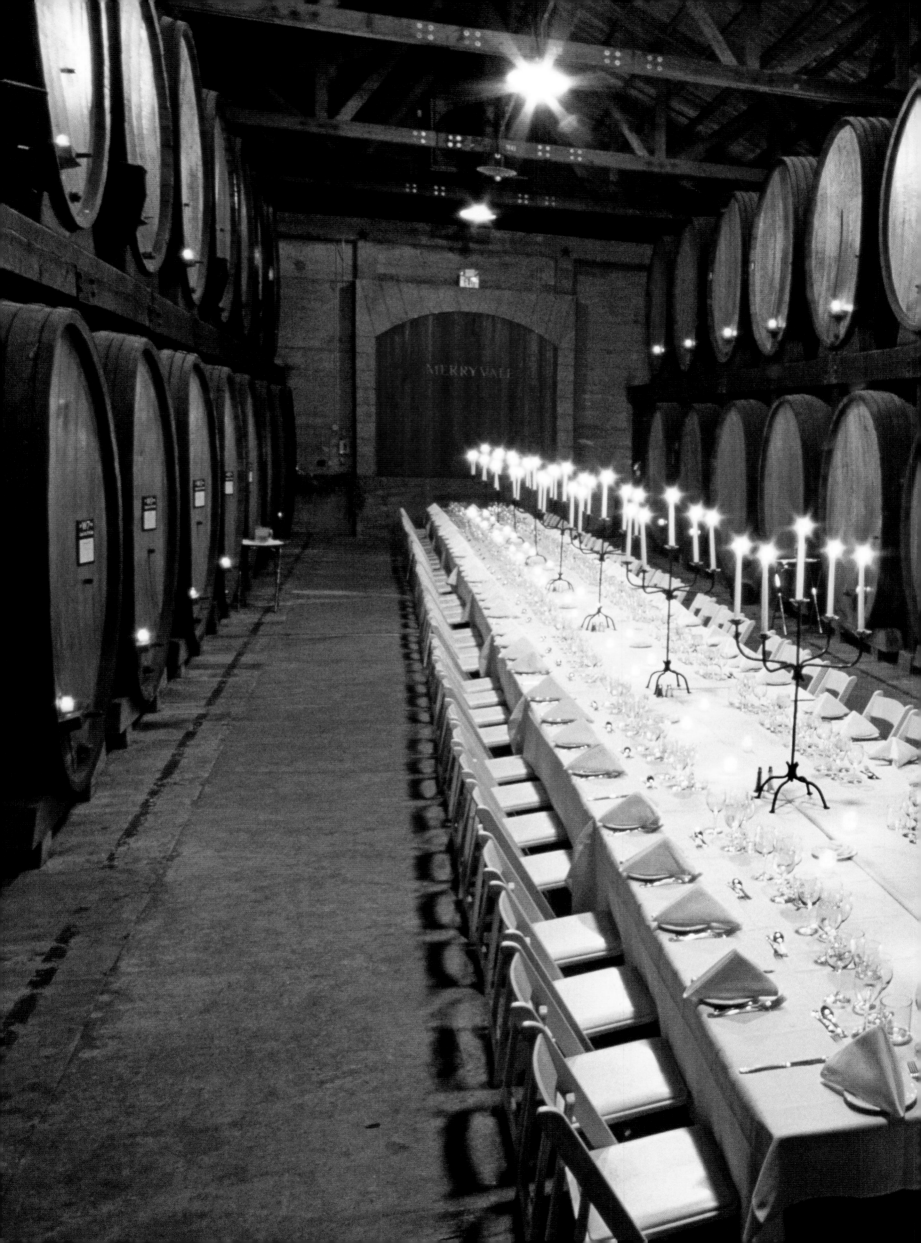

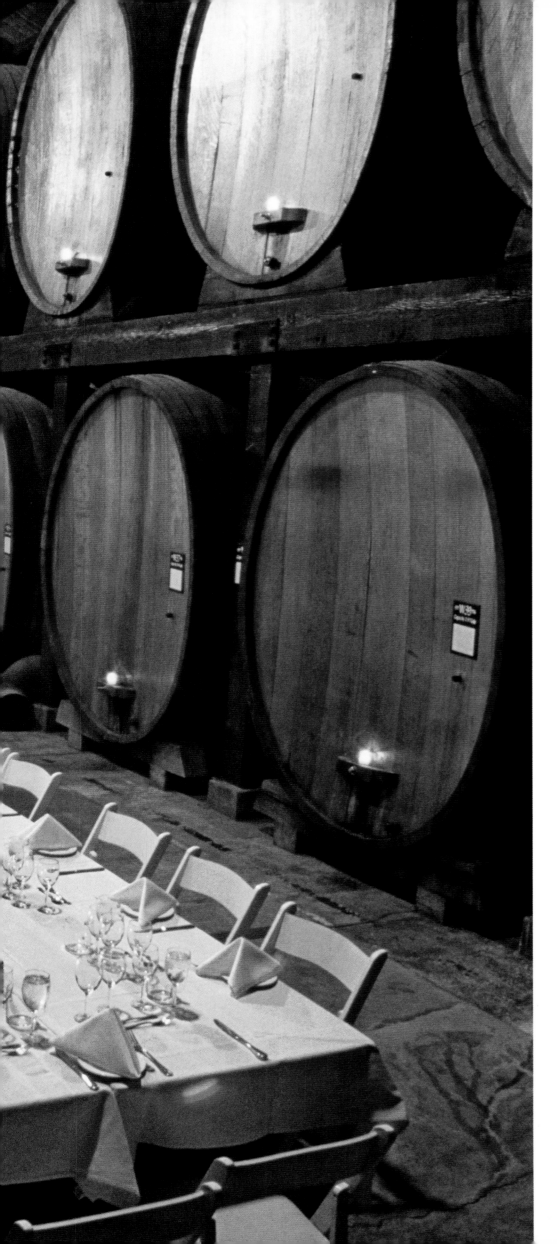

Napa Valley's Merryvale Vineyard features a historic cask room lined with two stories of century-old 2,000-gallon casks. Visitors can enjoy enchanting gourmet dinners with wine in a romantic candlelight atmosphere.

Bowling Ball Beach is one of the many beaches along the beautiful coastline of Mendocino County. It is famous for its distinctive bowling ball-like rocks on the shoreline. *(overleaf)*

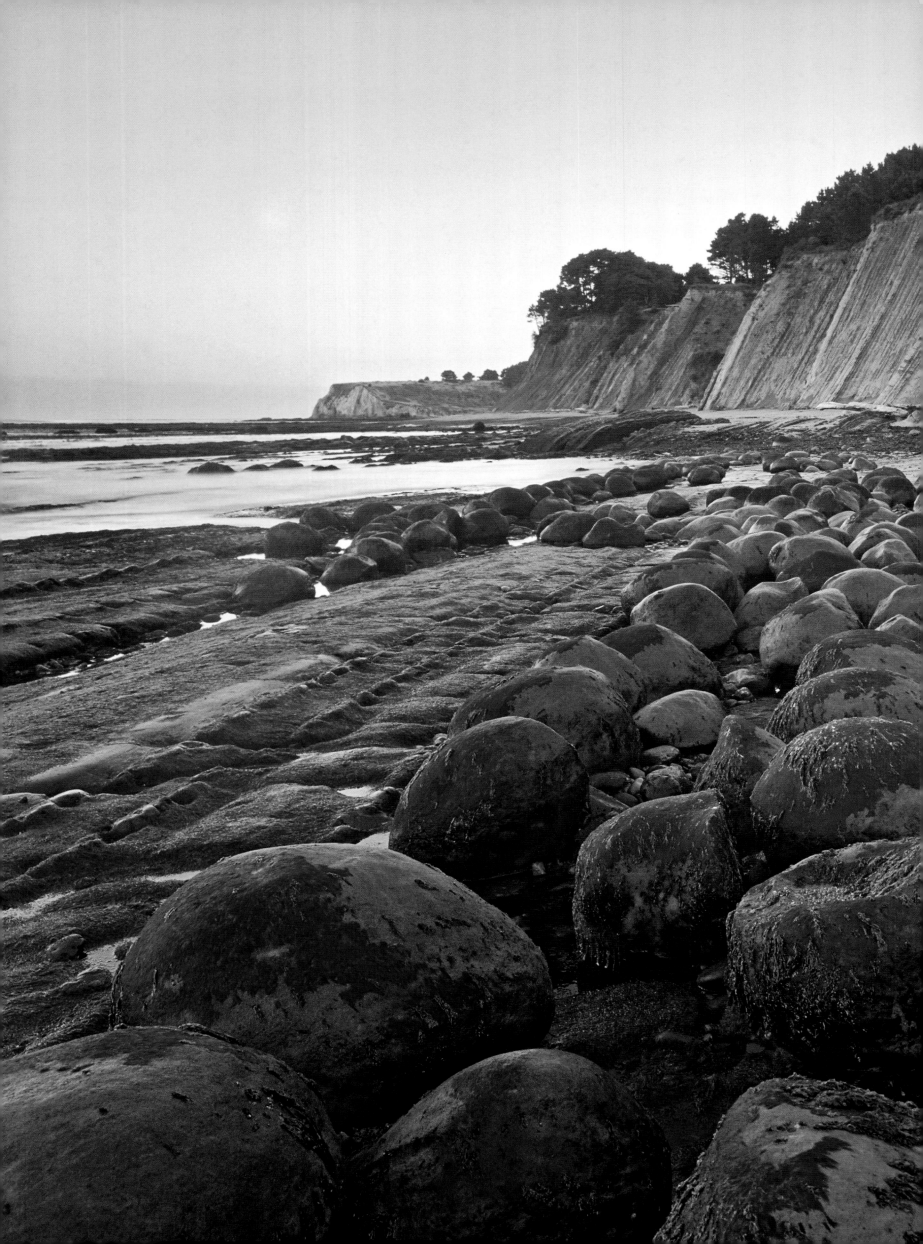

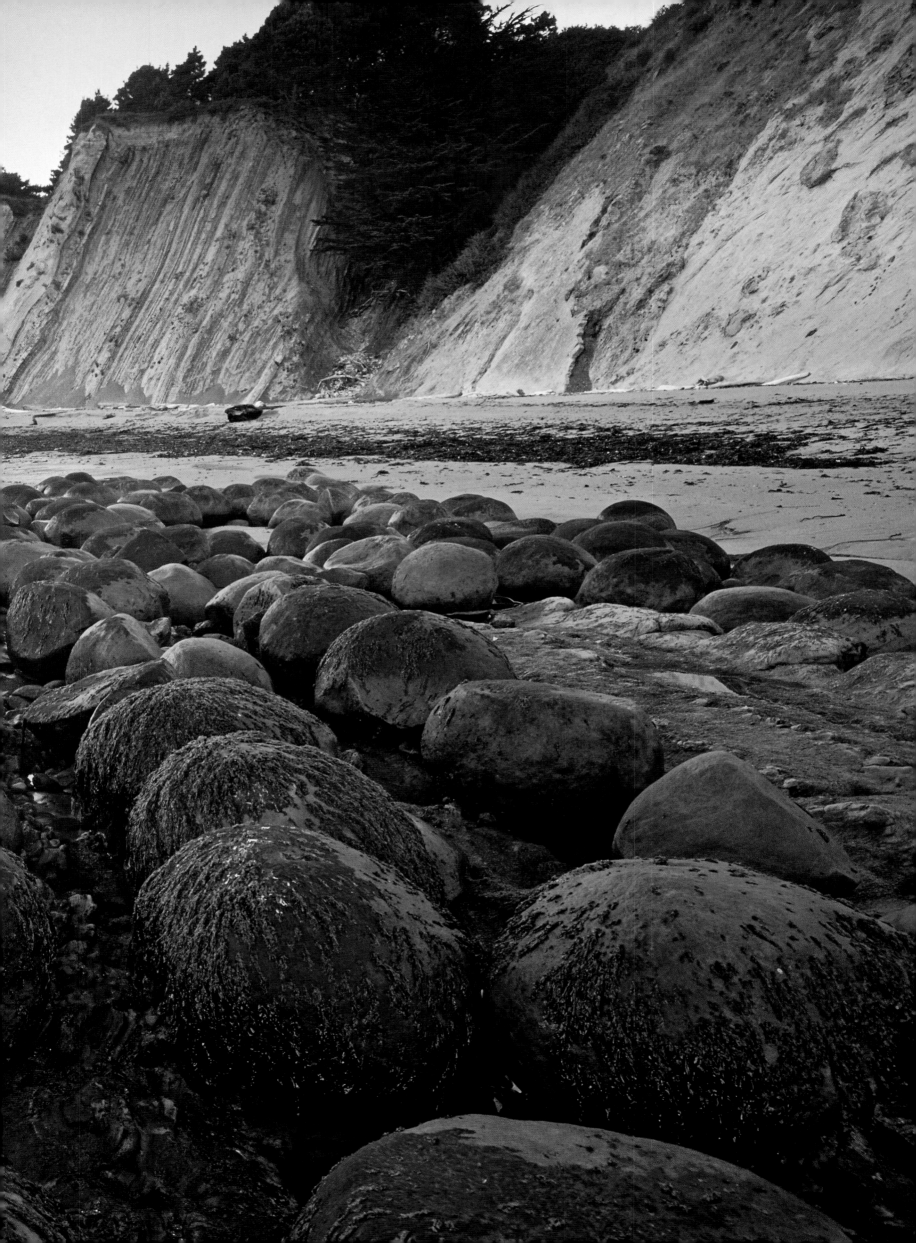

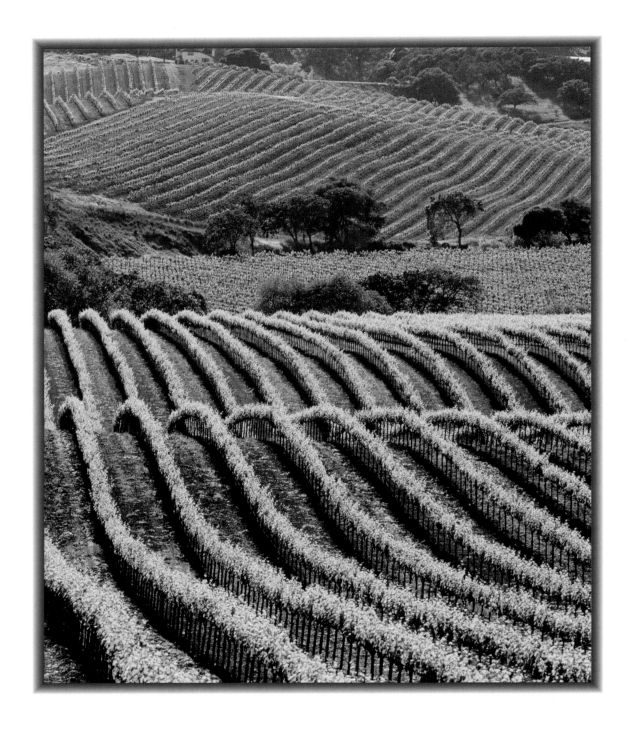

Napa Valley is Northern California's first-class wine-growing region and the premier wine destination in the U.S. Napa, meaning "land of plenty," was named by its first inhabitants, the Wappo Indians. Among its many intoxicating attractions, it features world-class wines, upscale restaurants, wine tours, spas, and hot-air balloon excursions.

Fort Ross State Historic Park, located in California's Sonoma County, features a restored Russian-American Company settlement, colonized from 1812 to 1841. Established to supply Alaska with agricultural food products, its multicultural settlers consisted of Russians, Native Alaskans, Creoles, and Californians. Today visitors come to the park to learn about California's history and world trade. *(right)*

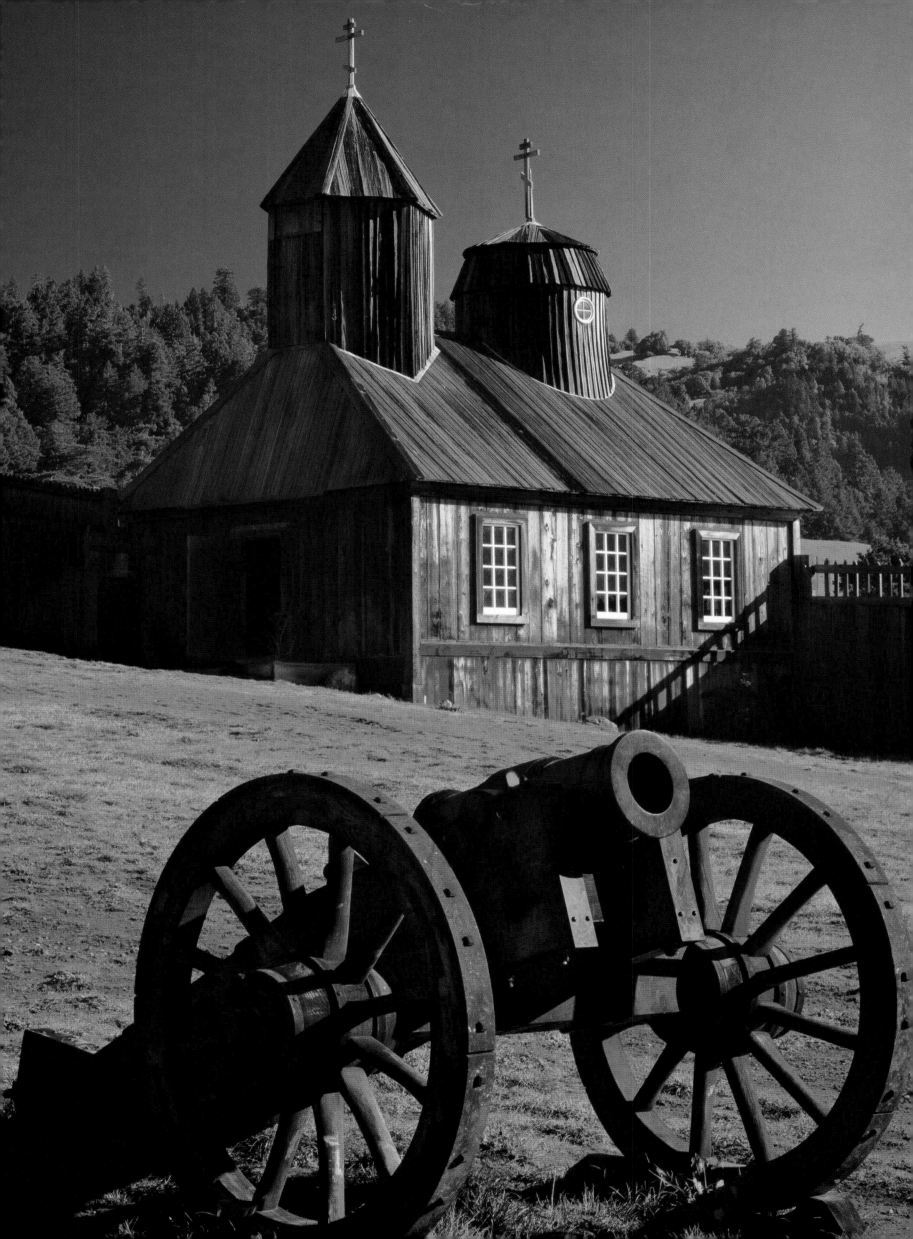

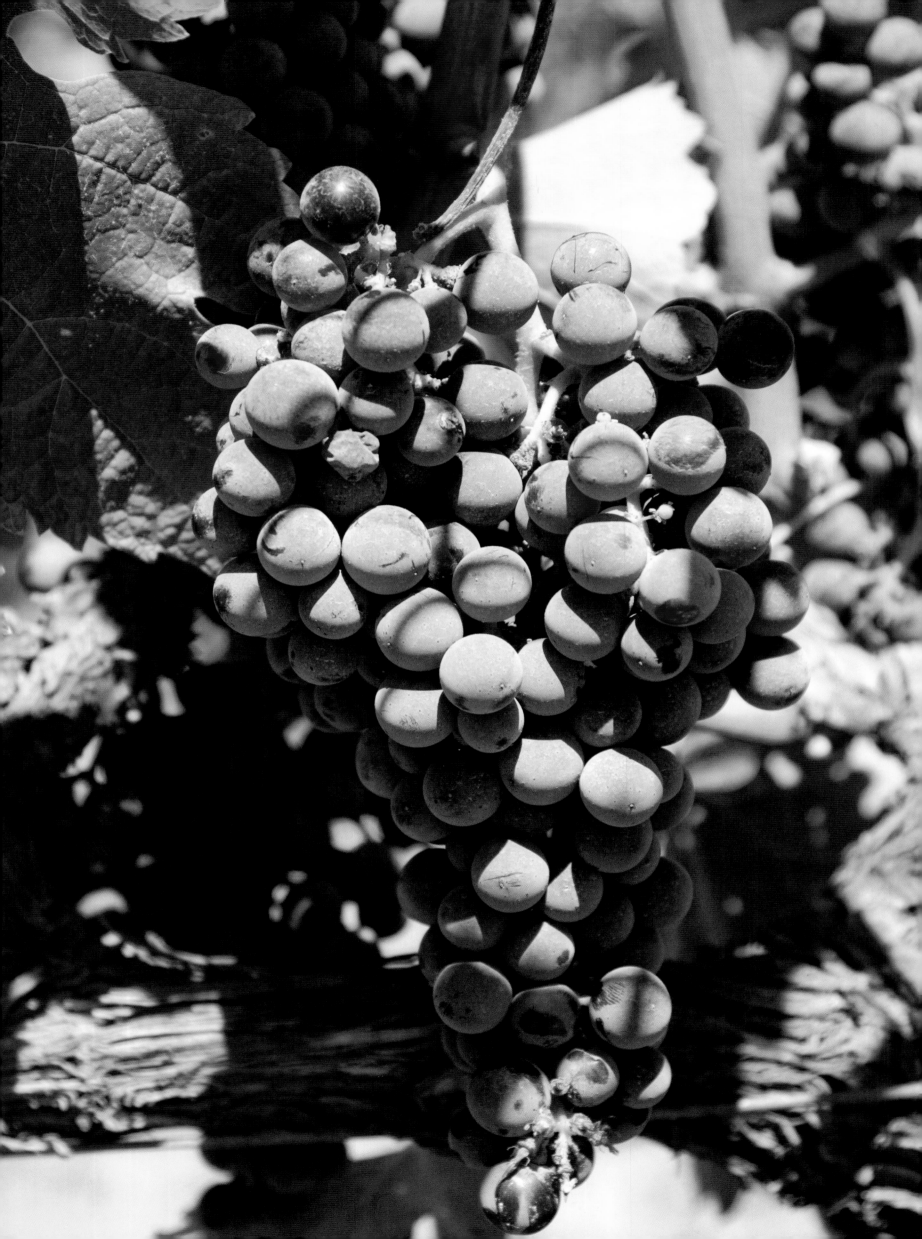

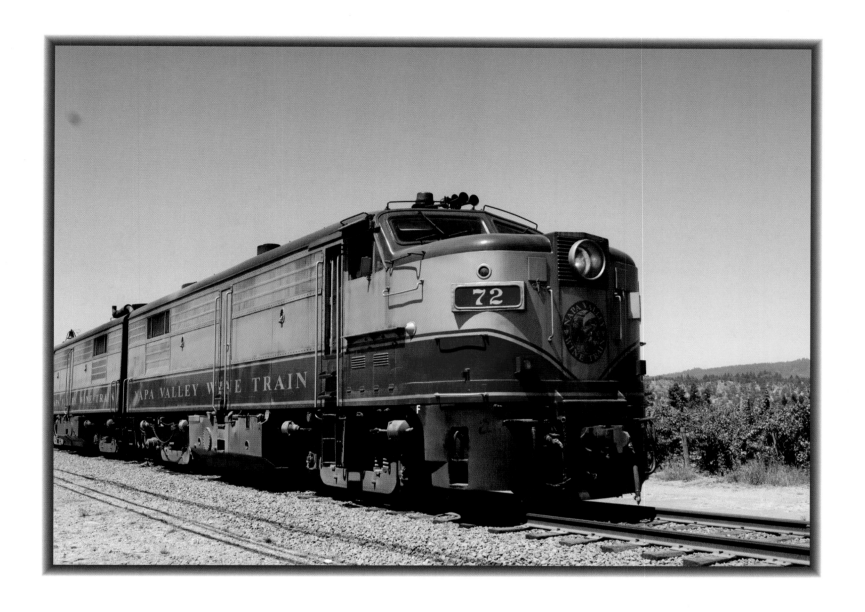

The Wine Train is one of the Napa Valley's feature attractions. Visitors enjoy
a scenic excursion through wine country on a vintage train, featuring gourmet
cuisine and world-class wines.

Northern California's wine country consists of several different counties, featuring
hundreds of world-famous wineries and vineyards. The warm climate and
sheltered valleys make it an ideal wine-growing region. *(left)*

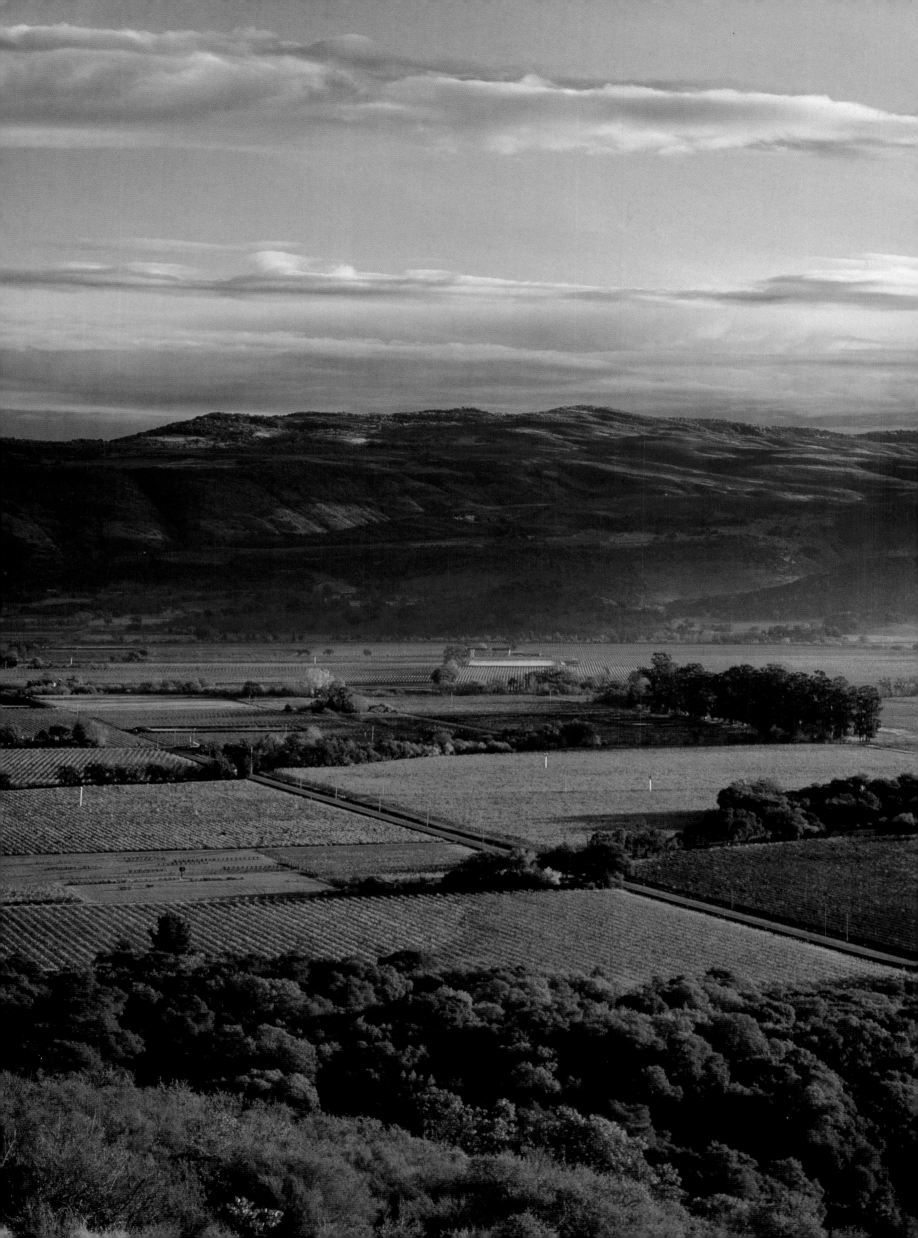

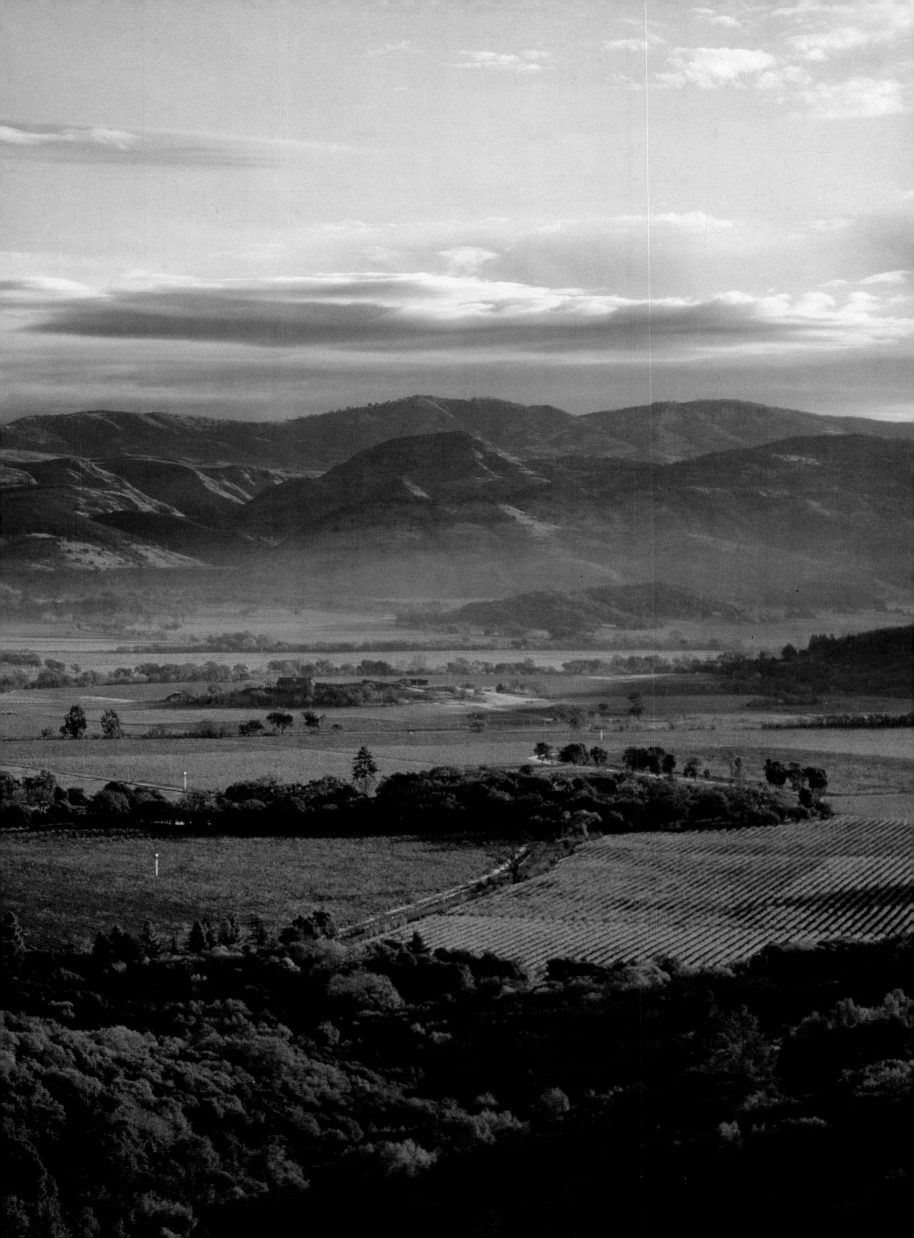

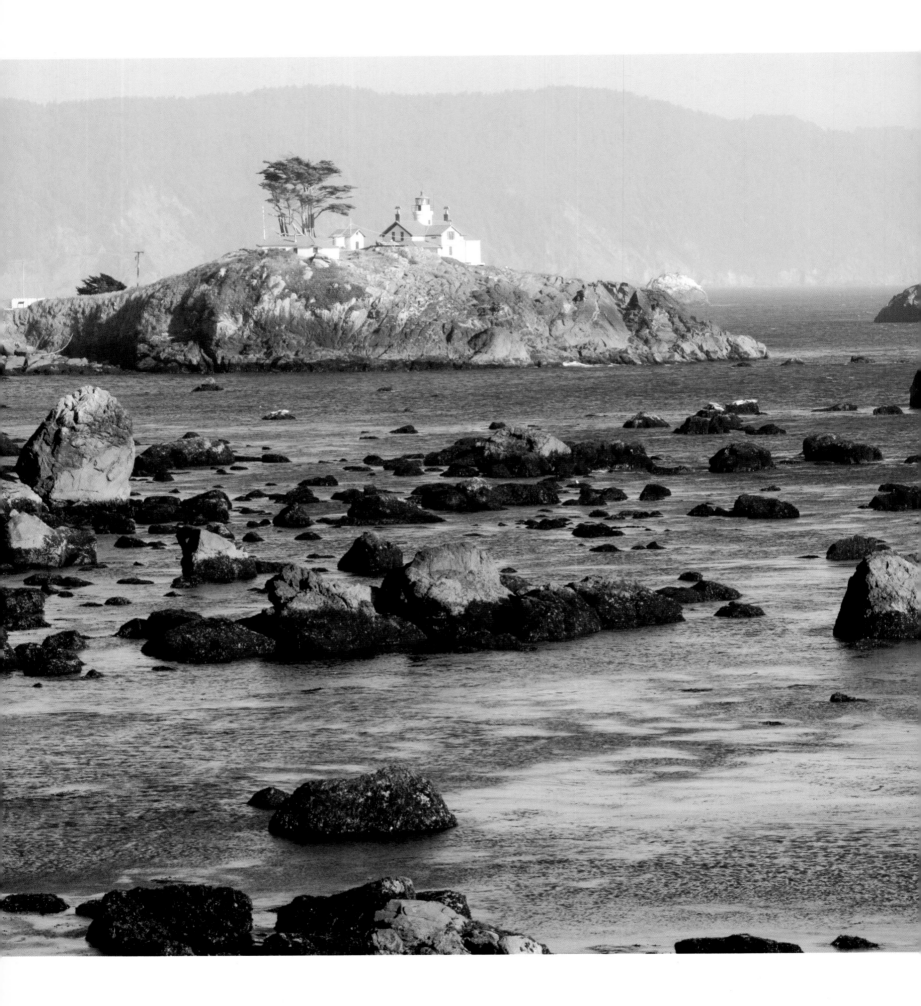

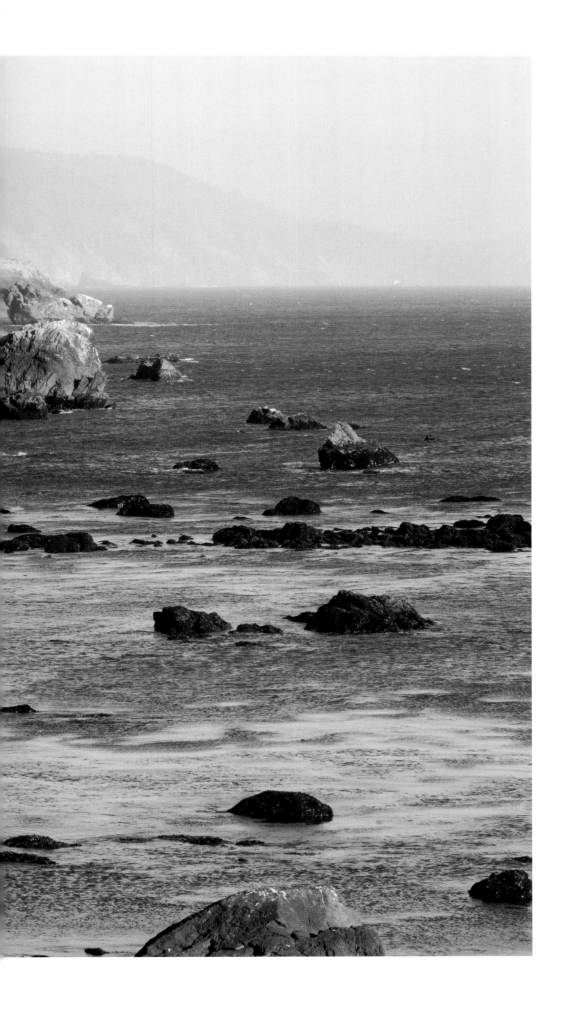

The Battery Point Lighthouse in Crescent City in Northern California was built in 1856. Over 150 years later, this lighthouse stands as a museum and remains active as a private navigational aid.

Napa Valley attracts many visitors during its fall harvest season. Home to over 200 wineries, its 35-mile stretch bursts with spectacular golden vineyards and colorful rolling hills. *(previous pages)*

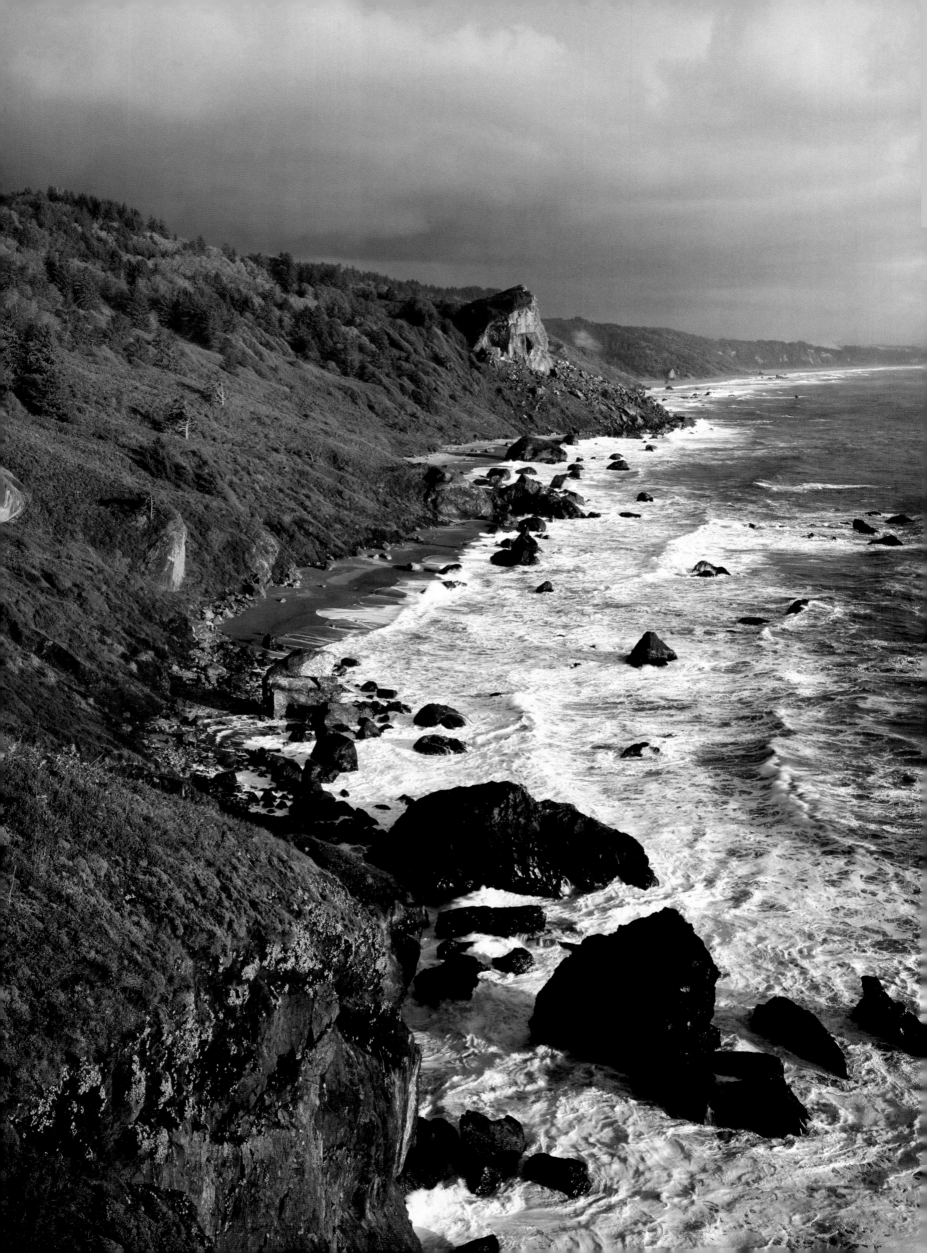

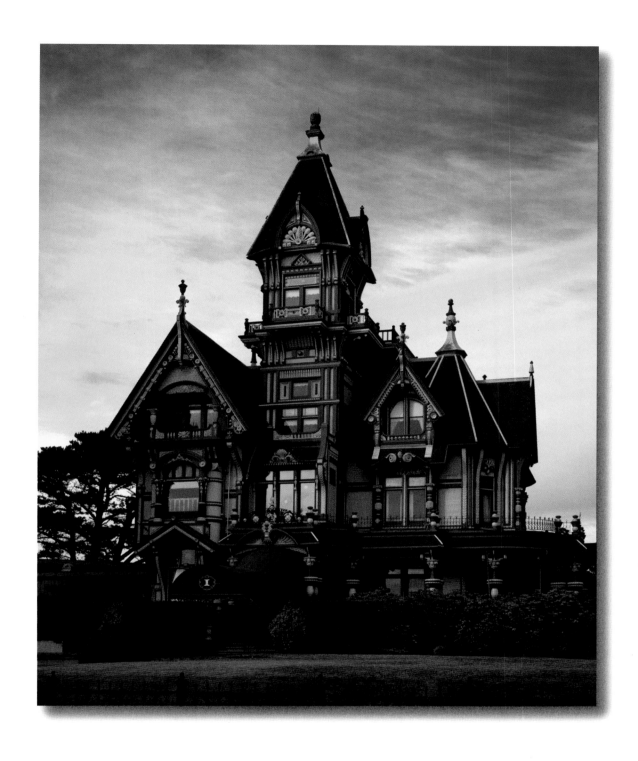

Eureka has a large number of Victorian-style houses, the most notable being the Carson Mansion. It is regarded as "one of the most written about and photographed" Victorian houses in California. As one of Eureka' s richest citizens, timber wholesaler William Carson had the house built of redwood, white mahogany, and other exotic woods from around the world. This unique property took over two years and 100 men to build.

The California Coastal Trail, a group of several public trails along the coast, is one of the most adventurous ways to experience the Pacific Coast. Hikers, bikers, equestrians, and wheelchair riders can experience this vast coastline through a variety of day trips or hiking/camping trips of several days. *(left)*

The Trinidad Memorial Lighthouse is a full-size accurate replica of the original 1871 Trinidad Head Lighthouse. The fog bell from the original lighthouse hangs next to the replica. The lighthouse features a memorial for those buried and lost at sea, and each day the bell rings at noon in their memory.

The second highest volcano in the Cascade Range, Mount Shasta reaches up to 14,161 feet. Located in Siskiyou County in Northern California, Mount Shasta provides year-round recreational activities. Poet Joaquin Miller once described it as follows: "Lonely as God, and white as a winter moon, Mount Shasta starts up sudden and solitary from the heart of the great black forests of Northern California." *(overleaf)*

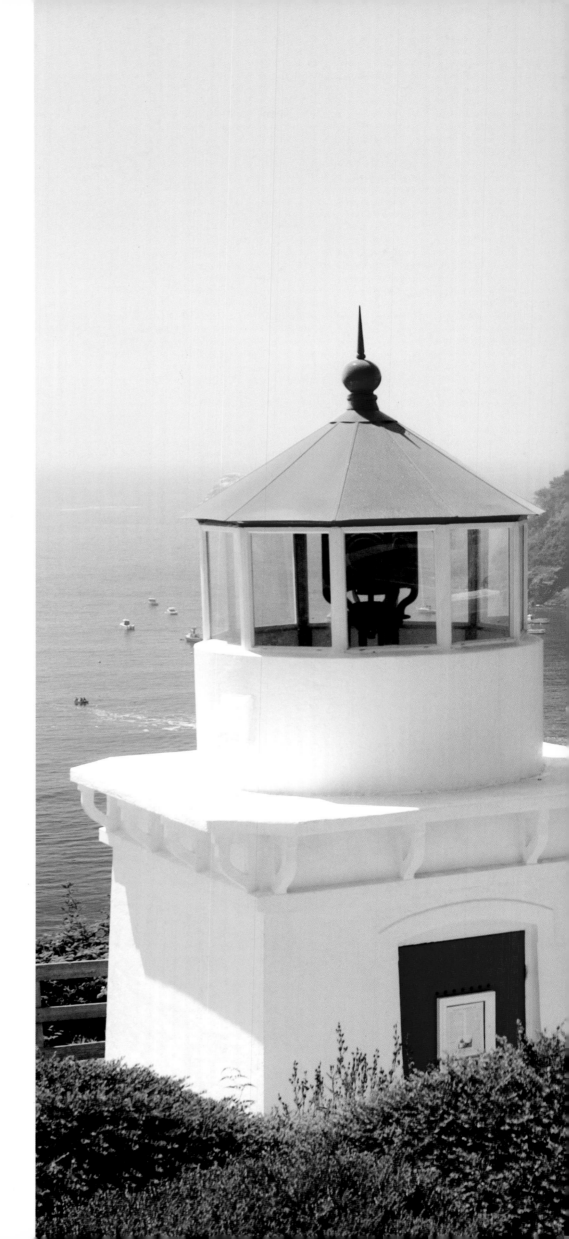

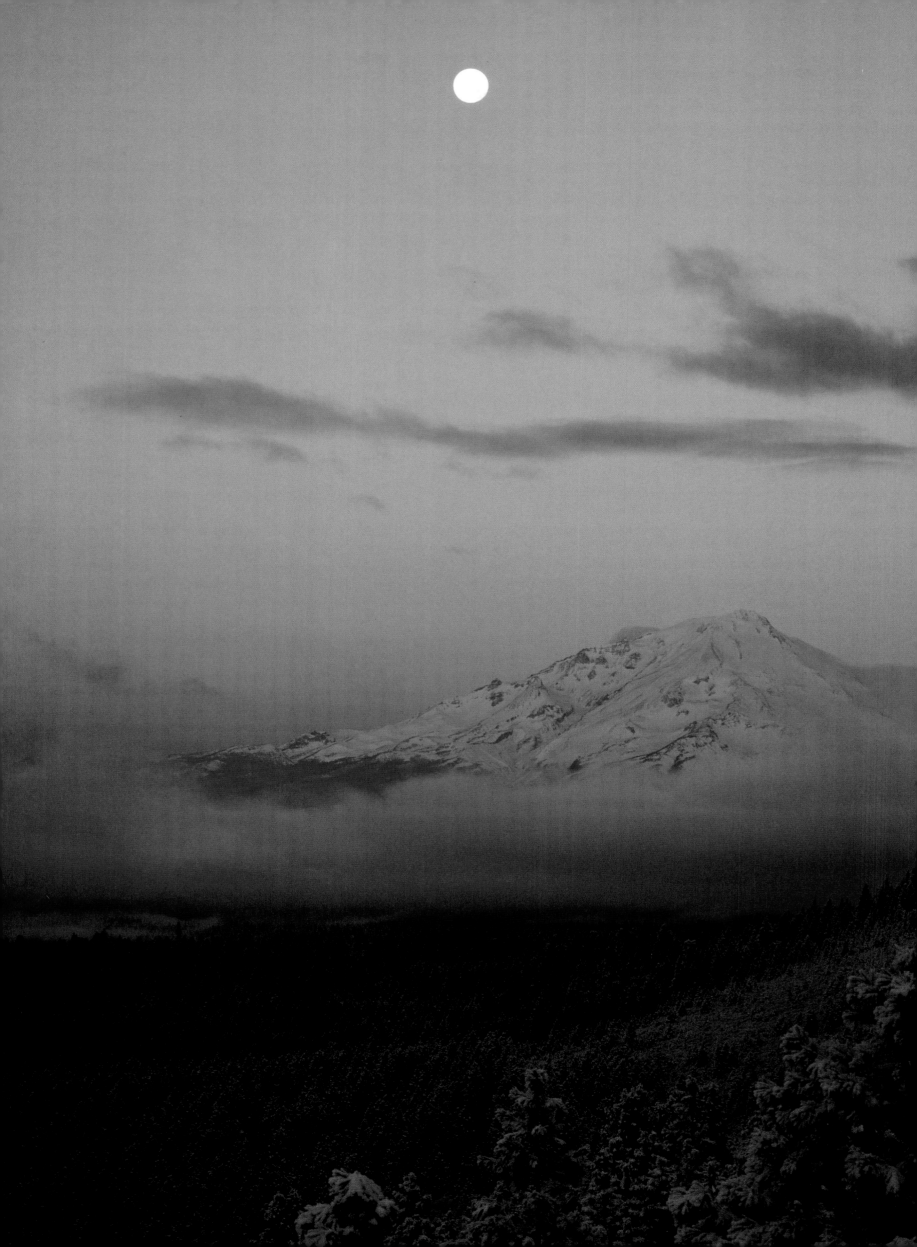

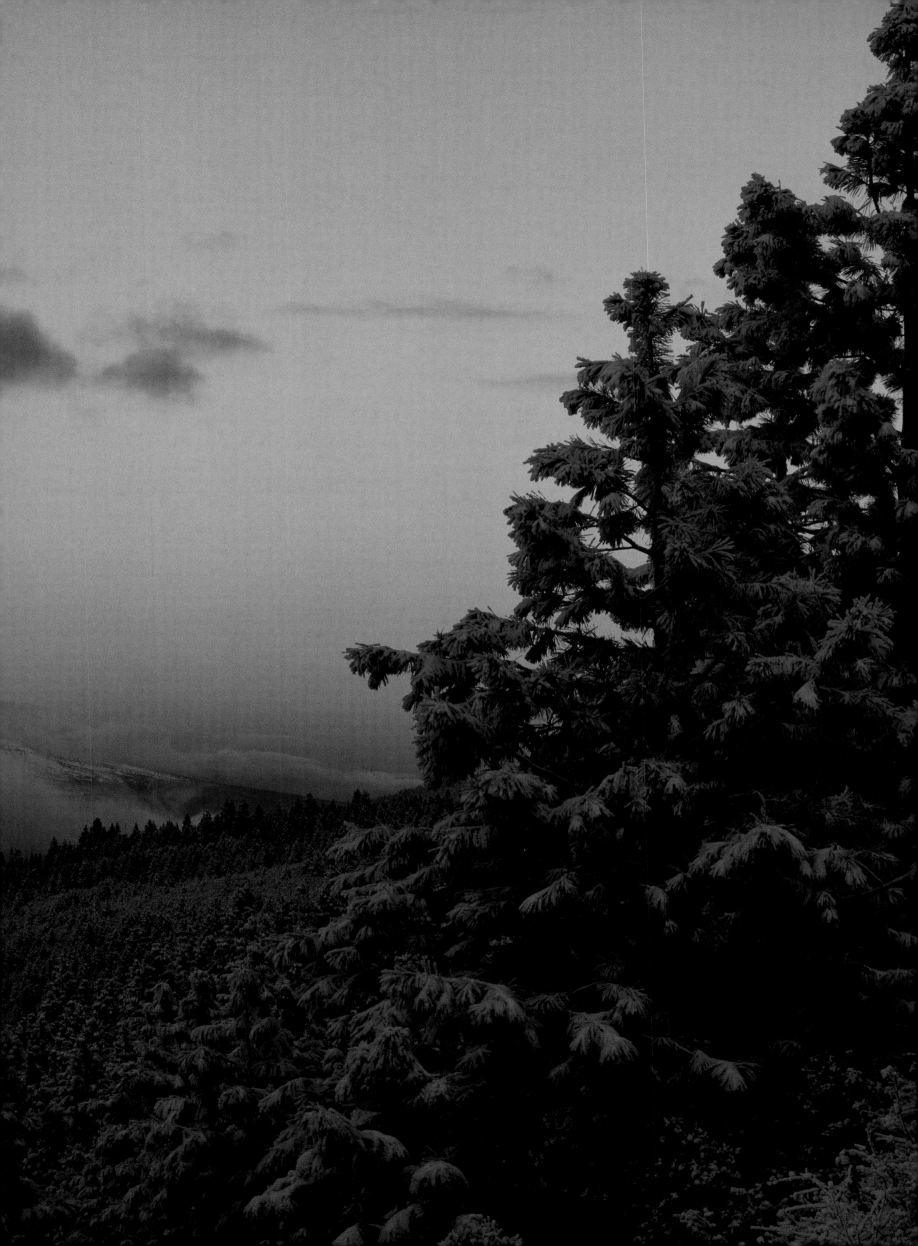

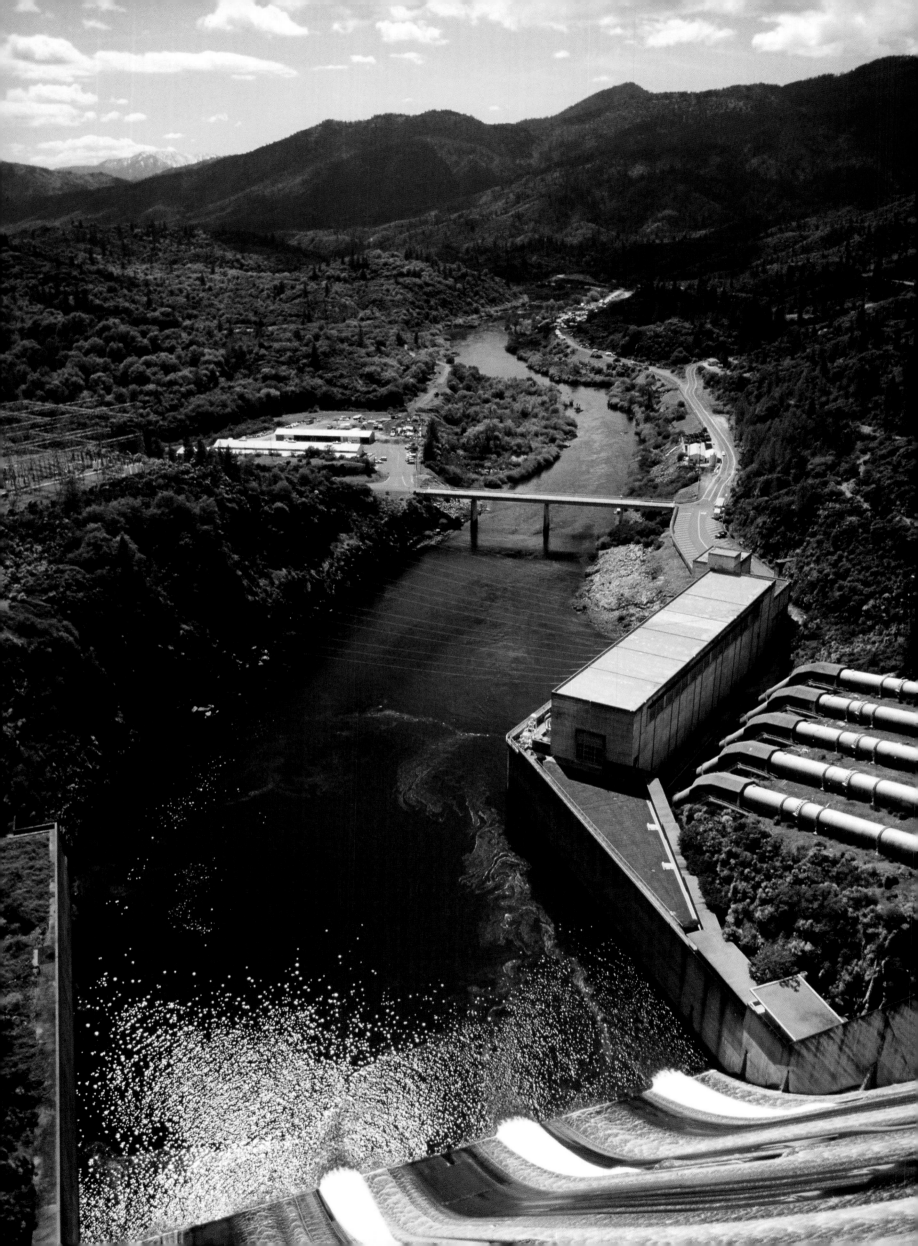

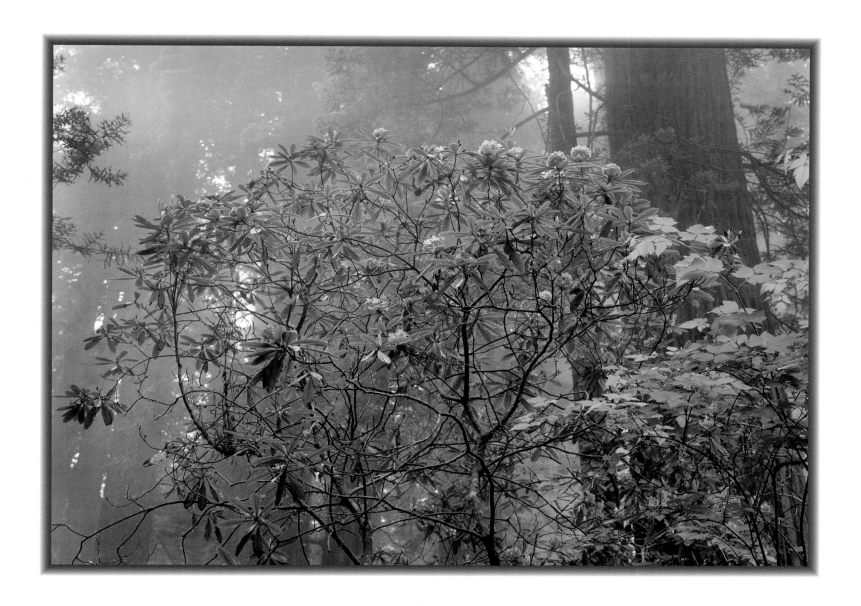

In the spring, alluring pink and purple California native rhododendrons embroider the Redwood Forest. These beautiful flowers are in bloom mid-May to early June.

The Shasta Dam above Redding, California, is situated on the Sacramento River. The construction of this curved gravity dam began in 1938 and was completed in 1944. It has a height of 602 feet, a length of 3,460 feet, and is considered a great achievement in civil engineering. *(left)*

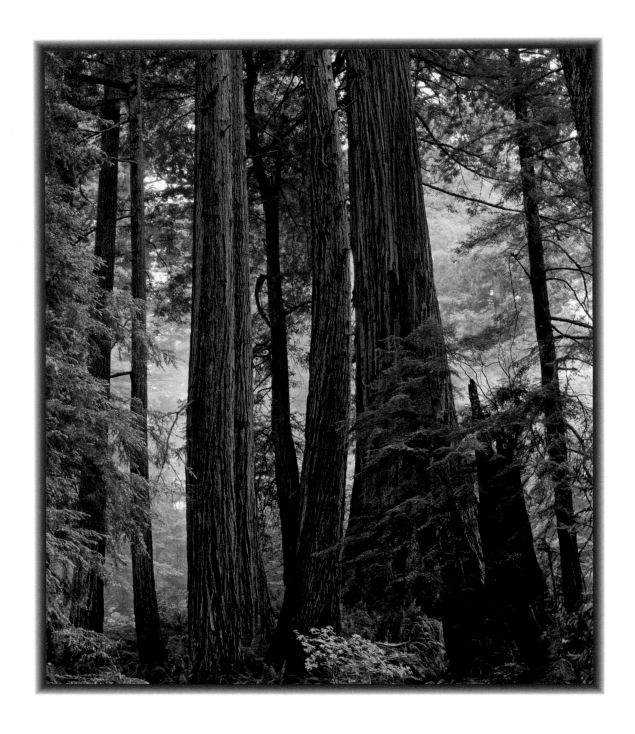

Growing along the northern and central California coast are some of the world's tallest trees: coast redwoods. Four parks have been established in California to preserve these magnificent trees — Redwood National Park, Jedediah Smith Redwoods State Park, Del Norte Coast Redwoods State Park, and Prairie Creek Redwoods State Park.

Coast redwoods can grow taller than 300 feet, with trunk diameters up to 20 feet. On average these ancient trees live up to 600 years, but have been known to survive 2,000 years. *(right)*

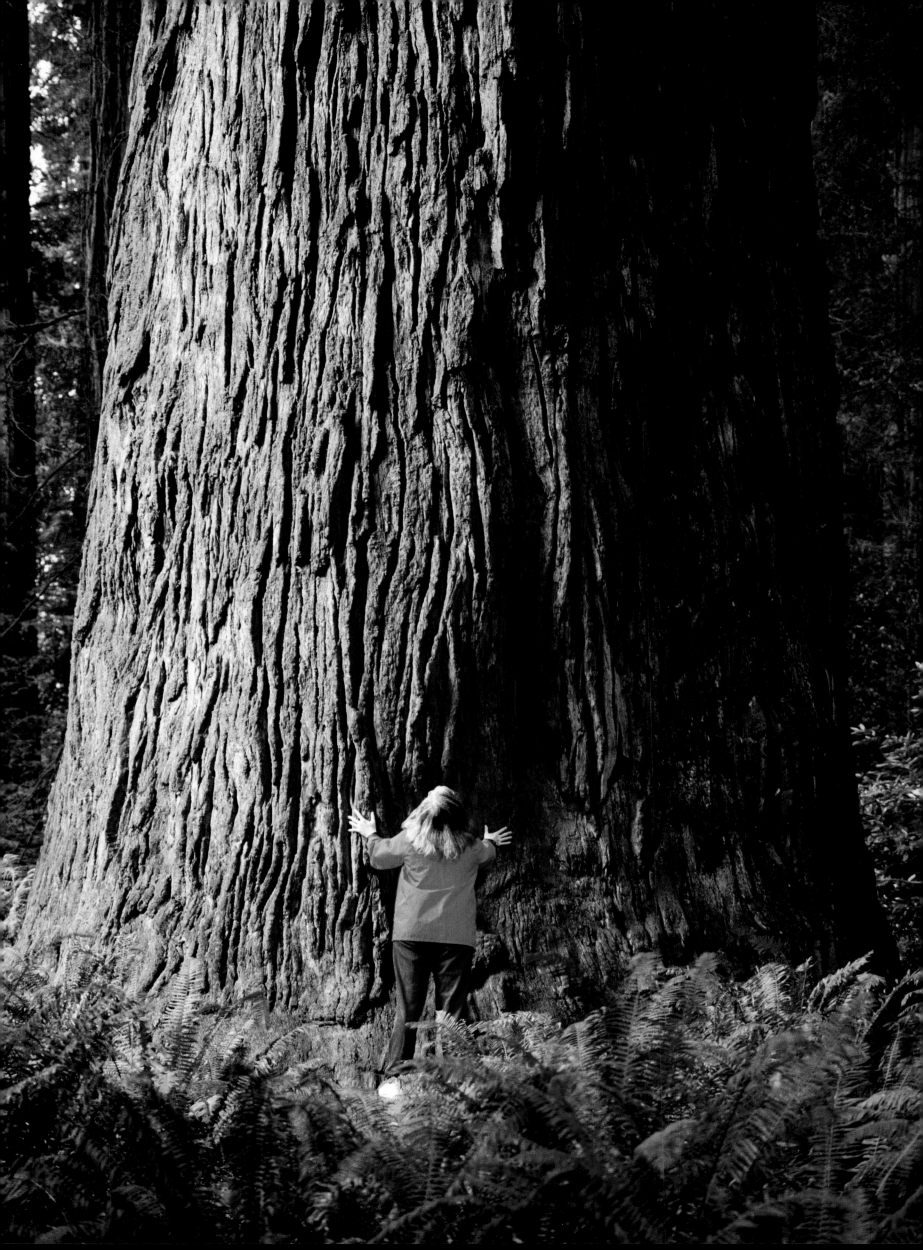

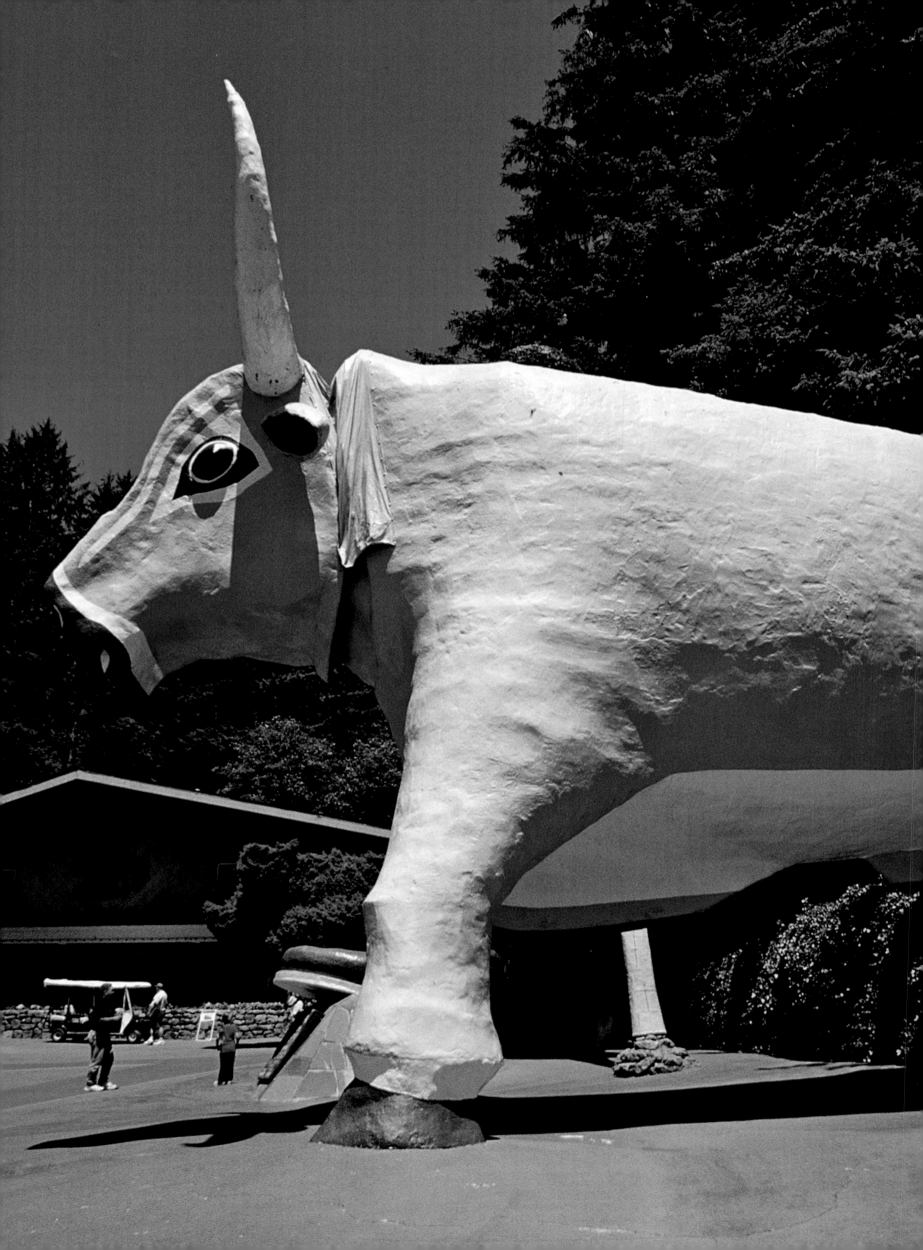

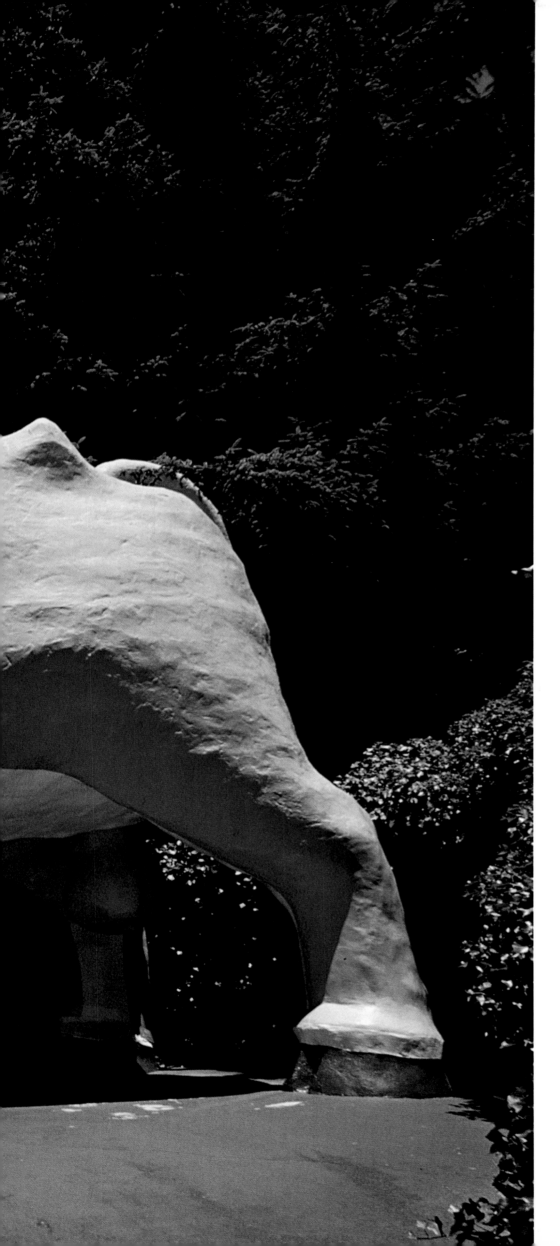

The Trees of Mystery are the feature tourist attraction in northern California's Redwood National Park. Visitors here are welcomed by two enormous fiberglass statues — Paul Bunyan, the legendary folklore hero, stands 49 feet and 2 inches tall, and his companion, Babe the ox, rises up to 35 feet.

189

The Redwood Coast is characterized by the thriving redwood forest, breathtaking cliffs, sea stacks, sandy beaches, and the enchanting surf of the Pacific Ocean. Visitors driving along the coastline can catch magnificent views of primitive beauty.

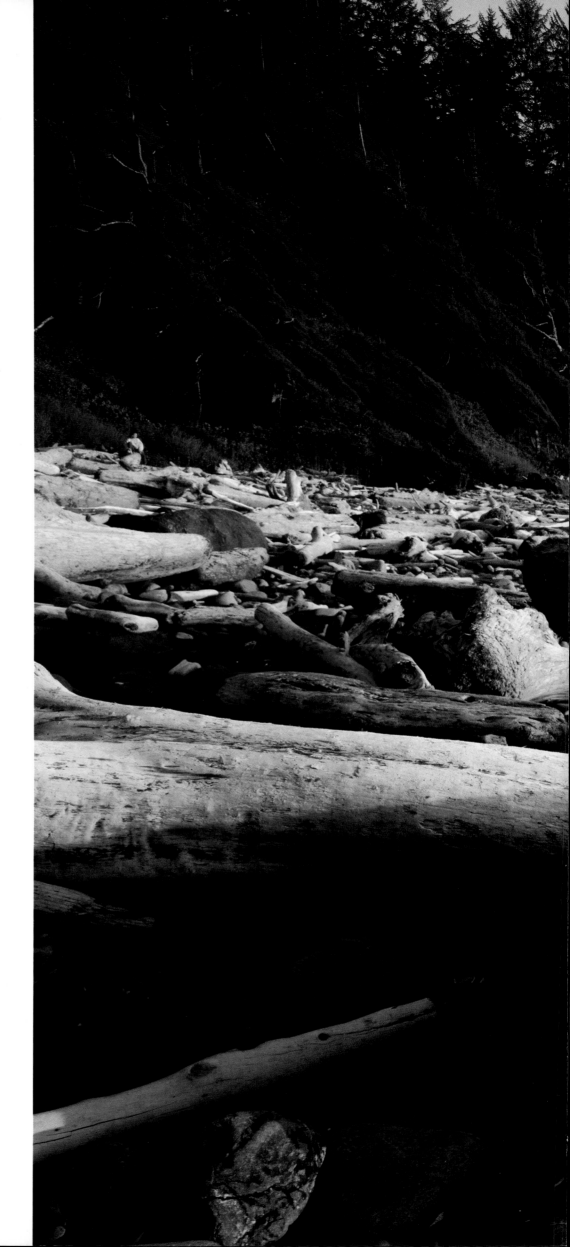

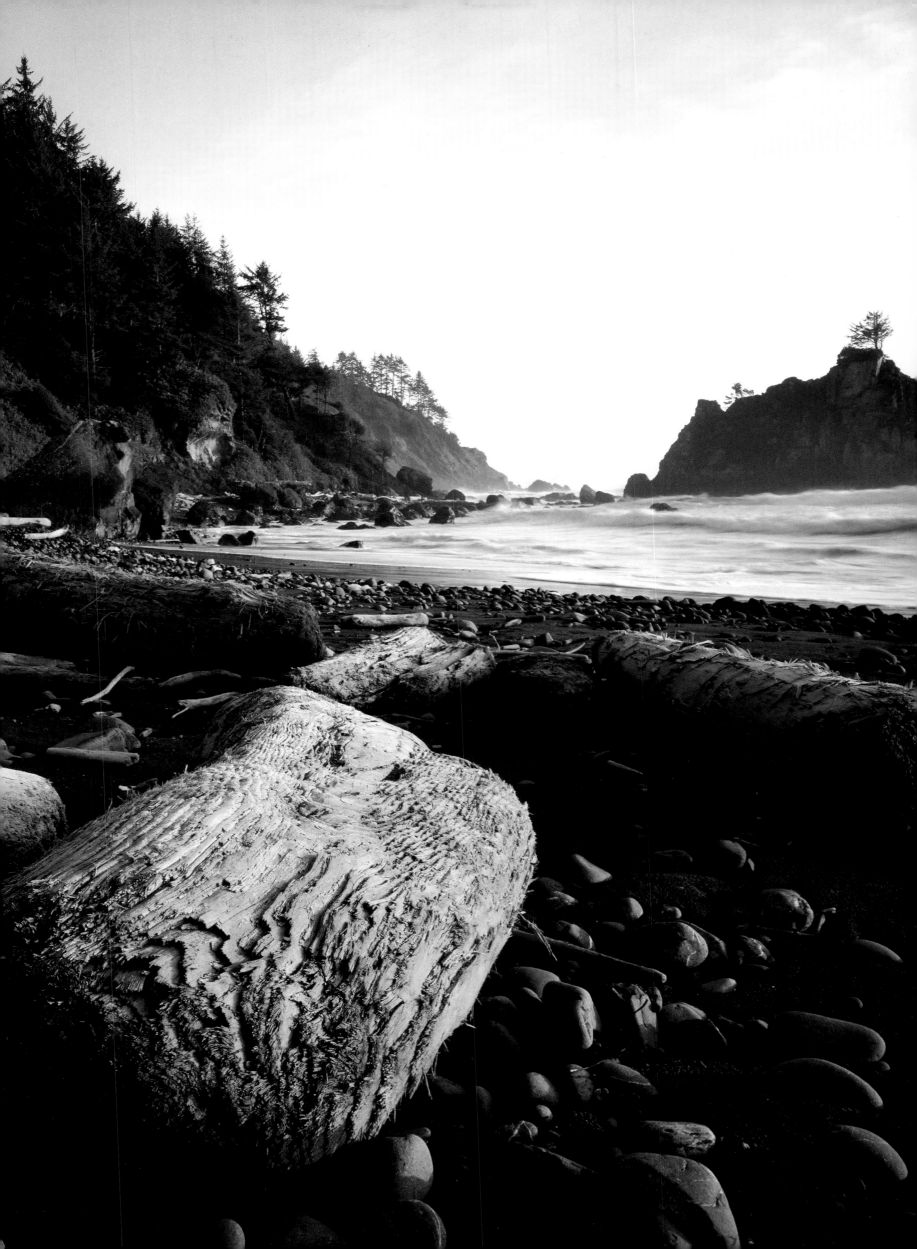

PHOTO CREDITS

Adam Jones/ Dembinsky Photo Assoc. 118–19

Adam Jones/ First Light 124–25

A.G.E. Foto Stock/First Light 1, 64–65, 76–77, 79

Alan Nelson/ Dembinsky Photo Assoc. 178, 190–91

Bill Bachman/ Folio, Inc. 74

B. W. Marsh/ First Light 142

Chris Cheadle/ First Light 132–33

Dennis Flaherty/ First Light 148

Doug Scott/ First Light 93

G. Alan Nelson/ Dembinsky Photo Assoc. 25

Imagestate/First Light 113, 143

Jeff Greenberg/Unicorn stock photos 18, 20–21, 149, 159, 166–67

Jim Corwin/ First Light 184

John Crall/ A.G.E. Foto Stock 60–61

John W. Warden/ A.G.E. Foto Stock 50

José Fuste Raga/ First Light 98–99

Jürgen Vogt 22, 32–33, 38–39, 44–45 , 54–55, 69, 72–73, 86–87, 97, 112, 128–29, 135, 152, 156, 157, 162, 163, 172, 173, 176–77, 180–81

Kevin Schafer/ First Light 14–15

Larry Ulrich 2, 160–61, 170, 174–75, 179

Liane Cary/ First Light 90

Londie G. Padelsky/Larry Ulrich 92

Mark E. Gibson/Folio 108, 136–37

Mark E. Gibson/Unicorn stock photos 19, 91

Mark Newman/ First Light 52

Michael Burch 23

Mode Images/First Light 187

P. Coll/ First Light 171

Paul Higley/Larry Ulrich 182–83

Picture Finders Ltd./First Light 146–47

R. Matina/ First Light 78–79

Richard Cummins/ Folio 16–17, 40–41, 42–43, 46–47, 53, 51, 58–59, 66, 67, 68, 75, 88–89, 106–07, 109, 153, 155, 158, 188–89

Richard T. Nowitz/ Folio 114–15

Robert Rathe/ Folio 150–51

Spencer Grant/First Light 80

Steve Mulligan 34–35, 48–49, 110–11, 164

Terry Donelly/ Dembinsky Photo Assoc. 28–29

Tim Fitzharris 5, 6–7, 8–9, 10–11, 12–13, 24, 30–31, 36–37, 56–57, 62–63, 82–83, 94–95, 96, 100–01, 102–03, 104, 105, 116–17, 120, 121, 130–31, 134, 138–39, 140–41, 144–45, 165, 168–69, 185, 186

Tom Till 26–27, 70–71, 122–23, 126–27

Walter Bibikow/ Folio, Inc. 81, 154

Wendy Connett/ First Light 84–85